W9-DAM-649

COLBY JUNIOR
COLLEGE

TOWN·OF·NEW·LONDON
1779
NEW·HAMPSHIRE

COLBY JUNIOR COLLEGE FOR WOMEN
PARAT AE SERVIRE
CONPUS
1837

FRIENDS
OF THE
LIBRARY

René Gardi African Crafts and Craftsmen

René Gardi African Crafts and Craftsmen

English translation by Sigrid MacRae

VNR VAN NOSTRAND REINHOLD COMPANY
NEW YORK CINCINNATI TORONTO LONDON MELBOURNE

TT
119
W4
G313

59743

Graphic design	Hans Thöni, Grafiker VSG/SWB, Bern
Photos of artifacts	Karl Buri, Historical Museum, Bern
All other photos	René Gardi
Gravure	Prolith AG, Bern
Typesetting	Cooper & Beatty, Limited, Toronto
Offset printing	Büchler & Co AG, Wabern

Swiss edition copyright © 1969 by René Gardi

Van Nostrand Reinhold Company Regional Offices:
New York Cincinnati Chicago Millbrae Dallas

Van Nostrand Reinhold Company Foreign Offices:
London Toronto Melbourne

Library of Congress Catalog Card Number 73-126874

All rights reserved. No part of this work covered by the copyright
hereon may be reproduced or used in any form or by any means—graphic,
electronic, or mechanical, including photocopying, recording, taping,
or information storage and retrieval systems—without written
permission of the publisher. Printed in Switzerland.

Published by Van Nostrand Reinhold Company
A division of Litton Educational Publishing, Inc.
450 West 33rd Street, New York, N.Y. 10001

Published simultaneously in Canada by
Van Nostrand Reinhold Ltd.

16 15 14 13 12 11 10 9 8 7 6 5 4 3 2 1

Contents

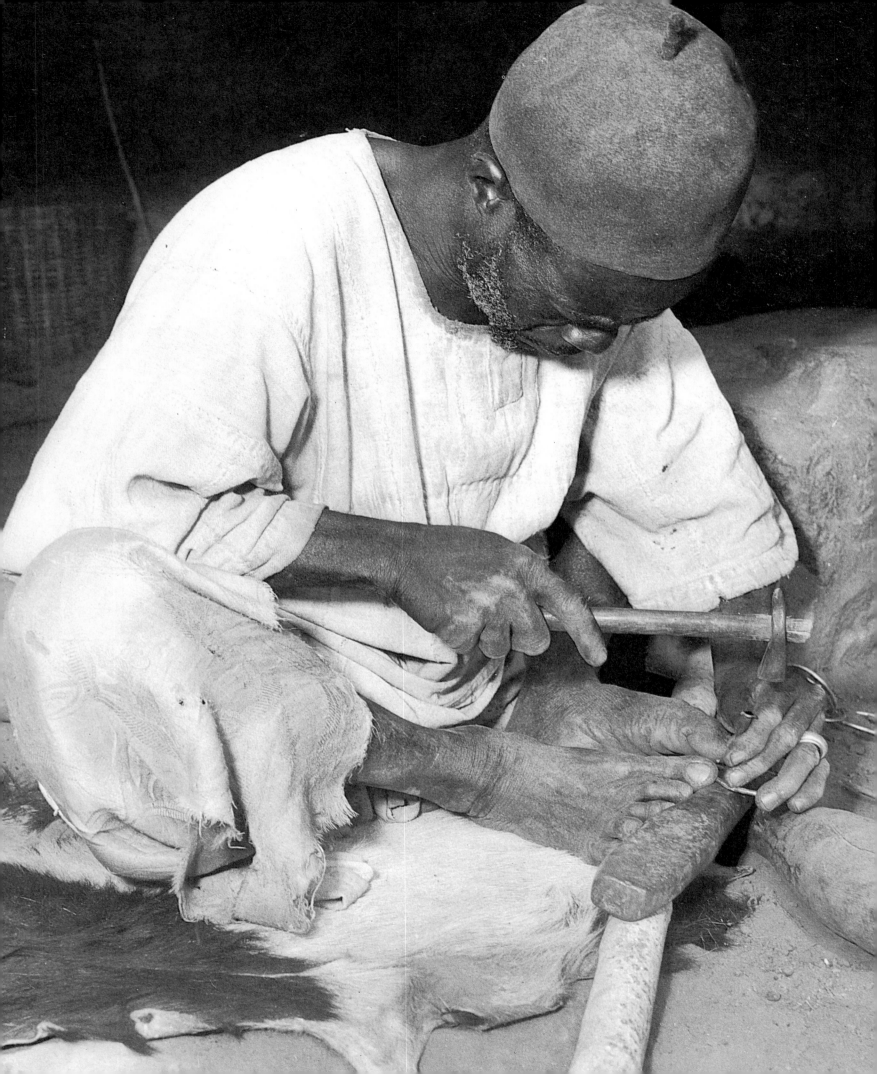

One all-too-prevalent opinion holds that only peoples without history or culture inhabit the Dark Continent. As late as the end of the eighteenth century, the English philosopher David Hume wrote that there were no inventive crafts, no arts, and no science in Africa. This false and barbaric opinion has not yet been completely rooted out. The fact that we have now come to appreciate the work of African craftsmen and to prize the objects of representative art has still not changed the erroneous judgment that the artistic expressions of the African are "primitive." Certainly the homemade tools he uses are primitive, as are the workshops in which he creates, but surely not the remarkable results that are achieved under such circumstances.

For centuries, the white man in Africa has comported himself with boundless arrogance. The disruption of everyday life and the destruction of religious and social ties, caused by stupidity, greed, and unscrupulousness, have already grown to unimaginable proportions in many places, without the intruders having succeeded in offering a valid substitute. So it is hardly surprising that, because of this, traditional art has atrophied, along with many other things.

The decay has long since set in and the reasons for it are manifold. The penetration of Islam from the north with its animosity toward pictures, its iconoclasm, destroyed the postulates for the representation of holy pictures. Then the old feudal lords in the interior were disempowered by the colonial authorities on the coast. The old kingdoms disappeared and the princely courts were disbanded. Along with the destruction of old ideas, many craftsmen who made ancestor figures and other holy sculptures lost their *raison d'être*. The substitutes now offered for this are sales to resident whites and to tourists, who seldom distinguish themselves by good taste and therefore

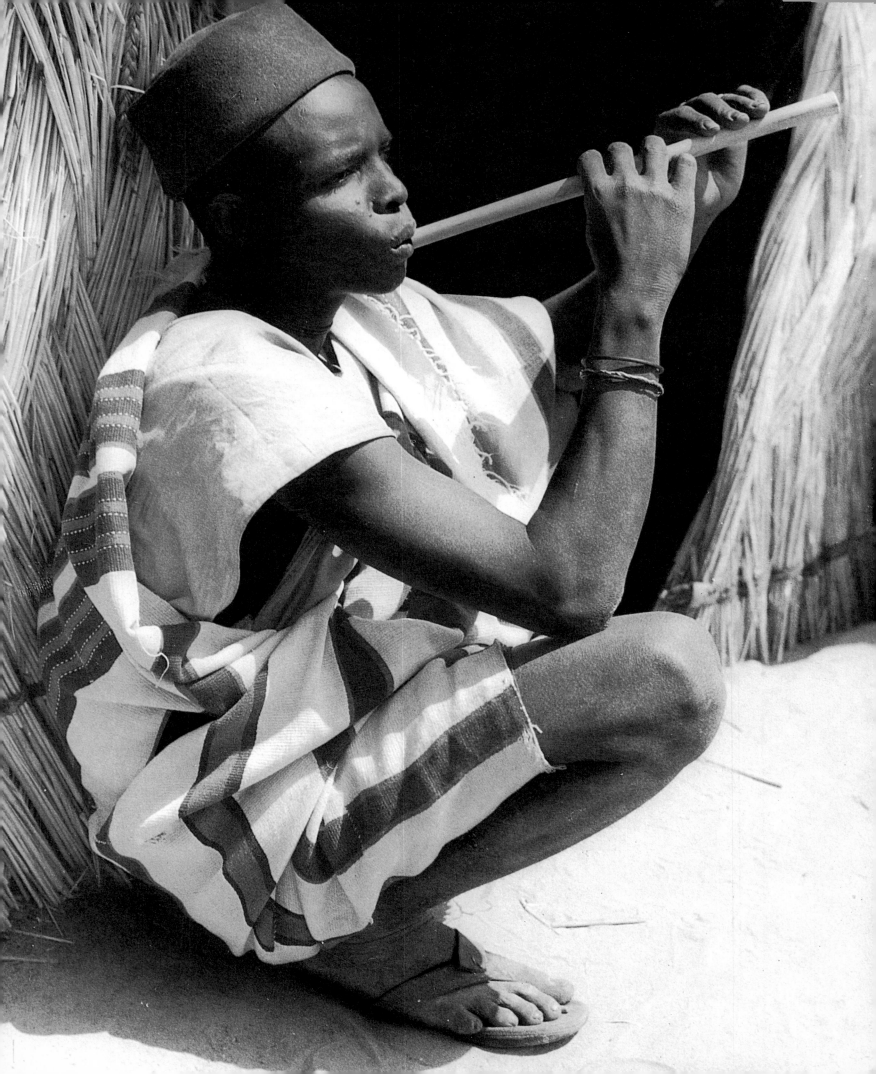

promote the degeneration. The colonial powers tried to forbid secret socie-
ties: they condemned the tribal rites because they were of doubtful morals,
and they ridiculed acts of faith. (The present-day governments are no less
zealous.) Because of this, in many places—fortunately not everywhere—the
rug was pulled out from under African art, because it is determined by reli-
gion. It is not intended merely to be "beautiful" in our sense. In fact, it can
only truly come into being when all the old ideas are intact because the
masks, the ancestor figures, and the statues are supposed to be effective, to
radiate power, and to protect. Production of these objects is always con-
nected with ritual. The African also expects—or expected—that the orna-
ments and figures so often found on the most ordinary everyday objects
would be effective too.

The traditional crafts are, of course, threatened with decay by the new
imports, by plastic materials, by automobile tires for raw material (used for
sandals, for example), by the cheapest mass-goods, and by all the "odds-
and-ends for our brothers" that are exported greedily to Africa. The machine
is beginning to be deified, and handiwork is considered degrading. In Co-
tonou, Dahomey, I bought my bread every day at a little wooden shack. The
seller, a boy by the name of Christopher, was hardly fifteen years old, and I
knew that his father had a little furniture-making shop (without machines).
I asked the boy why he did not want to learn his father's trade. Christopher
looked at me, frightened, and answered very indignantly: *"Mais, Monsieur,* I
went to school!" He who can read and write becomes a merchant, or would
like to be employed by the state as an officeworker, but he does not even
consider being a farmer or craftsman.

The young boy at the left, here playing his little flute and forgetting all need
and hardship, has not yet felt these attacks. He wove the blanket he wears.
He is a craftsman and lives in a region far from the big cities with their unrest.
Even in present-day Africa there are large areas that lie peacefully dormant.
On this enormous continent there is not only disruption, war, upheaval, revo-
lution, hunger, and need, but also the lounge-chair, an object taken over
from us as a symbol of peace, relaxation, tradition, and honest laziness.

Thus it was a comforting experience still to meet proud and capable crafts-
men on all of my last trips—since 1961 I have been either in the Sahara or in
West Africa seven times. It was wonderful to sit in the sand somewhere in a
simple workshop under a woven-mat roof and watch a caster, a weaver, or a
dyer, or admire the skillful hands of a young woman who was decorating a
saddlebag with bright embroidery, or one who knew how to turn out a fin-
ished jar, even without a potter's wheel. Again and again I admired the calm,
the ease, and the dedication with which they worked. There was a true
humanity, both in their dealings with children, who helped, and with the
friendly neighbors, who watched. There was no talk of accounts, production,

and rationalization. No one was in a hurry. Everywhere I had a strong feeling of the close relationship of a craftsman to his work, a concentration, a dedication of the self, and a self-forgetfulness that, in our part of the world, is found almost solely in the artist or the hobbyist.

Many other things are also different. Naturally the craftsman in Africa produces objects that are needed in the family or in larger communities. But the boundaries between house crafts and professional crafts are fluid. Every peasant in the wilderness is capable of making his own tools, with the exception of the iron parts. Every fisherman can carve an oar or weave a net. One makes one's own baskets and makes pottery at home. And a young man who marries, as the son of country people, builds his own house for himself and his wife. I was astonished to realize more than once in the wilderness of northern Cameroon, or among the simple nomads of the Sahara, that of all the strange things that I wore or carried with me, which were so greatly admired by these people, I could not have produced a single one of them myself—not the hiking boots, nor the zipper, nor the rucksack, nor the ballpoint pen, nor my handkerchief, nor my sunglasses. But almost everything belonging to a magnificent farmstead in the Mandara Hills had been made by the proud inhabitants.

People who were particularly good at one art also began to work for others on commission, and so specialists—the professional craftsmen—came into being. But they often remained farmers or planters. Now they work in their workshops only when there is nothing to do in the fields during the dry season. There are also groups of craftsmen who have emigrated to another area and who live there more or less as a special caste. An example of this is the glassmakers of Bida.

Machines are unknown in traditional crafts, and so there is no industrial mass-production, and division of labor is rather rare. The craftsman often provides his raw materials himself. He selects the wood, cuts down the tree, and has usually made all his tools himself, too. He is no production-line worker who only sees parts of the whole. One senses the joy in success, and it is conceivable that the smith might scratch on a particularly successful dagger: "It is by me, Mohammed." The German ethnologist Hans Himmelheber tells about a craftsman (and I quote from memory) who, in the evening, would set out the figures he had made that day and look at them. In answer to the inquisitive question of why he did it, he replied, "One looks at them and finds pleasure in it."

Every time I compared the primitive workshops and the few tools with the end-products, I always marvelled anew, and was inclined not to speak of craftsmen, but of artists, or at least of art-craftsmen. It is not so easy to draw the line between handicrafts and art. The African does not mean the same thing by art that we do. It is largely anonymous. Naturally there is a differen-

tiation between the master and the beginner. A particularly good carver can "make a name for himself," but in a completely different sense. In our society, where one no longer hangs "pictures" on the living-room wall, but "investments," all other practicing artists are regarded as superfluous parasites.

African art and African crafts are often combined into art-crafts, because the objects for everyday use are also made as beautifully as possible and decorated in some way. Calabashes are decorated with ornamentations. Pots are simply decorated. Cloth is dyed pleasant colors. The old goldweights are not prosaic geometric forms but wonderful little carved pieces. Well, there will be sufficient evidence of this in the following chapters. But ornaments, color, and decoration did not simply answer the need for something beautiful. They were also bound up with ideas of healing and protection. One can see that this is not so simple, and I will guard against the use of the word "primitive" in connection with the form or appearance of an object in the following pages. Most of the craftsmen still have a pronounced pride in completing a work as well as possible. And where one is conscious of tradition, the time spent in creating a work of art hardly plays an important part, and the hours are not counted. A good craftsman never lets himself be pressed, and an impatient patron can seldom try to persuade him, with tips,

to hurry or to commit himself to a delivery date. "Allah gives us time, but he did not say anything about haste." This oft-quoted saying is valid not only for the peoples of the Sahara but also for those in the savanna region.

I once ordered some crates, in which I wanted to pack my ethnographic collection, from an old carpenter in a West African coastal city. Two young apprentices there were trying with a handsaw to cut a beam in half lengthwise. They worked with a will, but very slowly, and repeatedly allowed themselves rest breaks. Despite that, they were perspiring since it was a particularly warm day. Throughout the course of the day, the break-times were longer than the time they worked. Next to me stood a second observer, some kind of professional do-nothing, a friendly, chatty man, who was very proud that I, the European, seemed to admire the two able, young, African craftsmen. *"C'est formidable,"* he said, "how those fellows work. One has to be well fed to survive and endure that." He did not doubt that I was in accord.

I do know that African craftsmen, of whom I am going to speak for almost 250 pages of text and pictures, work too irrationally, too slowly, and too diffusely by our standards. With their old-fashioned, backward methods they will never get on in the world. If they do not change their sleepy, lackadaisical way of working, if they do not get used to regular working times, do not industrialize, and do not give up their superfluous ornaments and decorations, the standard of living will remain as low as it has been until now. Most African officials are also of this opinion. They are hardly interested in the promulgation of native crafts. That is not spectacular. They believe that one can skip over centuries of human development. The craftsmen should finally be sensible, no longer pay homage to the ancestor cult, and stop preparing for a task with ritual sacrifices. Finally, they should manufacture, standardize, produce, hurry, talk less, and not play happily in the sand with little stones in the middle of the day, and should put aside their leisureliness. In a word, they should become "efficient" in the sense of the industrious European. But unfortunately I am not sure that they would be happier, or whether their dedication and absorption in their work would be the same. If only someone had a recipe for mitigating social need without simultaneously destroying the old culture! Well, now I would like to ask the reader to follow me through some West African countries, to get to know a few craftsmen and their work. And I would like to hope the reader will admire and respect them, too.

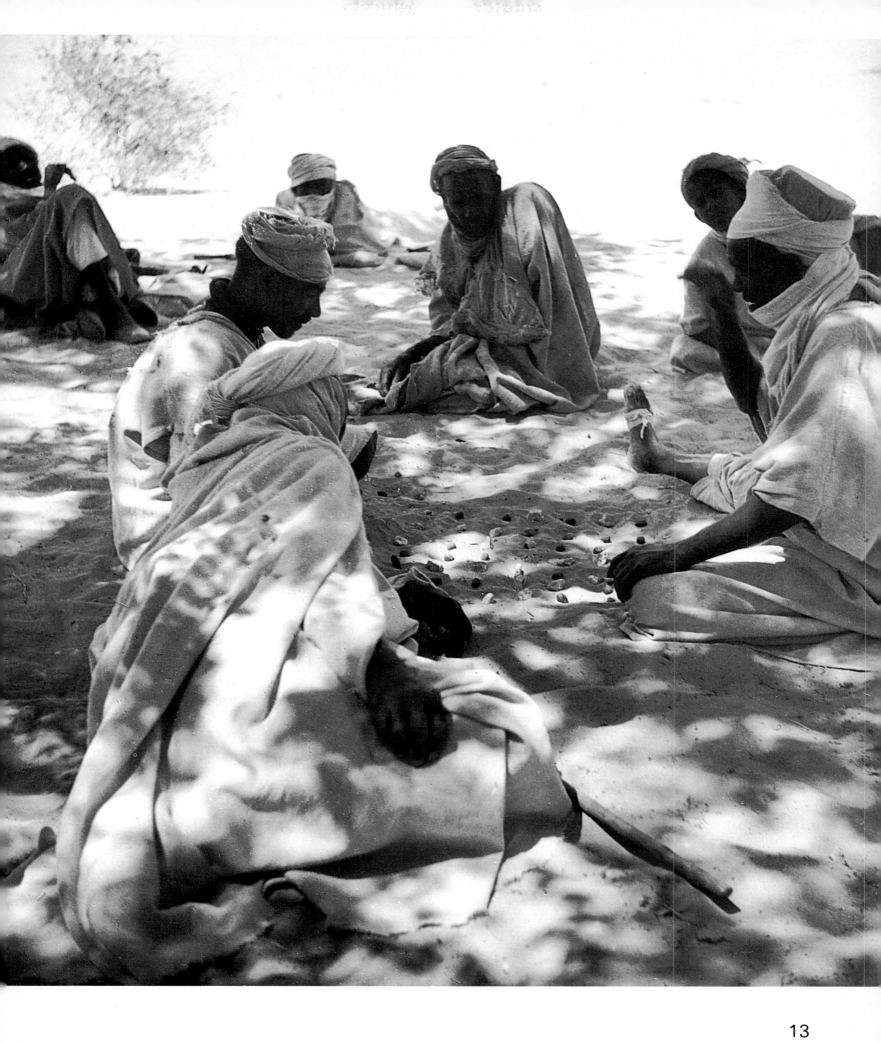

The "Iron-Cookers"

In the harsh granite landscape of my old dreamland in the Mandara Hills of northern Cameroon live a number of small, animistic hill tribes very much cut off from the outside world. They have little contact even with the Muslim valley peoples who have pressured them into withdrawing farther and farther. Of all these mountain peoples, the Matakam are the ones I know best. I have been fascinated by and devoted to them for almost twenty years. They are people with small farms, and they plant millet in the rainy season, keep a few sheep and goats in the barren pasturelands, and, if all goes well, own a pair of oxen. They live in scattered settlements like kings at their courts—admittedly kings without servants. They lead an archaic existence, worry little, do not concern themselves with the future, and still understand that rare art of living for the moment.

I found, once, in the lonely valleys of that isolated country, an ancient iron culture. There, in the middle of the twentieth century, the "high ovens" still smoke. There, the black Hephaestus still understands the art of iron production. The pictures up to page 23 are old ones of the Matakam. They are from 1953, and my discussion of them is drawn from my own previous publications. I am doing this because when I recently returned there for the fifth time, I saw that the smiths are still practicing the secret and mysterious art of transforming hot ore into malleable iron. It is said that they "cook iron." It is a fascinating ritual, an extraordinary mixture of well-developed metallurgy and magic. In an age when astronauts fly around the earth in their space capsules and are capable of photographing the far side of the moon, I sat next to the oven and watched secret blood sacrifices and listened to the magic sounds of the harp that accompany the work. I felt with a beating heart that I had gone back many centuries in the history of man.

For ore, iron oxide (magnetite, with the formula Fe_3O_4) is used. This is obtained in the form of a gray powder. The reduction in the glowing charcoal occurs at a temperature below that of the melting point of iron. The result is a puddle, a mixture of iron pieces, slag, and charcoal remnants. Elsewhere in Africa, the normal reduction oven consists of a clay cylinder open at the top. Air is blown into it from holes near the bottom. The oven of the Matakam is fundamentally different. The common double-bowl bellows is not at the bottom of the oven but at the top. This requires a clay pipe, about six feet long, for conducting the air from the bellows to the bottom of the oven. Because these pipes go through the glowing charcoal, the pumped-in air is heated. Its effect is heightened because, by means of this trick, the reduction temperature in the oven rises. The Matakam smiths thus work like modern ironworkers, with prewarmed bellows air that is forced into the glowing supply pipe. Since the clay pipe bakes onto the puddle in the course of each firing of the oven, it can only be used once and therefore must be replaced each time (picture at right).

The assistants take turns at the bellows. They are protected by a little wall from heat and the poisonous carbon monoxide fumes that pour out of the round supply opening. The smith works the bellows forcefully and with incredible speed. He sings at the same time and begs the god Dzikilé to give

6

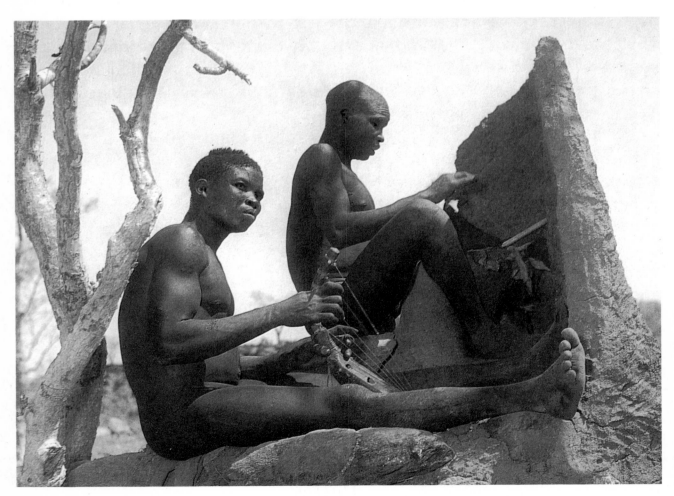

16

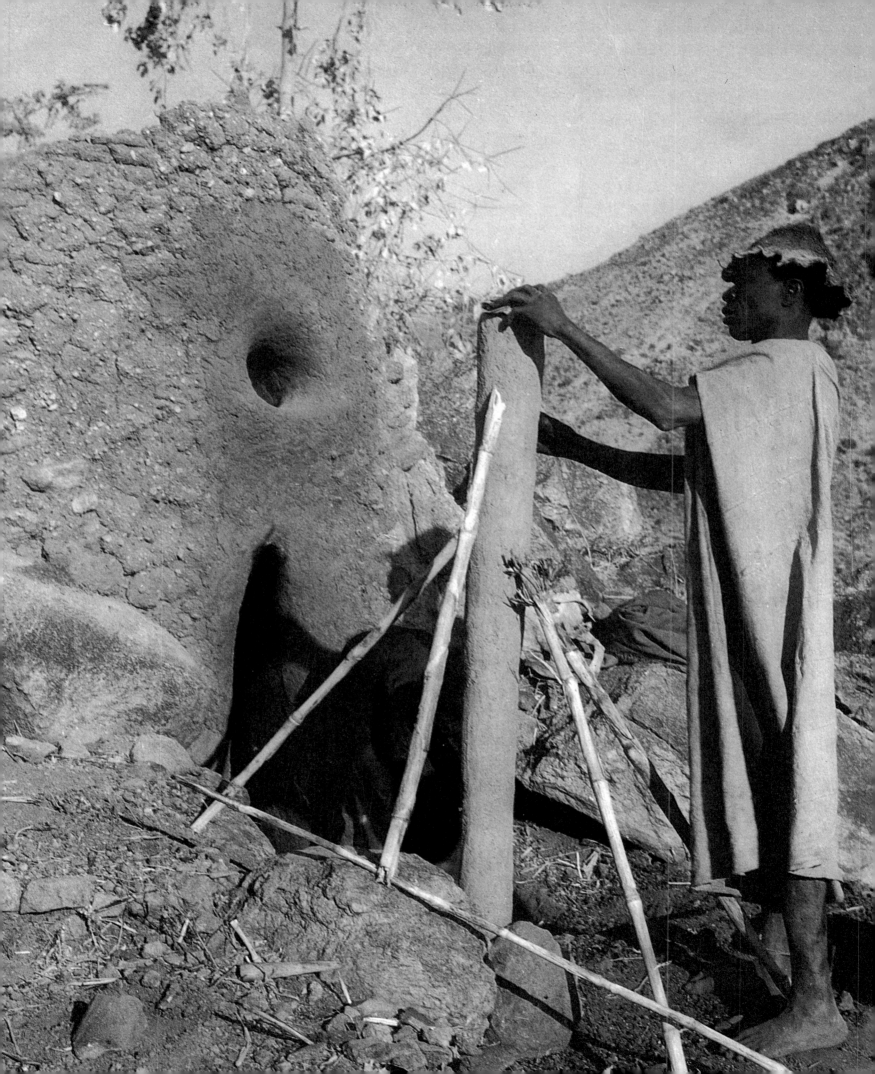

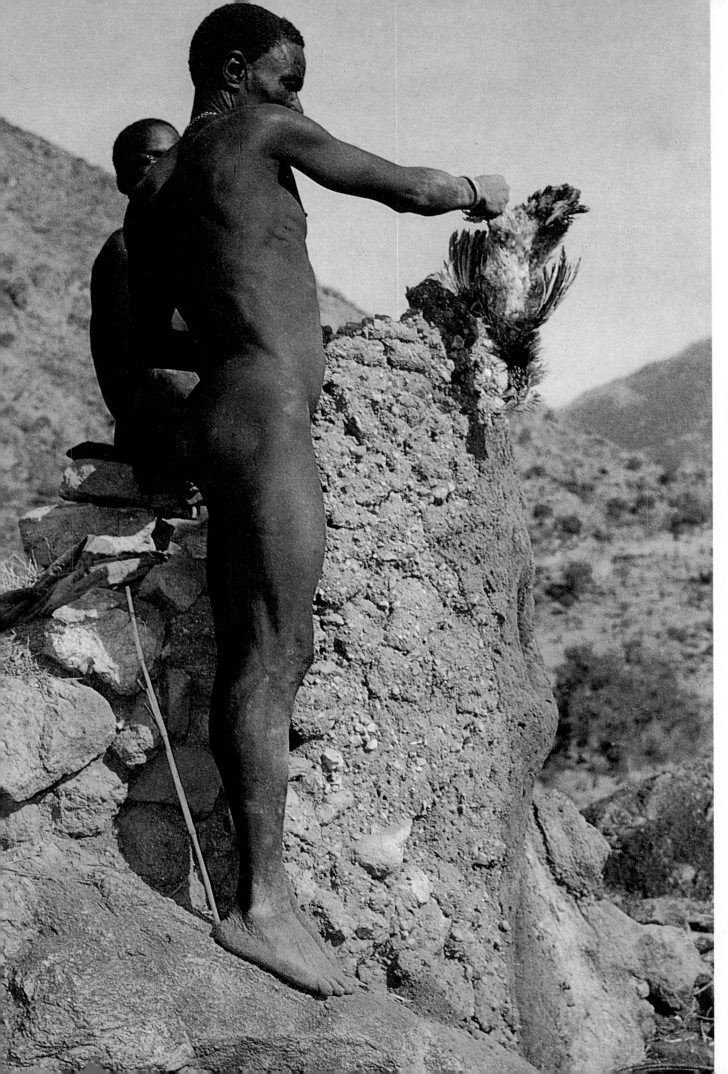

8

good iron. He is accompanied by the simple melodies of the harpist, for both of them know very well that it is necessary to make music if the work is to succeed. Songs and tones of the harp, therefore, are not only there to inspire the bellows operator rhythmically but they also have, according to the smiths, a magical effect. The harp-playing is just as important as the blood sacrifice that is presented to the oven by Truada, the head smith (opposite page). With a strong straw, he has cut into the neck of the chicken and is letting the blood run over the collar of the oven, the seat of the deity. After that, he beats the bird as hard as he can against the oven and throws it in the sand. The smiths watch the movements of the dying animal in great suspense, because from this oracle they can tell whether the offering has been accepted.

The iron-cooking process takes a whole day and night. Vermilion and sulfur-yellow flames shoot out of the newly broken hole in the oven door that had been walled up. The new hole is where the cement-like slag is scratched out. (Before each production process, the large door is walled up. As soon as the clay pipe is set in, it is opened again in order to take out the puddle.) Then comes the most exciting moment. More than twenty-four hours after the beginning, the oven door is broken and opened. The puddle inside is still very hot and glowing. With a concerted effort the smiths pull at it, loosen it

9

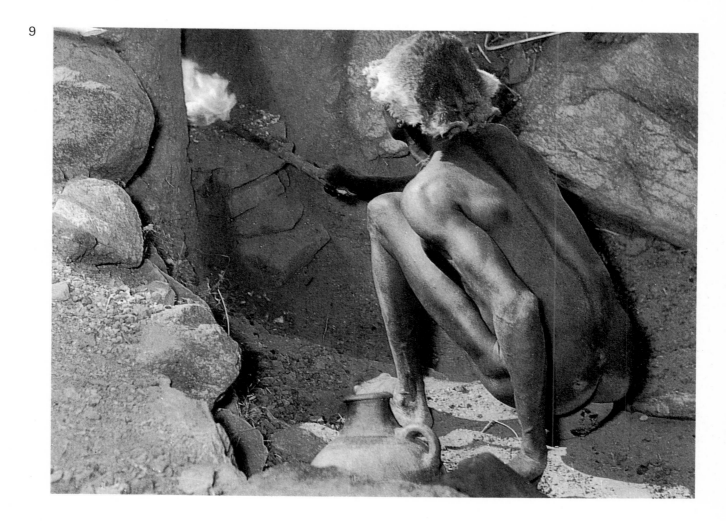

with wooden poles from the wall of the oven, and break the used clay pipes into pieces. To cool off the oven, a calabash-full of water is tossed inside. It hisses, smokes, steams, and smells of sulfur. Finally the puddle falls down, a massive block. The smiths catch their breaths and discuss how they can bring out the hard block that is wedged between the side walls of the oven without damaging the oven too seriously. The result of their wild and strenuous efforts is shown in the picture at right. Everyone agrees that it was certainly worth sacrificing a chicken to Dzikilé and sharing millet beer and millet porridge with the oven. It was also not in vain to sing and play the harp untiringly during the painstaking bellows work. The puddle, weighing perhaps a ton, finds its way into the smithy the next day. There it is shattered, and then one can pick out the separate little chips of iron that, when weighed in the hand, are perceptibly heavier than the less pure pieces. The iron in the puddle is found only in pieces about the size of a cherry pit or a nut. The pieces all have rough surfaces and irregular shapes. A temperature of the melting point of iron, 1500 degrees Celsius (Centigrade), is never attained in African ovens, so in this method of smelting no molten iron that would be pourable can result. It is actually closer to slag iron.

The scraped-out bits of iron are hammered cold in the smithy of the Matakam with a "two-handed" stone hammer on a stone anvil. They are beaten flat and shattered, then melted down in the hearth and worked some more. These pieces of iron are easily worked because in the relatively low oven temperature they have absorbed very little carbon, so they have not become hard and brittle. Bit by bit there emerges a four-sided bar of iron about a foot long.

From this iron bar, knives, agricultural tools, sickles, weapons, and jewelry are made, all according to the clients' wishes. The metal is heated repeatedly in the glowing charcoal and "carbonized," so that it contains the right proportion of carbon; then it is tempered in a thin solution of mud. Thus the iron is transformed into steel!

Among the Matakam the work in the smithy, like that in the smelting process, is accompanied by all sorts of offerings and magic that are regarded as indispensable. The smiths of the Matakam knew how to establish a strong overall position for themselves. Their handiwork not only brings them material advantages but it also places those who understand how to deal with fire, and those who can "cook iron," in a position of uncontested leadership. The smith is esteemed and feared. He is a prophet and a soothsayer. He interprets the oracles in various ways, traffics with spirits and ancestors, and is an intermediary between the living and the dead. The smiths and their families live outside the tribal community. No Matakam will voluntarily enter the house of a smith. He will never drink water or eat millet porridge from the same bowl as a smith. No son of a smith will ever take a bride who is not from

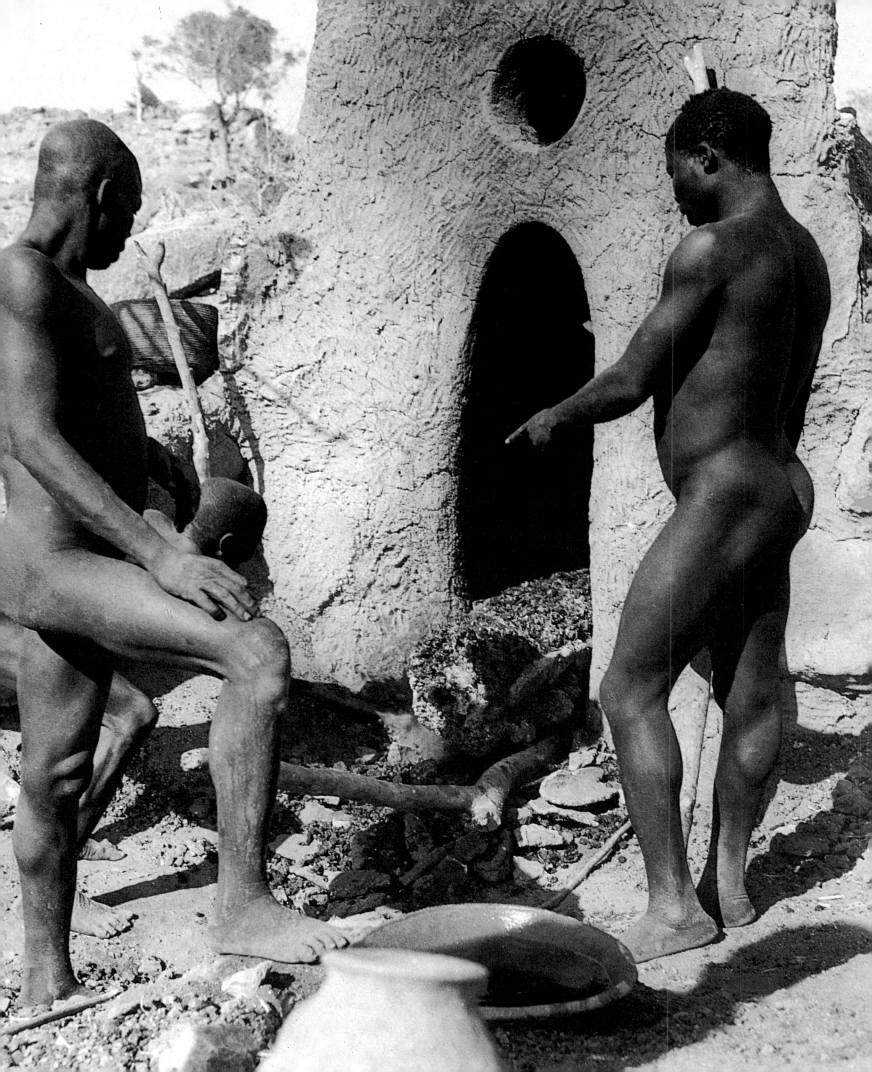

a smith's family. The smith, the ironworker, is also the leader of the ceremonies for the dead. He is the gravedigger, and only he dares to touch a corpse. His wife functions as a midwife and is also the only one in the tribe to produce pots, jugs, and bowls. The smith makes farm tools and weapons, sells medicines, and buries his patients. His wife makes pottery, helps the young mothers in their difficult hours, and instructs the young in the rough land of the Matakam. One can easily understand from all this that the smith's guild has truly made itself indispensable.

In the eyes of all settled farmers in Black Africa, the caste of the smiths is surrounded by many mysteries. The smiths are regarded as magicians. They are involved with secret societies. They are often socially separated from the others and enjoy many special privileges of a social and political nature. This is true also for other specialists who work not with iron but with silver and gold, and it is especially true for the guild of the brassfounders.

The position of the smiths is very different among the shepherds and nomadic peoples in the Sahara and in some parts of the Western Sudan. There the smiths belong to the lowest castes. They are scorned as settled people who work with their hands, but at the same time they are feared because they have a number of magical powers at their disposal. As a rule they are socially isolated from the others.

In the photograph at the right stands—like an idol in the landscape—the reduction oven of the Matakam smiths going full blast. One of these witnesses of bygone ages has been glowing for several hours. At the top, on the covered bellows system, sits an assistant who works the skins and sings magical songs while being accompanied by the harpist. The oval oven door has been walled up except for one opening where the slag is to be scratched out. The round opening above is necessary for supplying the oven at regular intervals with charcoal and iron ore. The sacrificial chicken is roasting on a stick in front of the oven door. The straw mat keeps the front wall shadowed so that one can judge what is going on inside by the flames. The clay bowl in the foreground contains the magnetite, which is thrown into the glowing charcoal in small quantities.

I photographed the Matakam cooking iron about fifteen years ago, and—at least in the remote valleys of the Mandara Hills—hardly a thing has changed. At most, the dress has altered a bit, for since independence there are clothing regulations. In the vicinity of the district capital, Mokolo, members of a high-pressure tour group are photographing the iron-cooker who works the bellows for several minutes until the picture-snapping is over. In the oven, only a little wood is burning. It contains no ore, and no iron will result. But no one notices that, for who could take the time to sit there for a day or two and wait until they break open the oven wall? As soon as the tourist car has disappeared, the smith picks up his tips and goes home.

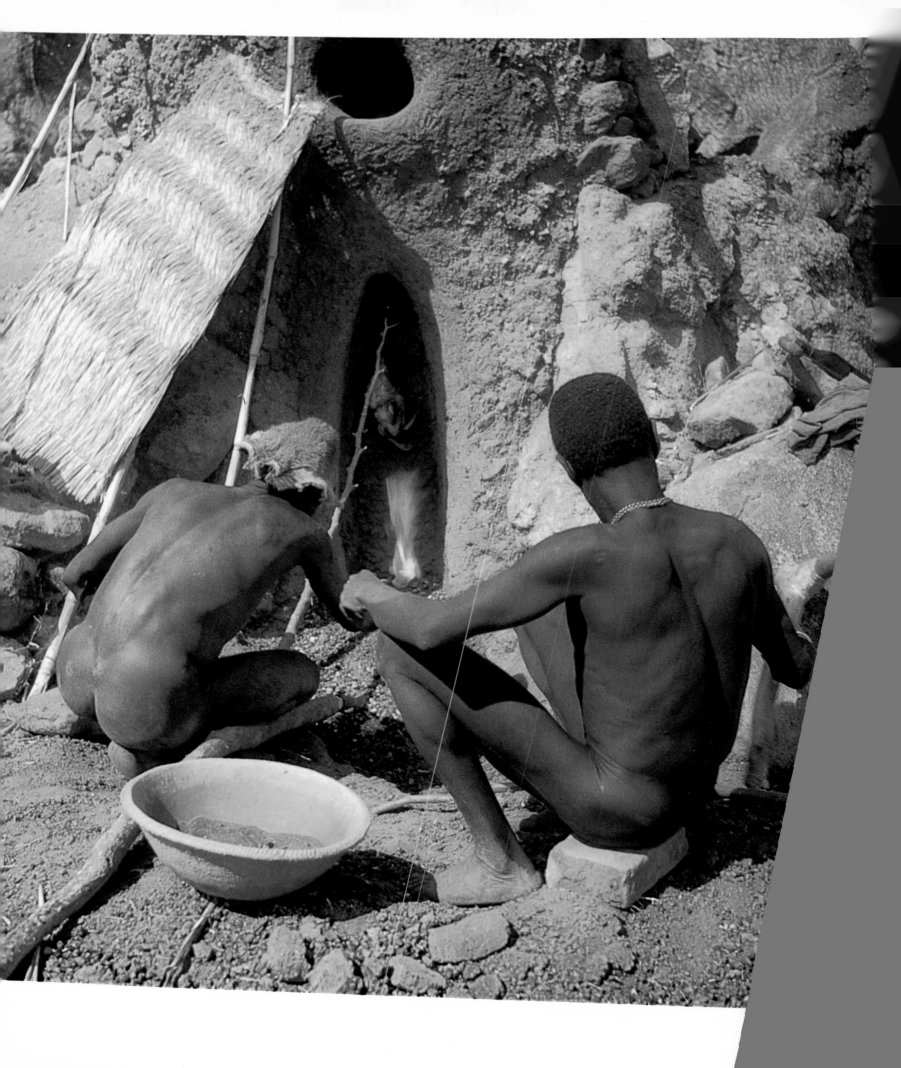

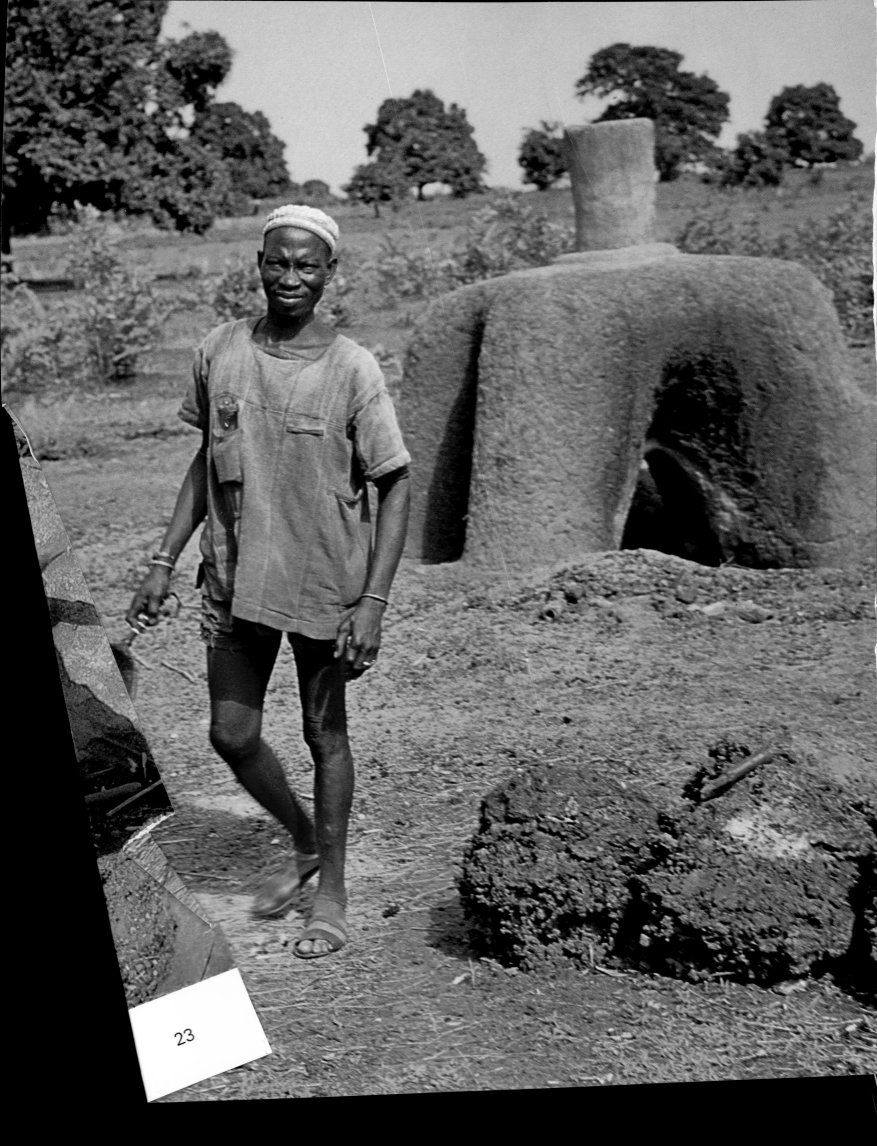

23

For many years, I believed that the Matakam were the last West Africans who still produced iron regularly. I was honestly surprised, therefore, when, in the spring of 1968, in western Upper Volta and northern Ivory Coast, I ran into smiths who still maintained their furnaces and regularly operated them.

In the capital of Upper Volta, Ouagadougou—how that sounds!—I heard for the first time, from the government ethnologist, that the "iron-cooking" had still not entirely disappeared. But he did not know anything specific. Farther west in the country, in Bobo-Dioulasso, I fell into a conversation on this subject with a Dutch priest who taught at a secondary school. He did not know anything specific either, but he introduced me to a young African who had been a teacher in the vicinity of Tourny where this ancient art was still practiced. Several years had gone by since he had been there, but he was sure that iron was still being made. And so he suggested driving there to find out. That was a terrific idea! But when I heard that it was about a hundred miles, more than half of the trip on bad roads, I found the idea less terrific, because this expedition did not fit into my time schedule.

But of course we went. And should one of my readers ever be in the vicinity and want to see one of a dozen or more "high ovens" like the one in the picture opposite, I will even explain how to get there. From Bobo-Dioulasso one takes a big highway south for fifty miles to Banfora, then twenty-five miles west on a little road through charming hilly country, past swamps with blue waterlilies, along the edges of forests with orchids, to the Senufo village of Sondou. The road gets bad, but one can still easily reach Kankalaba, a miserable village. Here we had to stop, because my guide had been the schoolmaster here. He greeted all his friends, and the village chief offered us millet beer. But we soon proceeded to the ironworking village of Tourny. Ten of these old furnaces were standing around in the landscape, with dozens of chair-high blocks and chunks of classic puddles in front of them. Each oven was four-legged, and crowned with a high chimney. During operation, the four openings are walled up. There was no trace of a bellows. On the ground—so I was told—pipes are placed into the four oven doors, and the natural draft is sufficient for attaining the necessary temperature. Next to each oven there is a small offering-place. It contains a buried pitcher smeared with chicken blood. I was unlucky, though, because the last fire had been extinguished two weeks before my arrival. The ore is brought by bicycle from a quarry four miles away. It consists of chunks of red laterite almost as hard as stone. Well, even if the chimneys were not smoking, because the rainy season threatened, the expedition had not been pointless. I had obtained ore samples, a couple of big pieces of puddle iron, and I was able to acquire a number of bracelets made by the iron-workers of the village of Tourny.

In Koni, a little village on the road only nine miles from our headquarters at

Korhogo, I was more successful. At that time we stayed about six weeks in northern Ivory Coast, in the region of the well-known Senufo people, so I had the opportunity of visiting the smiths at regular intervals. Both pictures show the extraction of ore as well as iron oxide. Somewhere in the wilderness, hidden in a ravine, a good hour's walk from the ovens, is the ore supply. The red laterite soil, and the new leaves of the shrubs, a result of the first rains, were glowing with color. Here the ore-bearing soil is painstakingly dragged out of about a dozen narrow holes. The new holes are not very deep, but in the older ones the workers may have to climb down nearly fifty feet. Down there the heavy soil is loosened with a short-handled hoe and shovelled into flat wooden bowls. Down in the shaft it is so dark that they have to use a flashlight. Steps are cut into the sides of the shaft; on them the workers stand straddled one over the other. In the deepest pits, six or seven people

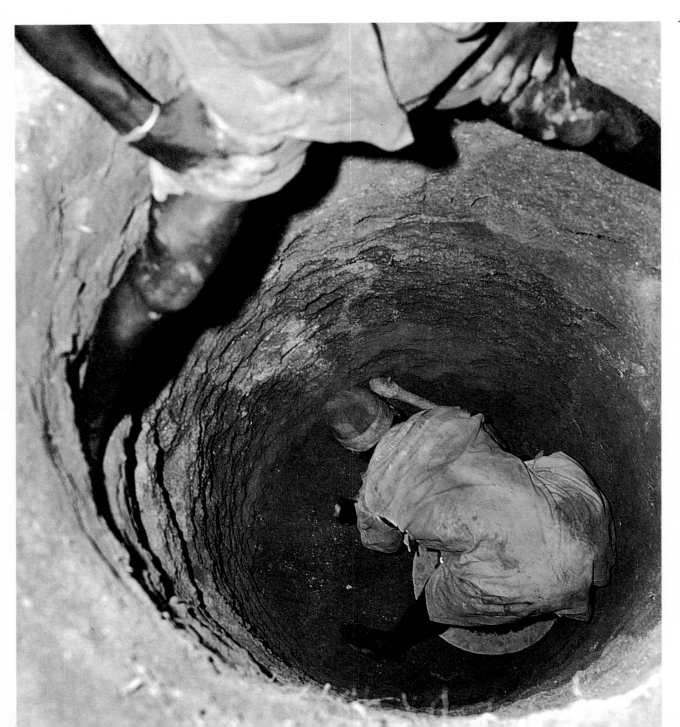

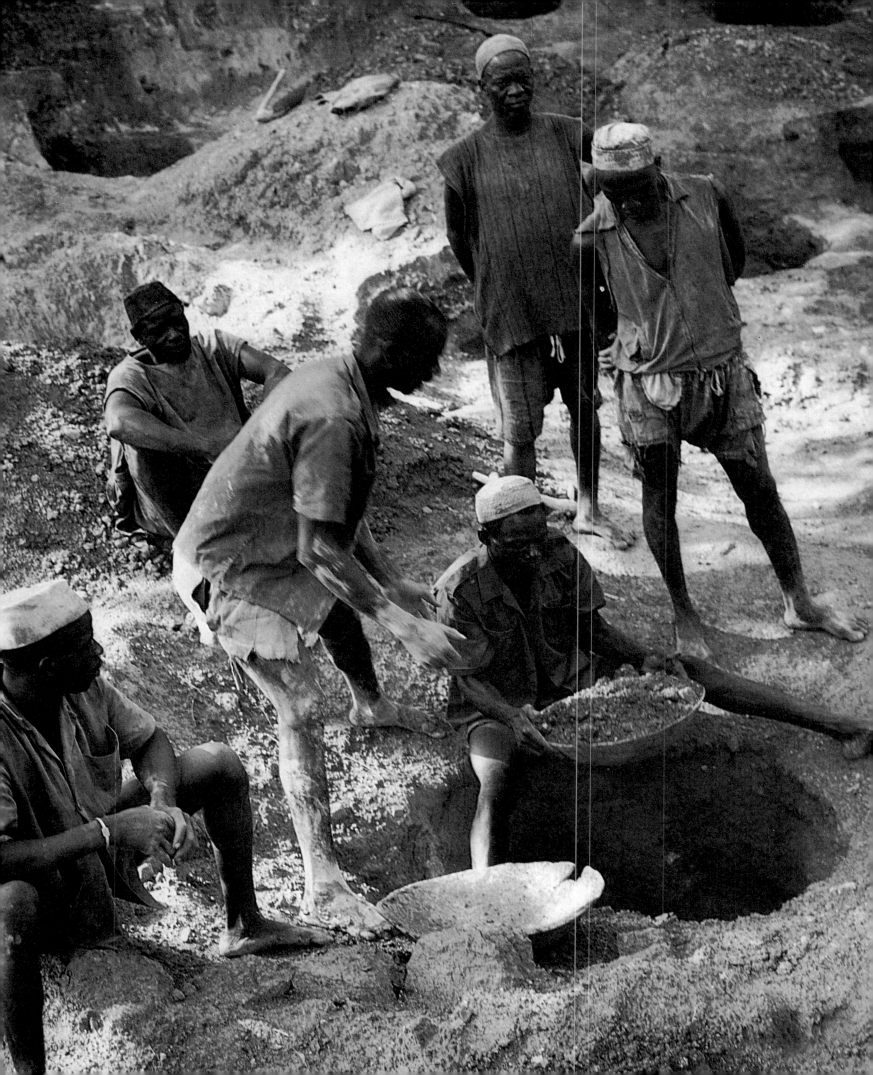

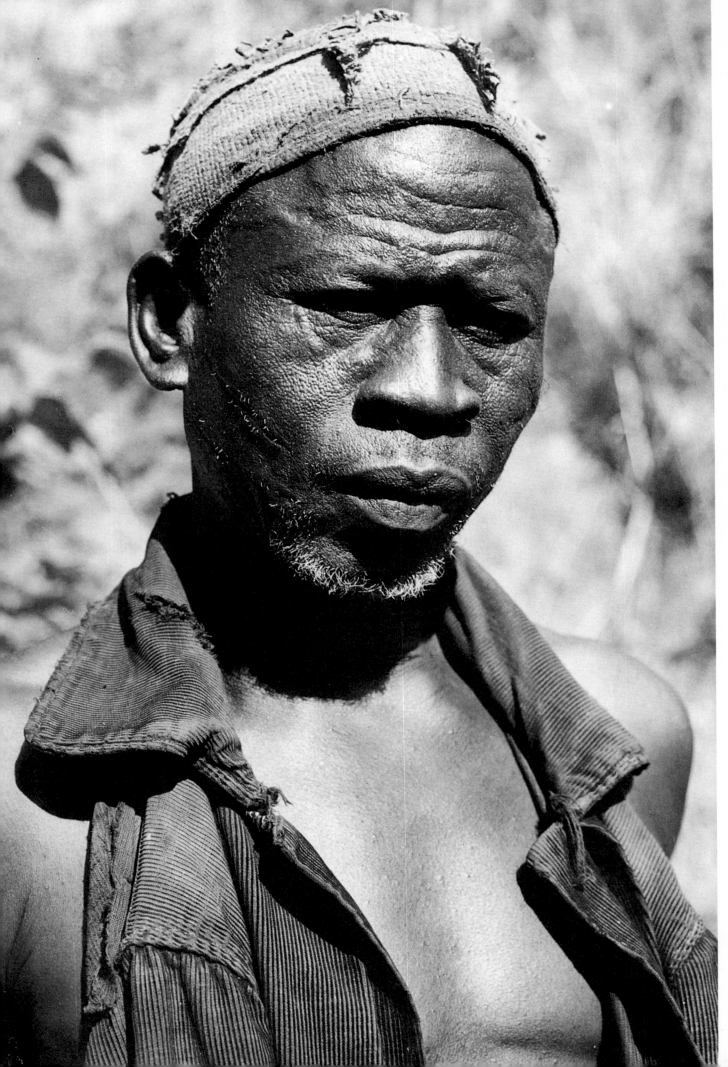

are needed. The bottommost worker fills the bowl with earth and then reaches up and hands it to the man above him. The next man reaches down, takes the bowl, and in his turn stretches up to the next man in the narrow shaft with the load in his hands. And so it goes on, until the uppermost worker takes the earth and throws it on a pile—"good" to the right and "bad" to the left. It is easy to tell by the color whether it is from an iron-bearing layer.

The men work quickly. They sweat, and soil keeps tumbling over the edges of the bowls. They were all smeared with damp earth but obviously in good spirits. They worked this way the entire day that I watched, until the supply that had been gathered was apparently sufficient for one or two weeks. While watching these primitive and difficult labor methods, it is interesting to realize that these people do not have to work eight-hour days for weeks, months, and years at a time (with three weeks' paid vacation, health insurance, and pension plan) at such tedious drudgery. After one or two days of great effort, they then are able to relax and do nothing for a while.

Why someone did not erect a frame, with a rope and pot over the hole as at every well, no one could explain. They knew about the wheel, after all, since most of the people had arrived on bicycles, and some even with small motorcycles. The good soil was put into sacks and taken to the edge of a little river on the package racks of the bicycles. There the ore was washed out. So they transported on bicycles ore that was then transformed into iron by mediæval methods. And in Koni—I do not want to forget to mention this—these mediæval ovens stand at the side of a broad, well-maintained road on which about fifty cars pass by every day. In this unique manner, ancient and modern times are in direct contact.

Sélégué Dégogné is the name of the old master (picture at left) who was present at the pit, at the ore-washing, and, naturally, at the iron-cooking. He was already old according to the Africans, although he seemed barely fifty to me, so no one expected him to work with the others. He was the one who "knew the best." Everyone recognized his authority, and if someone made a mistake, angry wrinkles formed on his brow. He squatted there constantly, watched, gave very few orders, and did not personally lift a finger. Everyone felt that this was proper. He was the boss, no one contradicted him. As usual, the iron-cookers of Koni were all related to one another and so stayed very close together.

Among Senufo workmen, an ordinary man without the prestige of a chief does not stop work for a whole day without any apparent reason. He has certain days "off," however. So that everyone understands this, and does not reproach him, he paints a white oval with a vertical axis on his calf. A pass for laziness, so to speak. This practice, however, has a deeper origin. In fact, the man determined, or a magician prophesied, that the coming day was

dangerous, inauspicious, and bad for him, because an evil spirit, a devil in some form, had taken possession of him. So naturally it would be stupid to undertake anything on such a bad day, to go away, to leave the village. In short, it is wise not to work on such a day if life and health are held dear. And one is best protected against the dangerous evil by a white painting on the left leg.

There are other serious reasons for not working. For example, it is proper that one takes part in the ceremonies for the dead that are held for relatives far away. In some circumstances the ceremony lasts more than a day. One has to travel and is not loath to stay a few days. It might even be that one could be invited to a puberty rite.

We can thus see that a bit more time than optimistic planners imagine is needed to transform the African into a good industrial worker. He does not give up his life patterns and notions as easily as one might think. He is conservative to the depths of his soul and suspicious when confronted with innovation.

Now to return to the story of ironworking: it is an ancient art in Africa. Africans were transforming ore into malleable iron while neolithic men were still chipping their stone axes in Europe. Presumably the technique came to Africa from the Near East via Upper Egypt. Magnetite, an easily reducible ore, is plentiful there. The proximity of very simple fire-pits to the "highly developed" reducing ovens proves that one must be dealing with self-development and that they did not take over a highly developed iron technique from another continent. This speaks for the great age of African iron techniques. The Bronze Age was bypassed. They came directly from the Stone into the Iron Age. (Bronze-casting came later.) But the ironworking technique developed incredibly slowly. The conscious will to technical improvements, to "progress," is absent. Nothing is based on research and scientific knowledge as things are with us. The only basis is tradition and a very slowly progressing experience. Africans are not Prometheus figures. They often do not want to know "what lies beyond the hills." This is no value judgment. A strong tradition allows that craft techniques do not stand isolated but fit harmoniously into the life-style and the culture of the people concerned. This harmony, this fitting together of the forms of existence, without any of the separation between "work as breadwinning," and the "real life" that grows increasingly horrible to us, is still happily taken for granted by the African craftsman.

Now I should at last explain before the reader turns the page that in the picture opposite the greasy, reddish-green soil is being washed. The man is separating the lighter matter from the ore in the same way that gold is washed from the earth. He rocks and moves his bowl in a circular movement. Little by little the color of the contents changes. It gets darker until, in the end, a

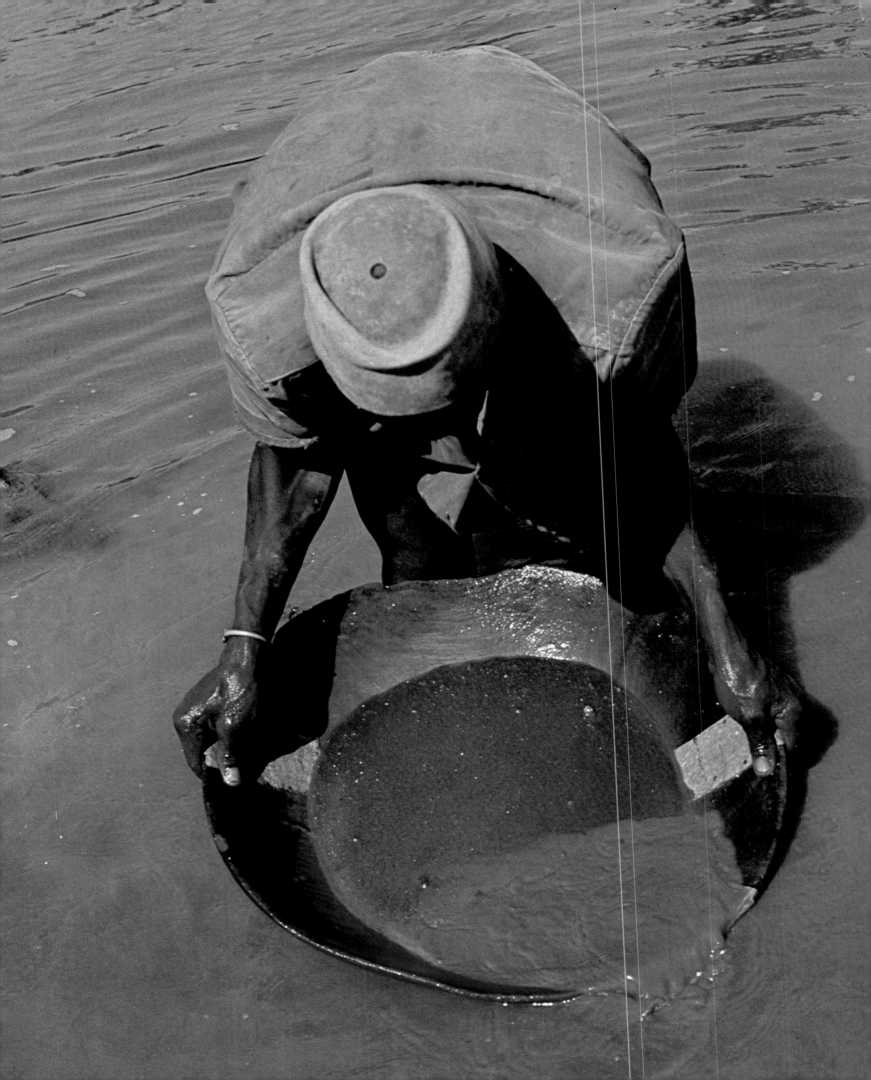

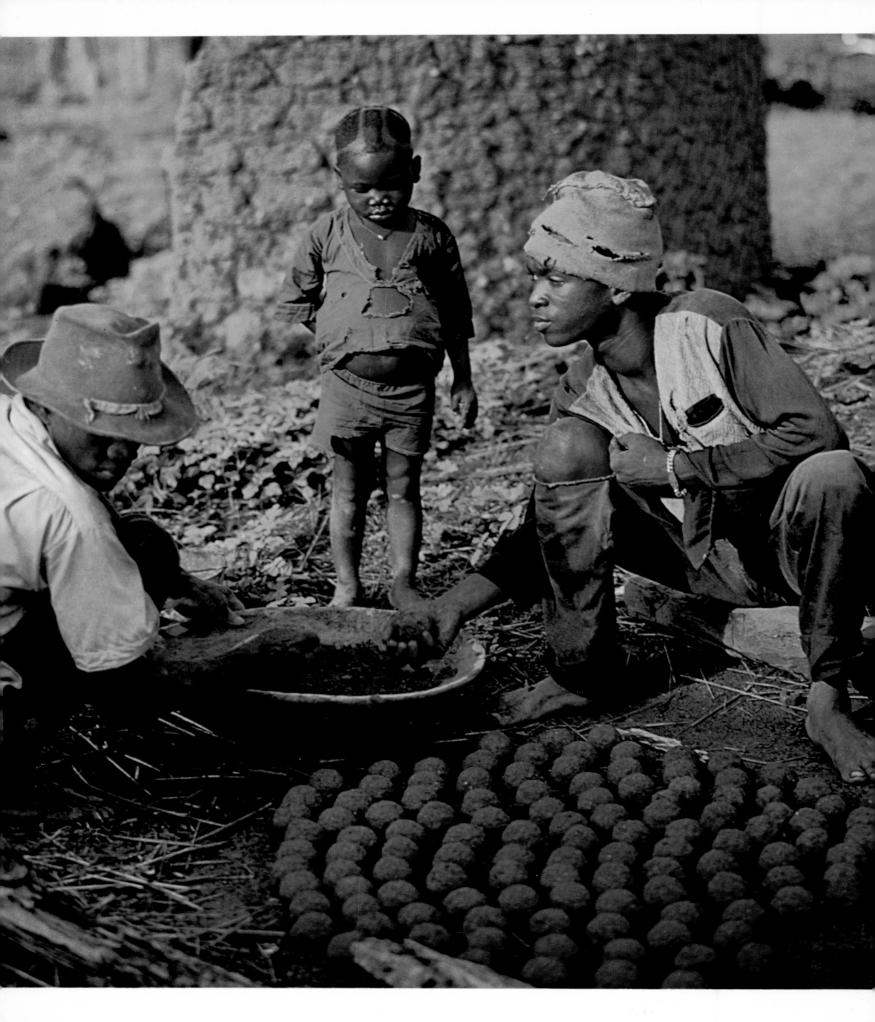

few handfuls of gray, kernelly sand are left over. This is the iron oxide. It is dumped into sacks and is again transported a few miles back to the village of Koni and into the ovens.

Then the smiths form balls out of the moist sand, as can be seen in the photograph opposite. I had the impression that the ore still contained considerable impurities. It fell apart very easily, and no one could explain why they did not let the sand, with its heavy ore content, dry—as is the case with the Matakam. Whenever I asked the reason for this roundabout practice I got the answer that so often drove me to desperation: *"C'est comme ça.* (That's the way it is.)" They were naturally not so curious as I to look for a reason.

For each production process, a hundred balls of ore are needed. And it is exactly a hundred balls—when I picked up two of them from a pile standing ready on a bowl beside the oven, they were immediately replaced. So perhaps they form the balls in order to measure an exact quantum, but that does not seem likely, since an earthenware pitcher or a wooden bowl of a specified size could be just as well adopted as a measure. For the entire process the hundred balls plus four large baskets of charcoal are needed. The charcoal is not made by the iron-cookers but rather by nearby villagers.

The old master Sélégué Dégogné and his people have already become iron-cooking specialists. They belong to the great, respected guild of the smiths, but they do not take the iron they produce beyond the cooking process. The last phase of their work consists of breaking up the puddle and scratching out the bits of iron. Divided into ridiculously small quantities, these bits are then offered for sale at the large weekly market in the city of Korhogo. There, in the immediate vicinity of a modern hotel, gas stations, a bookshop, and an airline office, genuine smiths purchase their iron, produced in their own country. Striking, even ludicrous, contrasts constantly appear side by side in Africa, and sometimes the effect is quite overwhelming.

The photographs on the next two pages show the "high oven" of the Senufo smiths. It is less impressive than the Matakam oven, and actually not as beautiful as that of Tourny. The round tower narrows until it reaches two-thirds its height—the overall height is about six feet. At the left, a climbing beam leads to the roof, since the oven is supplied from above. For this reason, the roof is solidly built—in fact, it even supported me. On top, two full baskets of charcoal stand ready, while the ore lies below, buried in charcoal. The balls fall apart as soon as they have been thrown into the maw of the oven. Where the smith is crouching, at the right, is the oven opening. There is no bellows system. Six clay pipes built into the base of the oven supply the necessary draft. In Koni, eight such ovens are currently in operation and it seems that there is no letup in the demand for this homemade iron.

59743

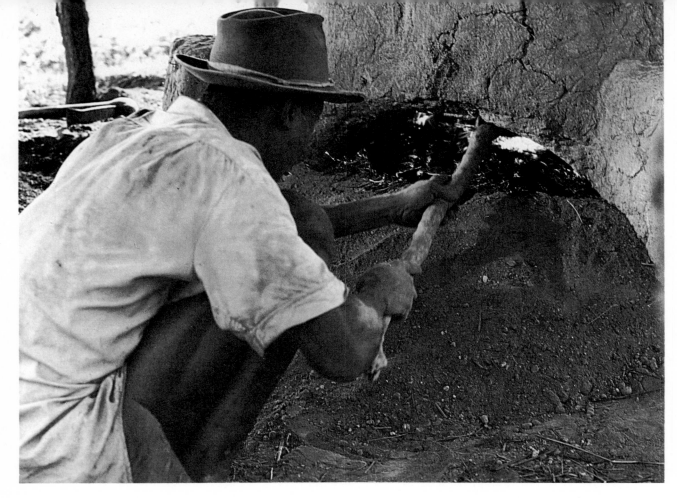

19

20

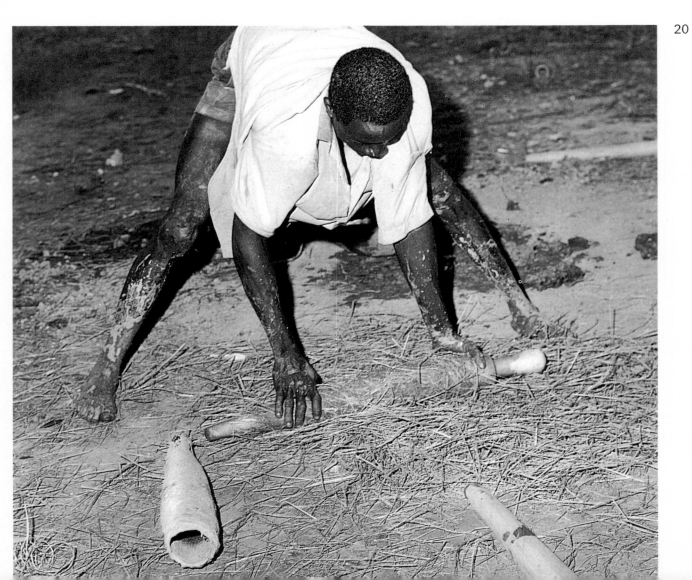

As shown in the picture at the upper left, the oven door is finished off at the top with a "basket curve." Shortly after sunrise, the oldest son of the master smith stuffed the base of the oven with dry, strawlike grass and lit it. Then he built a wall of earth in front of the door so that before long only a small part of the opening remained. Now he is busy spreading the embers evenly with a stick and loosening the charred bundles so that the fire can begin to blaze brightly. Even though there is no shortage of wood, none is used to set the charcoal afire.

He then inserts two long, clay pipes, puts a broken pipe between them (in order to save clay), and walls up the last opening with moist clay. He does the same thing with smaller openings at the rear of the oven. Here, too, he puts a clay pipe into each opening. They point in six different directions, like the axes of a hexagon, so that any prevailing wind from any direction will create a draft. The clay pipes in the picture at the lower right were made the day before the firing. A bluish clay was mixed with a bit of water until it became doughy; then it was mixed with a bit of shredded straw. When it is the consistency of stiff cake dough, the clay is formed around a wooden stick that is used as a mold. The mold, part of which is in front of the left foot of the man in the picture, is made of a piece of wood carved into a cone and polished flat. After the clay was shaped around the stick, the pipes were

21

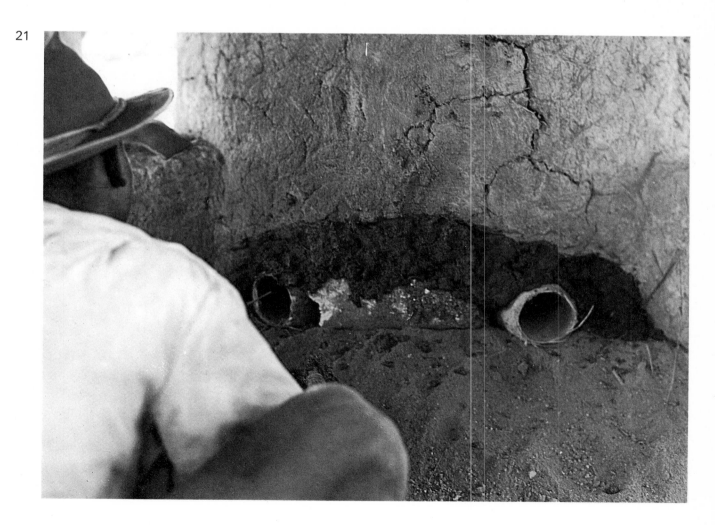

rolled briefly in cut straw. Then they were rubbed smooth with the palm of the hand, which removed protruding straws. In one day these pipes, which are very easy to pull off of the wooden mold, dry enough so that they can be used in the oven. The two pipes in the front of the opening are, naturally, shattered when the oven is opened, and the four in the back extend so far into the embers that they later fuse onto the puddle. They are also damaged at the mouth, so for every firing six new pipes must be produced.

Another time I was again allowed to watch the iron-cooking. One day the old man told me that on the next day they would light the oven, and he angled his arm eastward to indicate what time I should be there. "At eight o'clock," interpreted his sons, and I extracted a promise from them that they would not begin without me. They were as good as their word. As I was arriving, punctually, the oven was stuffed with straw bundles and then lit. This was with European matches. Several years before, when I had visited the Matakam, I had seen them strike a light with the sparks from flint and their own steel to get the fire going. It is hard to believe, when reading articles on the intricacies of African politics, that here and there Africans still need to make their own fire. During my caravan trek in the Tenere desert, I noticed that the Tuareg were able to rub up a fire with a hardwood stick on soft Euphorbia wood in thirty or forty seconds. But with the Senufo smiths fire is made more prosiacally. At 8:20 all the clay pipes had been set in, but the opening in the oven had not yet been fully closed—this was apparently in order to maintain a temporary draft.

Now the young smith climbed up the beam, the forerunner of the ladder, onto the solid roof, and emptied the first two baskets of charcoal into the oven. Charcoal is kept in a small hut out of the rain; one of the younger brothers had filled the baskets and carried them over. The old smith Dégogné sat watching all the work, once giving an order that was carried out immediately and without contradiction. His oldest son was perhaps just under thirty and had long since been the head of a family. This, of course, did not prevent him from recognizing the authority of his father. Because he apparently felt that I was surprised at this, the young smith explained to me: "It is not good to contradict the old man."

Only at 8:55 was the oven door finally sealed, and the remaining four pipes, which until then had only been pushed into place, were walled in. At nine o'clock the third basket of charcoal was brought over, and the contents were thrown into the chimney from above. The thick white clouds of smoke disappeared slowly. Later, red flames flickered over the chimney. Immediately after the third basket of charcoal, the hundred ore balls were put in. The smith aimed and threw them down one by one, so that they were evenly distributed over the charcoal on the bottom of the oven. They fell apart immediately. Possibly a hundred balls are made so they can be correctly

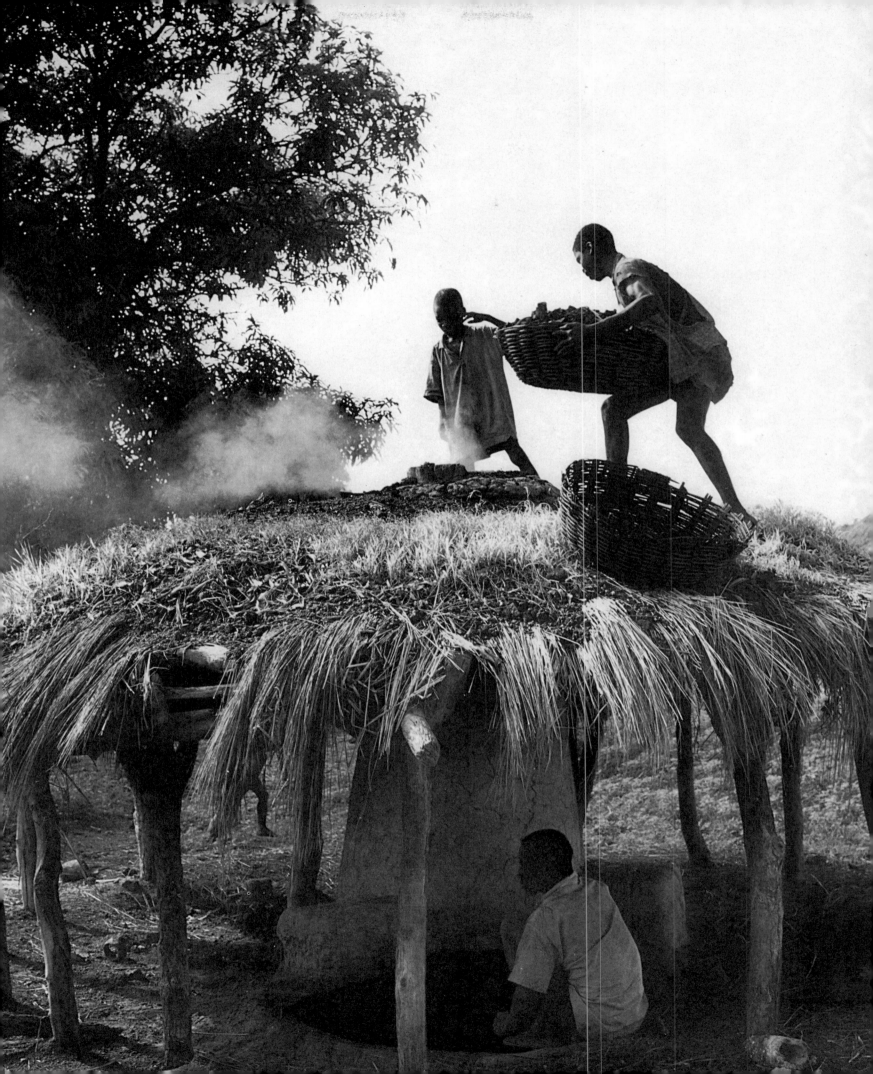

placed. Now there is nothing more to do: nothing else happens for quite some time. The fourth basket of charcoal is dumped in only around noontime, and then the iron is left to cook during the rest of the day. With the Matakam, two handfuls of ore were continually added throughout a twenty-four-hour period, and charcoal likewise, but among the Senufo all the ore goes in at once. With the Matakam all sorts of magic practices were performed: millet beer sharing, blood offerings, ritual music, and incantations. Nothing of the sort existed here. There was no offering place to be found, I found no traces of blood, and my questions in reference to these things seemed incomprehensible to the smiths.

After about twelve hours, the charcoal was completely burned up. With the exception of the addition of the fourth basket, there had been nothing to do since nine o'clock. And nothing to be seen, either. No slag was removed, there were no flame colors to be judged, and there was no bellows either. So we could drive home in peace.

The next morning at seven, the oven, which had cooled in the meanwhile, was opened. The wall of soil was cleared away and the walled-in pipes were shattered with a pick. Then the formless puddle was dragged out with some effort. A flat cake weighing roughly fifty pounds had resulted. There was no chair-high chunk like that produced by the smiths of Tourny, and certainly no mammoth column like that of the Matakam. Dégogné had a piece chipped off for him from the edge of the cake. He weighed it in his hand, looked at it, and appeared content. The puddle contained much iron; the thing was a success. The puddle was packed onto the package rack of a bicycle, and a son about sixteen years old took it home. There was again a supply in the village in case an ironworking smith should want to purchase metal. Immediately afterward, the oven was completely cleared out, the ashes removed, and about three days later the whole process began all over again. But in between the iron-cookers allowed themselves a rest!

In many places the smithies in which tools and agricultural implements are made for local use are located at a slight distance from the settlement. In the picture at right the workshops of the smiths of Tourny stand some ways from the town in the shade of venerable old trees, and I found another about twenty miles from the city of Korhogo. It was about 1,200 feet from the nearest clay houses of a little enclosed village named Nagbéléquékaha. Nagbéléquékaha! That is certainly a place name that is easy to remember! The workshop was covered by a straw roof that hung very low and was propped up by a round wall. The entrance was small, so one had to stoop way over to get inside. The back of the hut was occupied by an enormous monster of a bellows. Behind the leather bellows sat a cheerful, almost naked, little boy. In the front part of the hut a friendly old smith was wielding his incredible tools. His young assistant helped only when both hammers

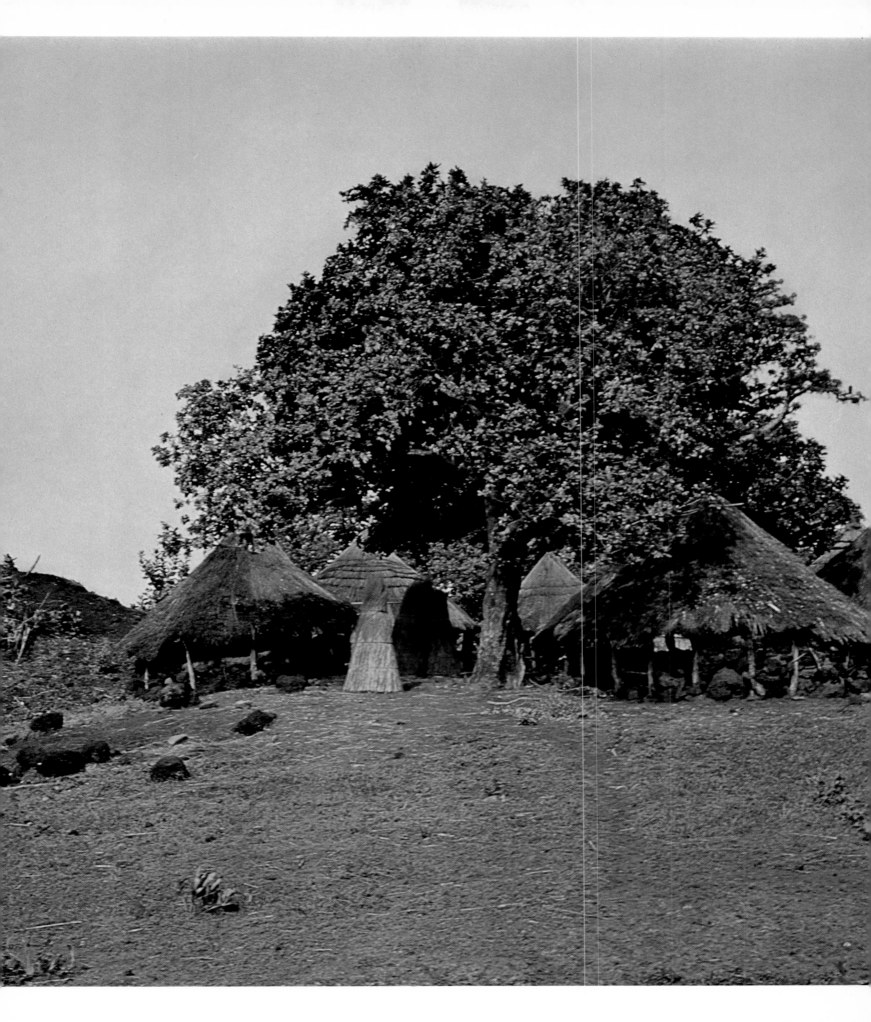

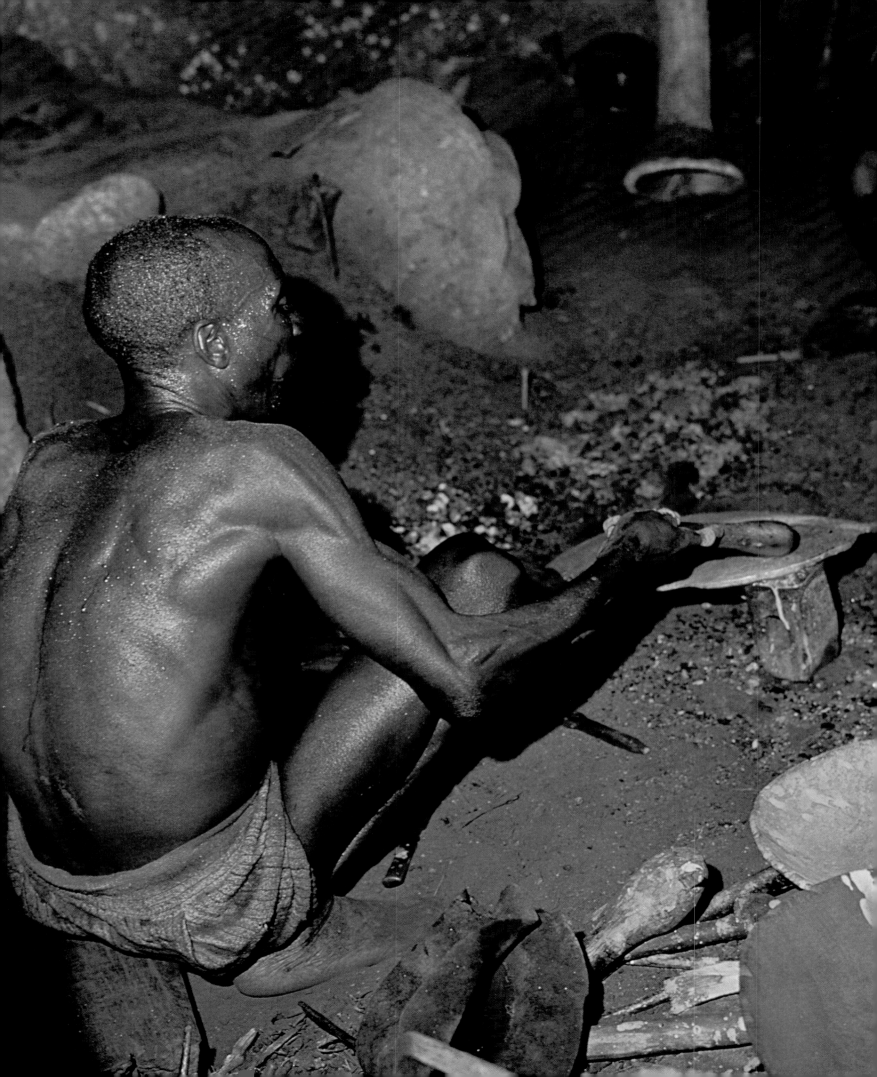

were being worked. The dark-skinned smith was sweating, and soot and coal dust on his smeared skin made him appear even darker and rather ghostly. On his face and back little streams of perspiration rolled through the sticky smear. Little was said, and the small bellows boy knew exactly when he was supposed to work the skins.

The smith was just working on a large hoe of the kind used by farmers to build up their table-high piles of earth for the cultivation of yams. Yams, or *ignam,* develop shank-sized tubers. In the foreground lie the smith's tools: the usual tongs, hammers, an iron pestle, and to the right a stone cudgel (picture below). Here I learned something new. The hoe had been worn down in the front by heavy use. Now the smith set about replacing the missing iron. With one hand he sprinkled iron kernels from the bowl under his hand on the thin spots. This was the homemade iron and it was stuck on with a brushstroke of thin clay paste. He then threw a handful of ashes over the implement before he put it in the embers. As soon as the iron was red-hot, he hammered the added metal flat. Because the process was repeated several times, there was eventually enough iron added to forge the tool back to its original length.

So there emerged, after painstaking labor, a new hoe with a hardly visible, seamless patch.

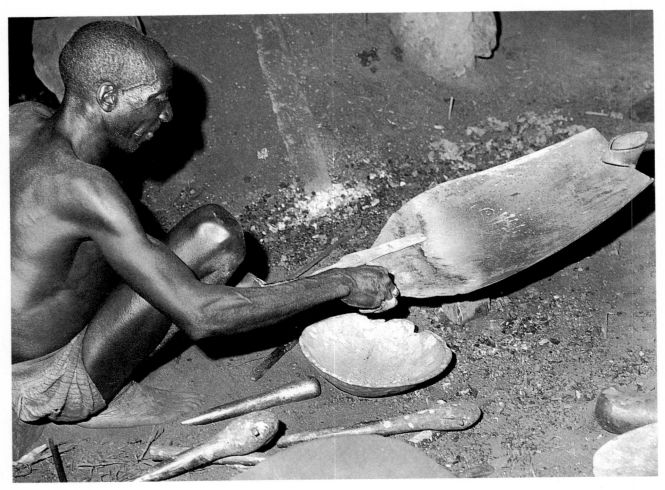

In both pictures on these pages, two clay pipes shaped like long "trumpets" are visible. At the left, the funnel is at the top, and at the right, below. This seems confusing, but it is due to different photographic angles. In the picture at the right it is correct. There it opens directly into the hearth, that is, into the depression where the charcoal is glowing. Above, by the funnel of this pipe, are the two small pipes of the bellows system. There, they are inserted only about two inches and they are not walled in with clay, so with the sucking of the bellows enough air reaches them from the side. African bellows have no vents. In the other picture (below right) a reserve pipe has simply been leaned up against the wall of the hut, with the broad funnel edge placed at the bottom in order to prevent it from tipping over.

In this chapter I have talked mainly about iron-cooking (iron smelting) and ironworking, but long before the white man appeared the smelting of oxidic copper minerals was known as well. At numerous copper sites in Zambia and in the neighboring Katanga region of the Congo, a strictly stratified group of specialists, with many special privileges, transforms the green malachite into metal. Goldsmithing has been known in Africa for centuries. Even today, there is still the large guild of the casters and smelters who work silver, brasslike alloys, and gold. These crafts are the subjects of the next chapter.

27

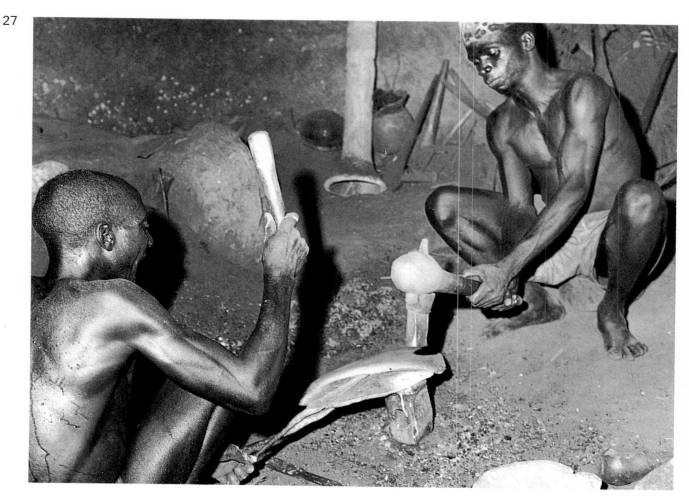

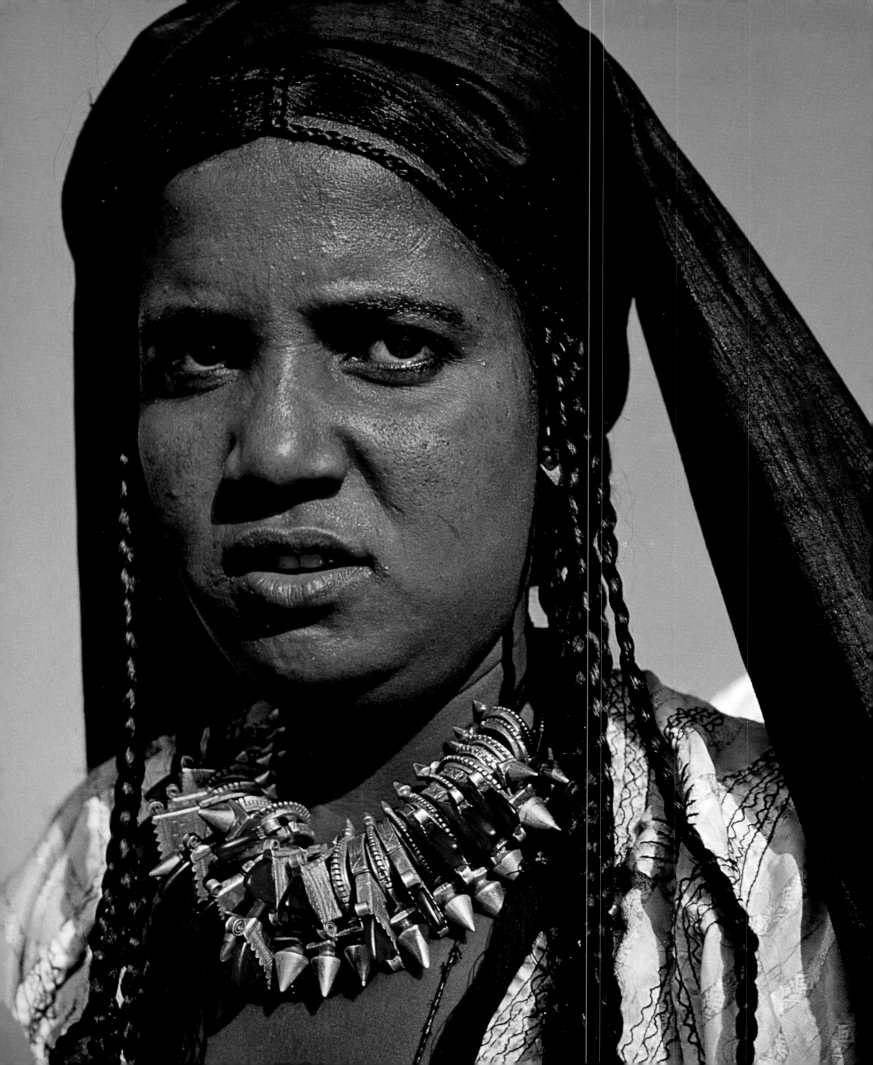

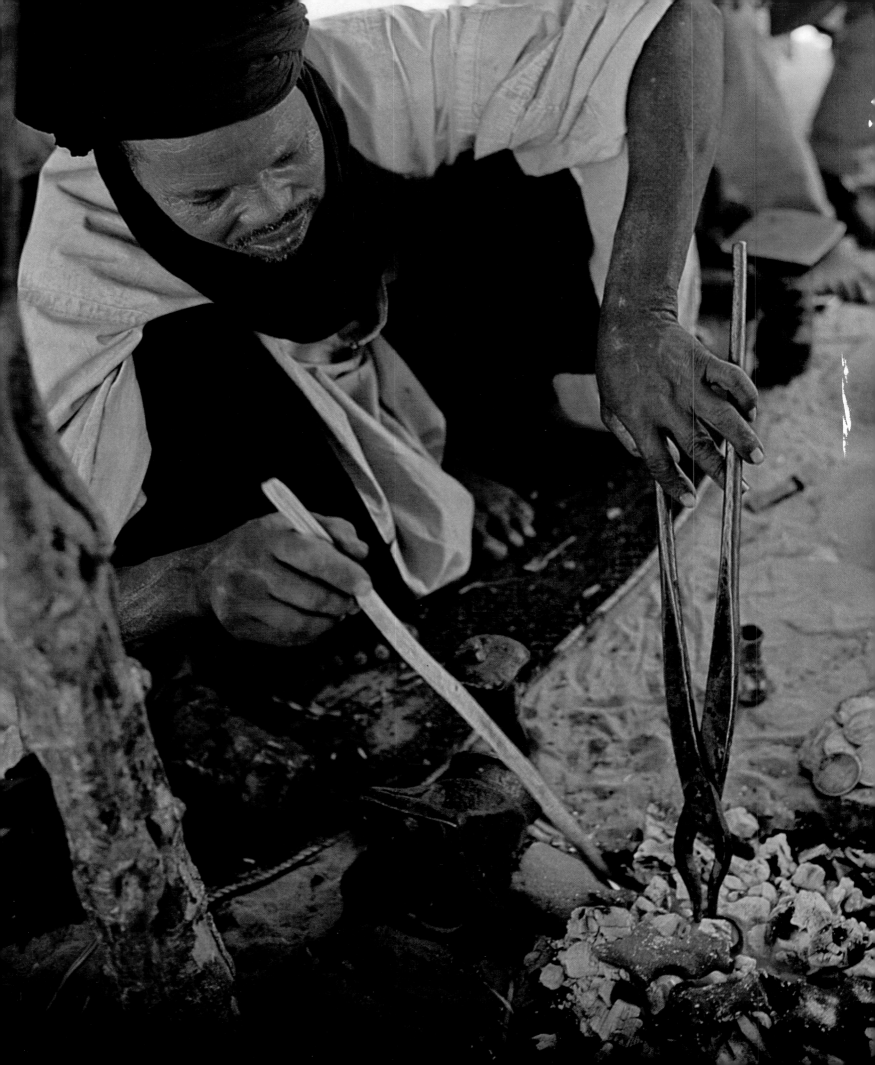

There at the left sits Mohammed Umama, a man of the Tuareg tribe of Kel Agalal in the Aïr massif, and he is in the process of casting a silver pendant. Mohammed is considered one of the best smiths for far and wide in the area around Agades (in the Republic of Niger, not to be confused with Nigeria, on the southern edge of the Sahara). I owe his acquaintance to my friendship with Monsieur Bernard Dudot, who has lived in these areas for many years as a teacher. He is one of those Frenchmen who have lost their soul to the country, and who need the breadth of the landscape, the height of the sky, and the cheerful ease of the African people in order to breathe. He is, like me, an amateur folklorist, and he is interested in craft techniques and knows all the good craftsmen. Aside from that, he collects with a passion. So there grew up for a time, while I was living in Agades and on trips together in the Aïr region, a feeling of cooperation and camaraderie for which I am very grateful.

Mohammed Umama of the caste of established smiths had become a specialist in silver work. He was currently producing those silver pendants included uner the general heading of "Cross of Agades." On page 47 is a picture of a girl from the Aïr in holiday dress, adorned with all the silver jewelry she owns. One can assume that, in earlier years, magical and healing effects were ascribed to these pendants, but the young girls of today, and their mothers too, know nothing of the tradition. They regard the Agades cross simply as an ornament, and naturally as a symbol of wealth too. It is worn by all the Tuareg of the Aïr and many of the tribes living farther to the south. The origins and symbolic power of this singular form, which also appears in the famous Tuareg saddle, have been puzzled over, without any agreement, by many specialists. So I would like, in this chapter, to report a

little about our friend Mohammed Umama and to describe how he produces the famous silver ornament. He also produces small, richly engraved sugar-hammers, decorated rectangular silver pendants into which phrases from the Koran and magic formulas are placed for good fortune, jewelry for the women, but, above all, the silver crosses.

Mohammed's workshop is about two or three miles from Agades, at the edge of the Kor River, which does not flow every year. A pitiful hut, covered with straw mats, in the middle of a plain exposed to many sandstorms. A few crippled, thorny trees. And scattered about are the mat tents of settled nomads, for whom the proximity of a city is convenient. Mohammed also owns a farm very near his workshop: within a thorn hedge stand four pretty mat tents and next to them, a corral with a fiery little horse and a couple of goats. Mohammed, a skillful craftsman, is not poor, and earns a good living for his family.

A pretty daughter, Iifalla, is already married, naturally to a smith also, but he is by no means worth as much as his father-in-law. Then there is Sidi, the eighteen-year-old son, who squats near his father for several hours a day and tries to help. But he has little staying power yet, and prefers to race around on the horse his father gave him. At the last festival in Agades it was always Sidi, the son of Mohammed the smith, who won the horse races. Abella, another daughter, never appears in the workshop. Then comes Ataher—he is thirteen and beginning to swing a hammer and produce knives out of scraps of iron. And then come three or four other children, none of whom go to school to learn the arts of reading and writing, even though there is a school quite close by. Their father does not consider school necessary for his boys, to say nothing of the girls.

Again and again we drove out to see Mohammed. Often Bernard Dudot accompanied me, when he had the time, and every time I was amazed at the creation of such consummate works of art with such rudimentary equipment.

Mohammed would squat cross-legged on his mat for hours: he seldom stood up. Again and again he pushed back the wide sleeves of his robe or rearranged his head wrap, which often slipped. From where he sat he could reach everything he needed. In front of him in the sand stood a broad anvil that served as a little worktable. A little to the right of that was the forge, nothing but a little pit in the sand with three stones around it. The movable bellows was worked by one of the sons. A few tools, tongs, a hammer, and files, lay about, and some scrap metal rested against the supports of the hut. A little wooden box contained all sorts of precious things: snuff, matches, cartridge cases, the silver supply, and chisels for engraving. That was the entire equipment of the "atelier." Here Mohammed felt good, and in his element. He liked to laugh, and seemed always to be happy and in good

spirits. And he always had time, even while working, to chat a bit. Whenever we arrived, he was seldom alone. The boys helped. They worked the bellows, got new charcoal, or brought their father water to drink. Neighbors' children sat on the sand and watched interestedly, although they had seen the procedures a hundred times before. Everyone who passed by stopped, greeted the respected smith ceremoniously, and said, "*Lafia, lafia loo* (Peace be with you)," and then sat down in the shadow of the roof. They chatted or exchanged news, or simply were silent together. Every day a youth with his basket of wares balanced on his head made his rounds. He tried to sell the women in the tents peanuts, sweets, matches, or soap, but when he got to Mohammed he was sure to sit down and stay at least an hour as a welcome, silent onlooker. And then he moved on. A passerby on his way to town was sure to be seen by the smith. They would call out a few sentences to each other, or perhaps Mohammed would ask the other to bring him something from town. It was all so incredibly normal, such a matter of course. It was life enveloped in friendliness, in mutual participation, and also in curiosity about others. There was no uncertainty and no fear.

I always marvelled at Mohammed's quiet, friendly manner—the way he squatted there in the center of his shop with his family and ruled with never a harsh word. The boys obeyed him immediately, and without the least back-

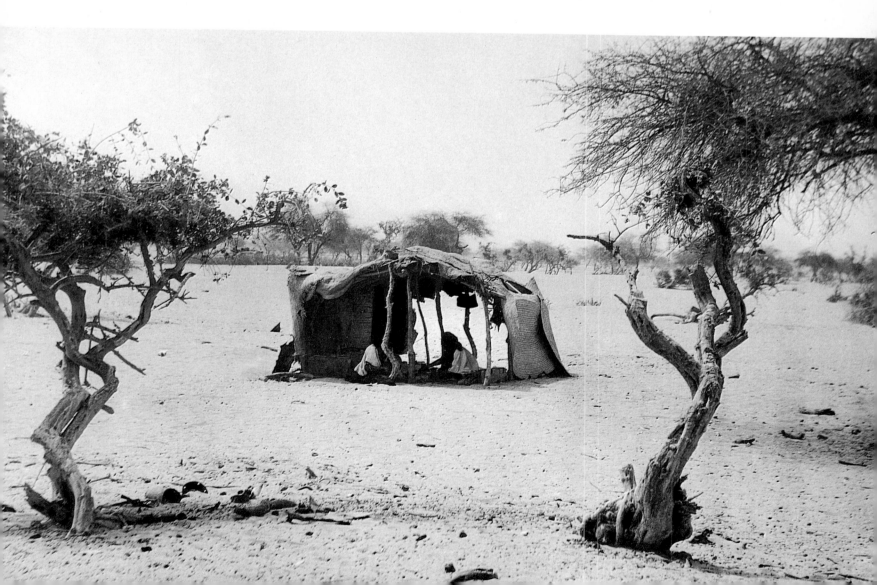

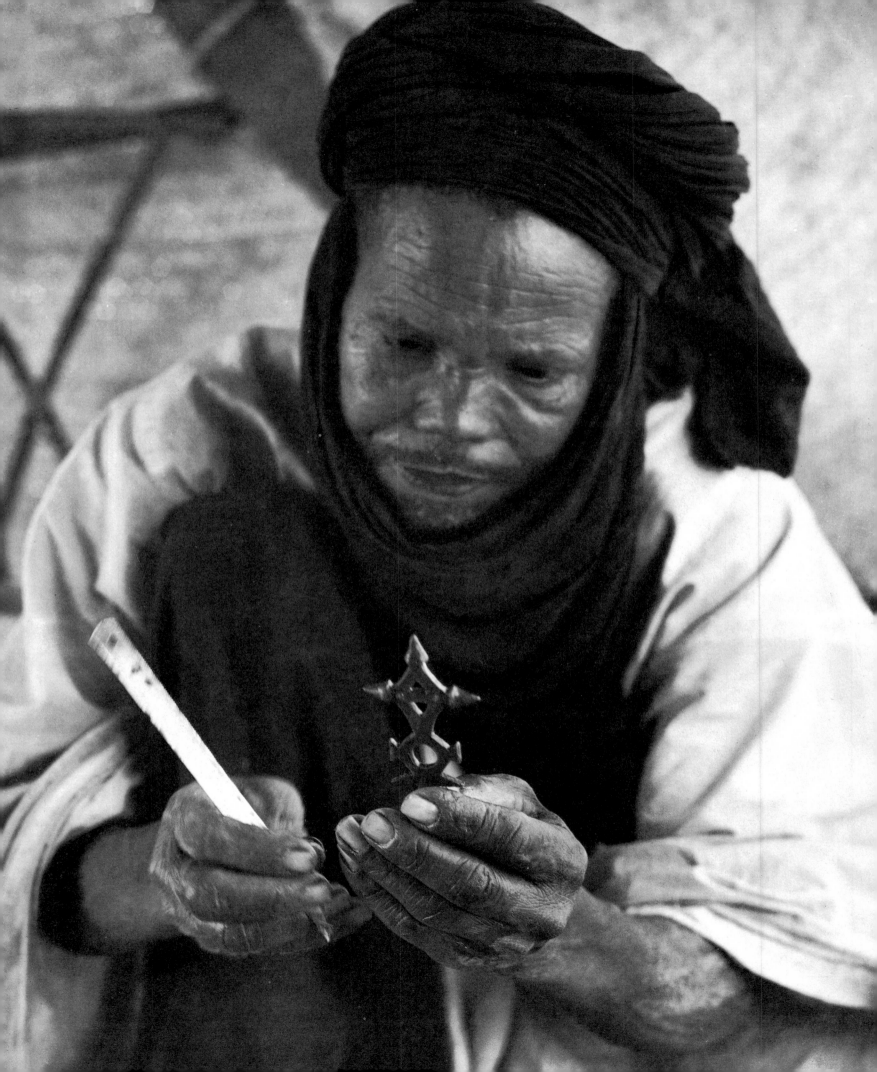

talk, because they naturally recognized their father's authority. This was no wonder, because every day when they tried to form a piece of wax or to bend a small piece of glowing iron, they realized that their father could do it better. They laughed a lot, they slapped each other's open palms upon finding some small thing amusing. And they showed genuine pride, childlike happiness without reservation and with a smiling face, if a casting came out particularly well. So there sat Mohammed Umama, this master of his craft, in his billowing, inexpensive *boubou,* and when the wind blew he would calmly shake the sand out of the robe from time to time. His working methods were perhaps antiquated, and many things were inexpedient. Sometimes he was also lazy, but that too belongs to the picture of the handcraftsman. It seems to me that to relate all of this here is at least as important as the description of the technical procedure in the production of a piece of silver jewelry. It is valuable to

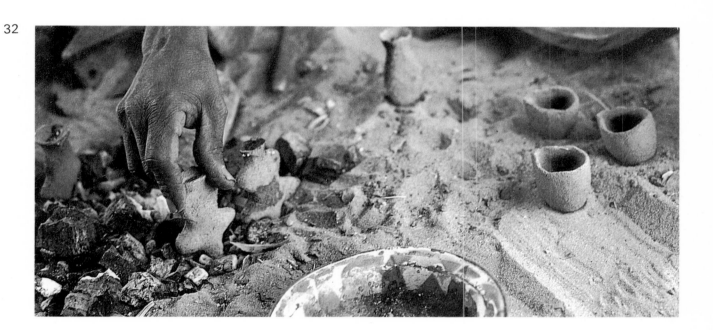

the understanding of the dignity and honor of such a master craftsman. He employs the lost-wax technique, which has been widespread in West Africa for centuries. The object, a pendant, is carefully formed in wax (picture at left). The beeswax comes from Nigeria and is bought at the market in flat cakes. It is used over and over, melted down anew and kneaded, so that it has long since lost its beautiful pale wax color. A cross in the shape of the number one (far left in the picture on page 60) is to be made. It is the cross of Tahoua, one that differs only slightly from the cross of Agades. Mohammed works without any mold whatsoever. He relies only on his eye, and again and again he discovers a small irregularity that he eliminates before he finally prepares to cover the wax model with a well-purified clay paste, without deforming it. The casting mold dries quickly, and then it is lightly burned with the others in glowing charcoal (picture above).

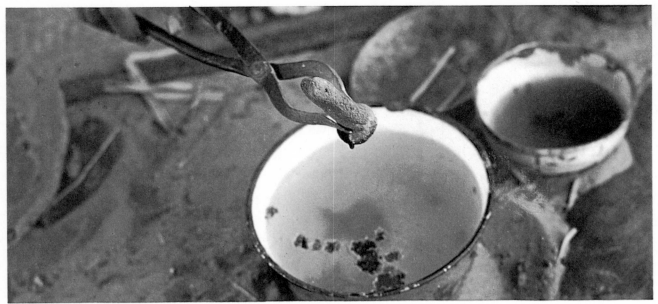

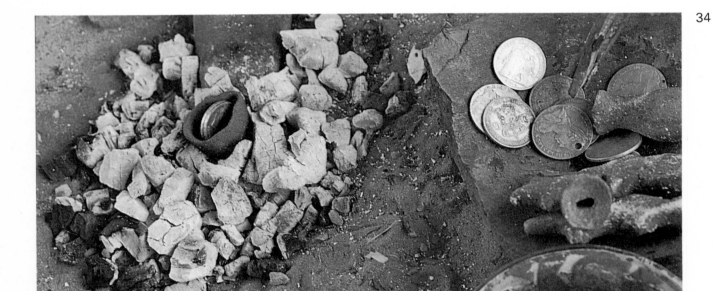

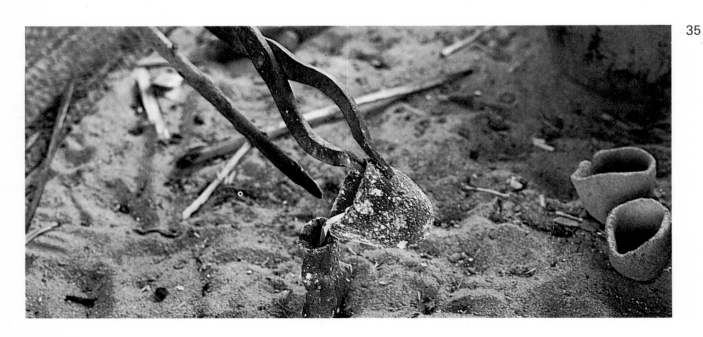

Very soon the wax, which melts in the heat, is poured out of the tilted form and into a bowl filled with water. There it hardens, and, as we have already mentioned, is saved for later use. This process is repeated several times, until there is not a single drop of wax left in the clay form (picture at top). In this way, Mohammed prepared several casting molds and then set about melting the silver in little clay crucibles that had been well fired (center picture). In the coals is the melting crucible holding two silver coins. At the right, more silver money lies next to prepared casting molds. At the time, I ordered all sorts of different forms of the ornamental cross from the silversmith—the Agades cross, the Tahoua cross, one that is typical for the region of the oasis of Iferouane, and so on—and I bought samples from the production process from him, too.

What I needed was a series of every cross-form: the model filled with wax, the casting mold, the raw ornament as it emerges from the shattered mold, and then the finished, engraved cross. I told him that at home I would put all the pieces in a large house, called a museum, and display them to show people how the smiths of Agades make their silver crosses. He understood that very well. But he did not have enough silver to satisfy all my wishes, so we went to town together to buy Maria Theresa talers from the dealers. This old coin from Austria is, strangely enough, still very respected today, and still in circulation. One can find not only old pieces but also completely new ones that have been recently minted and exported to Africa. These silver talers are apparently trusted more than paper money. We went first to the Hausa tradesmen and found none there—or perhaps they just did not want to sell us any. We then went on from one Mozabite trader to another until we had gathered enough talers. We needed about twenty, which cost me 140 francs altogether. Another time I will remember to take small silver ingots with me from Switzerland. A few days later, when I wanted to buy a few more talers, these good businessmen had raised the price by 50 rappes in accordance with the old law of supply-and-demand, which is just as valid for the African market as it is for us.

Silver melts at nearly 800 degrees Centigrade, and that temperature is easily reached in the white-hot coals being blown by the bellows. So it did not take long before the two talers necessary to make a cross had become molten. Mohammed had stuck his mold into the sand, seized the crucible with the tongs, and, with the help of a little wooden stick, had carefully and deftly poured the silver stream into the mold (bottom picture). And it was demonstrated again how well his working place had been selected. He was enthroned on his mat with everything arranged perfectly: the forge to the right, the tongs at hand, the molds in front of him in the sand, the silver supply just behind him in the little box. He scarcely had to move to perform all the required functions.

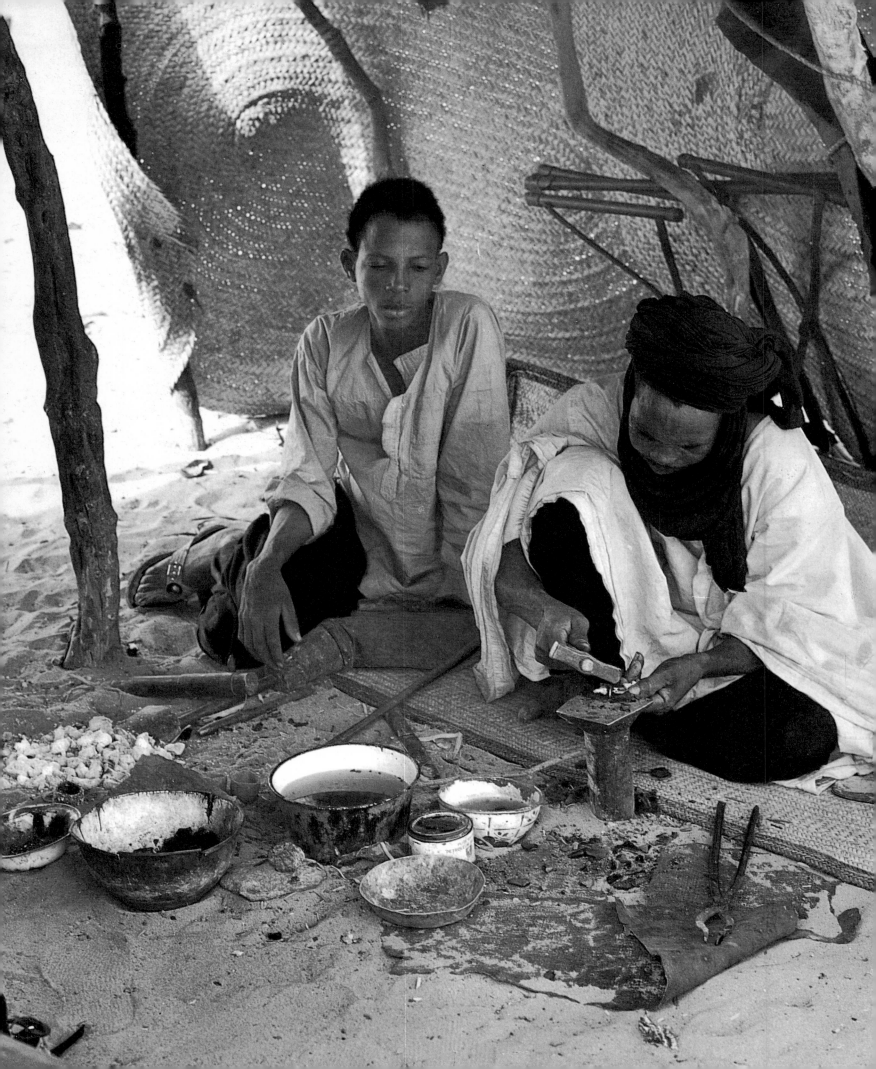

Now one should really look closely again at the primitive worksite at the left. It is truly primitive, workbench and machines are absent, and it is open to all the elements, the heat of midday, the cold of a January morning, the dust and the sand. And then look ahead to page 60 to see beautifully engraved pendants from Mohammed's workshop; it is hard to believe that they were made under this scanty mat roof.

Mohammed is about to shatter the cooled mold, and Sidi, the son, watches him with interest, because it is an exciting moment, and only now will Mohammed know whether the casting has been successful. (Sidi does not yet wear a face wrap, but as soon as he is a year or two older, he, too, will veil his face according to Tuareg custom.) The mold must be broken in order to get the cast piece out, so each piece is unique and not reproducible. Each represents an original. As they come out of the forms now, the silver crosses are not particularly beautiful. Their surfaces are covered with a layer of oxidation. It is sulfur yellow and rough and there is no shine. So Mohammed prepares in a clay bowl a bath of some chunks of a natural salt that caravans bring from Kaouar, more than 400 miles away. The two crosses are boiled for several minutes in this solution (picture below), and soon the beautiful patina of silver appears. The grimy surface, which also may be due to burnt wax remnants, has disappeared. Mohammed then files away the casting

37

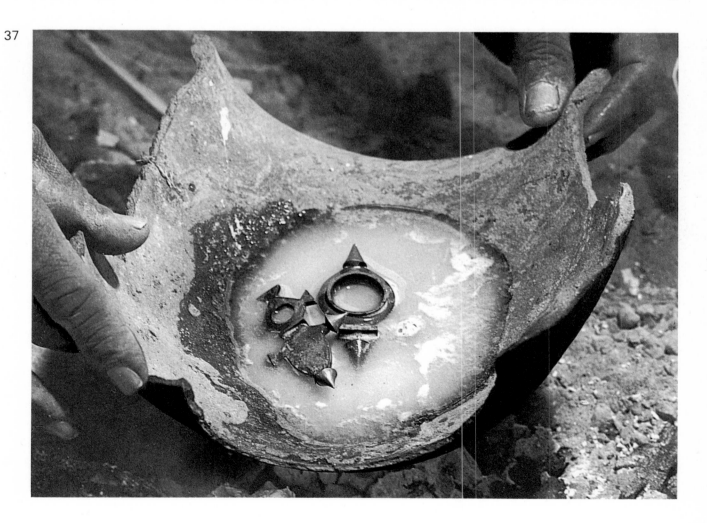

nipple and rubs the ornaments with fine sand, of which there is plenty in his shop. And now begins the last, artful job, the engraving. The picture below shows how he has learned to use the simplest tools in the most ingenious way.

The piece being worked on must not slip, so there is a hole in the anvil into which is stuck a handy chisel as a brace for the little piece of wood. Mohammed lays the cross in the indentation, holds both the silver cross and the board tightly with his left hand, and then engraves fine designs in the silver. He works freehand and without a pattern, using a little steel burin that is sharpened constantly. In the picture below, he is working on the classic form of the Iferouane cross.

The quality of the craftsman is judged by the refinement of the engraving. With the same lost-wax technique used for the crosses, Mohammed makes broad rings, large amulets that are worn as pendants, little hammers to break up lump sugar, and all manner of souvenirs for tourists. In the picture at right, a Targia who wants to treat herself to a new cross sits with Mohammed. She has brought two Maria Theresa talers, and now they discuss slowly, circumspectly, and exactly in what form it should be finished. Mohammed knows how to make all the pendants customary to the region and he also knows from long experience where they come from and what they are called. The

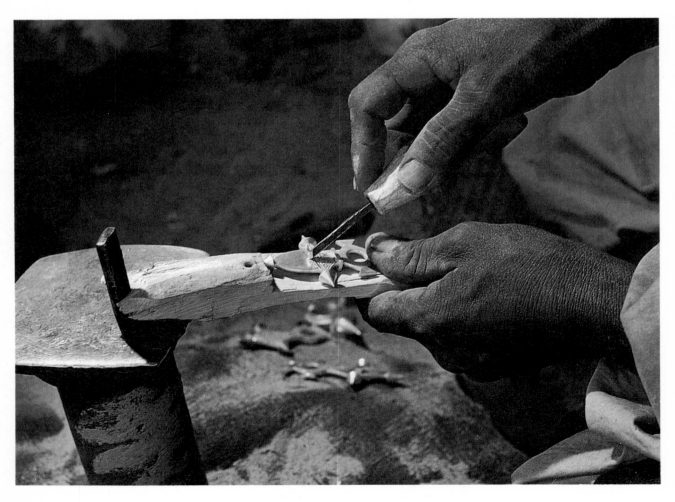

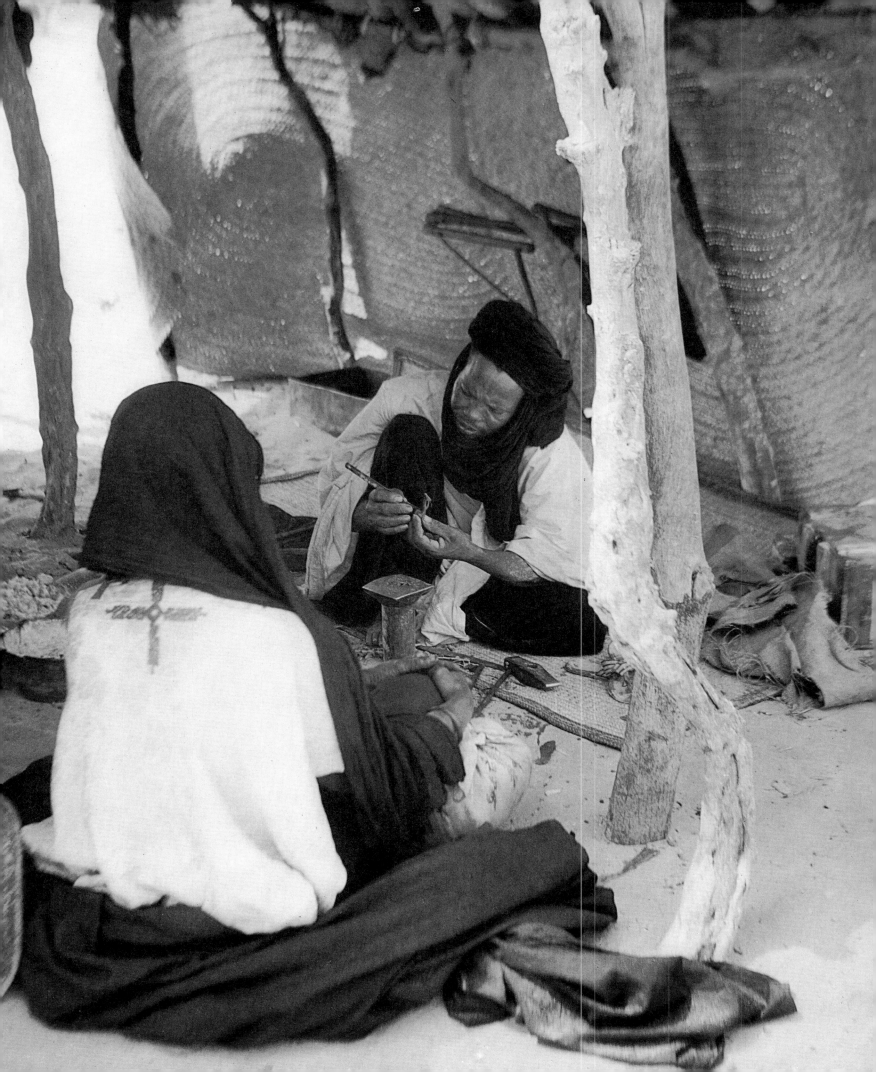

crosses in the picture below are, from left to right: the cross of Tahoua (Tahoua is a town west of Agades); the cross of Iferouane (the name of an oasis in the Aïr); the Zakkat, a form very popular with the women in Agades; the classic cross of Agades; and the Barchakeia, a Hausa favorite. My little collection, which Mohammed made, is very incomplete: in Monsieur Dudot's apartment hangs a collection of three dozen silver and stone crosses, neatly mounted on a dark board. They all resemble one another in that they point to a common, unknown origin, yet they all differ from each other in their details. Mohammed Umama is a Targui (masculine singular for Tuareg). The smiths, the Inaden caste, have a unique position within Tuareg tribes. Although they are usually darker-skinned than the Imochar, the warrior caste, they are not negroid. Their hair is smooth and not curly. With the nomadic Tuareg, crafts were never developed: that would have been contrary to their way of life. But

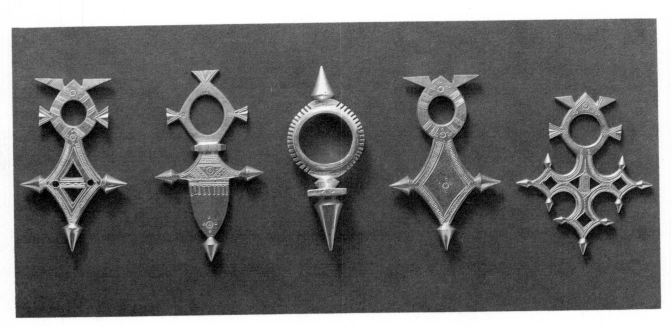

one still needs all sorts of tools and weapons, and everyone loves jewelry. It is the job of specialists to provide the tribe with all these things. One calls them smiths but therein lies the concept of "craftsman." They are black-smiths and silversmiths, but they also make wooden bowls, milking equipment, and mortars. They make spoons and ladles as well as beautiful camel saddles. Besides working silver, Mohammed Umama can work iron, make stone rings, or hollow out a tree-trunk for a mortar with a forcefully swung axe. He is a true craftsman.

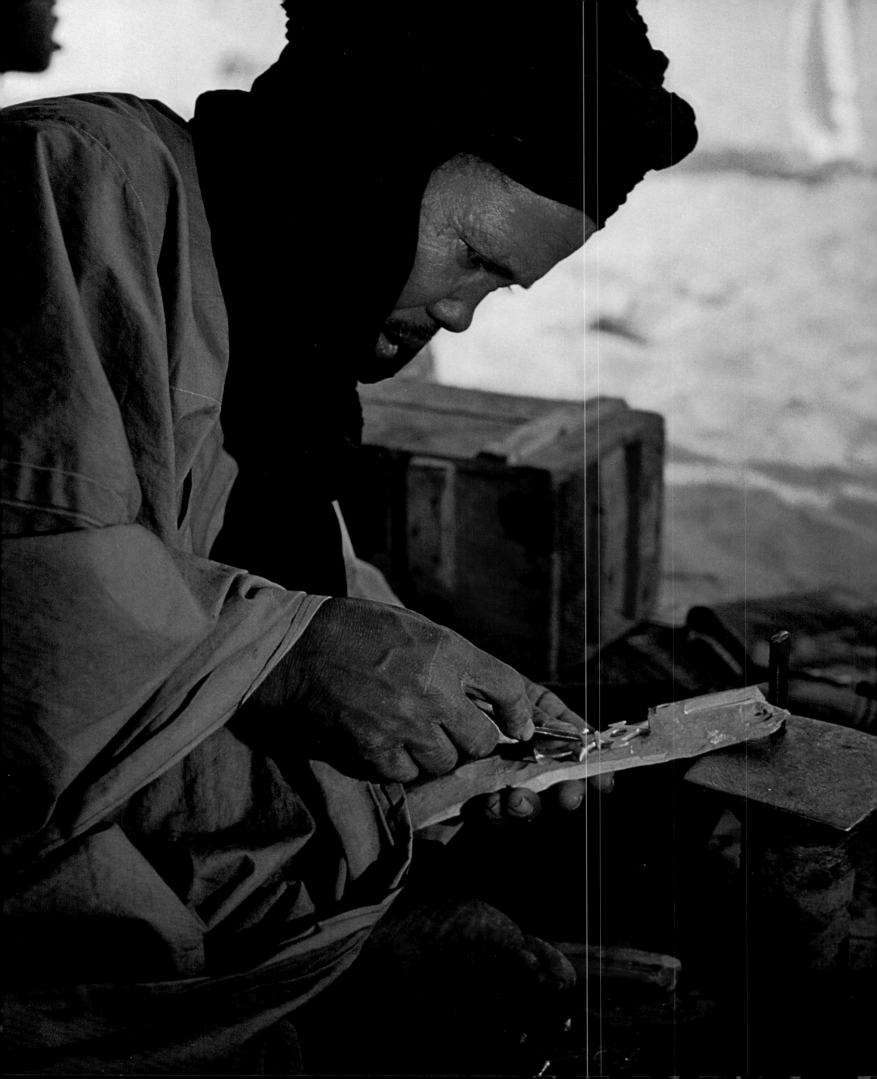

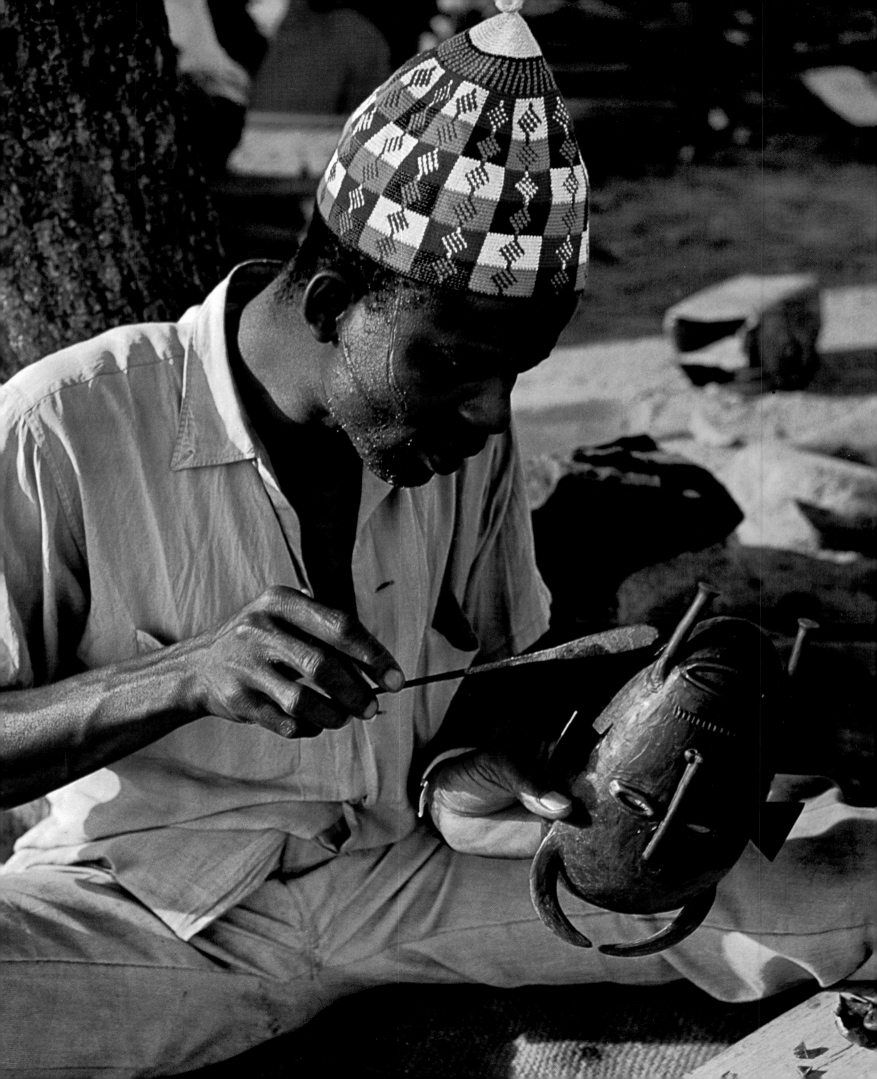

The Brass-Founders of Korhogo

42

Brahim Kulibary, who is forming a Senufo mask in wax at the left, lives in the K'go quarter at the edge of the city of Korhogo in northern Ivory Coast. He belongs to the guild of casters, who differ from smiths, although they too work with fire, bellows, and charcoal. It is hard for me to find the right name for this profession. These craftsmen use the lost-wax method. That means that the wax model and the clay form no longer exist after the casting is completed. Because wax is used for the model and is then melted out, the French call this the *cire-perdue* (lost-wax) method. The word "caster" defines only one part of their activities. They also shape the wax: they model with such good taste that, without exaggeration and with a clear conscience, one can speak of a craft as an art.

They cast jewelry, utensils, weapons, animal figures, sculpture-in-the-round, heads, entire groups, and plaques depicting both people and animals. The locales for the most significant examples of this casting art were, and to some extent still are, the Western Sudan, southwest Cameroon, the Ivory Coast, and southern Ghana. The technique must have been known in these lands for a long time, for the Arab writer al-Bakri, who travelled south of the Sahara in the eleventh century, mentioned metal figures. Among the modern Lobi (in Upper Volta) one finds very old castings, but the magnificent Benin figures and relief plaques of the Bini people, from the second half of the thirteenth and the fourteenth centuries, are the most famous. The Bini, whose kingdom collapsed in the seventeenth century, were the unequalled masters of metal-casting.

An alloy of copper and tin is called bronze. With zinc included, it is called brass. Brass was always preferred to pure copper because it is more easily smelted and less easily oxidized. (In order not to have to define the alloy

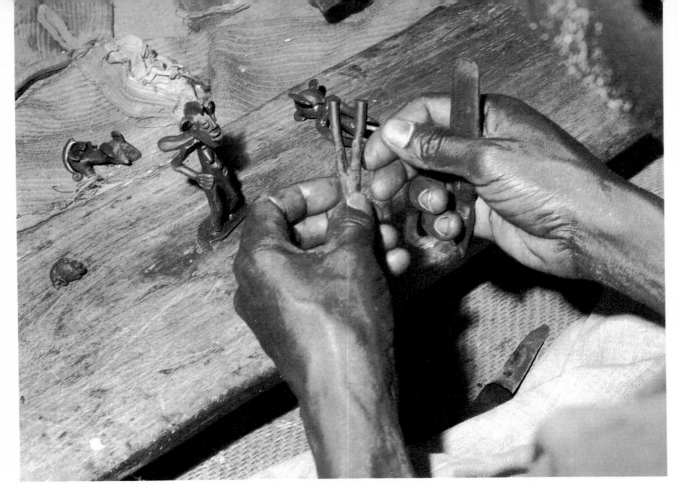

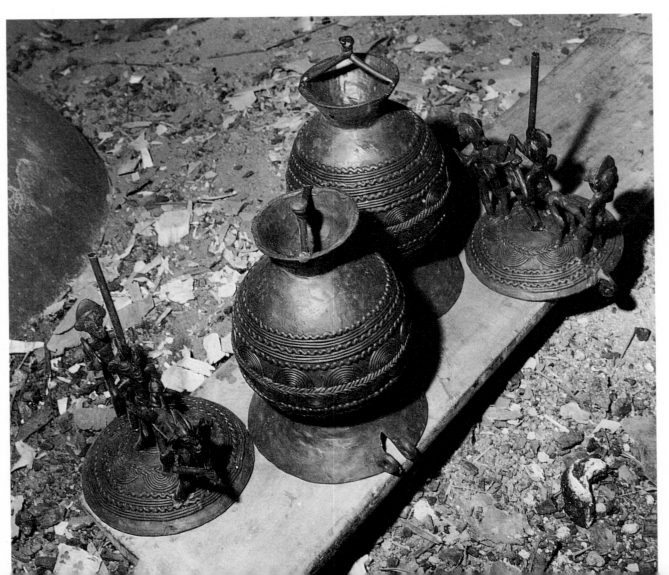

used for each piece, I shall speak generally of brass-founding.) The origin of the metals used is unclear, but it may be assumed that at first they came across the Sahara from the North, and later from trade along the coast. The Portuguese merchants of earlier centuries brought in whole shiploads of brass ingots and heavy brass rings, which were then reworked.

The old artist with the little white beard is Sengi Kulibary. He is simultaneously making several pitchers with removable covers. Well-rolled-out wax has been laid over a hollow clay core. The ornamentation has been made with wax threads (picture at lower left). The pitchers are upside-down, and the casting cords have already been affixed to the bottoms. The covers are decorated with figure groups. The picture at the upper left shows how Sengi shapes the figures with his fingers and a modelling stick. "There is the devil on horseback," he explains. "Ahead walks the devil's wife, and behind is a slave who has to cut grass for the horse." The wax model is encased in a clay paste, which must be so fine that the details of the wax-work can still be seen afterwards. The casting cord is again visible. It is attached, whenever possible, in an inconspicuous place in order not to have a disturbing effect. The wax comes from wild bees. As soon as the liquid honey has flowed out, the honeycomb is pulverized in a mortar. This mass is then boiled with water. The wax is skimmed off, cooled, reheated, and filtered through a cloth into a

45

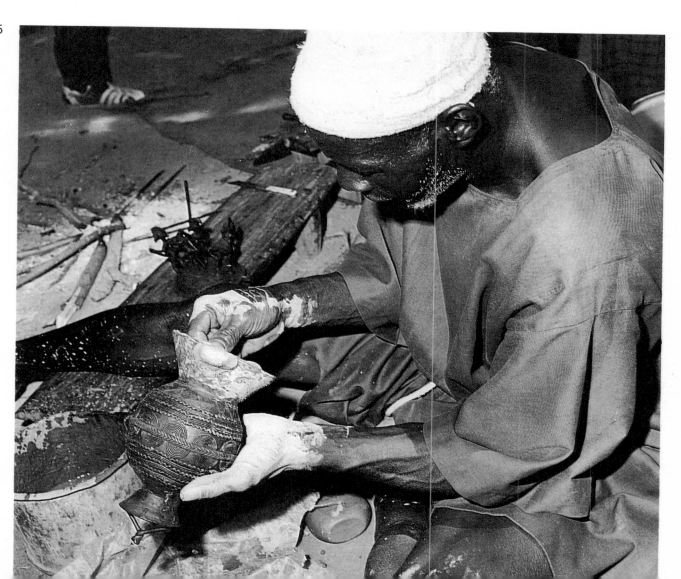

container of cold water. The result is flat cakes, which are laid in the sun before use so that they become soft and kneadable. The casters have set themselves up under a large mango tree. To the left of the bicycle stands the smelting furnace under a woven-mat roof. Sengi Kulibary here works with his younger brother, Brahim Kulibary, a third brother, Dju Kulibary, and yet a fourth. The latter is called Chaga Kulibary, and is only about eighteen years old. For the present he is given only menial tasks. All the men in the picture below are related to one another. In the group is a pair of young apprentices. The older one, in the picture at the right, is mixing clay paste that he will later form into balls the size of a loaf of bread and place under a damp cloth. Three boys work on rough-cast pieces with files, in order to learn the use of the tools. They also have to carry water and bring charcoal. And then file again! Like their fathers, they have to sit working for hours. And the same is true of the children of the weavers and the woodcarvers. Because they have to work at such an early age, they do not go to school: that is the darker side of the situation.

But these barely ten-year-old apprentices quickly grow into their fathers' profession. They watch, they learn, they are instructed. They develop into assistants. They are a part of the work, and the terrible isolation from one's father's profession, so common with us, never occurs. According to their

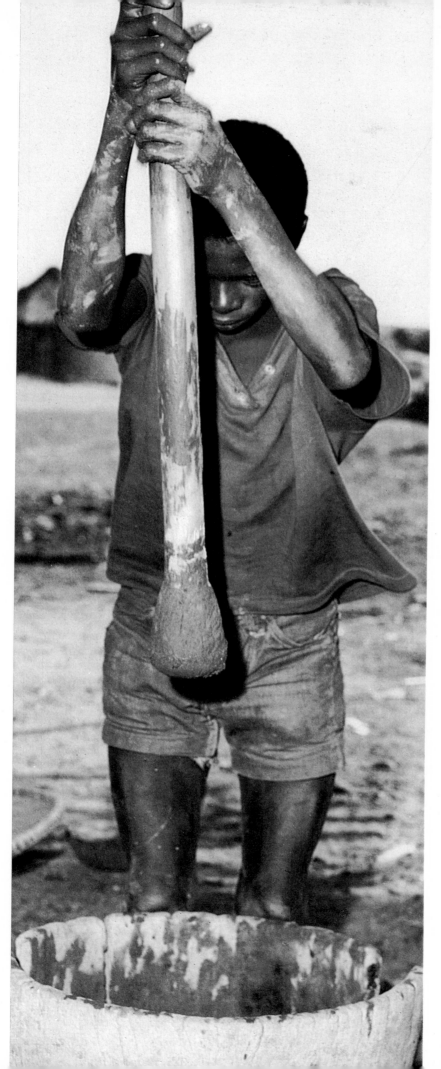

47

46

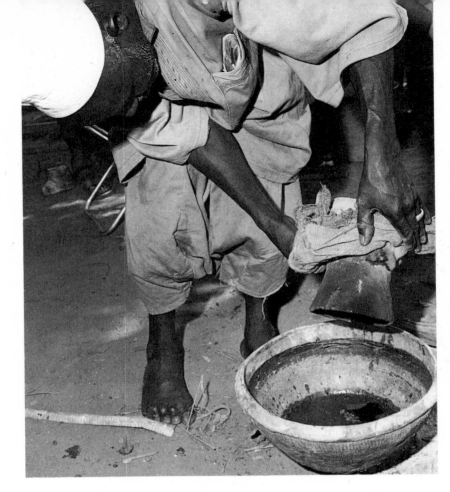

48

49

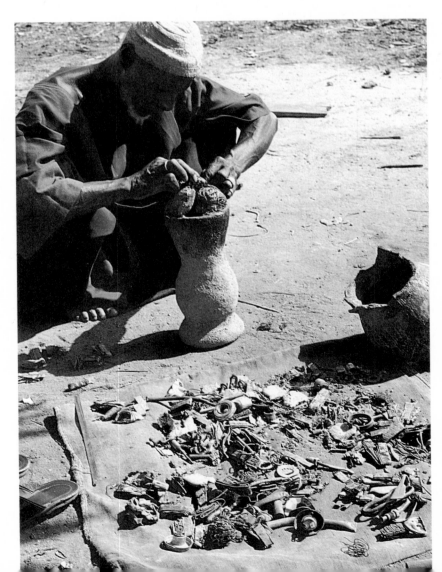

abilities, they grow into their fathers' profession in the most natural way. That, then, is the bright side of the situation.

The pictures on these pages show the preparations for the casting. The lost-wax process already has been described with reference to the making of the cross of Agades, but the technique of the brass-founders of Korhogo is somewhat different. The smith of Agades had the smelting crucible separate from the mold. Here the crucible is connected to the mold (picture below). A funnel, set on top of the wax model enveloped in clay, is the crucible. In the example below, the wax has already been melted out. The black spot in the crucible shows the casting channel. In the top picture at the left, the caster is in the process of emptying out the wax. He repeatedly places the crucible and form in the heat, until no more wax flows out and there is no more smoke from burning wax.

In the bottom picture at the left, the crucible is filled with metal. A pitcher, here shown upside-down, is about to be cast. Two invisible casting channels lead from the base of the funnel to the form (this corresponds to the wax model in plate 44). We can see what a hodgepodge of metal scraps is used. There is lead piping, parts of automobile batteries, brass screws, sheet brass, old water faucets, copper wires—in a word, the cheapest scrap metal, things that we would salvage only in wartime, if then.

50

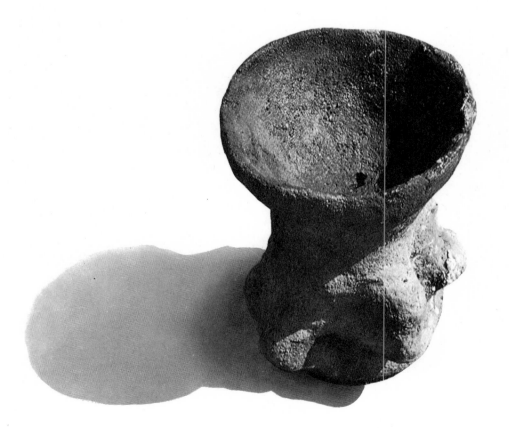

The young assistant, Chaga Kulibary, has covered the metal in the funnel with clay. A ball results, and then he envelops the whole thing—the casting form with its attached, metal-filled ball of clay—in another layer of clay. The entire arrangement is set in the sun to dry for several hours and then carried to the smelting furnace. At this point the form is turned over so that the metal lies at the bottom (picture at right).

The smelting oven is dug into the soil, so it is slightly deeper than can be seen here. The bottom of the pit is covered with charcoal. The form is placed on the charcoal, and more coals are added all around, without covering the form completely. For about four hours it is well heated. Then a mechanical bellows, barely visible at the lower left edge of the picture opposite, is used. For hours, Chaga untiringly turned the crank of the bellows, and only three times was additional charcoal put on.

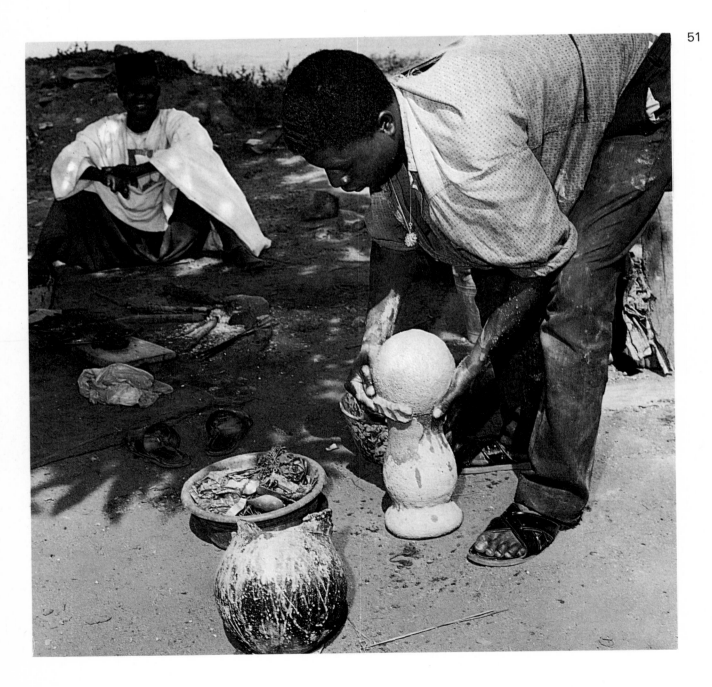

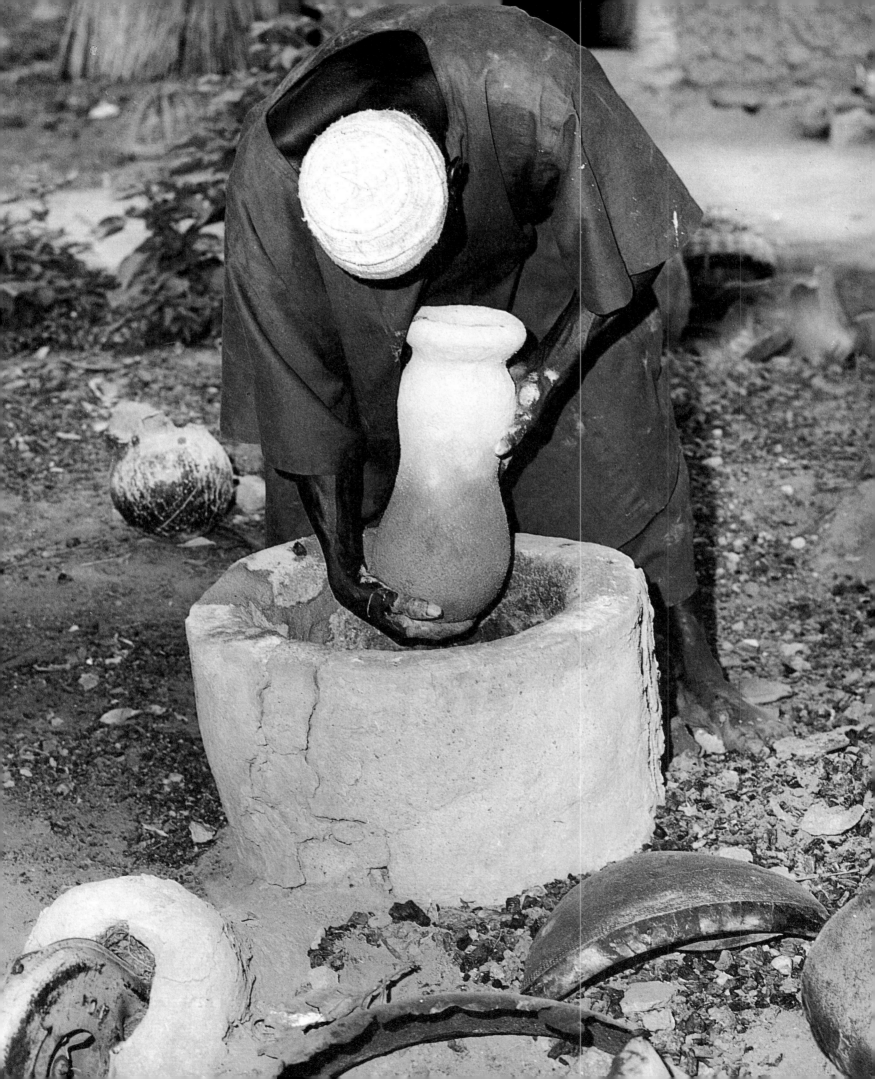

There is little more to relate. The large cast piece eventually is lifted out of the oven with a pair of very long tongs and stood on end. While still propped up by the tongs, it is turned around with a second pair of tongs, shaken a bit, and left to stand there for a while, as the picture below shows. The metal, which is now at the top again, flows through the casting channel into the mold. The air in the mold, as well as the gases that form with the cooling of the metal, will escape through the pores of the burnt clay. In books on this subject there are references to airholes that are made in the form, but I have never observed this. The only thing that remains is to let the form cool. One helps it along by placing it in a bowl of cold water, which, of course, immediately begins to boil and steam. Then the form is smashed, and only at this point can one see whether the casting was successful, whether enough metal was used. The jug is then cleaned and worked over with a file.

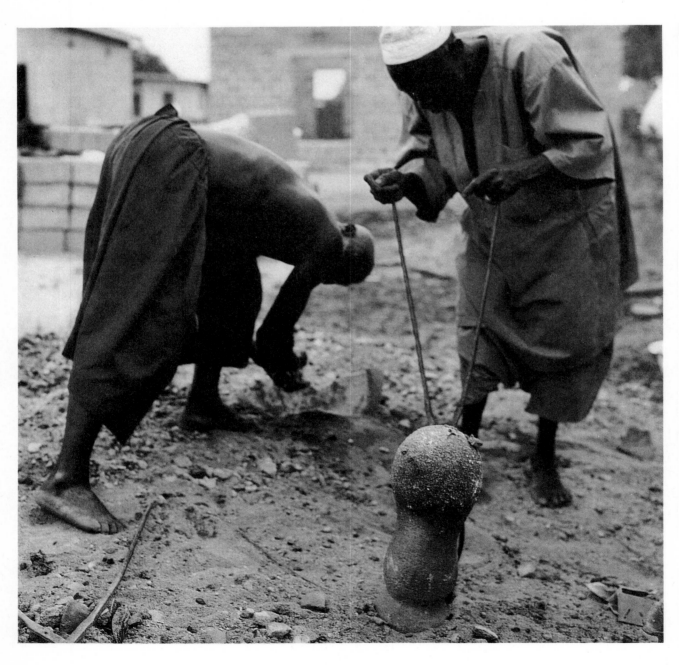

This, then, is how the procedure with the built-in smelting crucible differs from that described in the previous chapter. Not only the Tuareg smiths but also the Dan, the Kran, the Hausa, and the Bini pour the metal from the crucible into the form, while among the Akan, the Ashanti, the Baule, and the Bamum, to name the most important, the smelting crucible is connected to the form.

In comparing old cast pieces with new ones, I must sadly state that today they have become much worse, cruder and untidier. On the old ones, one will never discover file marks. The most delicate filigree of the wax-thread ornamentation is clearly visible. Also, flat surfaces of the old wax forms are smooth in the cast piece, without help from the file. Now, artisans are in a hurry, and therefore less careful. The Senufo casters of Korhogo produce masks by the hundreds, but of course my own people also use mass-produc-

54

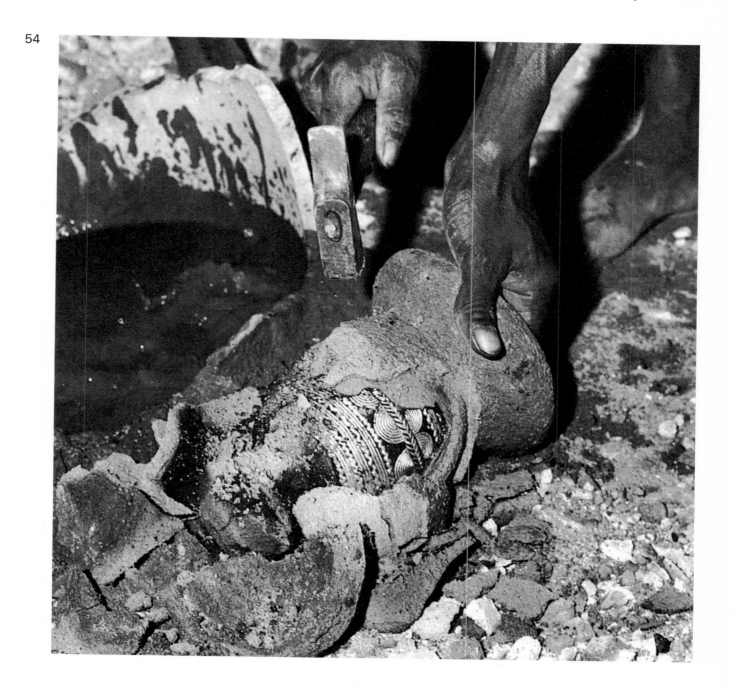

tion techniques. The Senufo casters always had at least a half-dozen pitchers, rings, or masks in progress; all looked very much alike. They procured supplies for themselves just as manufacturers do. Thus it is not surprising that the works have diminished in quality, although when measured against the completely primitive resources used, the result is still thoroughly estimable.

At the time I not only bought all sorts of objects from the Korhogo casters, but the tools as well. That, however, was fraught with difficulties, even though the modelling sticks, the tongs, or the metal bars wrought into spatulas are easy to replace. Tools are consecrated and are sold only in an emergency. There was, for example, the slightly curved workboard, decorated with a stylized crocodile head, on which wax was rolled out and pulled into threads. Sengi Kulibary is using that board in the picture at right. His wax pitcher, onto which he is fitting the cover, is resting on it. Although I was very anxious to buy this board, it took three days to transact the purchase agreement. Each day, while running my fingers over the wood polished smooth by long use, I asked about the board. I offered what was really an unreasonable sum, because it was only a hardwood board on four short feet. But the old man remained inflexible. The board had belonged to his grandfather, then to his father, explained Sengi, and they would most certainly not be in accord. But then I got the board after all, thanks to the persuasiveness of my interpreter, Fatagoma Ouatara. For his sake, the man parted with it, and I paid so much that he could have bought himself a half-dozen new ones from the carver. But the question, of course, was not one of money. I was impressed by the man's piety, and rather ashamed that I hadn't respected it more. In a similar instance, when I was unable to buy the beautiful tongs of a smith because it was impossible to ask the ancestors the price, we found another solution. After much hesitation the smith gave us the tool, and in return requested a mighty European hammer from us—an item that he thought would certainly gladden the heart of his deceased grandfather.

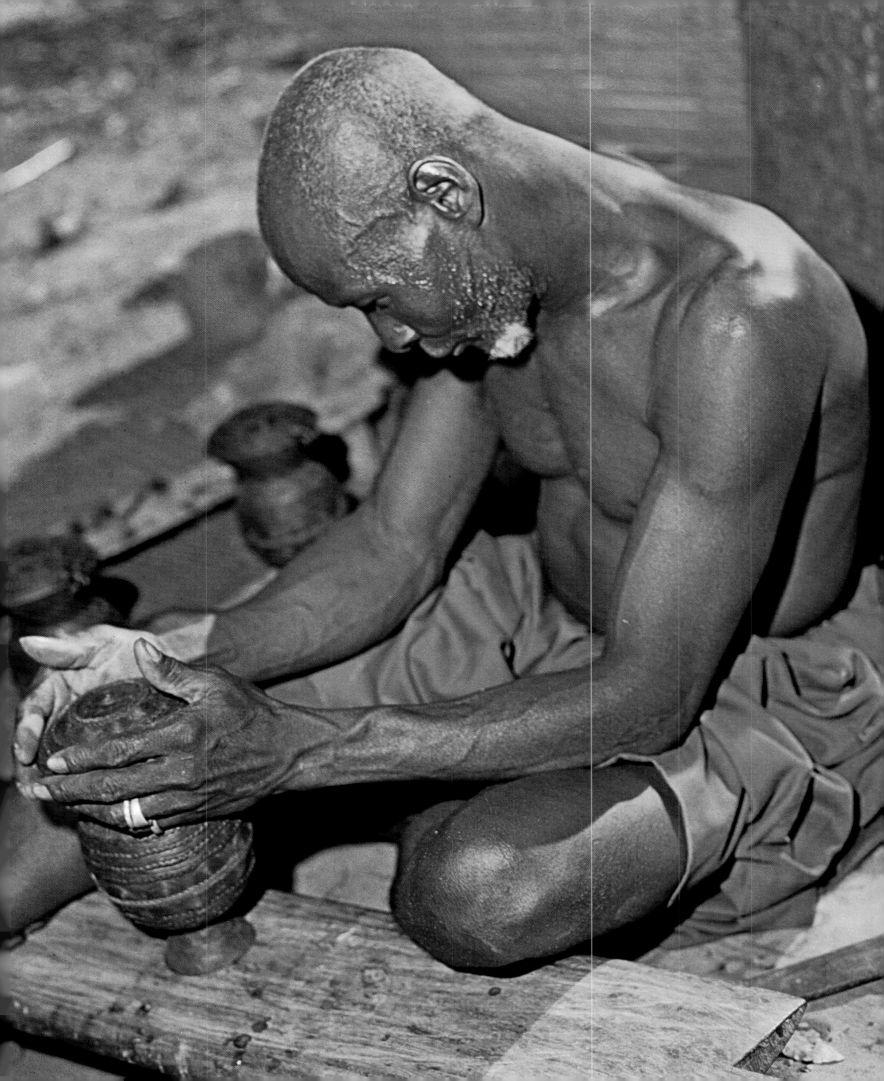

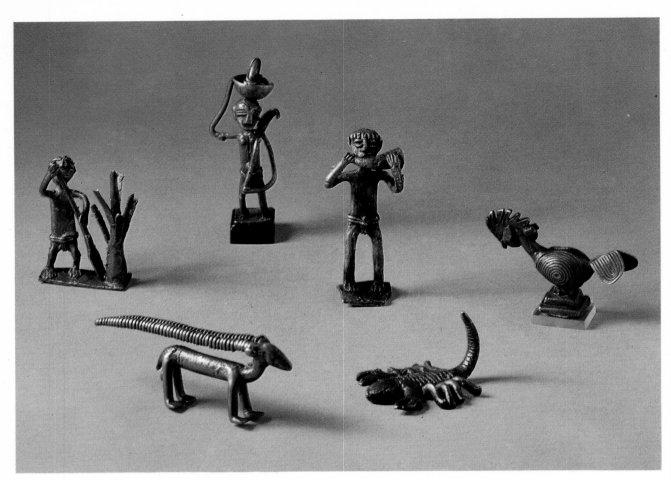

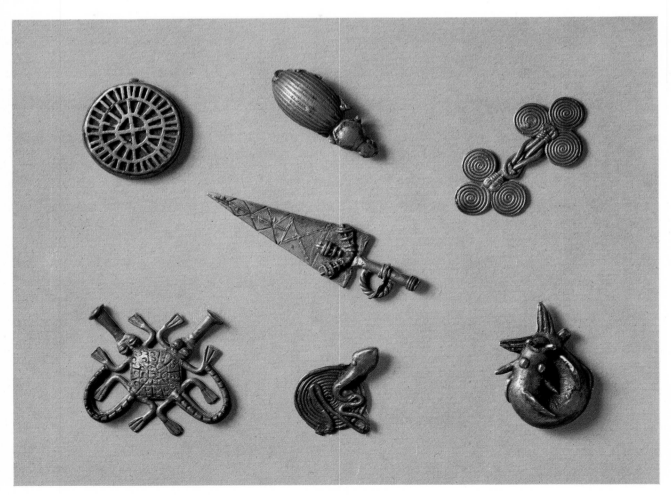

Dibi Koffi, the Goldsmith

At the left are reproduced some of the charming miniature sculptures that have long been among the most treasured objects of collectors. They were formerly used principally by the Ashanti of Ghana and the Baule of Ivory Coast as goldweights; however, they are common brass and not gold. The "goldsmiths" who produced them sometimes chose purely geometric forms (upper left object in the lower picture) or sometimes figural representations. Favorite motifs were often repeated, but there was an unbelievable variety of new ideas. The objects represented were totally naturalistic and cast with tiny details. In the figures, for example, the hairdos are so exact that one can recognize the status of the person represented. In these weights we can almost literally read the cultural history of different West African peoples because we find representations of activities or implements that are now rare or have disappeared. The upper picture at the left shows a gold digger with a digging tool and a calabash on his head, then a transverse horn-player and a bark-gatherer. The rooster symbolizes the proverb, "When the rooster is drunk, he forgets the bird of prey." The scorpion warns: "When the scorpion bites you, you must deal with him likewise," roughly the same as "An eye for an eye and a tooth for a tooth." And the antelope whose horns are too long and point backwards, or in the "wrong direction," is a symbol for the maxim, "In the end it's always, 'if only I had known that before.'" In the bottom picture at the lower left there are crossed crocodiles with two heads but only one body. That means: "They have only one stomach, yet they fight over food." And of the snake it is said: "She is feared even when she has no bad intentions." At the top right is a "knot of wisdom" with spirals on either end, a constantly recurring motif. The picture also shows a beetle; instead of wax models, small animals and fruits were often used. Beetles, little crabs, claws

of crabs, snails, grasshoppers, and similar insects, peanuts, or other fruits with hard shells, were enveloped in clay as part of the lost-wax process. A beetle or a peanut could not be melted out like wax, but since they are organic, they burn, and the fine ashes can be shaken out. The casts, needless to say, are thus extraordinarily true to nature.

These weights were used for the weighing of gold dust. At the conclusion of a deal, two corresponding goldweights, that of the buyer and that of the seller, were compared. The seller put gold dust on his little scale until it balanced his goldweight, and the buyer repeated the process on his scale with his own weight, and only then were the goods, corresponding to the agreed-upon price, doled out.

The Ashanti kings must have disposed of unimaginable gold riches in their time. Their clothes were embroidered with gold, their thrones sheathed with gold, and the jewelry that they and their dignitaries wore was made of massive gold. It is no coincidence that their land was called the Gold Coast. The affluence of the Ashanti and tribes to the north of them was reported by early travellers. In those days the goldsmiths were very respected artists at the royal courts. Only the rulers could dispose of gold, trade in gold, and wear gold ornaments. So the goldsmiths worked exclusively for them. They enjoyed all sorts of privileges, were organized as a guild, and were the only ones among the ''common people'' who had the right to wear gold rings. The gold they worked came from the land, and was washed out of the residual sands of the rivers.

With the gradual relaxation of the ruling power of the absolute monarchs after the penetration of the white man, minor chieftains assumed the right, to a greater and greater extent, to wear gold ornaments, and soon everyone with sufficient financial power ordered what he liked from the goldsmith. The goldsmiths, besides producing gold ornaments, were also entrusted with the casting of the brass miniatures. They were gradually transformed into middle-class artisans, who later even offered their wares for sale at markets, and sold to everyone who could afford them.

One of these goldsmiths is shown seated at left. He is a Baule named Dibi Koffi, and he comes from Bamboussou. Now he lives in Bouaké, a city in central Ivory Coast, where he owns a small but solid house. Dibi Koffi, a master of his craft, is about forty years old. He has two wives and nine children, all of whom I met: a nice family, with whom it is easy to feel comfortable. In addition, there were a few relatives whom he had to support. In the city of Bouaké, which is especially known for a large textile mill, there is a railroad station (complete with a buffet restaurant!), modern stores, banks, hotels, and, of course, cinemas: pulsing modern life. But all this does not prevent Dibi Koffi from producing his little works of art exactly as his ancestors did, with simple tools, calmly but with incredibly nimble fingers, and without rushing.

I ordered a gold pendant from Monsieur Koffi on the condition that I could watch while it was made. He agreed immediately and seemed to enjoy having a curious onlooker to whom he could relate little experiences and stories. I took a handful of goldweights out of a box and looked at them, and Koffi explained their significance. (They are still modelled and cast today, but no one thinks of weighing gold with them. They have now become collectors' items, pretty little works of art to "appreciate.") He knew the appropriate adage for each one, and he always concluded his explanation with the little phrase, "So say we, the Baule."

He constantly interrupted his work when he had something to relate and he waved his square paddle in the air.

He had lightly warmed the wax beforehand over a charcoal fire. After kneading it, he then pulled it into long shapes that he rolled into threads that were as thin as a horsehair.

He used a slightly curved paddle on a little curved board. He also used cold water during this procedure.

Then, as can be seen in the picture at right, he carefully wound the threads into a spiral. He used no tool, but only his well-jointed fingers. To make my pendant he needed two wax spirals of equal size that were easily lifted off the smooth workboard.

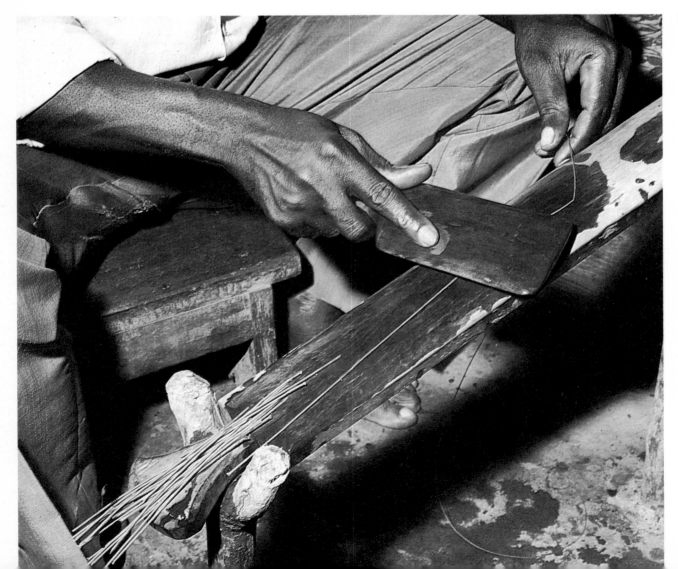

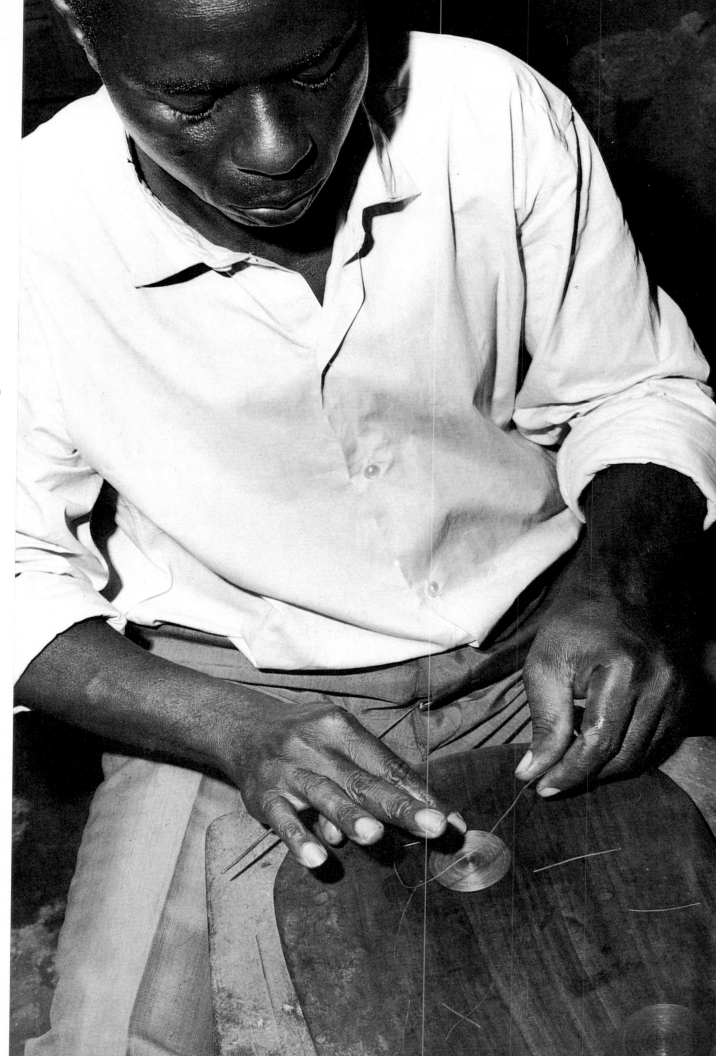

60

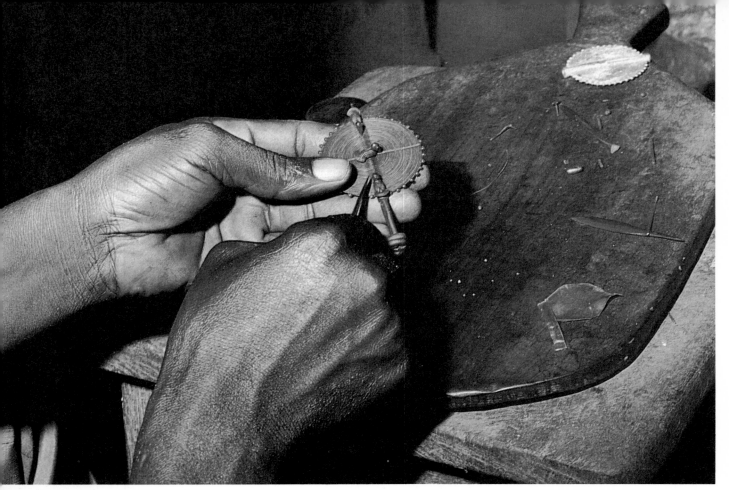

61

62

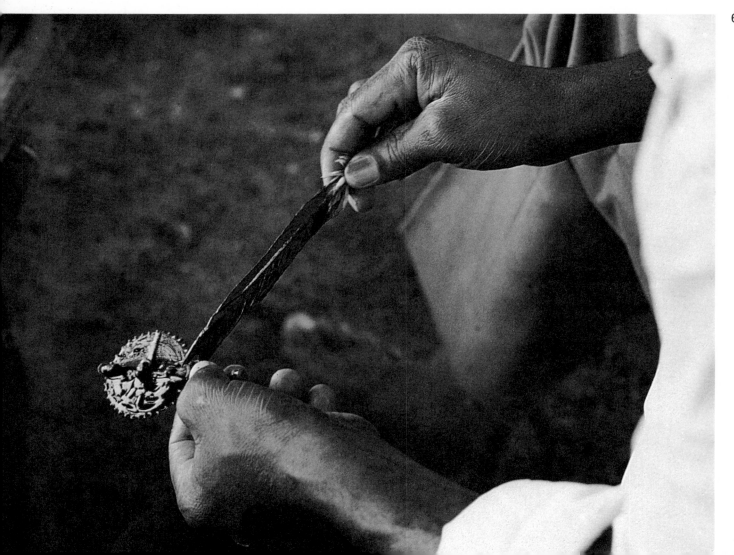

The center of my pendant, in the top picture at left, is to be hollow later, so a thread can be drawn through it. It is made of a mixture of pulverized charcoal and clay. This prepared core is pressed between the two spirals. The casting cord protrudes at the lower right. The three tiny birds are made of individual pieces of wax, as improbable as that seems. The tails and wings consist of fine spirals that were halved. For this work, Koffi used a small modelling spatula that he kept putting in his mouth so it would stay moist and warm. I could hardly comprehend how it was that he managed to set wax eyes into the little birds.

Such delicate work cannot simply be covered with a clay paste. Finely ground charcoal and well-purified clay were mixed 2:1 with water into a thin paste and then applied with a chicken feather (lower picture at left). As soon as the first layer was dry, a second followed, and then others, and only then was the prepared mold packed in clay. It was cast according to the usual technique.

It is worth mentioning that the firepit in this sober, functionally arranged room was safeguarded by a fetish (picture below). The casting was successful, the pretty gold pendant was cleaned with potash, I paid, and Koffi philosophized: "When one has given money, one has to say thank you. Otherwise it is not good."

63

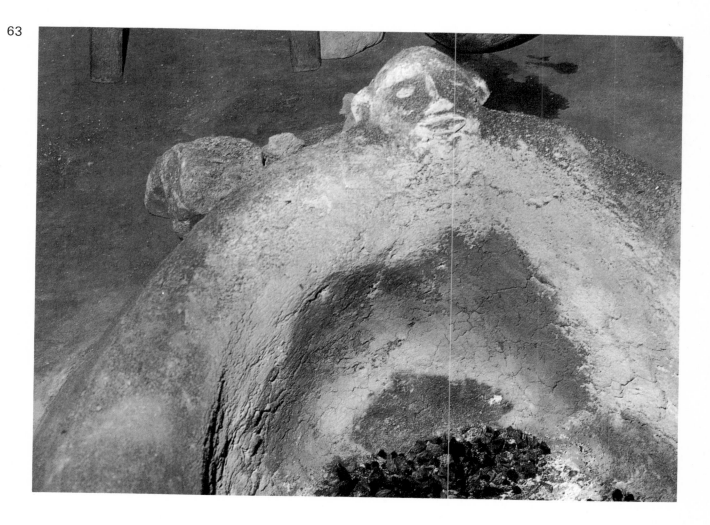

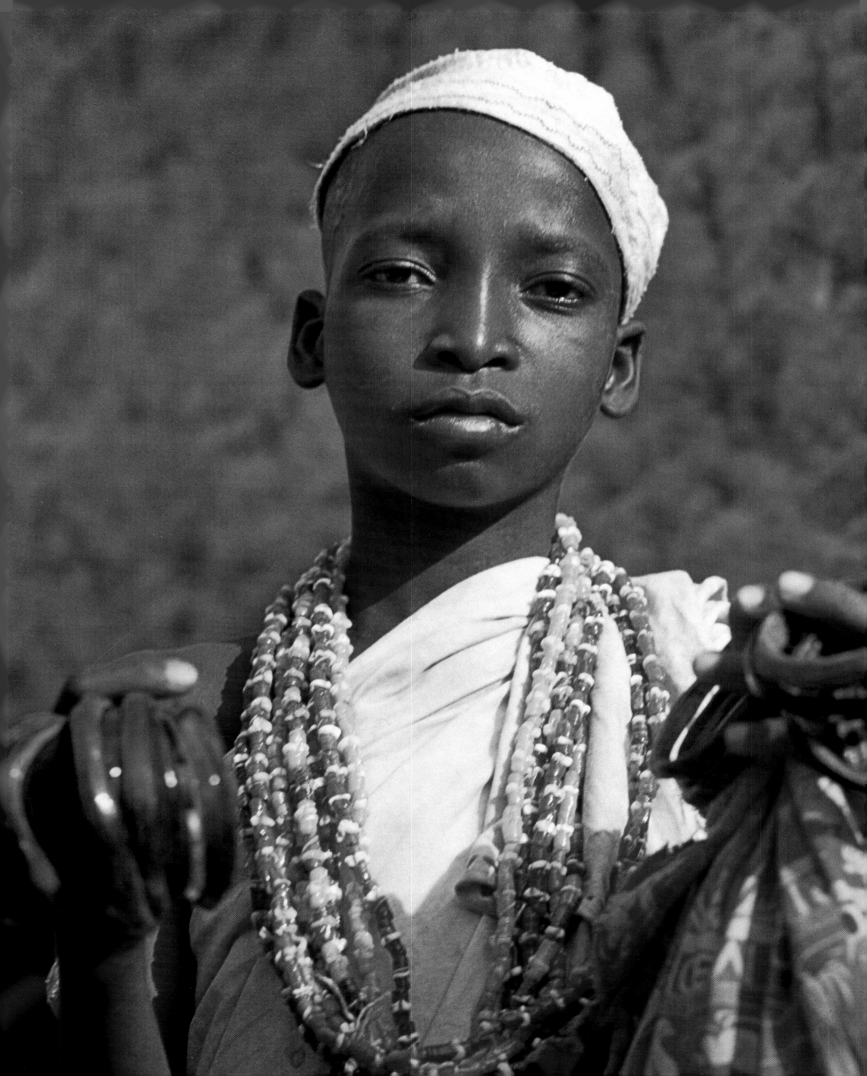

The Nupe boy at the left is selling glass beads and bracelets that were made by his father. One does not usually expect to read about glassmakers in connection with Africa, but in the Nigerian city of Bida the art of transforming miserable beer or medicine bottles into brightly colored bracelets and beads is still practiced. If one draws a straight line between the two largest cities in Nigeria, Lagos (on the coast) and Kano (in the far north), Bida is just about at the halfway point. The unexpectedly large city is currently the capital of the old kingdom of the Nupe, a Muslim people with a great past. Bida is thoroughly modern, but on sandy side-streets, and among the mud houses of the old quarters, one feels transported back into a mediæval African feudal period. Most of the men still wear splendid, richly embroidered, billowing gowns. In the alleyways, there are magnificent riders on fiery little horses, and many of them have a princely air. But they are only ordinary, well-to-do citizens out for a ride. They are always followed by properly humble servants, not on horseback like the masters but on English bicycles.

Before I looked around the glassmakers' quarter, and visited the craftsmen's shops, I paid my respects to the traditional spiritual head of the city, the Etsu Nupe, because if he recommended me, the glassmakers would be more approachable. We found the imposing clay palace easily. Guards were at the gate, and a herald announced our arrival with a large tuba. We were led through a small building into an interior courtyard, then into a cool reception hall. There sat a colorful throng that was also awaiting an audience. We were soon met and escorted through a second beautiful courtyard and into a throne-room. As soon as the chief arrived, all the subjects sank to their knees or prostrated themselves in the sand. We were soon granted our wishes in this oriental fairy-tale hall. We were thanked for our gifts and

promised every assistance, and we noticed with pleasure the very next day just how effective the princely intercession was.

The Nupe are the cousins of the Fulbe, with slim builds, fine limbs, and pretty faces. Within the Nupe, in an outlying quarter of the city of Bida, live a few families bound together in a strict guild, that of the glassmakers, who even now know how to guard their trade secrets well. The glassmakers sit for hours in the round, mat-covered mud huts with the characteristic little air-holes, in front of the low, burning-hot furnaces, and make not only their famous seamless glass bracelets, but also beads and little glass snakes as well.

The Bida glassmakers say that they come from the East and are not Nupe. Way-stations in their wanderings were the Bornuland in Chad, and, lastly, Kano, before they finally settled down with the Nupe in Bida.

It cannot be established with certainty when glass was first known in Africa. It is known, however, that glass was already being produced in Morocco in the eleventh century. There are countless finds of glass bracelets or at least pieces of them from the southern Sahara. A particularly rich site was an old *ksar* in the Djado, a region in the northeast corner of the Niger Republic. It is assumed that glass jewelry was introduced from North Africa in the Middle Ages, but the old production sites still remain undiscovered. Glass beads and bracelets are still produced in Cairo today. The glassmakers of Hebron in Israel are especially famous, and recently I received glass bracelets from Afghanistan. On the other hand, there are finds of glazed earthenware from Ife (Yoruba culture) that prove that glass must have been known very early in Black Africa.

The glass bracelets of Bida (upper picture at right) have a peculiar resemblance to glass bracelets known in Europe from Celtic times (lower picture at right). The Historical Museum in Bern owns a beautiful collection of unbroken bracelets that come from the vicinity of Bern. They are from the Middle Latène period, so they are now about 2,200 years old. Such bracelets are also known from most areas settled by the Celts. In these beautifully turned bracelets, the flat inner surface and the seamlessness are conspicuous, peculiarities evidently closely connected to the production techniques. Air bubbles are not round but flat and pulled out into ellipses.

Less ancient glass bracelets from Rome, Greece, or the Near East were made of drawn glass bars that were bent and then squashed together. Below is a Roman glass bracelet the inside of which, in contrast to the Celtic bracelets, is round. Furthermore, one can clearly recognize that it is not seamless. Apparently the Celts' technique was lost, and we probably can assume that the glassmaking technique of the Celts was a spontaneous invention. No one could explain to the ancient historians the exact method used by the

68

69

70

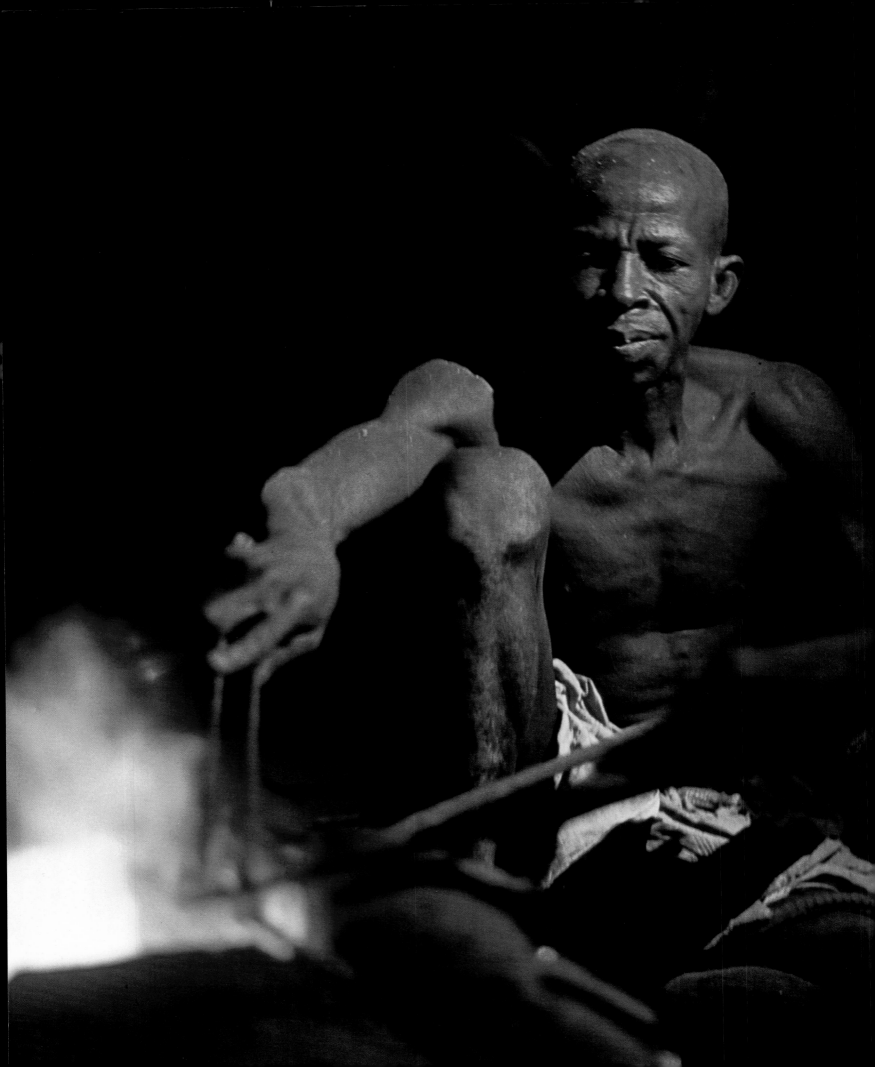

Celts for creating their bracelets. But because the Bida bracelets are also seamless and flat on the inside, and because the enclosed glass bubbles are also elliptical, the working techniques must be very similar. Certainly the Bida glassmakers did not acquire their ability in a direct line from the Celts. There are surely no historical connections. However, on the next page I will describe in detail how the man who is working at his glass furnace in the picture at the left produces his bracelets. This will probably also explain how the Celts of the Latène period in Europe made their beautiful, seamless bracelets more than 2,000 years ago.

At present, Bida is the only place in Africa where the technique has remained in use, and one wonders how it got to Nigeria. We know that the glassmakers are regarded as strangers among the Nupe. They were originally, according to Leo Frobenius, of the Jewish religion. In a recent article, Manfred Korfmann observed that the workers of the Hebron glass factory, which is very ancient, produce their bracelets in the same fashion as the people of Bida, except for unimportant variations. A connection between Bida and Hebron, or other glassmaking areas of the Near East, can be considered plausible. So the art of working glass could also have come to Africa from the Orient, but this would have been very early, as proven by the ancient finds from Ife.

For even being able to include glassmaking in this volume, I owe my thanks to Dr. Thea Haevernick of the Roman-Germanic Museum in Mainz, Germany. She first made me aware of the probable similarity in the Celts' and the Bida peoples' working techniques in the production of bracelets. Mrs. Haevernick is one of the best connoisseurs of archæological glass. She loves it so passionately that she has given up her vacations to search for glass beads and bracelets in European museums and to acquaint herself with them. That also led her to our collection in Bern. Since she had seen my work on Matakam smiths and knew of my predilection for African craft techniques, she visited me and told me about the strange connections discussed above. She asked me to go, one day, to see whether the furnaces of Bida were still in operation. The documentation that Mrs. Haevernick procured for me at the time was almost nonexistent: a text by Frobenius that was more than fifty years old, plus a couple of pages by the English ethnologist, S. F. Nadel, from his work on the Nupe. The experts in Nigeria, whom we queried directly, did not answer. This plan, with such scanty information, scarcely filled me with enthusiasm. However, during a slack period in work in Dahomey I travelled with my co-worker, the photographer Ulrich Schweizer, nearly 400 miles from Cotonou to Bida, to do the helpful Mrs. Haevernick the favor. Without any new information, we set off, into the blue, so to speak, to look for glassmakers. We did not regret it, because on our second day we sat, enthralled, in the glassmakers' huts.

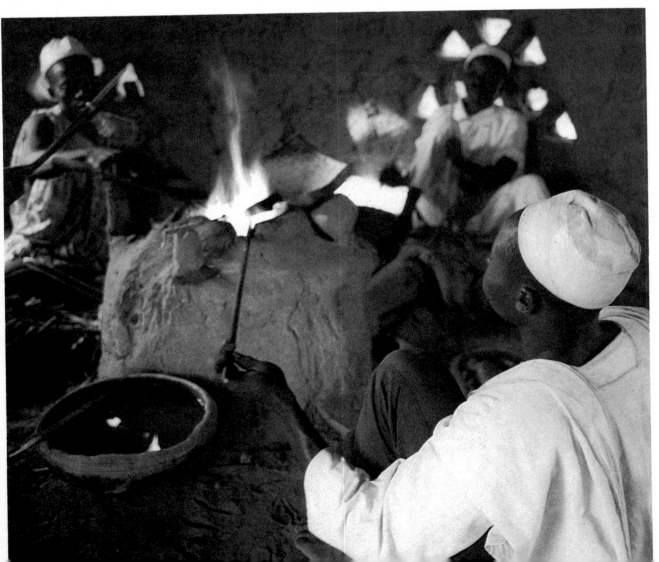

Perhaps the two pictures at the left will prove that we had reason to be enthusiastic. The upper one is a black-and-white reproduction of a water-color done by a co-worker of Frobenius before World War I. The lower photograph I took more than fifty years later. The similarity is quite startling, and it shows how tenaciously a technique can persist despite foreign influences. Only the clothing has changed. In the middle stands the oven whose wood fire is being fanned by a bellows operator. In 1911 he sat in front of the triangular airholes and moved the wooden staves of the bowl-bellows. His successor still sits in the same place and moves the wooden staves. The workers squat around the furnace and turn and twist the iron rods. And in the foreground still stands the same kind of earthenware bowl in which they are cooled.

What Frobenius wrote then is equally valid today. So I quote verbatim: "We step into one of the workshops, and there we are struck by the strange picture in front of us. In the dim house, five firelit figures, working assiduously, squat around a large firepot sunk into the floor. Red tongues of fire lick over the edge while one of the men pushes the staves of the panting bellows up and down with rapid movements. Other workers poke into the fire with tongs and iron rods and twirl white-hot glass rings between these tools. Black and colored bits of melted glass lie about. Bowls of water with knifelike tools laid over them stand near flat baskets containing pulverized charcoal. The still-hot goods are slowly cooled off in them. In a corner lie pale blue European glass bottles. Emptied, these bottles wander from the coast all the way to the glassmaking quarter of Bida, here to metamorphose into the bracelets popular throughout the entire Sudan. [These days, one can find enough glass bottles from thirsty people in Bida itself.] The craftsmen here are working bracelets in black-white-and-red marbleization, an imitation of the agate bracelets worn on the upper arm in Tuareg lands. The bracelet is formed from a single lump after much turning and twisting, forming and pressing, and twirling around the red-hot iron rod. We watch as the piece, progressing toward completion, gradually passes through the hands of the four associates, until, still red-hot, it finds its way to the already cooled, finished wares in the charcoal."

Thus the old master of German ethnologists, Leo Frobenius, described the production then, and the only difference I observed was that a bracelet does not "gradually pass through the hands of the four associates," but rather each worker finishes his piece himself.

It was much easier to make contact with the glassmakers than I had imagined. It was important that I had demonstrated my reverence—well fortified with gifts—to the Etsu Nupe. One of his ministers had advised the chief of the glassmakers of my wishes before I got there. They do not regard themselves as Nupe, but call themselves Massaga, and they live in their own quarter

apart from the other inhabitants of the city. Their chief is called Massaga-Fu. The profession passes from father to son, but the chief, on the other hand, is elected. It is usually one of his sons who is chosen, but only if he is truly capable. The chief is regarded as the most skilled glassmaker, but he works with the others only in emergencies. He is, for Africa, a truly amazing phenomenon—the manager, the master of the guild. He is responsible for the organization, buys the materials, collects the receipts, and pays the wages, which depend upon piecework produced in the individual glassmaking huts. There are at present about twelve huts still in operation, and there are always five men on a team.

The chief divides the work according to the need at the time—that is, according to the requirements of the market. He knows exactly in which hut green bracelets, beads, or snakes are being produced at any given time. When I was there the chief was Daniyalu, a man who commanded enormous respect, and before whom every visitor knelt in greeting. He was nonetheless very approachable, particularly after I had given him a pretty Swiss watch. I kept all the other glassmakers in the best of spirits, too, because I bought great quantities of bracelets and beads for museums.

We watched the beads being made: soft glass is wrapped around a thin iron rod and shaped with a flat knife. But above all, we observed closely how the bracelets are made, so I will now describe this process as precisely as possible.

Behind the mounted straw mat, the bellows operator sits, unseen, as shown in the upper picture at the right. The mat protects him slightly from the heat. All of the tools of the other four men are clearly visible. Prewarmed glass is melted onto the iron rods. In earlier times these rods were made by the smith; now they are "found" at building sites. They are reinforcing rods that are used in modern concrete construction. The long tongs are important. The man at the right is in the process of spreading out the melted glass with the tongs. The broad lamelliform knives (upper left and lower right in the picture) are used to form the lumps of glass. Iron rods, tongs, and knives are the only tools that are used.

The bellows operator is in full view in the lower picture. The bowl-bellows are similar to those that are also used by the smiths and casters of West Africa. Tanned and supple goatskins are bound over the curved edges of the "bowls." As the stave is lifted, the skin rises and air comes in from the narrow opening at the side. And with rapid downward thrusts, blasts of air go directly into the fire. The glassmakers do not use charcoal, like the smiths, but just wooden sticks. With the help of the bellows, however, they do attain temperatures sufficient to melt the glass. There sits the young man who moves both staves quickly and untiringly, and the blasts of air create a rhythmic sound that is reminiscent of the tom-tom and inspires the men. Now and then the

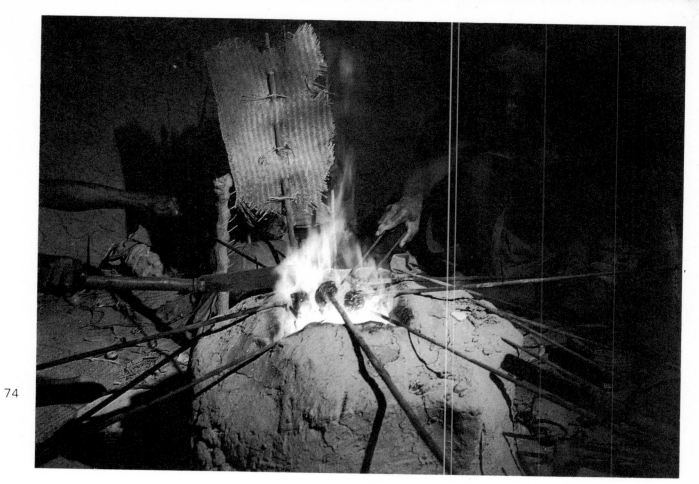

74

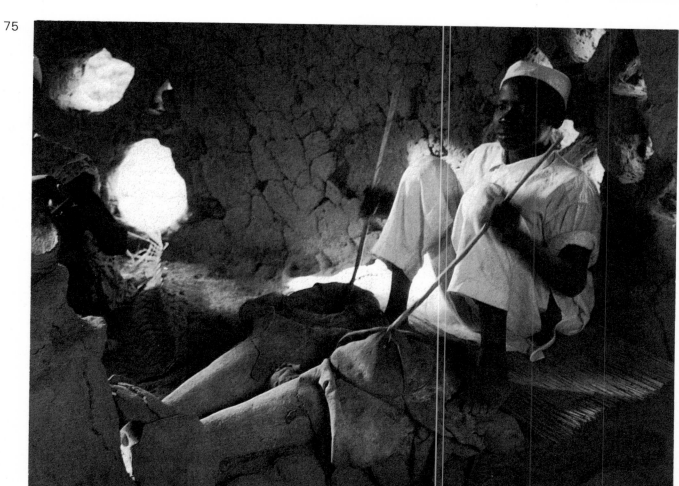

75

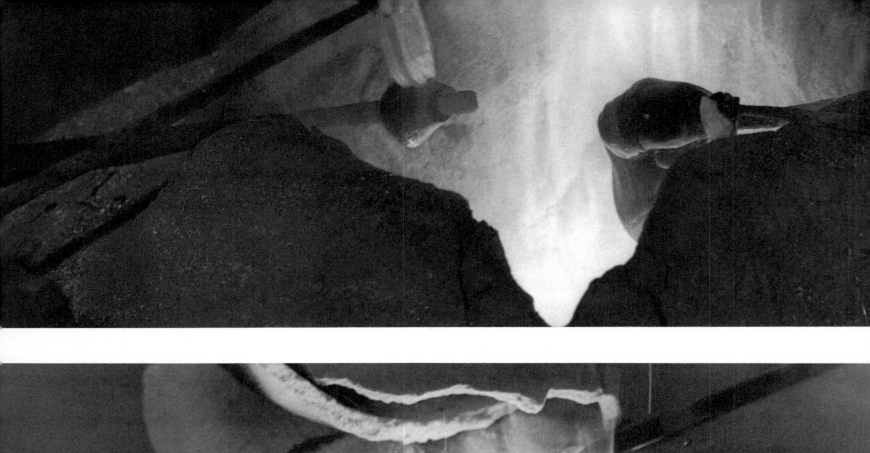
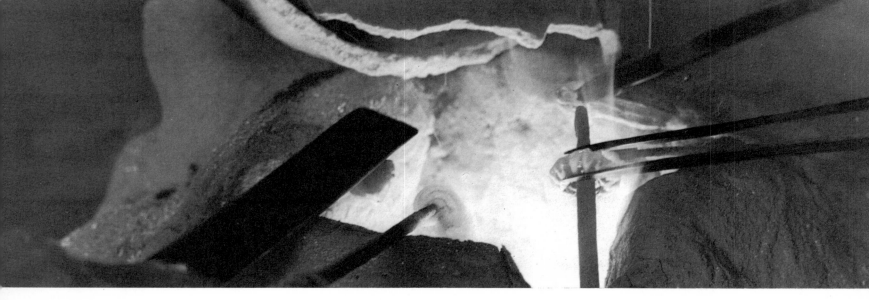
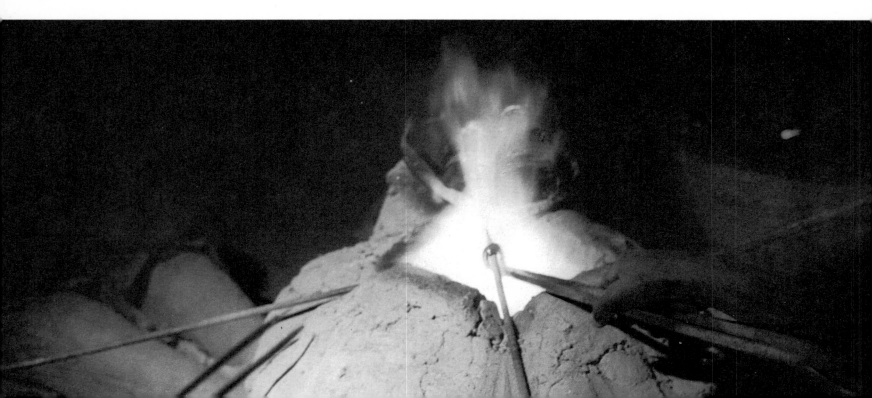

76

bellows operator is relieved. Then he sits in the place of the man who has relieved him, and makes glass bracelets in his turn. Without long-winded explanations, the three pictures at left are hardly comprehensible, so I ask patience. In the earthenware bowl that is visible at the upper edge of the center picture, the glass is preheated until it is "sticky" enough to melt onto the iron rod at the right in the upper picture. Out of this glass a bracelet is made. One of the men is always responsible for there being enough material of the right consistency hanging over the fire. He also has to see that the glass does not get too soft and drip into the fire. So he holds the rod in his hand, turning it at times, or lifting it a bit higher.

By its own weight, the soft mass pulls downward, forming "stalactites." Each one is caught at just the right moment by the three other men sitting around the same firepit—it is wrapped around one of their iron rods. It happens very quickly. With procrastination, the glass mass would drip from the rods again and again. Through practice and experience they always succeed in picking up just the right quantity of glass. Through practice and experience! In any case, the glass that I was supposed to pick up and wrap fell into the fire.

77

In the top picture, the iron rod, still visible, is constantly rotated with the left hand and the glass around it melts down into a smooth, thick ring that lies directly against the rod. The paler glass mass being held over the lump will further enhance the final result. Sometimes the glassmakers do not make just plain-colored bracelets, but two- or three-colored ones. Here a dab of the very liquid pale glass—perhaps from a perfume bottle or a jar of salve—is being added to the lump of glass. The two kinds of glass fuse like chocolate melting for cake icing. In plate 69 are two bracelets produced in this way. In the middle picture the next phases can be observed. At the right, the glass lump is just being pressed together with the tongs. Despite the red-hot color of the glass, it is clearly recognizable that at the right a two-color bracelet will result. At the left, another worker is pressing a profile into his bracelet, which, unfortunately, will never be as beautiful as the profiles of the Celtic bracelets. And the third man (between the two others) has just wrapped the glass around his rod.

78

In the lower picture, the most difficult procedure has just begun. With one arm of his long tongs, the worker moves along the rod (which is still directly over the flame) under the glass, loosens the ring, pulls it out, and widens it. The iron rod is constantly rotated with the left hand, and the glass is constantly moved and widened by the tongs and pulled out into an ellipse. The man works very quickly, very concentratedly, and his eyes do not leave his ring. He turns and turns and pulls and forms with unbelievable dexterity. The bracelet gets bigger and bigger. It is still glowing bright red but it gradually loses its elliptical shape. Then comes the decisive moment. As soon as the bracelet has been sufficiently widened, the iron rod is swung out of the fire

and the end of the rod is stuck into the hole in the outer wall of the forge. The rod is still rotated with the left hand and the glass is moved slightly outward. The bracelet is now round. Slowly it loses its red-hot color and hardens, until there is no longer any danger of its losing its form. Finally the bracelet is embedded in the wood ashes, and cooled slowly, to avoid internal stresses.

Now it is easy to understand that glass bracelets made in this way are seamless and that the inside becomes flat. Since the iron rod is not only rotated, but also swung lightly, centrifugal force works on the soft bracelet and is of course given a big assist by the arm of the tongs. That explains why the enclosed air bubbles, which were originally round, were later pulled out into ellipses.

The great similarity to Celtic bracelets leads us to conclude that at that time the same technique was employed. It is true that in the Latène period there was no iron, but wood that has lain in water for days, and is then constantly dampened, does not catch fire easily, and can surely be used for tools in the place of iron. Furthermore, as proof of this, little wooden splinters have been found fused in some Celtic bracelets. Of course, it should be re-emphasized that there are no historical connections of any sort between the Celts and the Massaga of Bida. But perhaps one can assume the working methods were identical. Unfortunately, no furnaces of the Celtic period have been

80

79

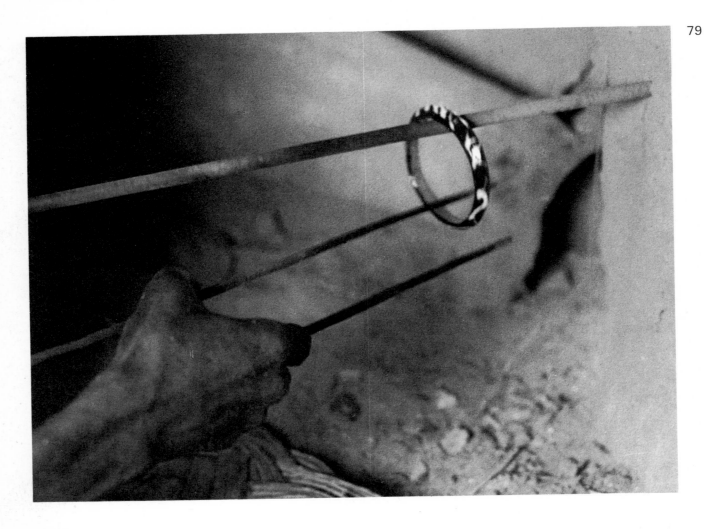

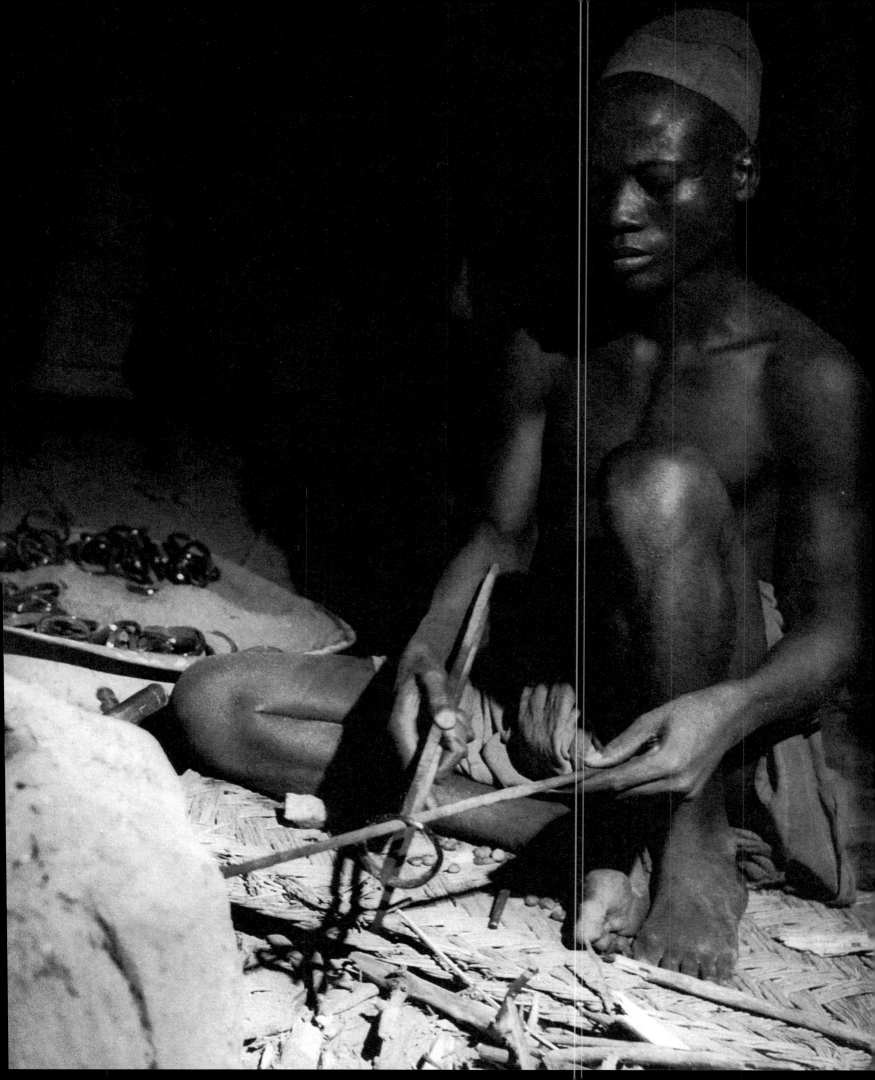

preserved for us. But a few years ago, in a Celtic settlement on the Enge Peninsula near Bern, a clay circle was found. It was not completely closed, and the diameter corresponded approximately to that of a furnace of the Massaga. Perhaps it was the foundation of a Celtic furnace. As at Bida, the bellows opened into the gap.

Well, to have watched, in our century, how skilled Celtic craftsmen may have made their bracelets more than 2,000 years ago is a fascinating experience. Our friends in Bida willingly showed us their work techniques. We went in and out whenever we pleased. We photographed and filmed, but there was one thing they did not show us: the making of glass for their own use. It was the wrong time—the moon was not right. Part of the material was missing. They were always finding new excuses, and I finally understood that they did not want to show us! They did not want to heat the glass before our eyes. But I know that they are still masters of this art despite the excess of European industrial glass. Unfortunately I discovered only very vaguely how it is made. A mixture of quartz sand, chalk, and natron (which comes from the northern shore of Lake Chad) is heated for many hours in the furnace. Through rapid cooling, a molten mass, dark brown to black in appearance, results. When held against the sun, however, it appears almost totally clear. I was able to buy some bracelets of this glass—the local people, strangely enough, call it "bikini" glass.

It was a splendid time that we spent with the glassmakers. Since we were there during Ramadan, the Muslim month of fasting, hardly any work was done. So the flickering bright firelight seemed all the more eerie. The perpetual rhythmic sound of the air blasts from the bellows, comparable to inspiring music, almost put the workers into a trance. There was infernal heat, faces bathed in perspiration, backs bathed in perspiration. Not a word was spoken, and a seriousness of purpose was in all the faces. We saw an unparalleled dedication, tough perseverance, and a diligence uninterrupted for hours at a time.

The products of the Massaga, the bright beads and the elegant bracelets, are very popular and easily sold. The goods go with the peddlers into distant regions. I have seen the bracelets and the beads in the markets of Lagos. At the edge of the airport in Kano they were offered to me by a Hausa trader. I found them in Agades and on the wrist of a beauty in Djanet in the middle of the Sahara. The glassmakers of Bida, the Massaga, enjoy a certain prosperity. They keep few animals and are no longer tillers of the soil. Their guild is still very tightly controlled and there are no rebels. It is not possible for outsiders to learn the trade, so they have a monopoly and there is no competition. The only threat is the importation of cellulose and bakelite bracelets, those symbols of nonculture with which the Europeans are now flooding all the African markets.

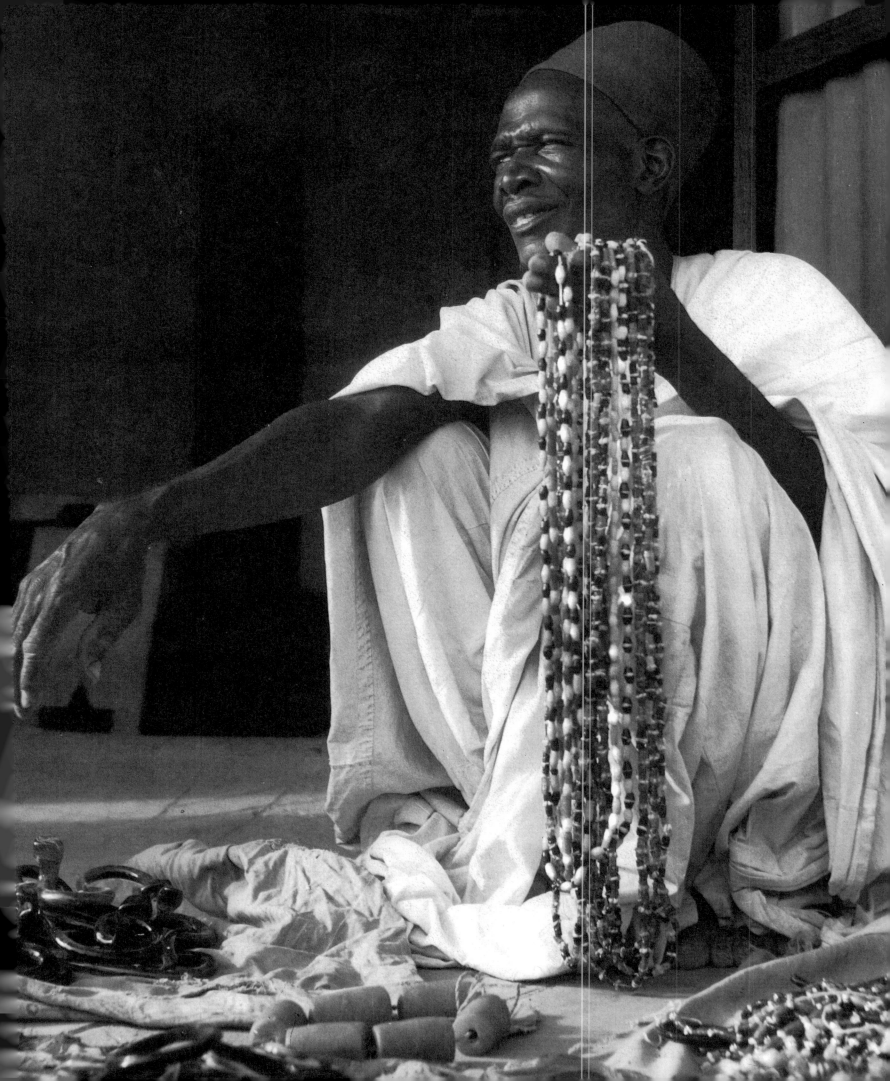

Pots, pots, nothing but pots! Pots like the ones shown at left (here joined by bright agamas of the lizard family) can be found at all the African markets, in all shapes and sizes, and they are cheap everywhere. In spite of that, the housewives are extremely careful in buying them. To select the right pot, they tap it; they look for cracks; they put it down again; they look for another. Under no circumstances do they buy just any pot. Sometimes a half-hour goes by before they have decided on one that costs less than a franc.

There seems to be no limit to the uses of the potters' wares. One cooks in them, keeps oil in slender-necked models, or uses monsters that hold up to sixty quarts of water as "refrigerators" because they are porous and unglazed. In keeping with the principle of cold due to evaporation, the contents remain cool. In Chad there is a small vessel half the size of an ostrich egg that is filled with hot coals. On a cool morning it is put under a billowing robe, so that while one is squatting the warmth pleasantly permeates the body. Sweet-smelling herbs are burned in pots to heighten pleasure. Fibers are dyed in large pots. Pots decorate the roofs of huts, and hold gables together. There are pottery oil-lamps for the fetish cult in southern Dahomey. Little children are bathed in pottery bowls. Hot glass bracelets are embedded in wood ashes and left to cool in pottery bowls. And among the Matakam in the Mandara Hills, one finds soul-urns, with faces and sexual parts, in which the ancestors live. And, finally, pots are also the round millet storage tanks that are widespread in all the lands of the Sudan. Among the Songhai on the Niger River, they can be up to fifteen feet high and so skillfully constructed that they do not develop cracks even in the burning heat of the sun. It is easy to present other examples: the decorated clay pipes of the Cameroon grasslands, or the strange vessels that are a part of the voodoo cult in Dahomey.

Ceramics have always been of great importance for identifying prehistoric cultures. Fired clay has lasted through the centuries, and if, at an archæological dig, nothing else comes to light, a few shards with some pitiful ornamentation are always found, to the comfort of the poor scholar. Then a virtue is made of adversity and one speaks of banded wares or grooved ceramics, and one utilizes these decorative elements as a system and a help in dating. Techniques similar to ones in use in the age of the Lake-Dwellers are still used in remote parts of Africa. That is why it is so intriguing to deal with African craft techniques—although they are not identical, they seem to be similar in many ways to those used at the dawn of Western prehistory. The chapter on the seamless glass bracelets is a good example of this.

The origins of the potter's art are obscure. One may perhaps assume (for Africa, too) that the use of clay vessels first became widely known when man had learned to cultivate useful plants. Of necessity, they began to establish permanent settlements. Roving hunters and nomadic herdsmen have little use for heavy, breakable pots. The raw material exists throughout Africa, since clay comes from the weathering of feldspar, which occurs in granite and most other crystalline rocks. A distinction is generally made between primary and secondary clay, that displaced by wind or by water. The chemical composition also depends on this, of course. Almost all clay contains impurities, such as ferric oxide, which makes the pots become red during the firing. But chemistry is not exactly relevant here, particularly since the African female potters are not concerned with it. For them, it is enough to know that they can shape clay at will and that they can improve the elasticity by removing large impurities (by purifying the clay), by degreasing "greasy" clays with a mixture of sand or crushed shards, or by mixing sticky clays with others.

In making a pot, one decides on several basic techniques. A lump of clay is first hollowed out by pressing inward, or by fitting the clay over a simple form. The opposite is also common—clay is fitted into a hollow form. A low, thick wall is "driven up" into a high, thin wall. And, finally, one can make a pot by laying rings or spirals of clay one on top of the other. That is the well-known coil technique. Usually, pot-making is a combination of these methods.

In the picture at the right, the Matakam woman, from the Mandara Hills in northern Cameroon, first fitted the clay base for the pot into the slightly hollowed tree-stump and pounded it with a stone cudgel until it was of overall even thickness. Then she carefully lifted it into a clay bowl filled with ashes. Bedded in the soft ashes, the bottom of the pot will not change its form, and the ashes prevent sticking. And then she built up the pot. The woman pulled and shaped the clay into coils and is now slowly forming the pot with them. She smoothes the walls with her hands or a leaf. The unfinished pot below her right hand shows this coil technique.

83

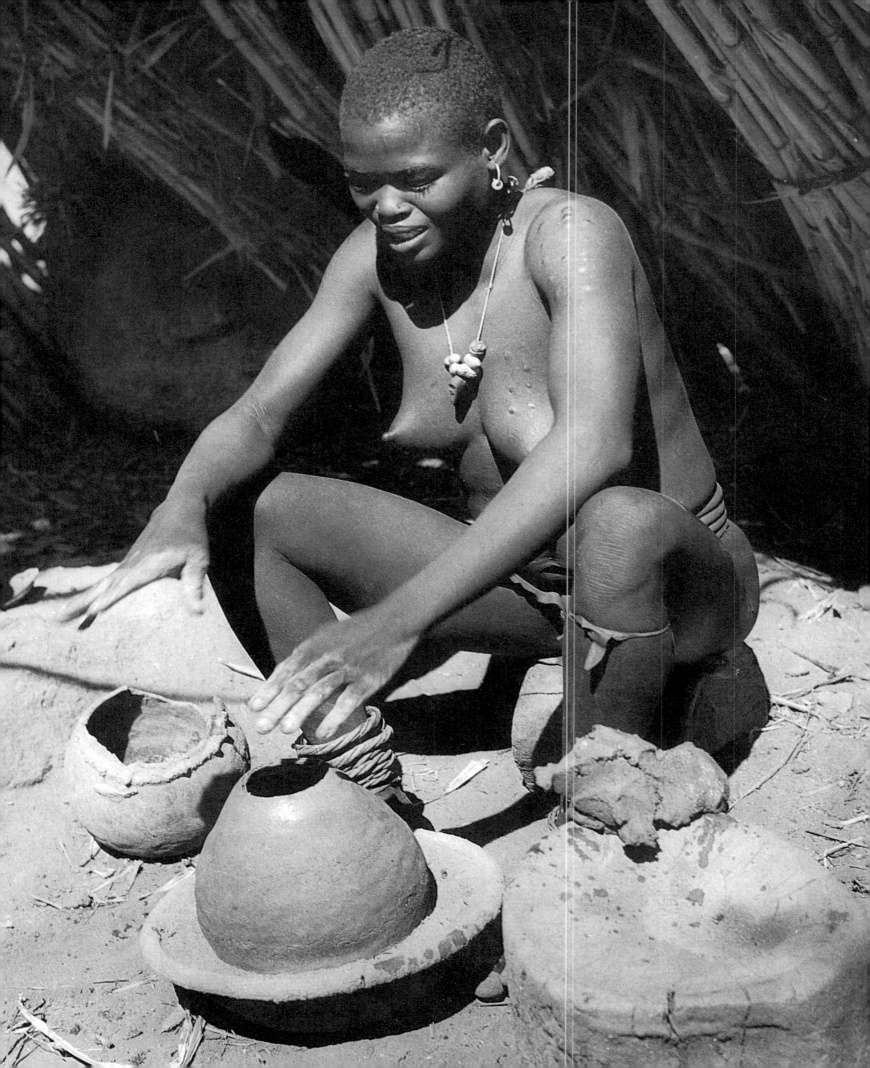

The woman at right, from the barely civilized Koma tribe (Alantika Hills, northern Cameroon) does not know the coil technique. She first hollowed out the lump, and then "drove" it with her hands. The bowl underneath helps her to keep the pot so completely circular. The potter stays in the same position during the work, but while she shapes with one hand, she turns the bowl with the other. In this way she is using a precursor of the potter's wheel, unknown in Black Africa. A test with a level would give an excellent result. In the picture below, the lip of the vessel is being smoothed with a piece of damp leather. The pots at the left and right are not identical, but they were made in the same place on the same day, and decorated in the same manner. The Koma woman wove three dry straws into a braid about three inches long, laid it obliquely across her right palm, and rolled it around the outside of the pot. In this way, a very simple but pretty pattern resulted.

84

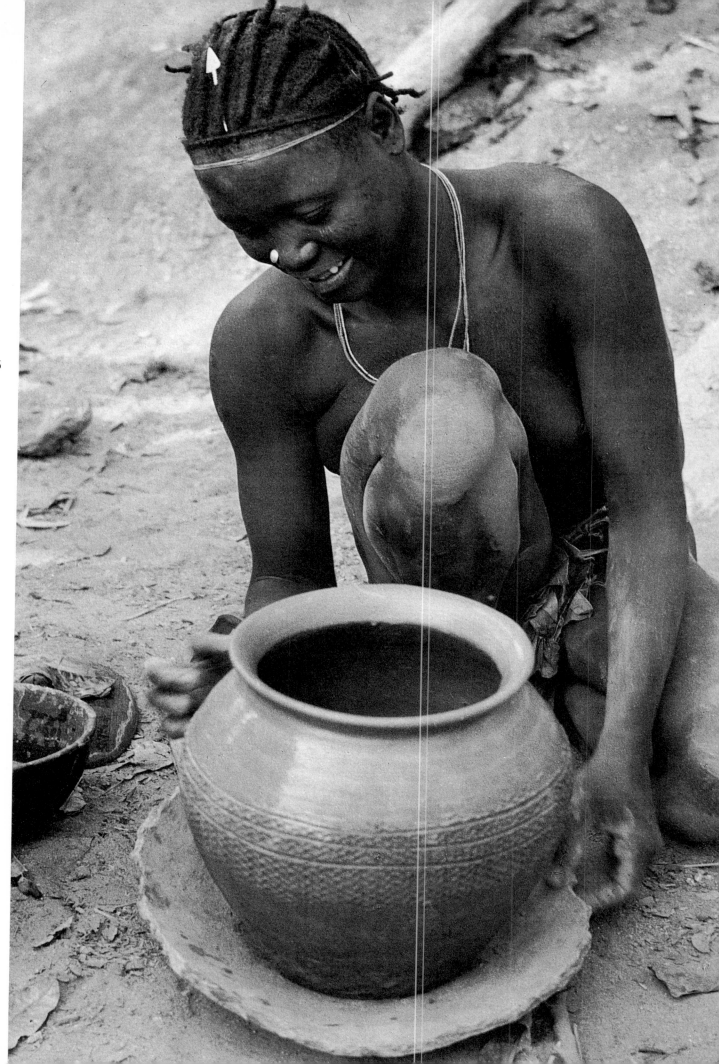
85

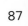

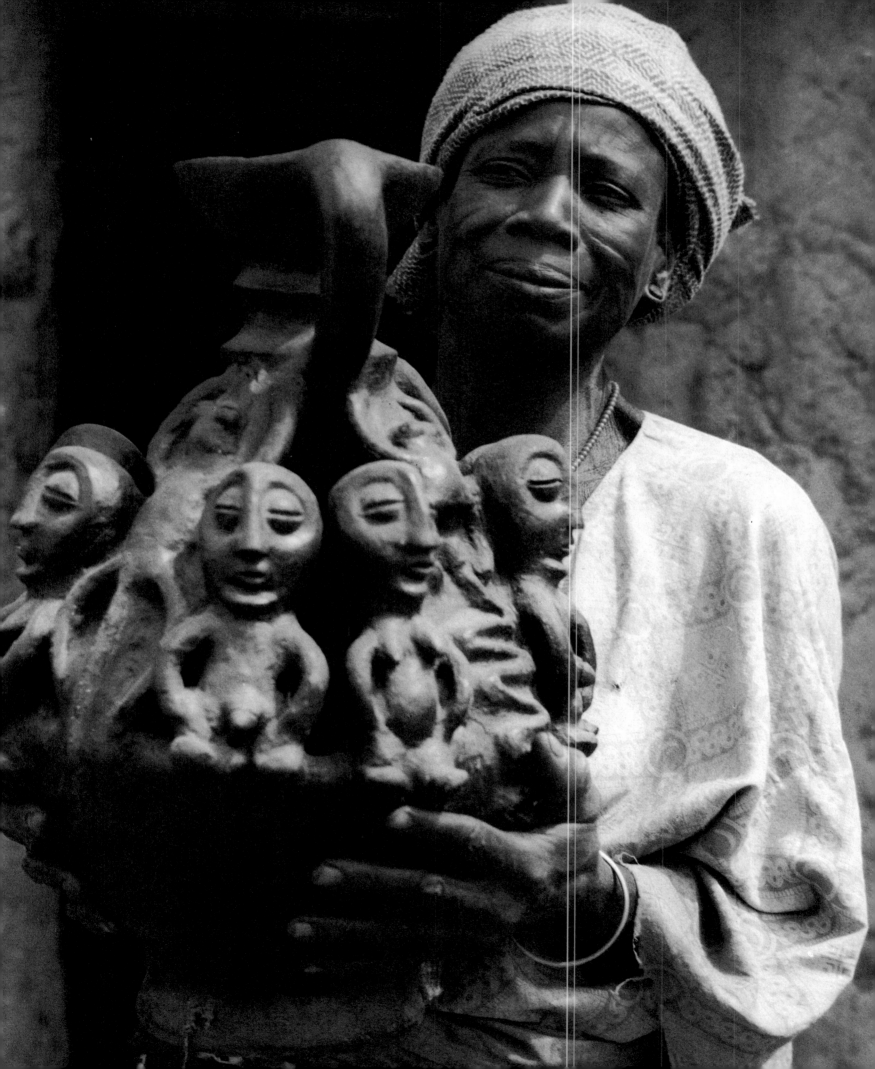

Most of the crafts are strictly divided according to sex. It never occurs to a woman to carve spoons, to say nothing of masks. In very few tribes is it customary for women to sit at a loom, and dyeing cloth was long regarded as dishonorable for them. Potting, on the other hand, is reserved for women. But in that, too, there are differences. Every woman is theoretically capable of creating a pot, but some villages have produced specialists. The women of such a potting village then supply the whole area with the necessary wares. In the Mandara Hills, only the wives of the smiths have the right to make a pot or a clay bowl. Another woman would never dare try her hand at this art.

African women seem to have little talent as creative artists. In comparison with the accomplishments of their men—the wood-sculptors or the mask-carvers, the goldsmiths or the casters—the shy decorations that one finds on the earthenware are rather ungainly. But, as usual, there are exceptions. The woman in plates 86 and 87 makes remarkable works of art out of clay, equestrian figures representing Dahomey's famous King Guézo, or large oil-lamps, for example. The artist—she does not even know the meaning of the term—lives in the little village of Tourou, just outside the city of Parakou in Dahomey. In plate 86, she is modelling the figures with which the large cult lamp is decorated, while her husband, in the background, watches. Four pairs of humans are symmetrically arranged around the belly of the big lamp, and between them are mythological symbols, modelled in half-relief. The figures, the vases, and the lamps are unfortunately very fragile because they are poorly fired. At the very end, they are painted with a shiny black vegetable dye.

Although the potters, in contrast to their men, have little artistic sense, they do have a sure sense of form, and feel the need to decorate their pots and jars. They scratch in simple linear ornamentation or press in patterns with dies. Or they roll stringlike braids or bits of chip-carved wood over the still-soft surface of the vessel. The application of plastic ornamentation, however, is rather rare. All of these decorating techniques are, in most cases, employed before the firing but only after the clay has dried slightly.

An illustration of the fact that pots and jars are sometimes painted is shown at the right. The painter is a Dindi woman from Malanville, the border town of Dahomey, on the Niger. On the enormous jar in which she keeps her water supply cool, she is renewing the not-very-durable colors. She has mixed kaolin and ochre, and is applying the linear design with a knife—for the broad bands of color she used a brush. The Kanuri women of Bilma, eastern Niger, whom I watched painting their pots, used red clay, a yellow from a soft stone, and black from ground charcoal. Instead of using water as a base for the colors, as the woman from Malanville does, the Kanuri use peanut oil.

In all my travels I have collected ceramics, among other things, but it has always been a risk, because as a rule they are pitifully poorly fired and there-

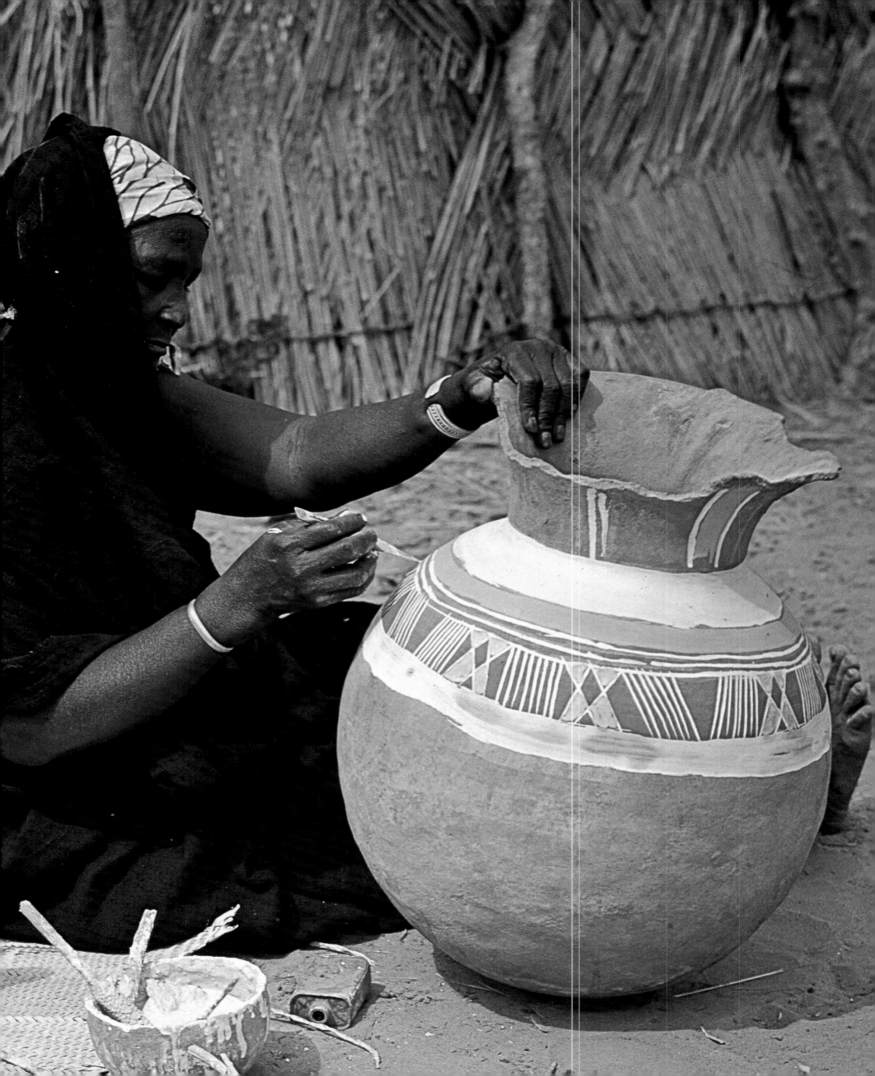

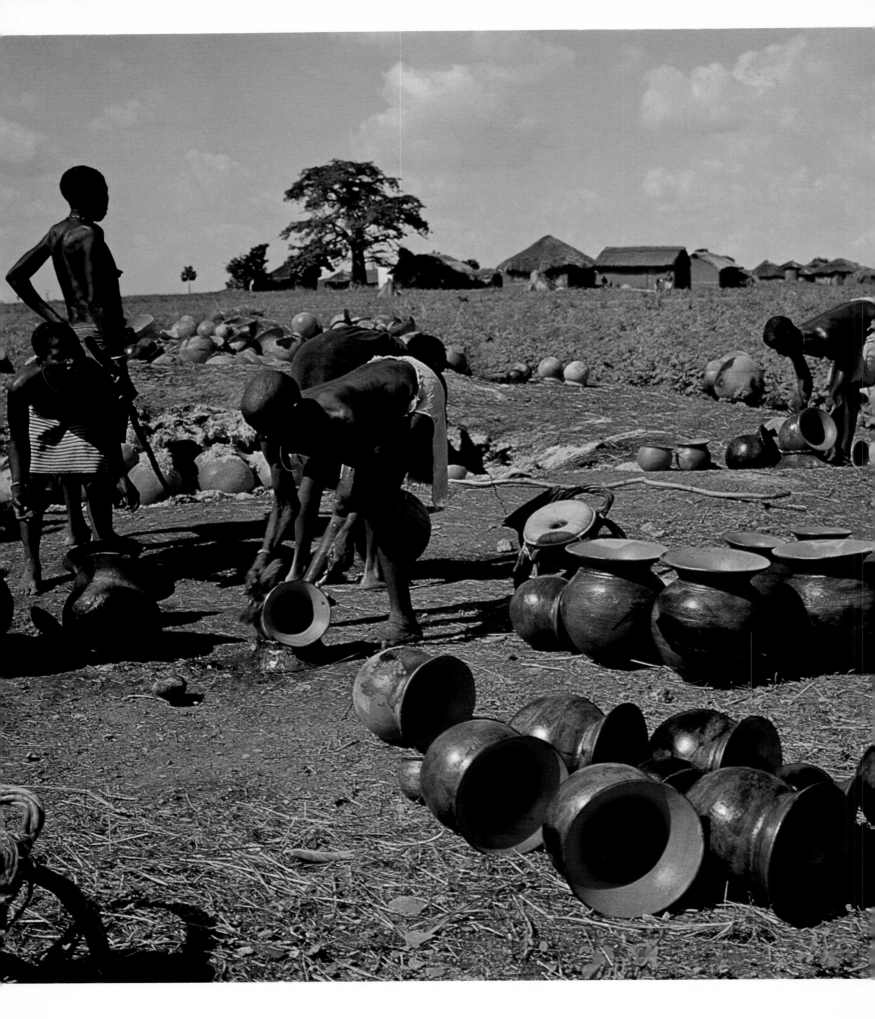

fore generally fragile. So, at home, despite all the careful packing in crates, I have often found a great deal of breakage. In order to avoid cracks, the pots are always dried slowly and carefully before they are fired. I noticed that only seldom were they set out in direct sunlight. They are put in a cool house or stood under the roof on the leeward side of a hut. Particularly careful potters even put a larger pot over the unfired pot, so that it dries very slowly. The clay gradually loses its elasticity and becomes leathery, but could immediately be resoftened with water. So it must be fired at a temperature of up to 400 degrees Centigrade, to get rid of the chemically bonded water. Naturally other chemical changes occur, too—we need not discuss them here. Through firing, the clay pot becomes hard, dry, and porous and can no longer be dissolved in water. At higher temperatures the clay loses its porousness, and it becomes a clinker, but in the open-pit firing, by far the most common method in the lands between the Sahara and the primeval forest, that is not the case. Such high temperatures can only be reached in kilns.

The picture at the left shows this primitive firing method, using a depression in the ground. We were on the way to Napiélédougou, a small provincial capital city in northern Ivory Coast. As we passed through the little potter's village, the women were lifting hot jars out of the dying embers with long wooden poles. Eighteen women smiled in our direction—old women, young, pretty creatures, and some with children on their backs. For this work in the proximity of the fire, they were dressed only in loincloths. No man or boy helped them. They would have regarded it as dishonorable to deal with pots. On the previous day, they had put more than 300 jars in layers in various places in the ground-oven, covered the whole thing with millet straw, brush, and a great deal of stiff, dry bush grass, and lit it. Throughout the entire day new bunches of grass had been thrown on top of the pile. As we arrived, we saw how the pots, now fired red as a result of the ferric oxide in the clay, were brought out while still hot and rubbed with an extract made from boiled leaves. Because of this, the outsides became a glowing dark brown, like chestnut wood.

A marked improvement in quality is achieved in many places by digging a two-foot-deep trench in which are put wood and straw. The dug-out soil is built up all around the trench like a wall, and sometimes, on top of this, channels are bored diagonally through the wall and into the trench—this is to achieve higher temperatures through ventilation. Here and there cylindrical ovens are also used; in those, the pots do not even come into direct contact with the fire.

In plate 90, it is not a woman who is shaping a pottery jug, but a young boy with a handsome, intelligent face. His name is Albert, and he is the nephew of a minister in Dahomey. I met him in a little pottery school in Cotonou, a

unique school for training craftsmen. It made such a deep impression on me that I would like to mention it as an excellent example of meaningful and sensible development aid. A French ceramicist, Monsieur Coustère, in co-operation with the International Labor Organization in Geneva and the government of Dahomey, had been commissioned to train about twenty boys as potters. The teacher recruited his pupils from throughout the whole country, and then installed himself in an empty warehouse near the harbor in Cotonou. The boys kept house and administered their little community by themselves, under the fatherly and discreet leadership of the ceramicist. There were Fon and Yoruba boys from the south, Gun from the west, and Dindi, Bariba, and Somba boys from the north. Every part of the country was represented because it was intended that the youths, after their two-year apprenticeship, should set themselves up in their native villages. There they were to be given help to establish themselves in the hopes that they, as young masters, would, in their turn, educate other boys to be potters' assistants.

Monsieur Coustère went about his work very conscientiously. The pupils practiced preparation of the clay and worked with simple, foot-operated potters' wheels. They learned how to operate a kiln so that the beautiful jars, pots, and bowls that they made so diligently were transformed into useful and solid wares.

Anything that can be produced in a country by its small craftsmen should not be imported. If that policy were practiced, it would be a good solution for balance-of-payment and unemployment problems. This ceramics school is certainly in accord with the theory that the only real help is the kind that leads to self-help.

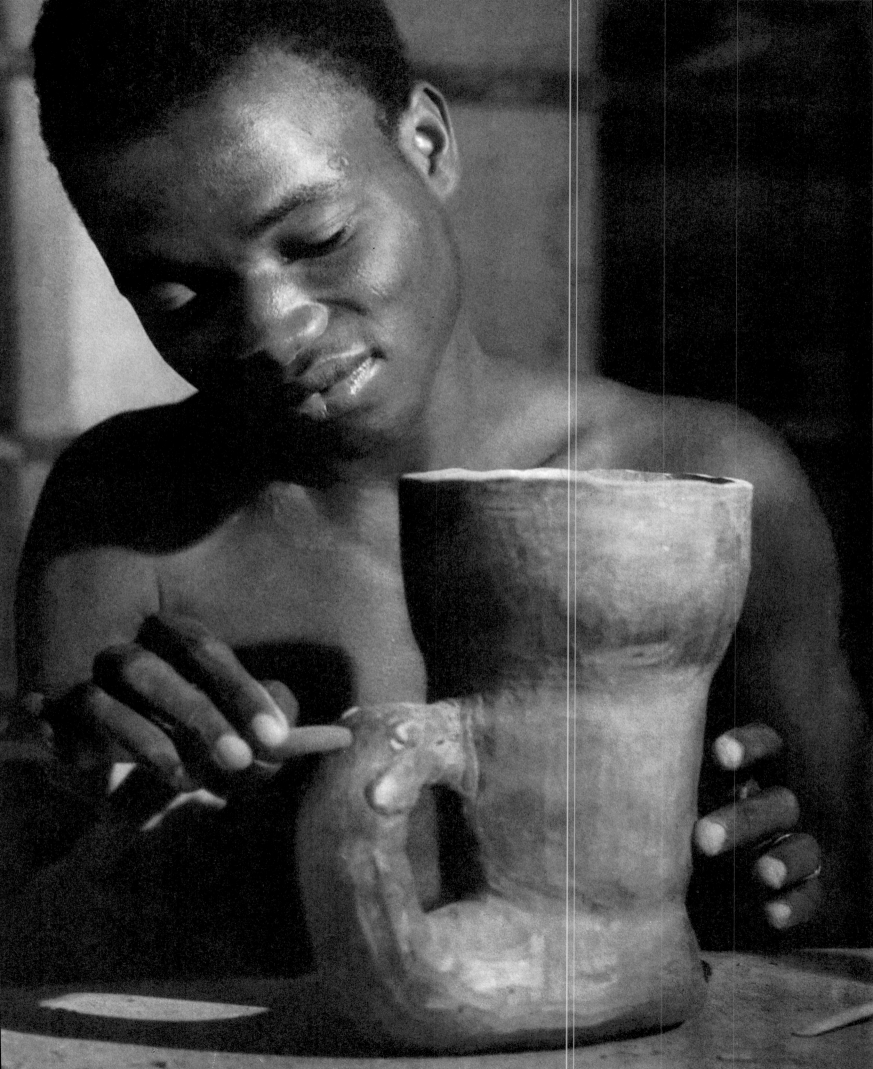

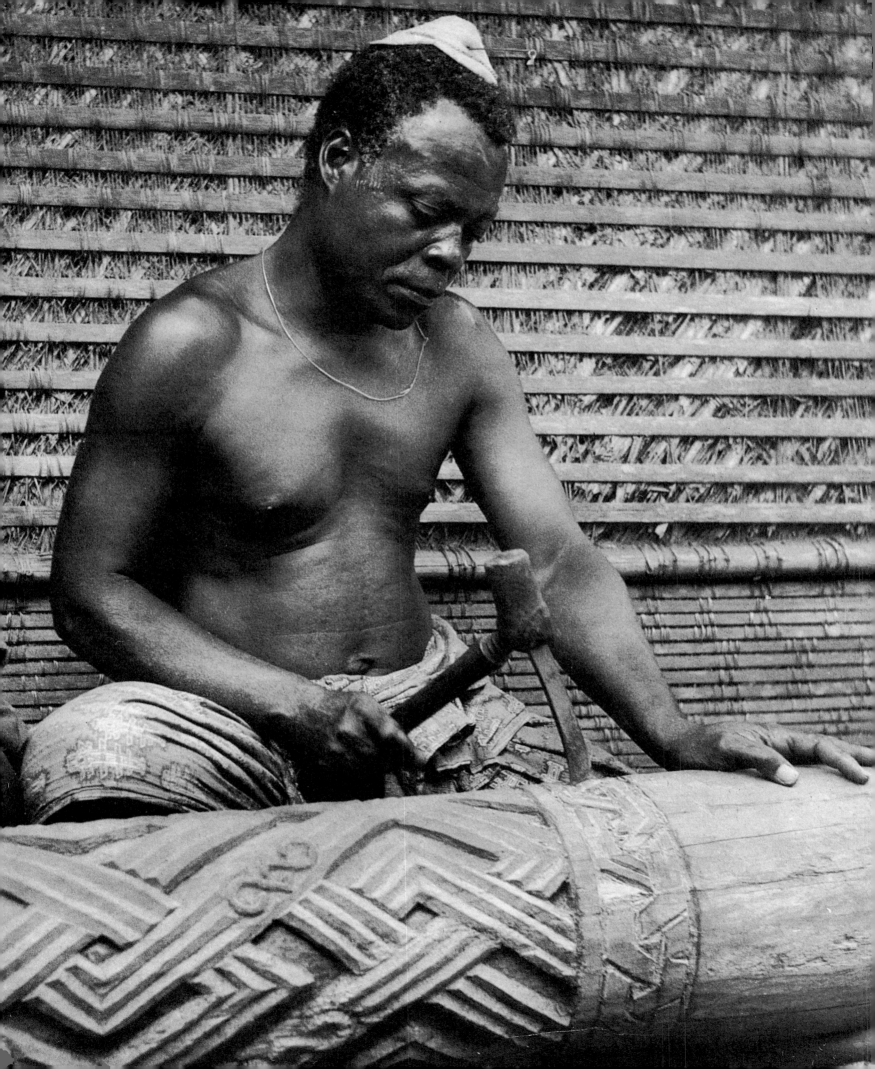

The man at left, shown decorating a thick house-post with the ornamentation so characteristic for his people, is a Bakuba. He works, usually, with an axe and an adze (the iron cutting edge of the adze is crosswise to the axis). As always, the hand of the craftsman is beautiful, but perhaps it is more important to look at the strong face and the quiet seriousness that is radiating from it. Here, with this master, one again feels the dedication with which he is absorbed in his work.

The Bakuba people live in the heart of the Congo Basin, near the Sankuru River, and it is said that they came there only a thousand years ago. They got the name Bakuba from their present neighbors, the Baluba. They call themselves Bashi Bushongo, "the people of the Bushongo land," but the name Bakuba has become so common that now everyone uses it.

The art of carving is not known throughout Africa: ornamented drums or wooden masks and ancestor figures are not found everywhere. Several centers have developed: the lands of the Guinea coast, the Cameroon grasslands, and the Congo Basin are regions famous for it. Of the Congolese woodcarvers, the Bakuba have made a name for themselves with a completely individual style. Of course they achieved this without striving for it, since all their works were originally made only for their own use or pleasure. I took all the pictures on pages 118 through 123 in the Congo in 1950. Since then many things have changed. The people have had to "adjust." In those days they still refused to wear European cloth or materials. They wore the madiba, a cloth made of raffia fibers that was often more than twenty-five feet long. It was pulled tight and wrapped several times around the body and worn as a skirt. On their heads, the men wore droll little woven hats of twisted fibers—the carver at the left wears one too—that were secured to their curly

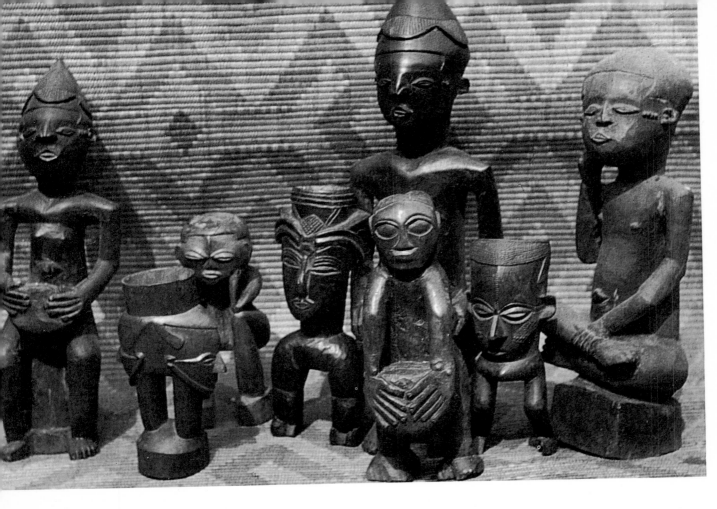

92

93

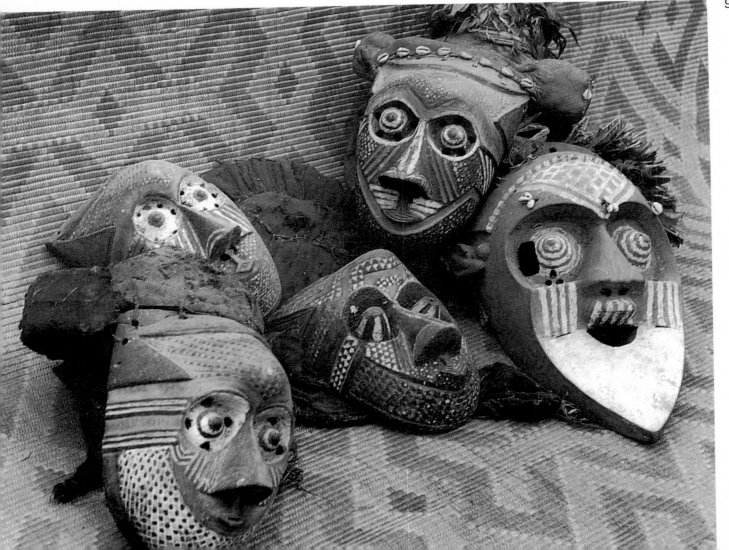

shocks of hair by hairpins that are now made out of bicycle-wheel spokes. Among the Bakuba, practically all everyday objects are decorated. The shaft of every spear, every spoon-handle, every pipe, every drinking cup, and every wooden box are richly decorated with figures or with the typically interlaced ornamentation that is also repeated in the raffia fabrics, on the mats, on house walls, on house-posts. It is even tattooed onto the stomachs of the women.

The three pictures on these two pages show a few samples of this Bakuba carving. A dignitary from the court of the King in Mushenge carried all these objects out into the open for me so that I could photograph them on one of the characteristic local mats, but unfortunately I was unable to buy them. In the upper picture at the left are five figures and three vessels for drinking palm wine. The latter also have human faces, so one drinks out of a wooden human skull, as it were.

A number of wooden boxes are shown on this page, below. The rich variety of forms is amazing, and the surface is almost always decorated with linear, interlaced patterns. Each carver has a whole repertory of these geometric ornamentations, all of which have particular names. It is even said that the name of the person who designed one of these patterns is still known. Originally, tukula-red was rubbed into the boxes. This is a decorative color that is

94

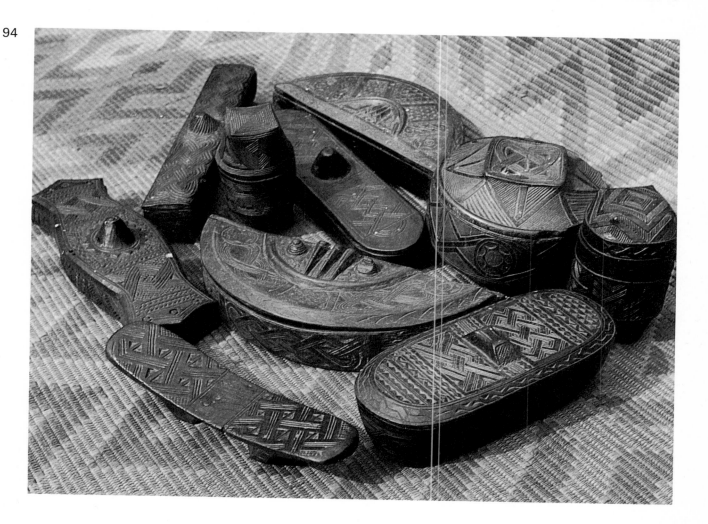

brought in from the regions north of the Sankuru. The red wood is ground to a fine powder on a stone.

The colored powder is mixed into a paste with palm wine and water in one of these beautiful boxes whenever it is required—just mixed, not stored—and then painted on the body on ceremonial occasions. The madiba, the raffia dress, is also dyed with the tukula-red. The powder is embedded in the grooves on the boxes. Corpses are rubbed down with it and masks are decorated with it, too. One is dealing, then, with a very important color, so it is easy to understand why the boxes in which it is mixed must be decorated. Every collector, moreover, will find the remnants of this dark brick-red color in the corners of his Bakuba boxes if they were actually used.

I found it very exciting at that time, in the land of the Bakuba, to crawl through the huts with the help of the man of the house, without whose permission I naturally would never have entered, to find all sorts of small ancestor figures hidden in dark corners, or particularly beautiful, ornamented drinking cups and tukula boxes. But even then it was difficult to get really good pieces, for I was neither the only one, nor the first, to snoop around there. Sometimes I succeeded in making a purchase, and sometimes not. What could I say when a friendly man named Mikabi, or Ningischanga, or Mabintschi told me: "No, I cannot sell you this box. My father gave it to me. Since he is dead, I cannot ask him if he would agree to my selling it. He gave me the box and I must pass it on to my children; surely you understand that. My father would truly not be happy to see me sell it."

Naturally I understood that, and left the man in peace, but I thought to myself how nice it would be if our forefathers in their farms and villages had said that nothing inherited from parents would ever be sold. Then perhaps today store windows would not have such dismal displays. To tell the truth, the Bakuba have not kept the boxes, the implements, the ancestor figures only out of piety, or even for reasons of conscious "house protection." They have kept these things largely because they were afraid of the revenge of discontented ancestors. Twenty years have passed since my last visit to the Bakuba. I am sure that probably there, too, with the passage of time, as in many places, respect for ancestors has been tempered to a considerable extent, and a "progressive" way of thinking has intruded.

The Bakuba are surrounded by tribes whose carving has also produced noteworthy results. The large carved drums at the right are used by the Denkese, a forest people living north of the Bakuba. The drums are two-toned, for one side wall is thicker than the other. This technique is also used by carvers of the Sepik River tribes in northeast New Guinea. There, in their "ghost houses," I have seen huge slit-drums decorated with carved crocodile heads. They were used not only to imitate the voices of ghosts but also to communicate news over long distances in a two-toned rhythm.

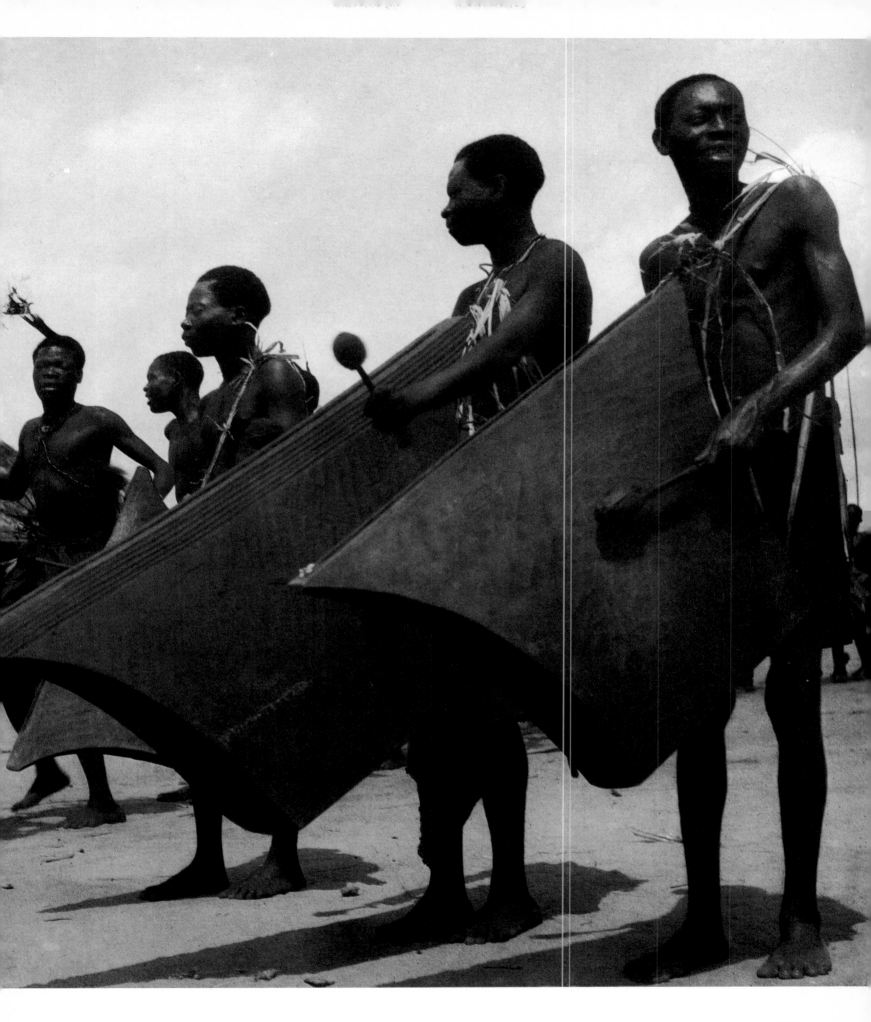

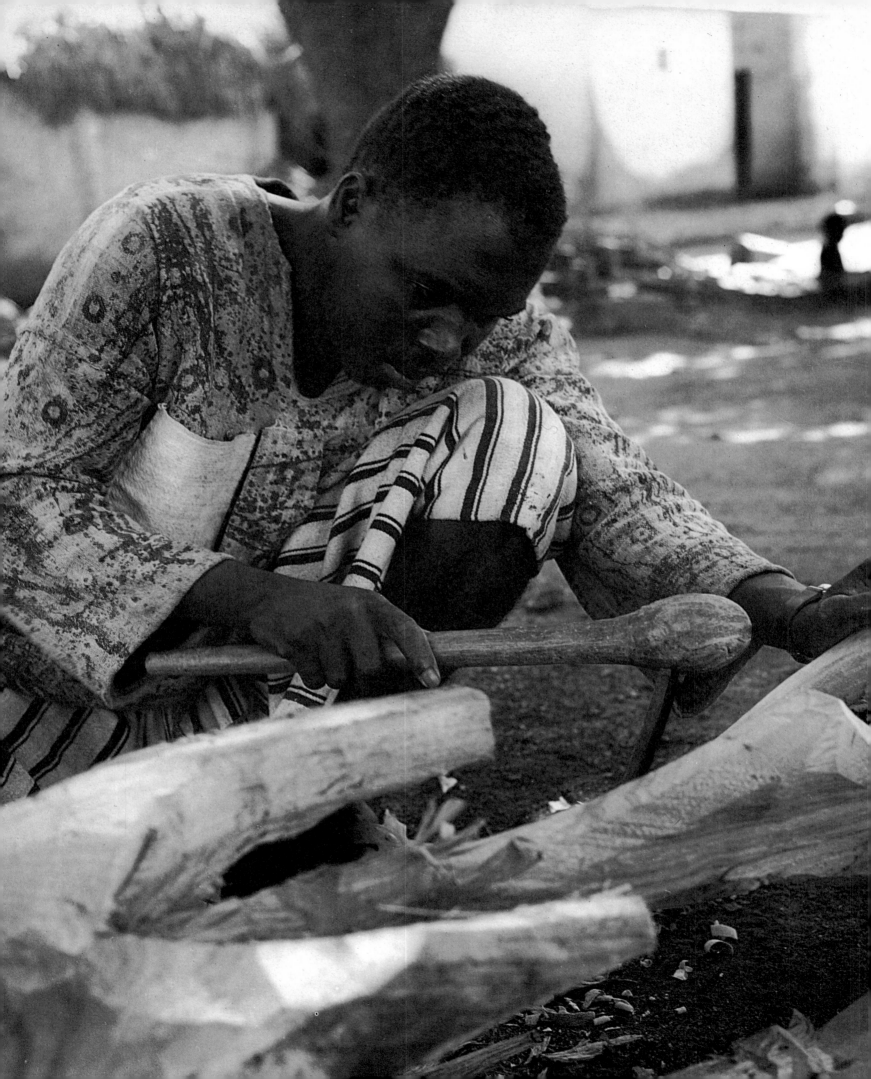

There are numerous descriptions, attempts at interpretation, analyses, and categorizations in the field of African art, principally on the art of the wood-carvers: masks, statues, and all sorts of other figural sculptural creations. Just before World War I, European artists discovered African sculpture, and objects that previously had been decried as hideous, heathen idols were slowly recognized for their true artistic value. Masks began to appear not only in anthropological collections but also in art museums, and we know that nowadays, since "Everyman" is collecting African art, good old sculptures can hardly be afforded. (I think these are probably cheaper at the antique dealers' shops in Paris than in Africa itself, where traders now seem to have lost all price standards.) Whole libraries could be filled with the books that have already been written on the subject of African art. They exist in countless languages, and because not all of the museum objects have yet been reproduced somewhere, new books will surely appear.

In this chapter, I would only like to tell of an encounter with some Senufo carvers I met in Korhogo, in Ivory Coast, in the spring of 1968. This encounter impressed me mainly because the carvers there produced masks and statues by the hundreds for the tourist trade, but at the same time they made "genuine" masks that were well hidden in the sacred groves. The men are organized into secret societies, and, now as then, the boys undergo initiation rites: the power of the cult with the masks seems unbroken. This juxtaposition is intriguing and exciting.

At the left sits Foley Kulibaly, who is carving for me a figure about five feet high. He belongs to the caste of the Kule, the woodcarvers, who all live together in the Koko quarter in Korhogo. He works, as usual, with an adze. Later on in the process, he will switch to a smaller one. The figure is to represent a female body with a strange, elongated animal head. The "real figure," which has been endowed with life and strength by magic rites, stands hidden next to others in the middle of a little sacred grove not too far away. Every Senufo village has such a grove. The figure is taken out only once every couple of years, or when important people die. My compatriot Emil Storrer was able to observe that at burials such a figure was carried at the front of the funeral procession and that the person carrying it stamped the ground mightily to drive away evil spirits. That would also explain why the large Senufo figures are always attached to pedestals almost as high as a kitchen stool. Day after day the carvers sat working under the trees or under the eaves of the roofs. Their apprentices, some of whom were very young, hovered over them. From time to time the boys were given instructions, but they learned mostly by just watching. Aside from the usual adze, they also used short knives. Those who did not have knives simply pulled the metal head off the wooden-handled adze and used it like a knife. Hammers, chisels, and planes were never used, and the wood rasp that appeared later was seldom used.

The knife is used in the following way: the mask being carved is pressed tight against the stomach. Then it is moved in the direction of the body, as if one were going to stab oneself with it. Wood that is still green and full of sap is preferred because it is much easier to work. In the end, the mask is dyed with a dark stain made of bark and mud. (In Cotonou, Dahomey, I once watched a couple of young boys painting their dreadful bas-reliefs of tasteless representations of women for European bedrooms. They were using ordinary shoe polish and then buffing them with a wool rag, just like we polish our Sunday shoes.)

The adult carvers of Korhogo work for themselves but are nonetheless strongly organized and united into a guild. When I first came to the carvers' quarter and cautiously tried to get friendly and then to photograph them, all of them refused my overtures. Only after I had paid my respects to the old chief (picture at right) was it possible. He lived in the same quarter, in a nice little house. When I arrived he was sitting in a lounge-chair, because, as chief, it is beneath his dignity to work. With the help of my capable interpreter, Fatagoma Ouatara, I submitted my request to watch the carvers and to take pictures. I asked him to persuade his people to grant me this. At the same time I asked him to accept a present as a token of my friendship. I discreetly slipped him a few banknotes. But he counted them very indiscreetly

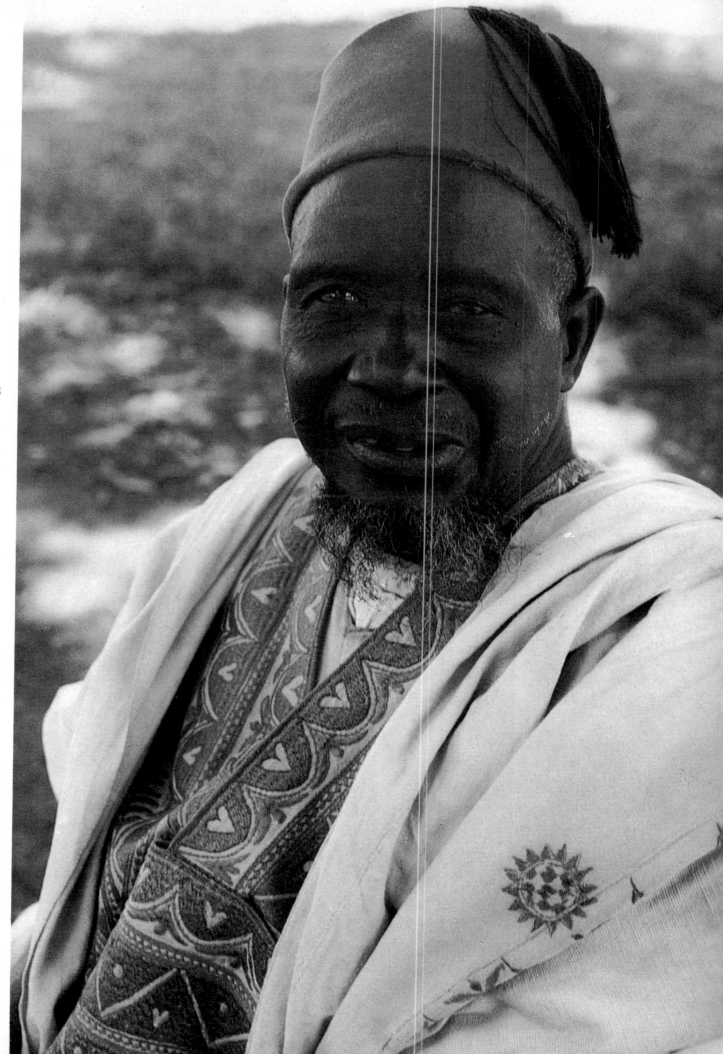

98

and unembarrassedly and explained that that was too little. So I doubled it. This was worth it because word soon got around that I had given the chief a present (which he would not, of course, share with anyone), and there were no more difficulties. Everyone was friendly and approachable and allowed me to photograph to my heart's content. But first I asked the gentlemen to move the ever-present and bothersome motorcycles out of the way.

Beside the chief's house was a little fetish hut. The outside wall was decorated with a brightly painted half-relief of a snake. In front of it stood an offering pitcher and a sacrifice-stick of clay. On the stick were the bloody feathers of a sacrificed chicken. That means that, despite the mass-production of masks and representations that now serve only as decoration, both the "simple peasants" and the woodcarvers as well still completely believe in the secret society, the power of the masks, and the necessity of sacrifices. The word *poro* always came up in conversations about the men's secret society, about its meeting place, the little sacred grove behind the village, and with reference to different sorts of masks. It is connected with ancestor worship and the mask cult, but it is also the word for the "devil" mask worn by the leader of the society for certain occasions. This devil plays specific roles in initiations (consecration ceremonies for youths), in the impressive burial ritual, and in special festivals dedicated to one single poro that recur every couple of years at the same time.

The color picture shows a particularly strange poro in the form of a cow. It is a specialty of the region of Sinématiali. There, even the smallest hamlet has this poro, which is named Nasolo. The leader of the men's society in the little village of Nagbéléquékaha was called Nagouga. For a good sum of money, he let himself be persuaded to introduce me to Nasolo, after he had shooed away the women and the uninitiated. With the sacrifice of a chicken, which I paid for, I excused myself, so to speak, for disturbing this spirit. Some old men beat drums and clanged bells and walked ahead of the mask in which two men were hidden. The structure resembled a cow, or, in any case, was intended to symbolize one, and maybe a buffalo, too. For a head it had a mighty, painted animal mask. A boy dressed from head to toe in a tightly braided mesh suit decorated with red and yellow tassels continuously danced around the poro with elegant steps and leaps. The masked figure emitted strange and frightening, deep, grunting tones. These tones, which can be heard far over the countryside, were to drive away all unauthorized people who were not allowed to see Nasolo on pain of death.

So I photographed this masked monster. Later, in another village with an equally simple name, Fediolokaha, I was also able to take photographs. But I was not allowed to see where the masks were kept. I was not prevented from going into the sacred grove with the men, but they were completely against my crawling into one of the round huts to find out what secret things, masks,

dance costumes, and poro figures were kept there. However, it was explained to me how Nasolo's sounds were made. The front man held a drum under his arm in such a way that the drumskin was in the back. A stick with a knob at the end was stuck through a small hole in the drumskin. Now the man in the rear, who, like the front man, is standing bent over under the structure, has to pull and rub on this stick with wet hands. Because of the knob he cannot pull the stick all the way out, but he can move it. Through movements similar to those of milking, he sets the drumskin vibrating with the stick, and some rather uncanny noises result.

The masks opposite I photographed in a little village called Nongohilékaha that was right on the main road just outside of Korhogo. Only the bare feet of the dancers can be seen under the coarsely woven garments. These masks represent antelopes with mighty horns, but at the same time they have characteristics of other animals—tusks of wild boar, and the teeth of beasts of prey. Traces of the blood of sacrifices were visible on them, and magic accoutrements in the form of bunches of feathers and porcupine quills had been stuck into them. These kinds of masks were called *Wabele*, and their keeper was a man named Dodan who was severely marked by leprosy. At the left stands a little hut in which the masks are kept. To the right, by the tree, a kind of Euphorbia similar to a cactus climbs up the tree. This is a plant that is also associated with magic in northern Cameroon and northern Dahomey. In front of the fetish house stood a large clay bowl half full of water. In this were some sticks of wood. They were made from the roots of holy trees, and dogs, chickens, and goats were sacrificed over them when necessary. The Wabele masks are used at ceremonies for the dead and also, every seven years, for very special ceremonies.

When I looked at the old man who protected the masks, I wondered, as I did so often, where the borderline could be found between real faith in the power of the masks and charlatanism. But my European friends in Korhogo, some of whom had been there for decades, repeatedly asserted that the power of the masks and their agents, the secret societies, was completely unbroken. If someone in the tribe is disobedient, breaks tabus, does not want to pay tribute to the chief, or performs certain unapproved activities, it is better for him to leave the village because in those instances there is a secret jurisdiction and the police seldom investigate a case if the poro is in some way involved. These special masks are kept in secret places, they are brought offerings, they are feared and obeyed. But at the same time the Hausa tradesmen sit in front of my hotel in Ouagadougou, in Bobo-Dioulasso, at the airport in Niamey, or wherever, and if I let myself get into a conversation, the only way I can defend myself against their importunity is to flee. They offer Senufo, Mossi, Bambara, and Baule masks and statues by the cartload (plate 101 on the following page)—they are all artificially antiqued

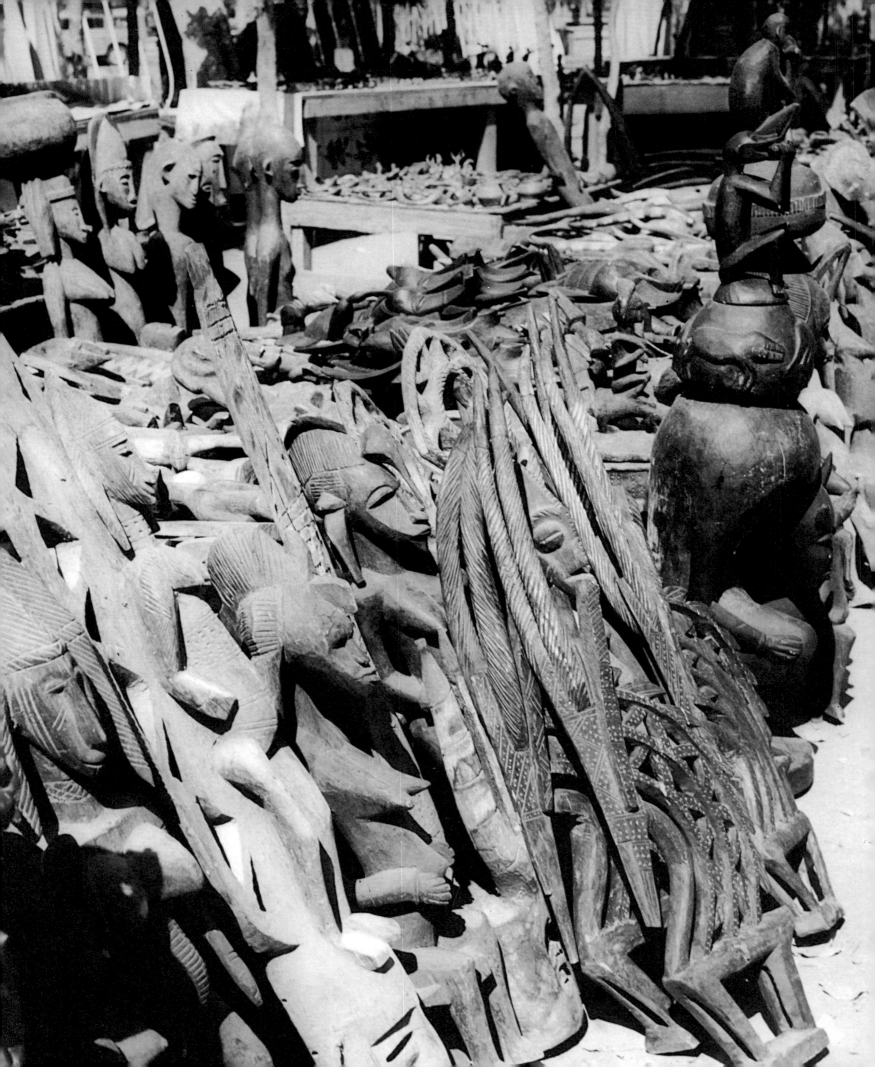

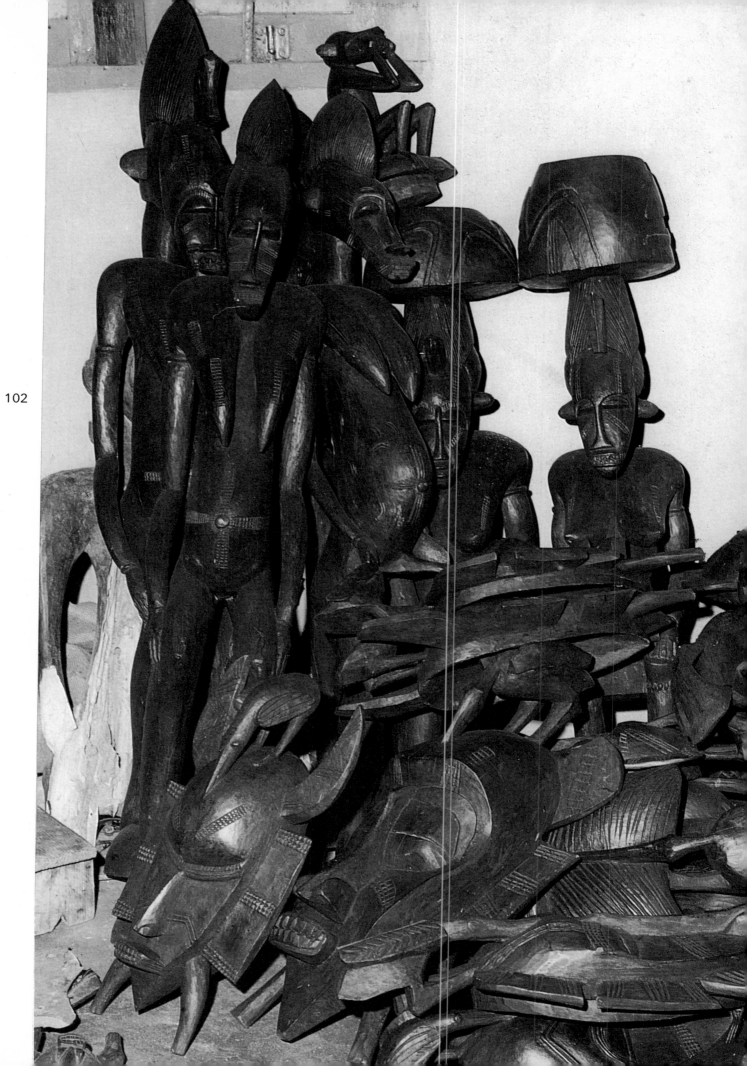

for the unsuspecting tourist and nonconnoisseur. In the houses of the Senufo carvers, the stained masks lay in disorderly piles (plate 102)—they have given up trying to make them appear old by various tricks. One of the carvers had a book on African art. He could neither read nor write but he was certainly capable of looking at the photographs and copying the masks reproduced there. This Senufo carver made, completely independently, not only the traditional masks of his people but also those in the style of the Bambara, the Bobo, and the Baule. He had really become a manufacturer. He knew that it was worth the trouble because what was not sold in Korhogo would be picked up another day in a truck by a dealer from Abidjan. One of these days I will probably find one of these masks again in my local department store. But there, at the right, is an old fellow who wears the national dress. He is a bit unsteady but diligent. He works calmly and tries—one is confident he can—to give his mask a soul, to breathe life into it. This juxtaposition, this simultaneity, this is really exciting. The Senufo believe in the power of the mask, the poro; they bring blood sacrifices; and then they coolly go home and produce masks the way a European might make wooden shoes.

10

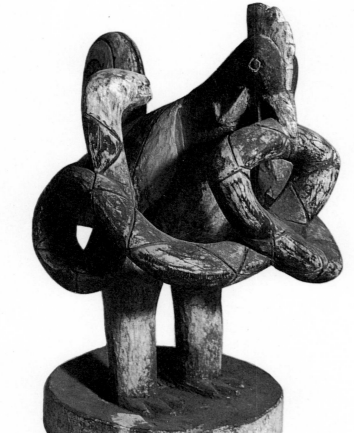

103

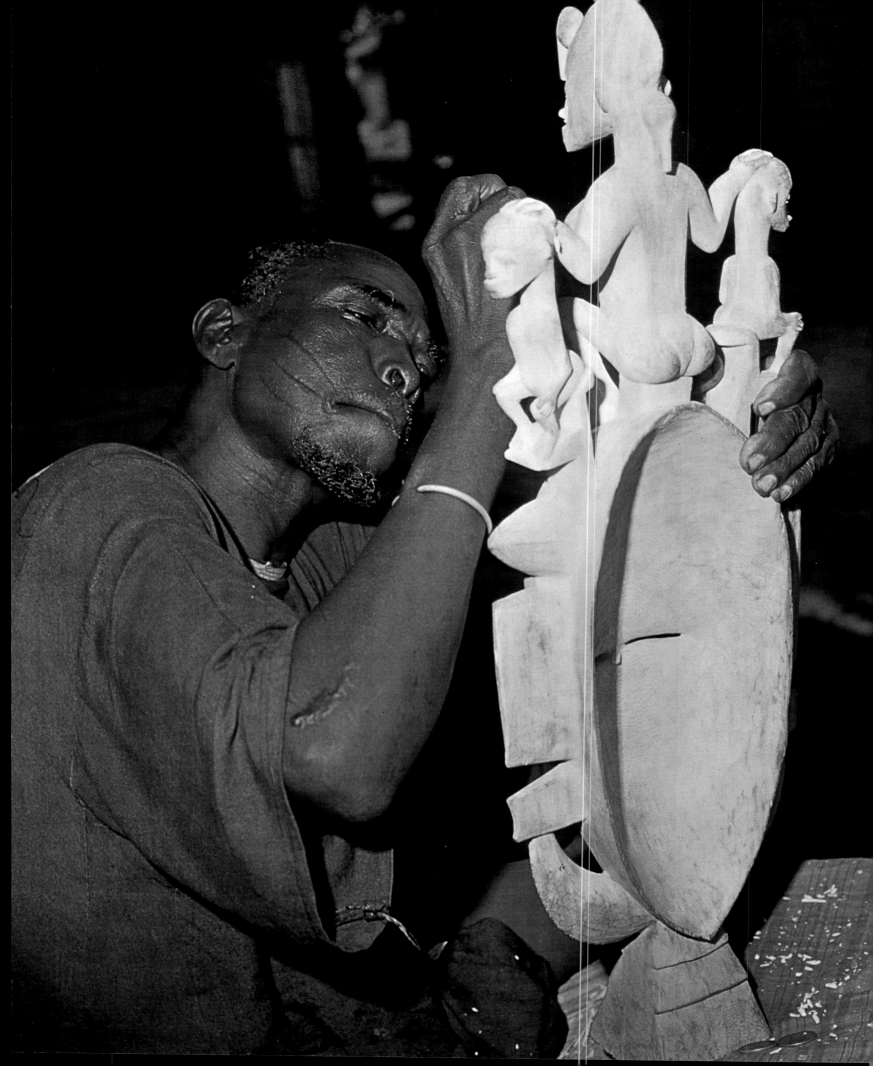

Calabashes from Wangai

The calabash is the name for all those different bowls, dishes, and containers that are made out of the hardened shells of a particular member of the gourd family. Botanists call it *Lagenaria vulgaris*, but in Africa there are as many names for this plant as there are tribes that cultivate it. The blossoms are white and the leaves are broad and large. One differentiates between the varieties that creep across fields and those that climb. Sometimes the fruits resemble pot-bellied flasks like the one in the picture opposite. Sometimes they are peculiarly long, or simply round, and I believe one can get the best picture by thinking of the varieties in which we find squashes. Naturally, the ways of using calabashes are correspondingly varied. If, for example, I cut the fruit hanging here on the vine crosswise, then from the lower half I would get the shape of an ordinary bowl. But if I cut a piece out of the top curvature of a bottle gourd, the result is the cheap and practical vessel in which the wandering shepherd carries his meager water supply. Peanut oil is stored in bottle gourds, and the nomad women use them to shake cream until it becomes a runny butter. In short, the calabash, like the pot, is an all-purpose vessel.

Before the introduction of enamel dishes from Europe, one could hardly imagine a single household in most of Africa without calabashes. They are very cheap and much prized by the nomadic tribes because of their light weight. Calabashes are used to dip water at the well. They are used as dishes, and milk is stored in them. The picture on the following page, for example, shows the milk supply in a round hut of the Fulbe, on the northern border of Dahomey. The calabash serves as a measure when buying millet, it is a drinking bowl, and eating dish, and, in areas where water must be conserved, it is used as a washbasin. It is also used as the sound apparatus of a

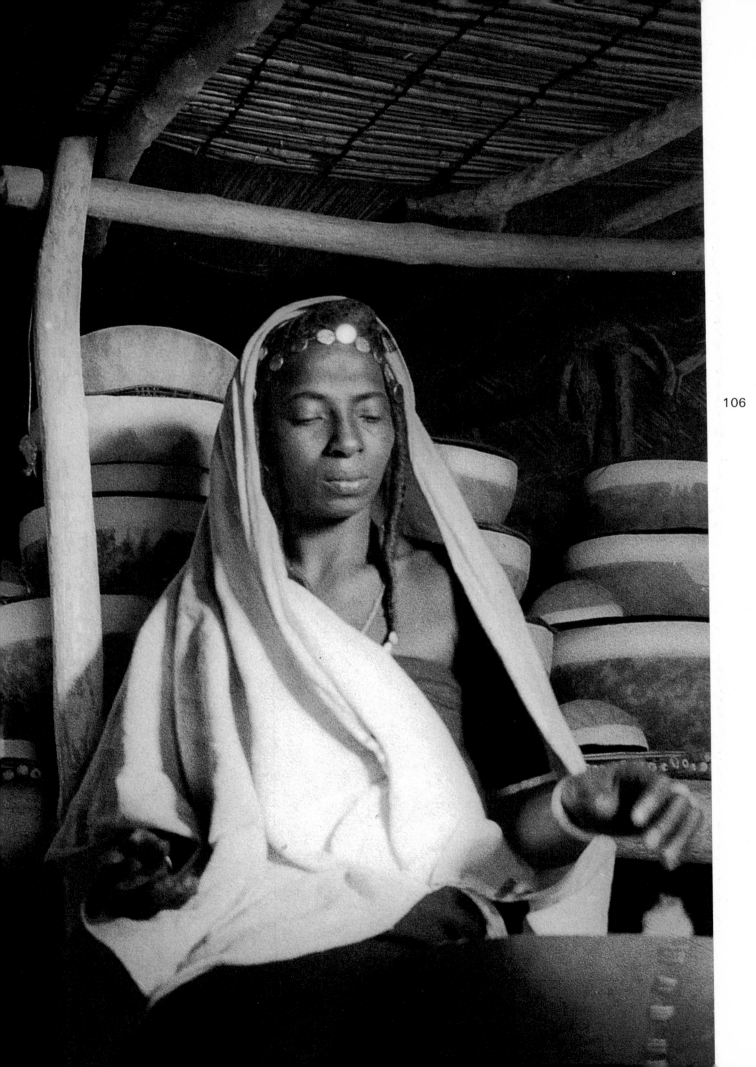

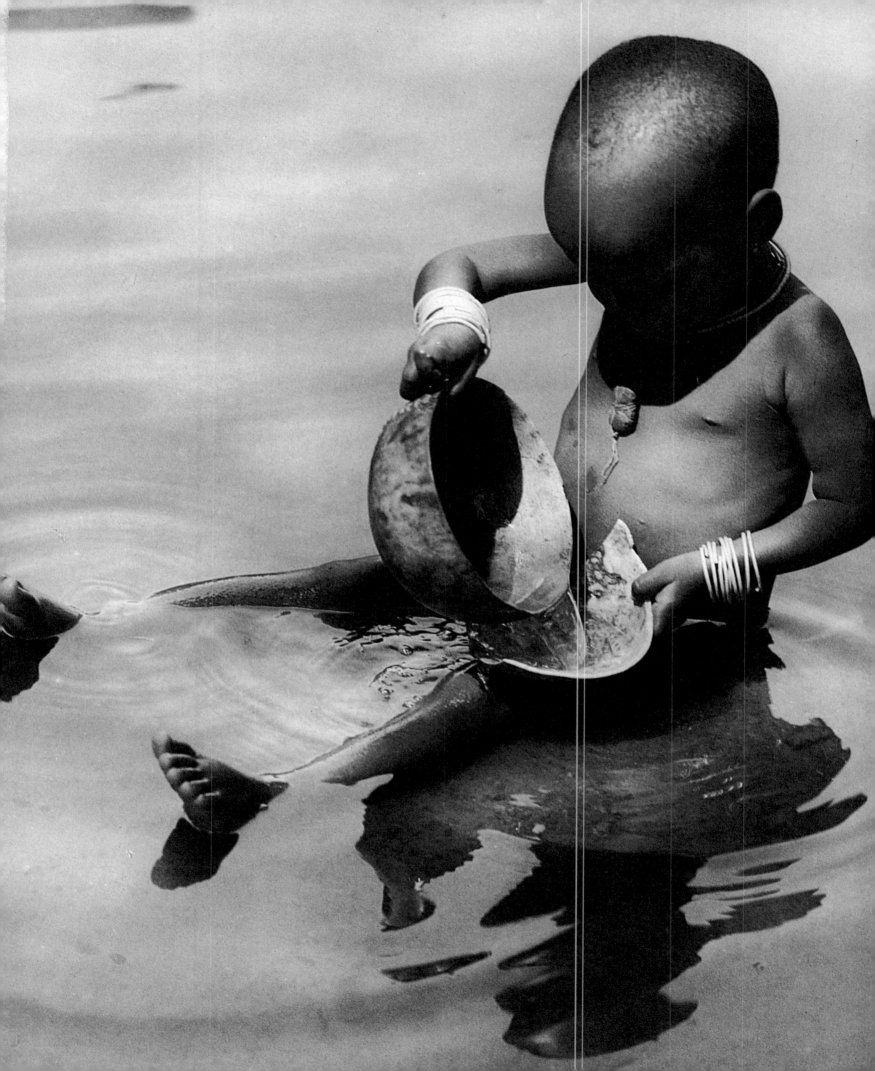

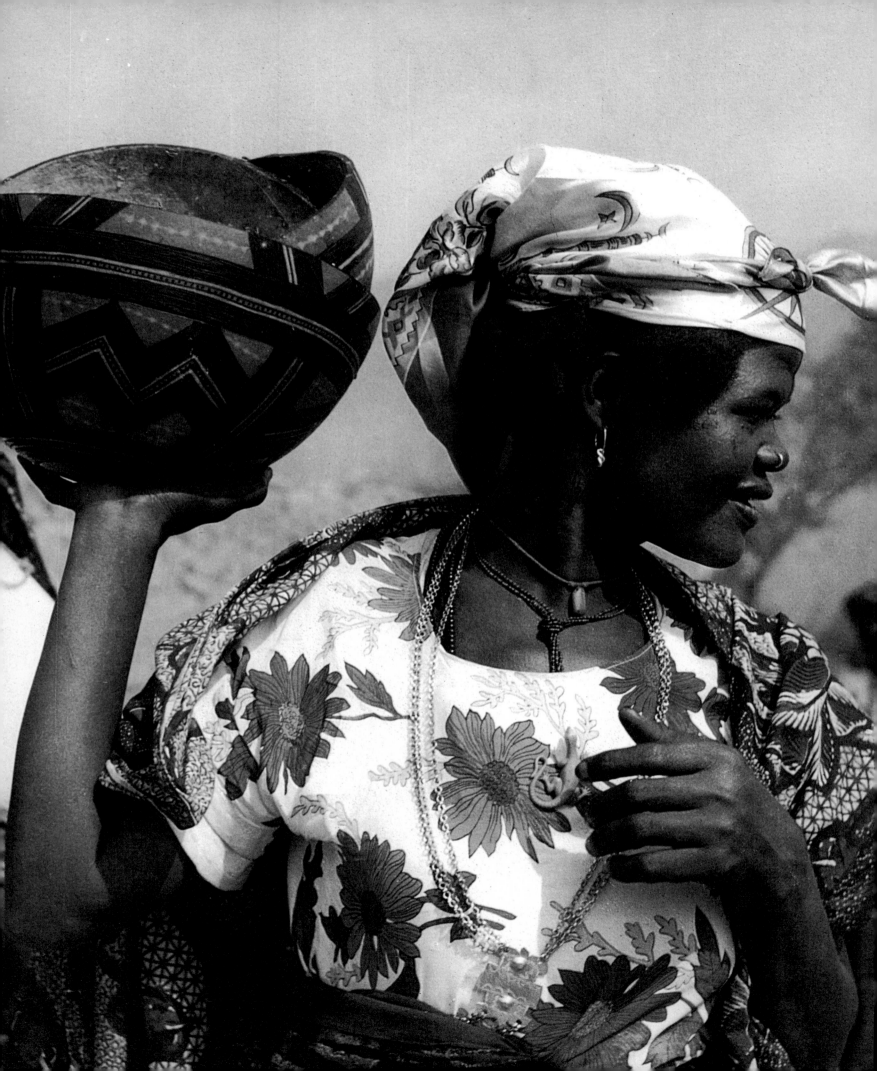

violin or a harp. The workers in the salt fields of Bilma lift salt out of pans with huge ''spoons'' made of half of a calabash. Flat gourd bowls serve as potter's wheels, and women stick their hands into peculiarly long calabashes, whose shape is reminiscent of zeppelins, in order to dye their fingernails in a henna brew. The Marabout keeps his ink, with which he copies the pages of the Koran, in a small ball-like calabash. The doddering old people among the Matakam hang calabashes from their belts for use as drinking vessels when millet beer is passed around.

As soon as a calabash has been decorated, its value changes. It is no longer simply an ordinary vessel but a symbol of personal wealth. It is deemed a great honor to be able to line up in one's hut as many prettily decorated calabashes as possible. They play an important part as presents in wedding ceremonies and are the major portion of a woman's dowry. The pictures on these pages come from Wangai, at the foot of the Alantika Hills in northern Cameroon. Below sits a woman decorating a calabash with a hot iron whose point resembles a spear. These calabashes are to be wedding presents for Haman Jadschi, the Muslim chief of the village.

While I was staying in Wangai, I went every morning to watch the progress of the work. Patiently and dextrously this skillful woman guided her iron tool. Her mother sat next to a small fire, stirred the coals, and heated the knives

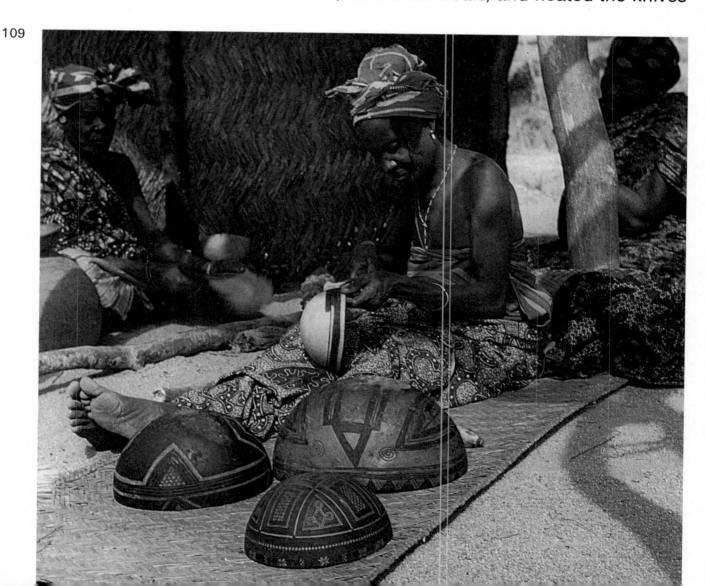

that were alternated every few minutes. The decorations are burned in with a sure hand and without hesitation, without having been predrawn. The woman might even have been incapable of using a drawing pencil. In Garoua, however, I once saw a woman draw in a few rough outlines with a piece of charcoal.

From what I could observe in Chad, in Cameroon, and in northern Dahomey, it was the women who decorated the calabashes. The motifs, naturally, change from country to country, sometimes even from village to village. The triangles, squares, spirals, circles, and broken lines are always arranged in different ways. The style changes, too, and one can easily tell whether a calabash comes from Wangai or Maroua, whether it was decorated in Zinder or in Tahoua. Sometimes the surfaces between the decorations are also dyed. Vegetable dyes, which lightly penetrate the surface and combine with the tannin of the fruit rind, form a decorative layer that cannot be washed off. In other areas, the ornamentation is not burned in but cut with a knife or engraved with an iron tool.

Now to return to Wangai. At the time we were there, dozens of calabashes were being made for the wedding festivities—each one was more beautiful than the other and none was quite like any other. Of course these Fulbe women always use the same motifs. They are determined by tradition and can often be explained. Yet I had the feeling that each woman was creating a new and unique work of art from within herself. She was not copying, she was using no model. And she never hesitated—she had in mind a certain idea of what she wanted to make. The young chief of Wangai, Haman Jadschi, was marrying a second time because his first wife had remained childless. So he found it necessary to take a second wife into his household. We had the pleasure of experiencing not only the complicated preparations but also the three-day feast. Together with numerous other wedding guests, we consumed the meat of the slaughtered oxen and tasted the honey cakes. Aside from that, we received, as local custom required, several of the wedding presents that had been brought to the festivities. A messenger from the chief brought me two braided mats and a good dozen richly decorated calabashes. As the wedding procession arrived from the neighboring village on the first day of the celebration, I was standing at the side of the road with the gaily clad and exuberant villagers. First came the colorful riders armed with lances, and then the musicians. There followed a train of highly varied and colorfully dressed Fulbe women, relatives and friends of the bride. They surrounded a litter borne by four strong men in which, mysteriously hidden by drapes, the bride was carried and bounced throughout the hot day. An army of about 150 bearers brought up the rear, bringing all the presents, the bride's dowry. There were ten *boubous*—billowing stately robes—five pairs of pants, several pairs of shoes, red turbans, and bolts of cotton cloth. And in

110

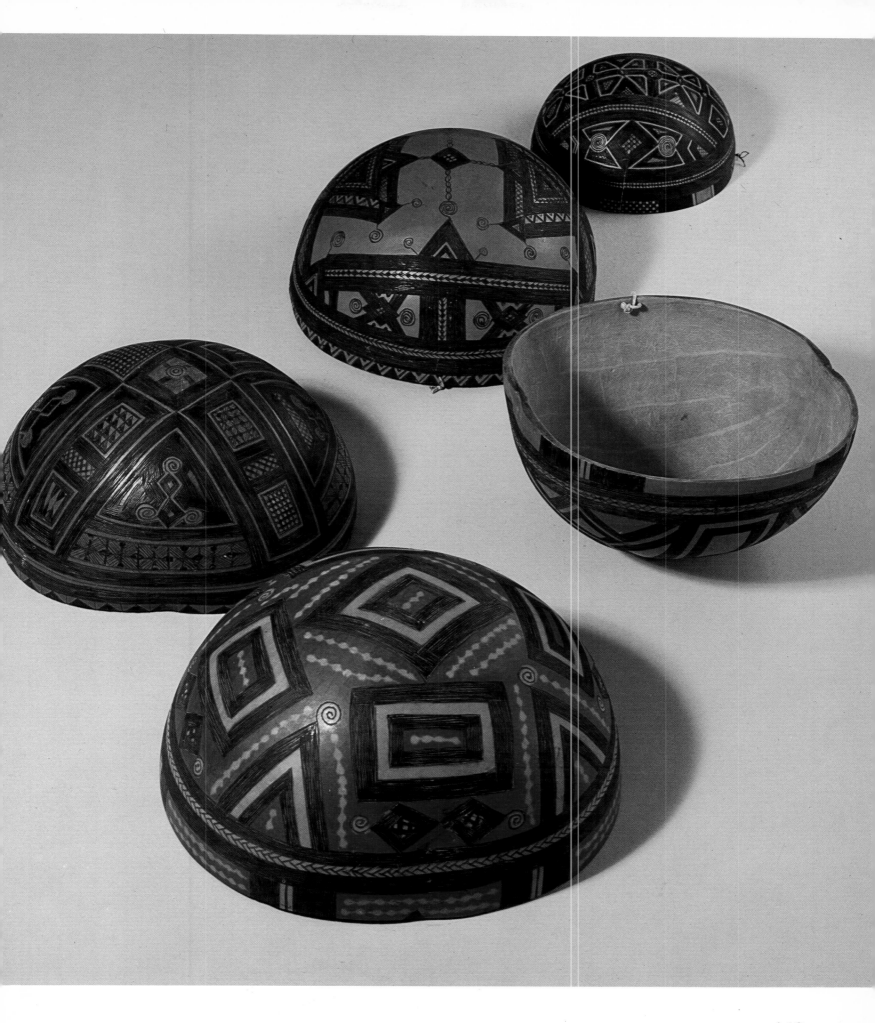

143

the more than a hundred large calabashes, all carried on heads, were ground millet, rice, sweets, honey balls, and roasted peanuts. And all of these calabashes had been ornamented in the most delightful way with the most beautiful decorations—with dark burned lines, geometric figures, and spirals of all sorts. Each calabash was entirely different. In addition, a cover of dyed, woven grasses had been placed atop each one. When all these presents had been set down at the large farmstead of the chief, so that they could be admired by the guests, naturally I crowded in too. I was impressed by the stately robes, I liked the many jars and the bright blankets, but nothing filled me with more enthusiasm than the colorful picture presented by the hundred-odd calabashes with their bright woven covers.

Millet, peanuts, or milk can be preserved just as well in an undecorated calabash as in a decorated one. But in a land where people are not yet so obsessed with functionalism, the decoration of an object is not regarded as a superfluity that yields nothing but rather as a necessity and a chance for self-expression.

It is sad to know that this ancient folk art is also doomed to extinction with the progress of civilization and industrialization. Sometime soon, the women will no longer find time to sharpen their knives on a stone, to lay them in the fire, and to burn the lovely interlaced decorations into the soft surface of the calabash shell. The calabashes are now being replaced by buckets of galvanized iron and plastic kettles, and by cheap enamel basins with horrible, garish stencilled patterns. These basins, which Europeans have introduced, last longer, and are easier to wash. It is almost impossible to get the smell of rancid oil or sour milk out of the porous shell of a calabash. That fact is unfortunate, because that is the reason why it will be increasingly difficult in the future to find the beautiful and well-decorated calabashes. And so, sadly, we progress yet another step farther into this dismal age of standardization.

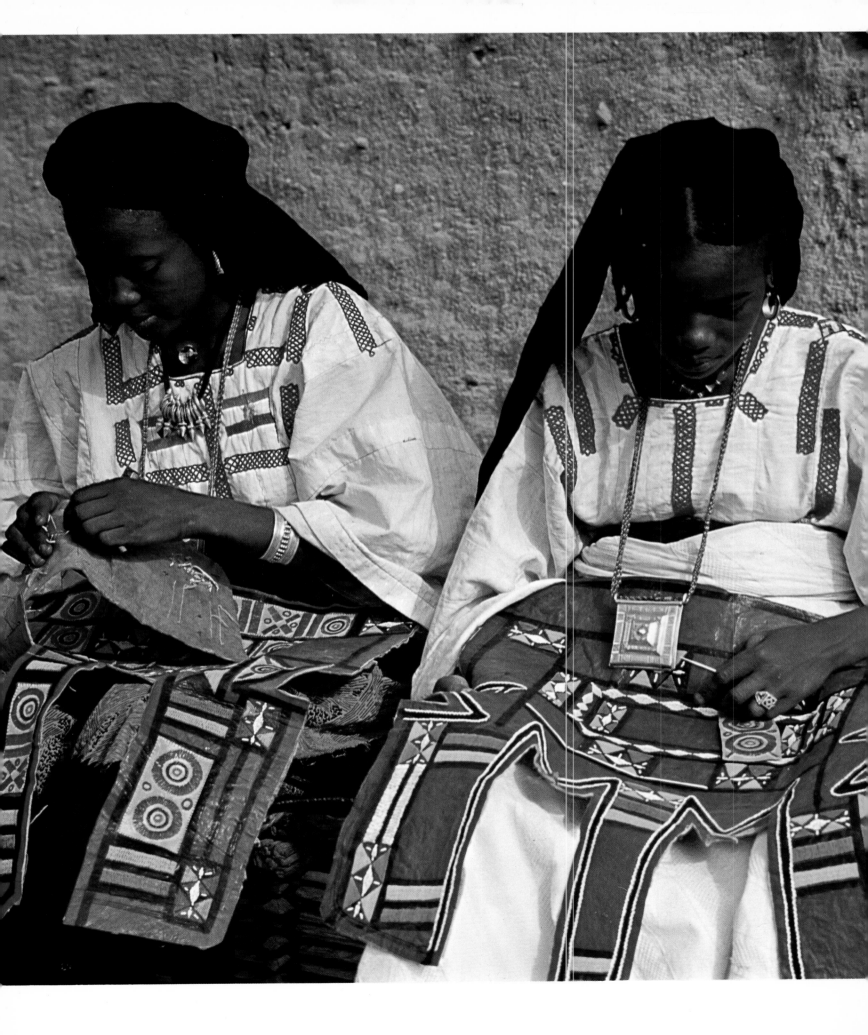

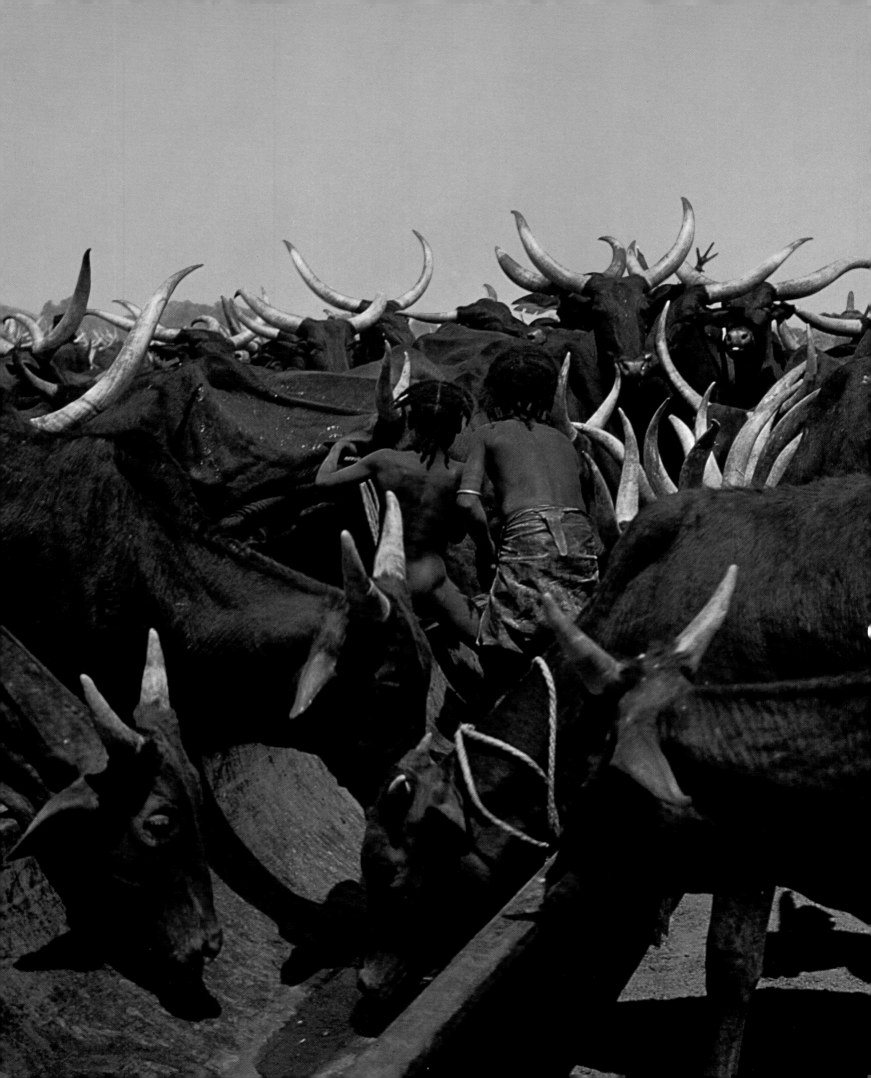

Decorated Leather

113 Needless to say, leather plays an important role among the nomadic tribes, particularly the Tuareg and the Fulbe. An enormous variety of things are made of leather—several of them will be mentioned here. On page 197, a large tent of the Iforas-Tuareg is shown. At several wells, and also at markets in the Western Sudan, I met shepherds, Bororo nomads like the boy in the picture at left, who wore nothing other than a piece of softened leather. They carried their provisions in leather sacks strung around their waists. Sometimes they wore leather hats, and certainly leather sandals. The people of a salt caravan that I followed through the Tenere region of the Sahara carried millet, which they planned to trade for dates or salt in Bilma, in large leather sacks. Also, tea and sugar, without which the Tuareg cannot live, were packed into little leather sacks. And like the nomads of the Sahara, they had brought water in tubes of mutton or goatskins, the famous *gerbas.* Caravan treks would be unthinkable without these.

In the next chapter I will discuss the Tuareg saddle that is covered with red-dyed goatskin and, in the chapter after that, the pretty parchment boxes, decorated with batik patterns, that are found in many tents. In Tuareg tents, you lean against richly decorated leather pillows, and clothes are stored in equally beautiful decorated leather bags. Milk is made into butter in large leather jars. Knives are kept in decorated leather sheaths. The bridles of riding camels are made of leather. Leather is still really indispensable, and in ages past, as now, the nomad craftsmen have known what to use for tanning and what plants or galls must be added to preserve certain leather colors and to remove the hair. They know how to make leather soft with butter, or how to impregnate it with a paste of roasted dates, and they know several methods for dyeing the tanned leather yellow, red, or *kano*-green. All the re-

maining pictures in this chapter, including the color picture of the two women working on page 147, concern the production of camel saddle bags. It is Tuareg women from Agades who have specialized in this work. Below is a detail of the leather bag whose underside is illustrated in plate 116. In the finished work, this portion is almost completely covered by the overlapping flap, as shown in plate 119. The woman at the right has just begun to draw the usual decorations, the colored lines, the broken lines, the triangles, stars, and checkerboard patterns, with a knife. The bag cover in plate 117 is almost too richly covered with design. On this are leather appliqués; the green squares that have been sewn on are embroidered with circles and bars of red cotton thread. Narrow borders of white leather occupy a large part of the pattern. The embroidery is in the Hausa style, while the trimming with the light strips of leather is in Tuareg style.

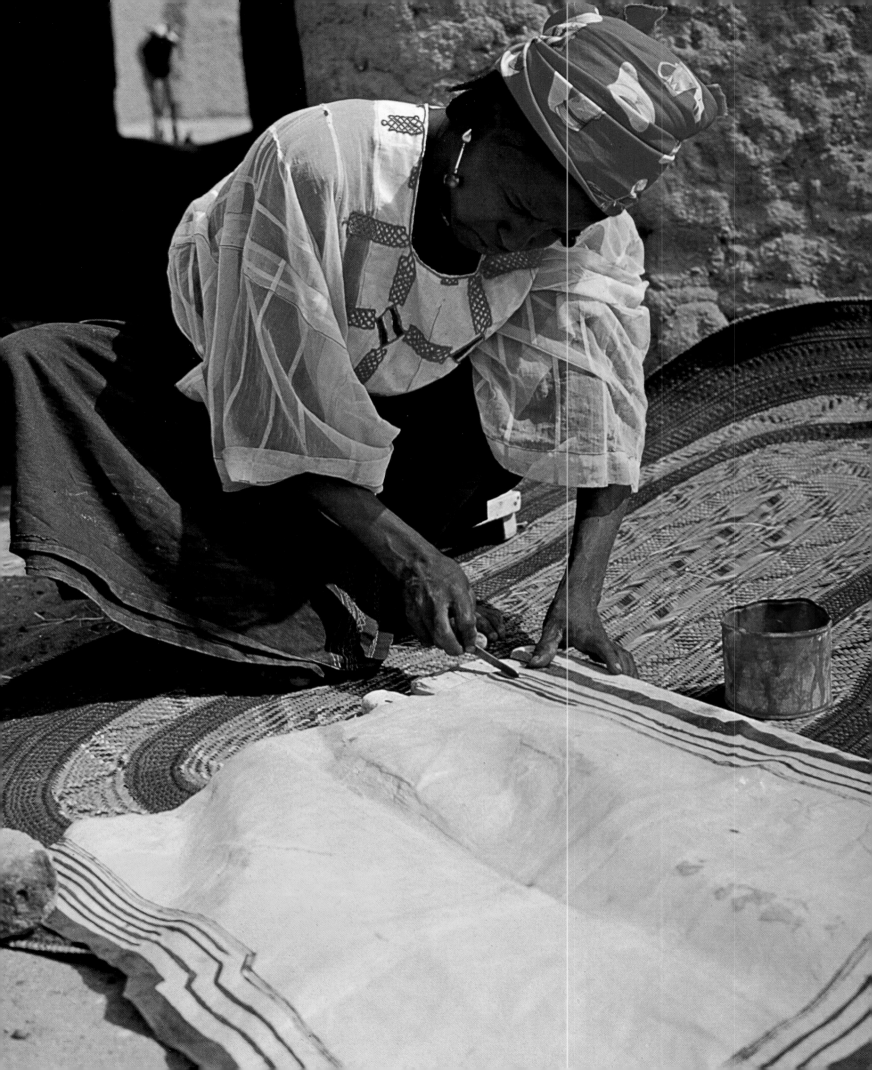

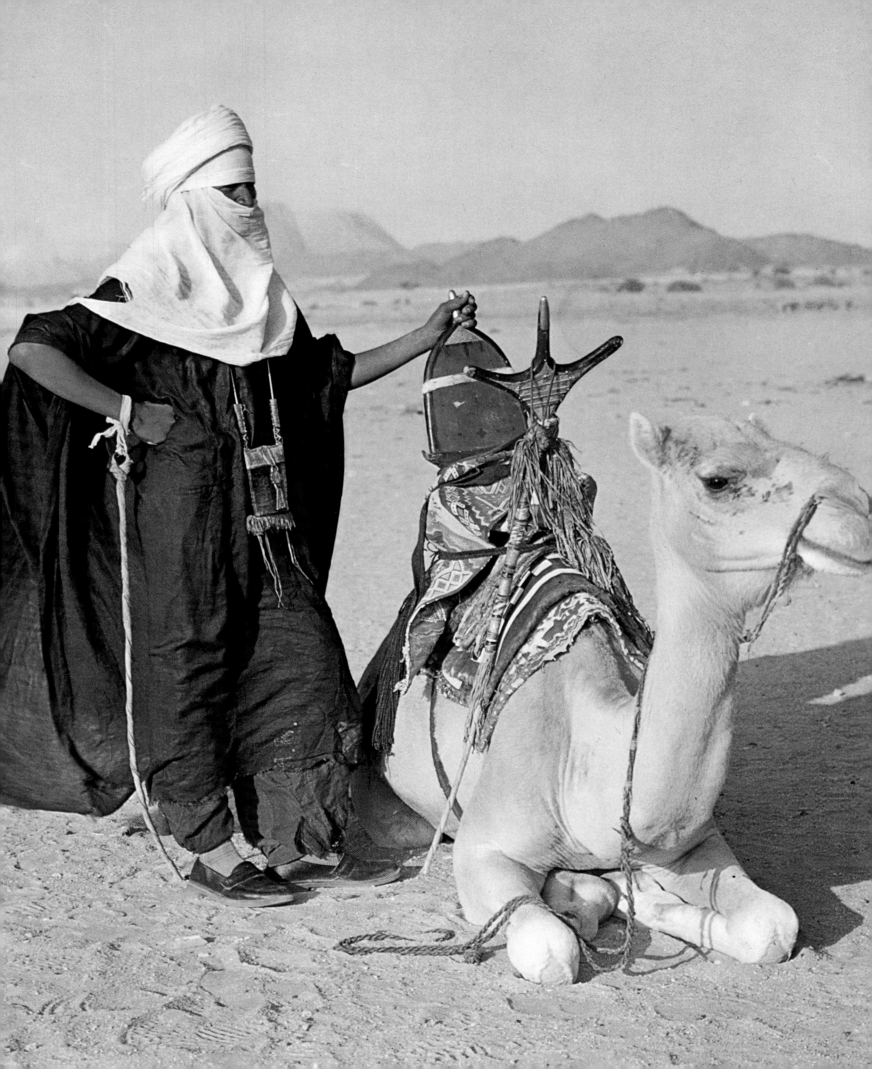

Haidara, the Saddlemaker

18

It is said that God created the desert in order that there might be a place where he could wander in peace, but soon he saw his error and corrected it. And so, to the glory of Allah, to the shame of his enemies, and for the use of mankind, the camel was created. To his feet He bound compassion, on his back He laid booty, and in his flanks He laid riches. He gave him, even without wings, the flight of a bird, and fortune was tied to his tail. Thus is the noble favorite animal of Allah celebrated in the great desert, and even today one cannot imagine the life of the nomads without this strange creature that is so marvelously suited to life in the sand and rocks of the Garden of Allah.

In the Sahara one only encounters the one-humped camel, the dromedary. The famous riding saddle of the Tuareg, the *rahla*, sits on the highest point of his back. If the terrain does not present too many obstacles, caravans usually travel about twenty-five miles in a day. But many a son of the desert has put up to forty miles behind him in the saddle of his white riding camel, and it is reported around campfires that a particularly good rider has gone almost 300 miles in a week. How could he have done that without the splendid saddle, covered in red leather, in which one sits as on a throne with the metal-sheathed horn between crossed legs? The feet lie comfortably in the hollows of the animal's neck. It is the pride of every Targui to own a richly decorated saddle, although to protect the red saffian leather and the silver or tinplate sheathing on the outside of the backrest, he usually wraps it with strips of canvas. But as he rides into town, or to ceremonies, he removes them. Tuareg men are prepared to pay two to three hundred francs for a beautiful saddle on which fittings and ornamentation are not spared. After I saw how long the saddlemaker worked on it, and with what care, I did not find the price too high either.

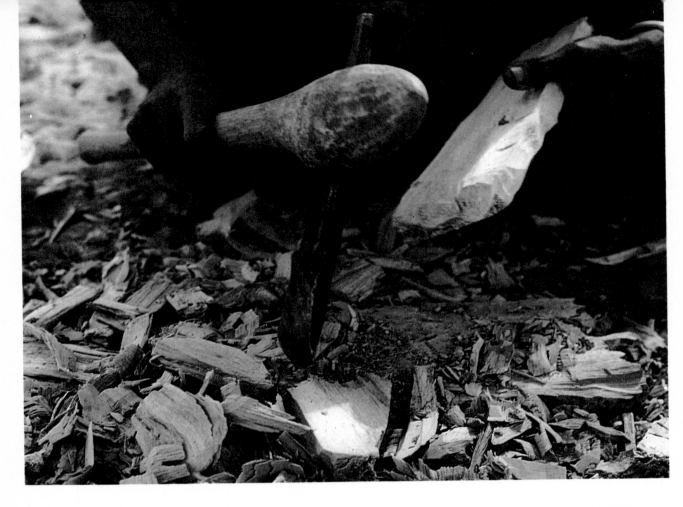

119

120

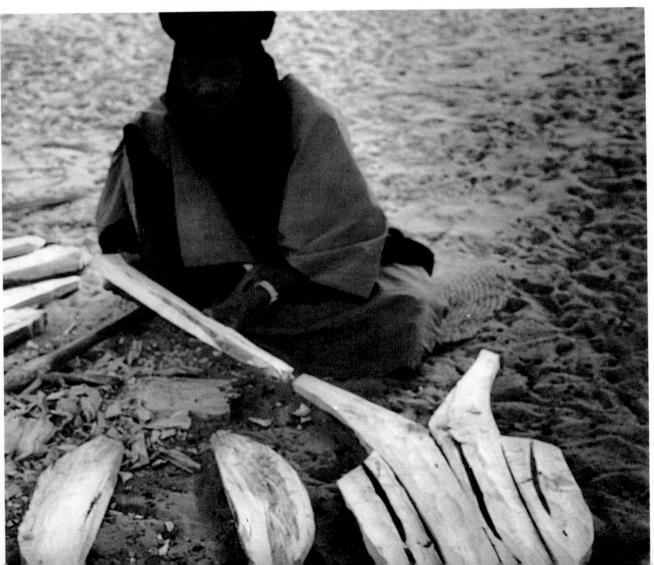

The best saddlemakers are the Tuareg smiths of the Aïr region. They have all settled around the city of Agades. The Tuareg, particularly those belonging to the noble castes, do not like handicraft work. These former lords of the desert have left the lowly chores of planting and drawing water at the well to their dark-skinned vassals, and no crafts have developed among them. But since they need all sorts of implements, tent pegs, weapons, jewelry, or saddles, they are dependent on the caste of the more-or-less-settled smiths. To them, smith means workman. The smith really does work iron. He makes tools and weapons. But it is also the smith who hollows mortars out of tree-trunks with an adze, carves spoons and wooden ladles, recasts Maria Theresa talers into ornamental silver crosses, and makes saddles. A good smith is able to practice a number of different handicrafts, but now a certain specialization is becoming evident.

The smith Haidara, of the Kel Owey branch of the Tuareg, lives, like his colleague Mohammed Umama, of whom we have spoken previously in connection with the cross of Agades, several miles from Agades. He owns some mat tents, and his workshop, which he shares with one of his brothers, is bigger than Mohammed's but just as simply arranged. Haidara, also an excellent silversmith, builds the best saddles, so I asked him to make one for me. For three full weeks I drove out to see him, to watch him, after he had finally succeeded in getting the necessary wood. He selected a large bush of the Euphorbia family that was as old as he could find. With age, the plant develops a trunk, although it never becomes very thick, so the backrest as well as the seat of the saddle must be put together from several pieces. But this pale wood is easily worked, and, above all, it is very light, this being its chief virtue.

The pictures at the left show Haidara in the first phase of the work. He does not use an adze, like the woodcarver in a previous chapter, but an axe. The cutting edge is parallel to the handle. The roughly hewn pieces are laid in the sand and fitted closely together. Haidara needs no pattern or template—he just relies on his sure eye. The crude object lying in the sand at the lower left has already taken shape in plate 121. As always, there was the same amazing revelation: the man managed to work the wood so finely with his heavy axe that it was as if he had used wood chisels, knives, planes, and who knows what other tools. He has nothing but an axe at his disposal. The horn consists of three parts, and the backrest of four. They fit together without gaps. Haidara fastens them together with wooden pegs, using neither glue nor nails. He would surely think it unworthy to use European nails, and he would regard such work as clumsy and imperfect.

The horn, the seat, the backrest, and the braces under the seat are worked so exactly that they can now be put together like a puzzle. Parts are padded with goatskin, and the various individual pieces are held together with strips

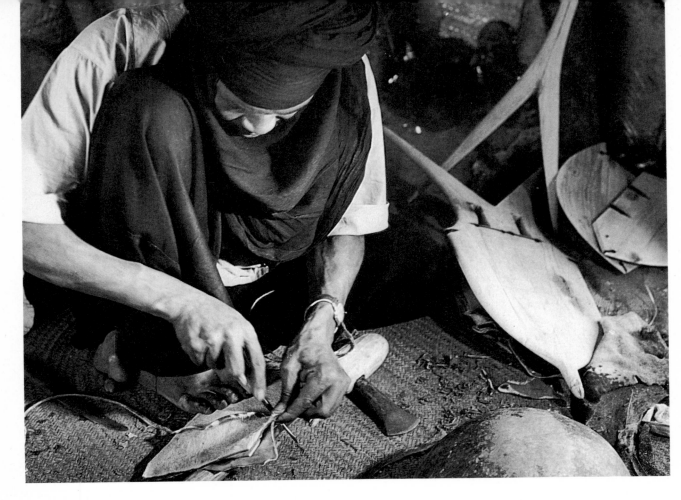

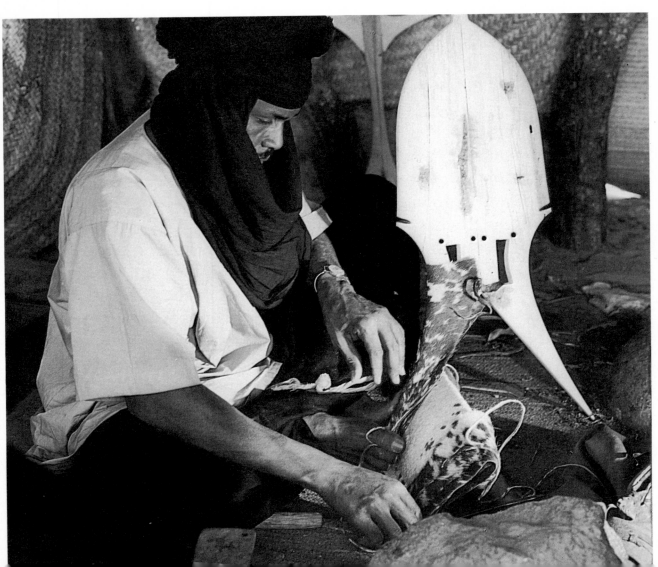

of skin. The smith himself cuts out these goatskin strips with a sharp knife. Other pieces of skin are closely trimmed with the same knife on an overturned earthenware bowl.

The two braces that will later support the left and right side walls of the camel stool are covered with skin (picture at upper left). The edges of the seat are also covered with strips of skin. Where it is not possible to wrap the wood, it must be glued. For glue, the saddlemaker uses only a gummy millet paste. Thus the underlying structure of the saddle is made, and is shown below, but the wood and all the strips of hide are later covered with leather, and will be invisible.

First the horn is covered with red goat leather. It, too, is glued on with millet paste, and then it is pressed down and polished with a long smooth stone that works like a bookbinder's creaser. The horn is ornamented with a few

123

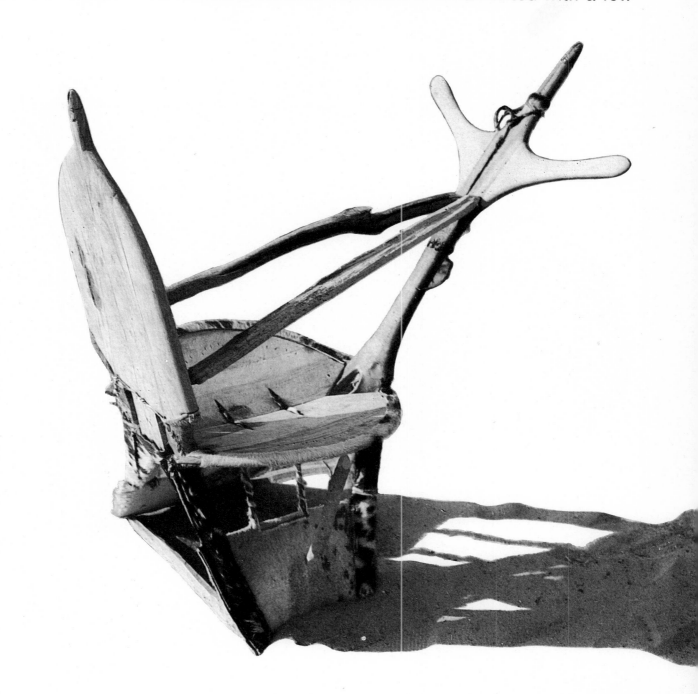

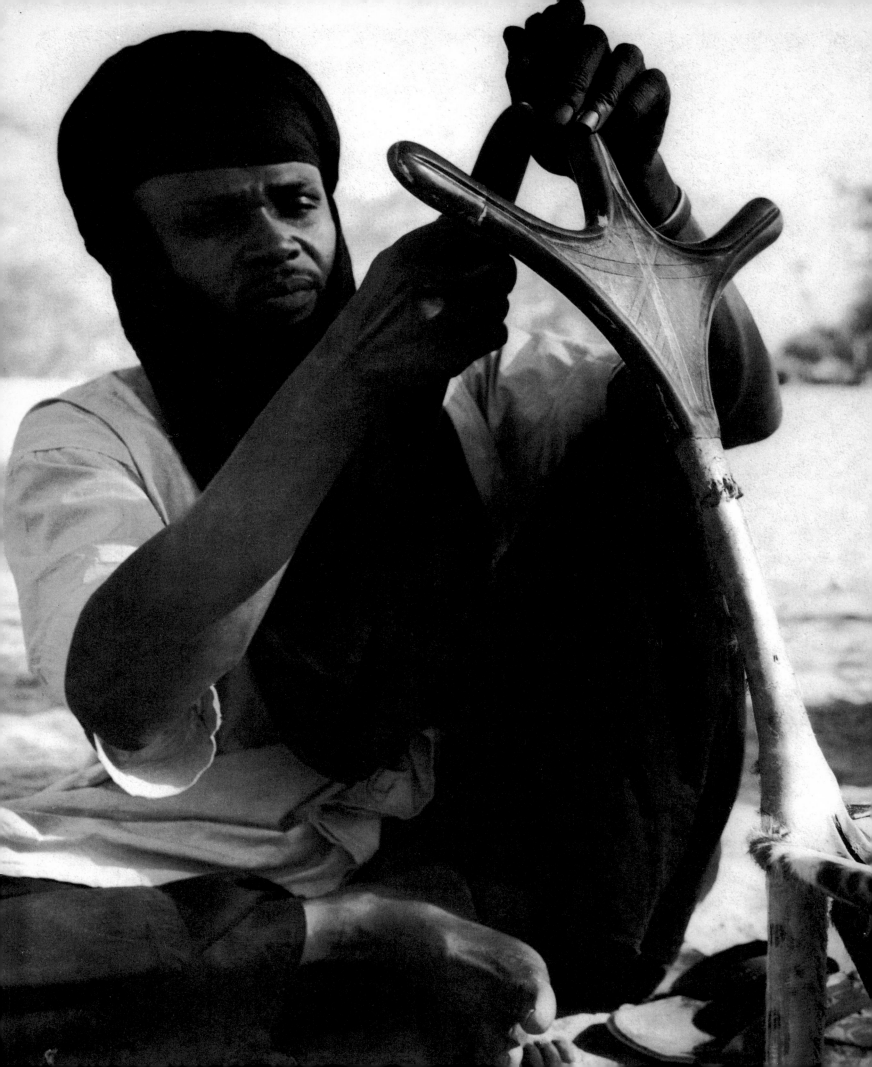

simple linear decorations. It takes several days before the entire saddle is covered with red leather, and Haidara goes over the glued spots again and again with his creaser. Finally the prongs are sheathed in sheet brass, and the outside of the backrest is particularly beautifully decorated. Thin strips of embossed and perforated silver and kano-green leather are glued on. The horn, so characteristic of the Tuareg saddle, is not a handle. As an awkward beginner I once broke one of these horns because, frightened by an unexpected move of the animal, I braced myself too hard against it while the camel was lying down. The horn is actually a decoration and a symbolic directional signal. The finished saddle is astonishingly light, thanks to the type of wood chosen.

Thus, in a construction period of three weeks, this rahla was made with only four tools: an axe, a knife, an awl, and a polishing stone. When it was not too hot, Haidara liked to sit outside in this wilderness on his mat under an acacia tree. At midday, when the sun became a plague, or the wind was blowing too strongly, he withdrew again under the roof of his workshop, where his brother was working with silver and wax with an assistant. The lifestyle of these smiths differed little from that of their forebears. They still used neither table nor chair, could neither read nor write, and usually ate with their hands. But there was no reluctance to accept what suited them from new things that came along. They wore European wristwatches, they went to the Agades airport to look at the four-engine plane that brought the mail twice weekly, and they went not unwillingly to the open-air cinema of Monsieur Boudon. At the cinema they admired the heroes of a sentimental Hindu film, or eagerly learned, from a dismal sex film, a horrible war movie, or a hair-raising western, the ways of the white man in far-off lands. Haidara also earned enough money to have become long accustomed to the cigarette. Well, a book could be written about those problems and influences alone.

Perhaps one finds it strange that Haidara needed three weeks to build my saddle. But one must not imagine that during these three weeks he worked an eight-hour day. In his mind, he would have been foolish to do that, and he could not understand my impatience. He could be neither pushed nor rushed. He had to let the glue dry, this was missing, that was missing. There were days when he felt no desire to work. There were other days when he had even less desire to do anything. Friends entertained him, the windblown sand was too disrupting, he had to buy a goat or visit the market, or he had to discuss important matters with relatives.

Eight to twelve and two to six? It is completely unthinkable to expect anything like those working hours. Haidara is not the only saddlemaker, of course, since the demand is great, even though a good saddle will last a rider a lifetime. There is no danger that the work will run out—it will always remain handwork.

Although commercial airliners now hop over the Sahara every night, trucks have been bumping over the roads for decades, and oil now flows through the pipelines, the caravans have not stopped plying their ancient routes. They still move calmly through the endless desert. Bringing up the rear, the pack animals bear salt, millet, and dates, and in front ride the Tuareg on their pale riding camels. They sit regally, garbed in their flowing gowns, in the rahlas, the magnificent saddles. With a singular dignity, the camels set their broad, soft soles the size of soup plates into the sand, day after day. Hour after hour they stride blinkingly along, putting one leg in front of the other, always in the same rhythm, and the proud, self-confident riders move their torsos in the same rhythm, always back and forth. So the caravans move along, each day like every other, and Allah grants them no shade. The caravan is timeless, and its procedure has never changed because it has always been right. It is an amazing and impressive sight to see a caravan move past; it always reminds one, whether one wishes it or not, of Biblical times.

1.

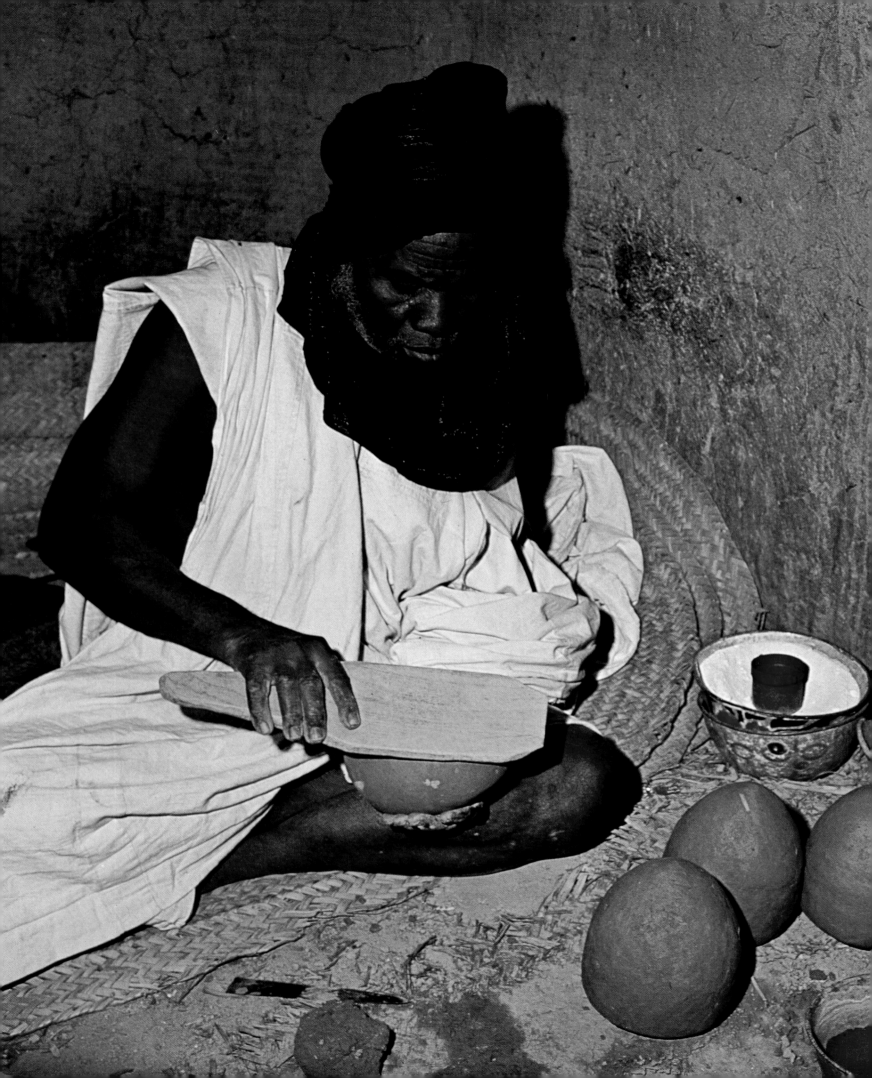

Decorated Parchment Boxes

Everyone who has ever crossed the Sahara as a tourist on the Hoggar route must have noticed prettily decorated parchment boxes. They are found as close to the Mediterranean as Ghardaïa, but more often in the markets and shops of In-Salah, Tamanrasset, and above all in Agades. In Hausa, they are called *battochi* in the plural, and *bata* in the singular. To be precise, this is only the designation for a very particular form of these boxes. So that you can properly understand what objects are being discussed in this chapter, turn to pages 174 and 175. At the left are several of the different forms—not all of them by any means—of these boxes made of untanned hides, and at the right is a bata about six inches high that resembles an ostrich egg.

These boxes are made only in Agades. At present there are still families of artisans who are masters of the art, and they all live together in the Obitara quarter in the southern part of the city. The family chiefs are Marabouts, devout men who know the Koran by heart and have the ability and privilege of copying the pages of the Koran. They are blacks who speak Hausa. Whether they were originally Hausa is impossible to determine due to the racial potpourri of Agades. With the help of my friend Bernard Dudot, long resident in Agades, I was able to meet a seventy-year-old master by the name of Andillo. He was the most respected of the boxmakers, and seemed to exercise the role of guildmaster. In the picture at the left, he is shown forming clay models with a board that is hollowed slightly on the underside. When the models are dry, they are covered with skin.

Andillo proved to be very approachable. He was friendly and he enjoyed displaying his talent. In order to observe all phases of the operation, Dudot and I drove to the Obitara quarter at regular intervals for about three weeks. A pleasant, cooperative relationship developed: we squatted side-by-side in

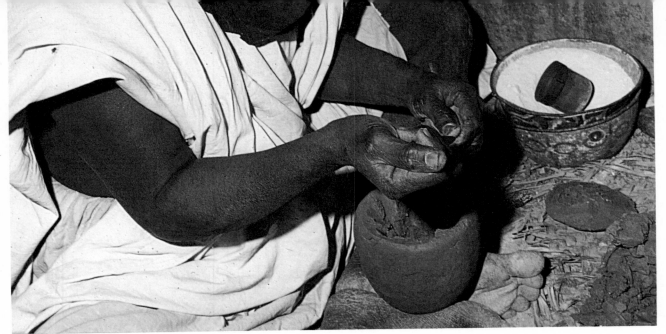

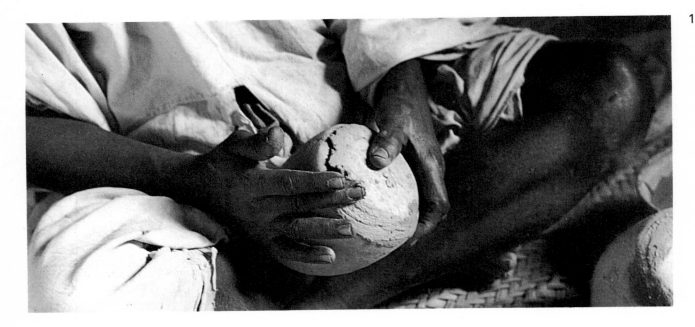

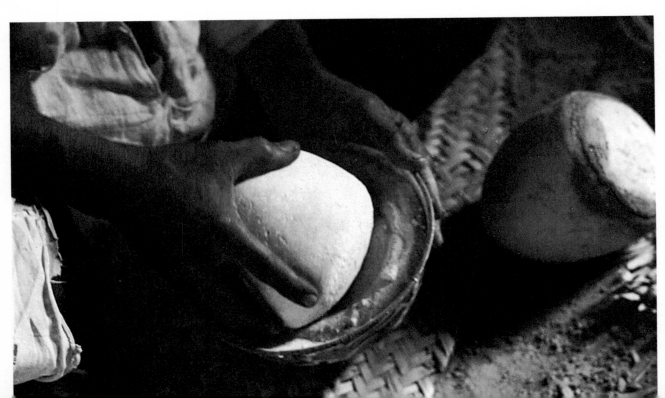

front of the craftsmen, watched, discussed, asked questions, and sometimes tried things ourselves. Bernard Dudot took notes for me, jotting down every detail, and I took pictures. I took color, black-and-white, changed lenses, got annoyed with the flash apparatus that occasionally did not work, and, as usual, used up too much film.

So now, with the pictures in hand, the technique is to be described; for this I have relied very heavily on Dudot's extensive notes. As was already mentioned, Andillo first forms the clay, as the color picture on page 164 shows. He then takes adequately purified clay, mixes it with water, and forms the mixture into balls with his palms. Now he takes one of these balls in his hollowed left hand and works it with a little wooden board that has been carved into a slightly conical shape. He has several such little boards with different varieties of concavities, and he alternates them according to the desired shape of the box. He moves the clay skillfully, and with little blows he slowly forms a very symmetrical shape about the size of an ostrich egg.

The next operation is shown in the top picture at the left. In order to be able eventually to loosen the skin that will cover the form, the form will need to be shattered. By then it has, of course, dried almost stone-hard, and would be difficult to break unless it were hollow. So, as soon as the clay has dried a bit and will no longer lose its form, Andillo cuts off the bottom. In the top picture, this piece is lying between Andillo's foot and the bowl. Now the master hollows out the form with a knife, or with only his fingers, until the walls are about an inch or so thick.

The middle picture shows how Andillo carefully puts the bottom back on again and coats the seam with clay. He does this so exactly that without lifting it it is impossible to tell whether a form is hollow or not. Now he lets it dry for an entire day.

The way the craftsman sits at his worksite is also clearly visible in these pictures. He is able to last for hours in this position, without stretching his legs once.

Now, before the form can be covered with the skin, he rubs it with a chalk powder. First he turns it several times in the tin bowl filled with the powder, and afterwards rubs the chalk in vigorously with his flattened hand. That is shown in the bottom picture at the left. Andillo explained to us—with the help of an interpreter, for he speaks scarcely a word of French—that this process was necessary to degrease the clay. Should one not do this, the skin would stick to the clay, and it could never be loosened. However, only the forms for the larger boxes the size of ostrich eggs are hollowed out. For smaller forms it is apparently not necessary. In order to loosen the small skin boxes from their clay cores, the workers tap them against a stone slab. They tap carefully and exactly, as if they wanted to crack the shell of a hard-boiled egg; sometimes they use a cudgel. As soon as the cover is loosened, the only thing that

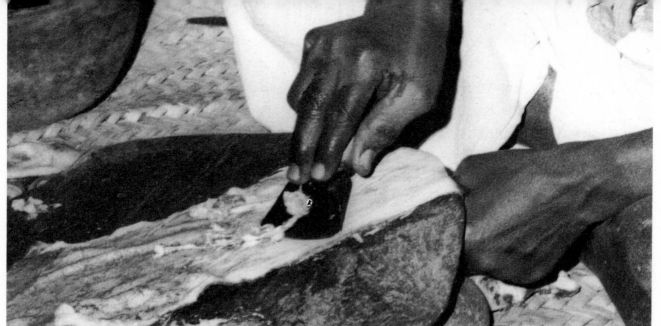

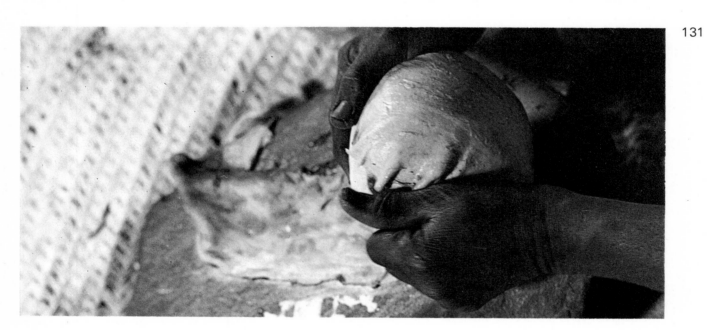

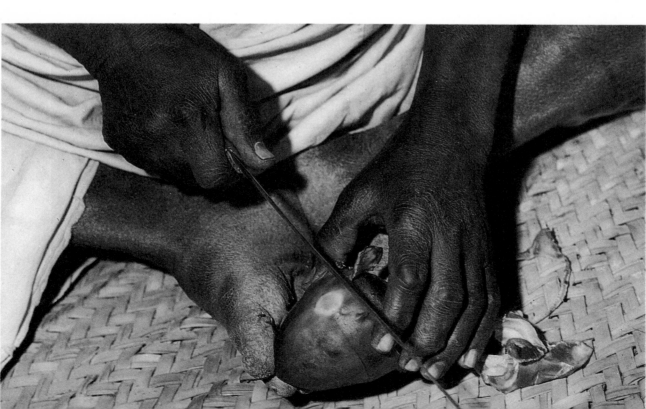

remains is to break up the clay completely, scratch it out, and clean the inside with a rag. The dried, but not tanned, skin of an ox or a camel is used to cover the form. Sheepskins or goatskins are not suitable because they are too thin. When I first held a bata in my hand, years ago—not somewhere out in the middle of the Sahara, but in Agades itself—I was told that it was made out of the skin of a camel driver. Since the skin is scraped so thin that it appears translucent, I, like many others, simply believed it, until I finally had the opportunity of watching the boxmakers.

Skins with the hair already removed had been soaked in water in an earthenware jar for about two or three days. Andillo takes a piece of this strong-smelling skin from the jar, wrings it out like a piece of laundry, and lays it out on a flat stone that has long since been polished smooth by decades of use (top picture at the left). The skin is carefully cleaned and scraped with a trapezoidal knife with a thin, sharp blade. The last remains of the skin are cut away, and all traces of fat and flesh must disappear. The knife is pushed along just as evenly as the blade in a razor. Andillo raises his hand slightly along the edges of the skin, so that the blade can cut away anything superfluous. The old man handles his knife so skillfully in the scraping that the borders of the skin become almost as thin as tissue paper. Later, when they are glued together, there is hardly any palpable unevenness.

Now this sticky-soft thin skin, which will harden to parchment, is modelled over the clay form. First the actual box is covered, then the lid. So first I shall describe the work on the bottom section (center picture). The skin has been cut down into a strip four-and-a-half inches wide, and as long as is needed, so that the ostrich-egg shape can be wrapped around its middle with one strip, for the time being. It is pressed on very carefully, and the folds, which are unavoidable because of the conical form, are smoothed over. The uncovered bottom is slightly convex. It is now covered with small remnants of skin that will stick fast together, in order to make a somewhat thicker and more solid bottom for the box. Then a circular second piece of skin is put over it. As mentioned above, the edges are scraped so thin that after a drying time of about two hours it is almost impossible to tell that the box consists of two parts. The edge is trimmed while the skin is still wet. Then the entire form, the bottom half of which is now covered with skin, is once again rolled in chalk powder. Now the skin for the lid of the box is laid over the point of the egg shape. It is pulled down over the form, stretched, the folds are smoothed, and then it is carefully checked to make sure that it is smooth all over. It must overlap the skin already applied by almost an inch. Now it is bound on with a string made of palm-leaf fibers, and the whole thing is set aside to dry for about an hour. But before the skin is completely dry, the edge is trimmed so that the cover overlaps the box by about a half-inch (picture at bottom left.)

The continuation of the work is taken over by the women. It is their job to decorate the boxes, and they do it while the skin is still tight on the clay forms. This process is shown in the pictures on pages 171 through 173.

Now we are dealing—to anticipate a bit—with a batik technique. The ornamentation is applied with wax. After the boxes are dyed, the wax is removed, and the figures appear light against a background dyed dark red. First Mariama, Andillo's wife, has to make the wax threads. She sits on the right in the picture opposite. She lays a smooth-as-silk, slightly curved board, which is always used for this purpose, across her knees. With the help of a piece about four inches in diameter from a broken calabash, a small wax ball is first rolled out into a little worm about finger length and the thickness of a cat-o'-nine-tails stalk, and then into arm's-length threads of equal thinness. Since both the board and the calabash shell are curved, a long wax thread is produced by pressing, rocking, and pulling between these two convex surfaces. The thread is then placed in a basket. The women sit out in the sun for this work, because the wax remains supple in its warming rays and can then be easily worked. Warm wax threads can be pressed onto the chalky skin, they stick, and there is no danger of their falling off at the wrong moment. It is also easy to remove them again later.

Mariama sits on a pretty mat, holding the bata to be decorated between her knees. She guides the wax threads with her right hand, laying them down artfully, and pressing them on gently with her left. They are later removed with a fingernail. As a rule the work begins precisely at the point of the egg shape, as shown in plate 135. Geometric figures, spirals, crossed lines, circles, and little triangles are made. Naturally the women do not predraw their designs and they do not use any kind of pattern. The designs often look alike, of course, and yet no box is ever quite like another. Each one is always a new, remarkable work of a true art-craftsman. The wax work on one box takes about one hour.

The boxes are next dyed. In a wide earthenware jar whose edges have been broken so that a sort of bowl has resulted, there is a half-inch-deep puddle of the common red color that is also used for dyeing leather. It is obtained from the stalks of sorgo, a kind of millet. The parchment box is placed in the bowl, and then the dye is ladled over it with a spoon, just as a cook might baste a roast. The process is repeated several times at brief intervals. After a scant hour, the color has already dried sufficiently. Now the wax threads can be removed easily, and the work appears for the first time in all its beauty. The cover can be lifted off the box only after the clay mold is shattered. A round cudgel is used for this. Now one can understand why the form was hollowed out. Here, as everywhere, there are, unfortunately, very great differences in quality. In the oases of the northern Sahara I have seen battochi with totally slovenly and miserable decorations, as if the wax threads had been stuck on in

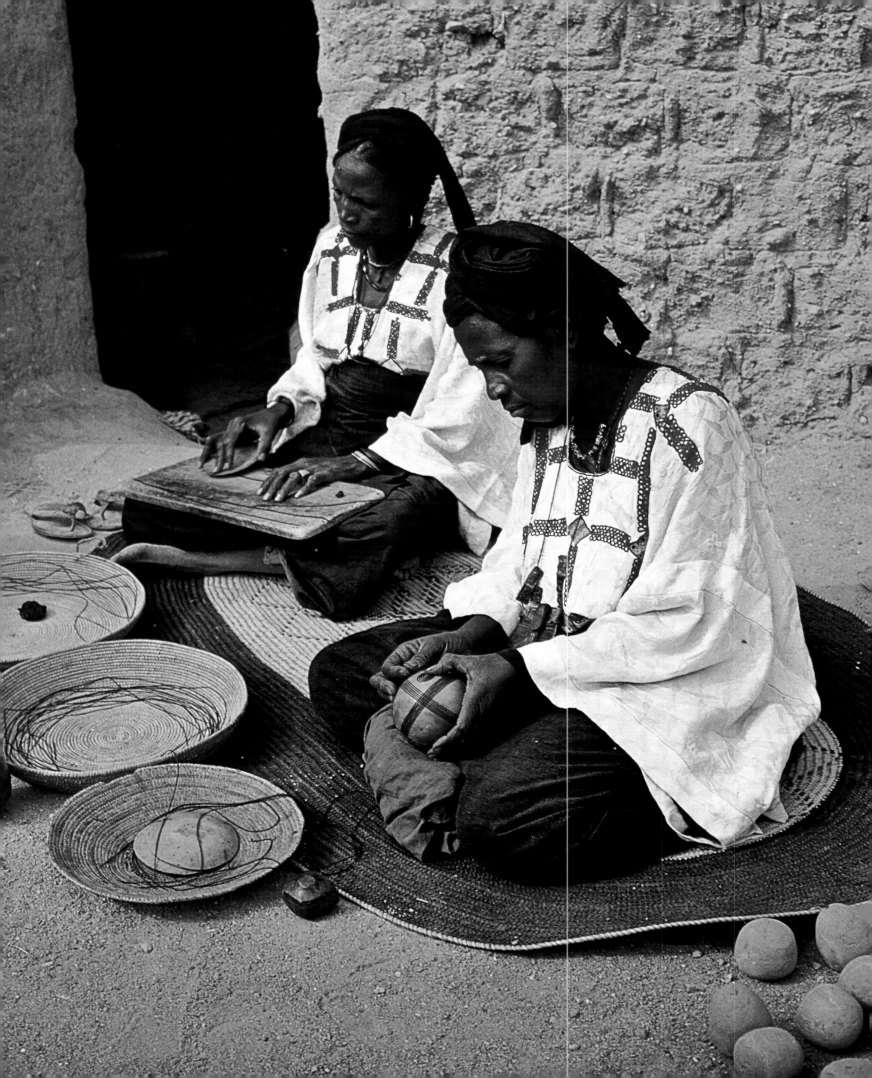

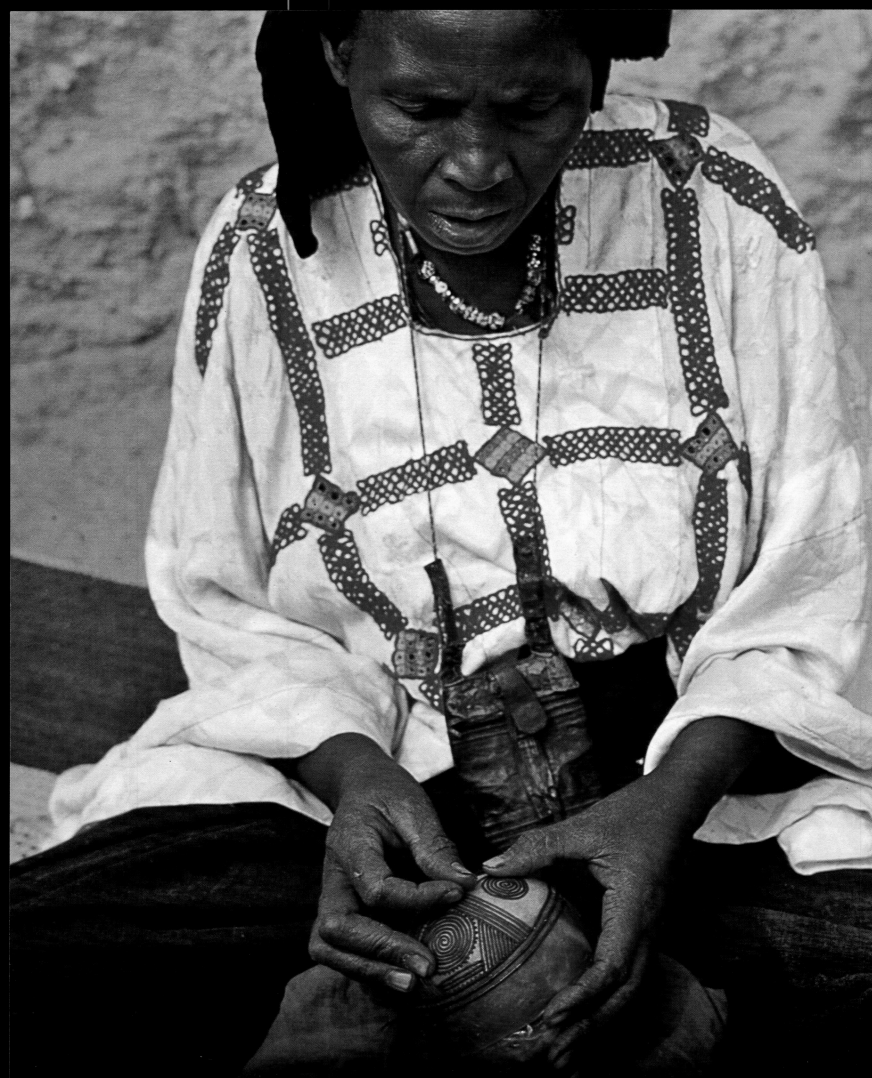

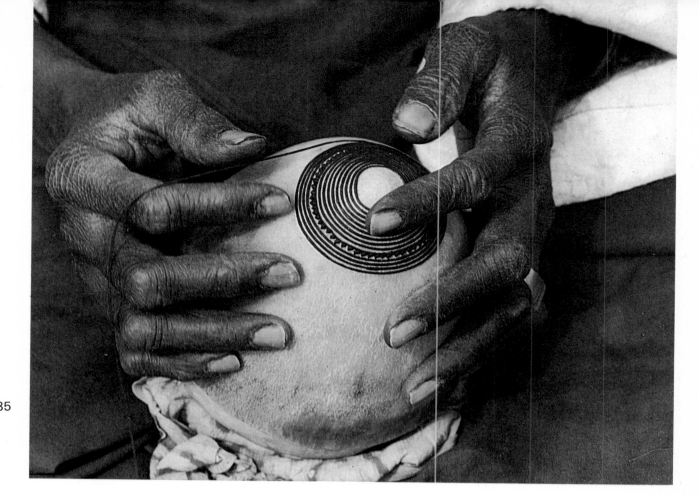

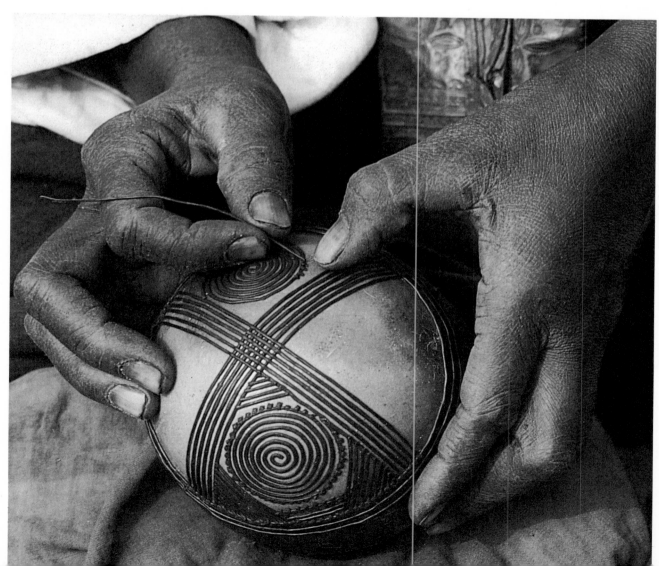

the greatest haste. This is because, it was explained to me, the Arab traders from the north pay so poorly.

The two women photographed, Mariama and Nana, had really mastered the art. Mariama is the wife of Andillo, and Nana is her younger sister. The parchment boxes pictured here were all decorated by them. Six different forms are recognizable, and each one has its own name. The box with six angles (lower left) is called, in Hausa, *kunkuru,* which means "turtle"; the rectangular one (above it) is simply *sanduki,* which means "little box." They are all little boxes and containers; they are useful for all sorts of things. They are perfume boxes, or they contain cosmetics, perhaps tobacco, and silver jewelry, too.

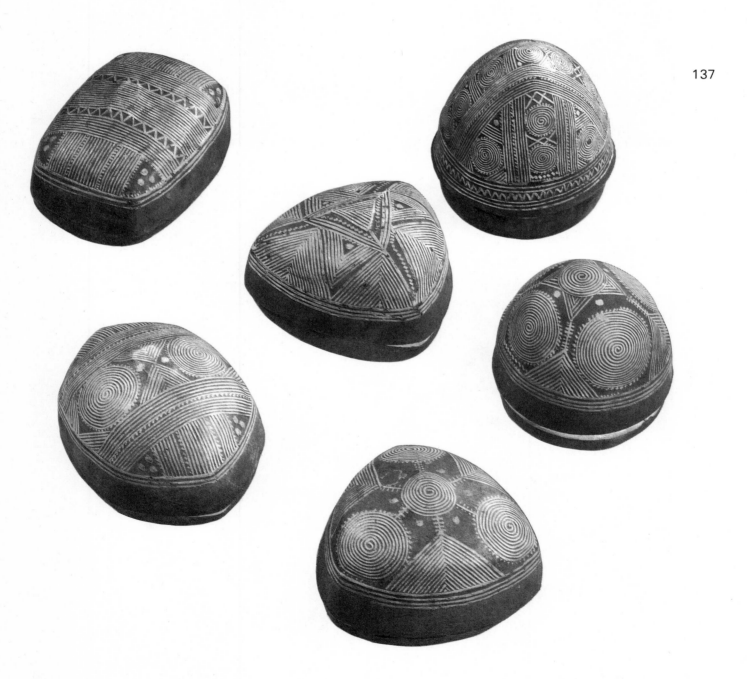

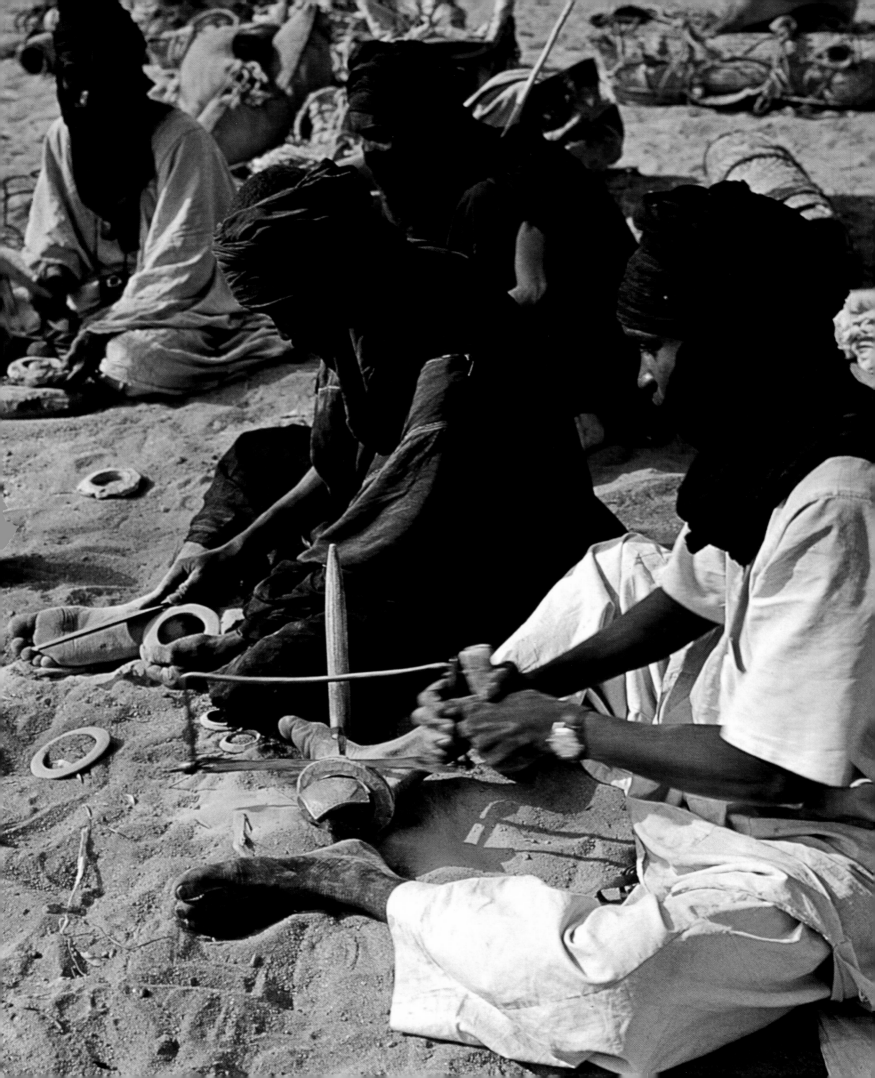

Bracelets Made of Stone

39

The Tuareg men of the southern Sahara love to wear beautifully polished stone bracelets on their upper arms. They wear them as jewelry, but at the same time they expect them to offer magic protection against evil spirits, and Mohammed Umama, the smith, is convinced that it cancels out evil curses. An arm-ring that has been worn for years is no longer a deep black but has taken on a wonderful greenish patina of age from rubbing, from the indigo-dyed cloth, and from the perspiration of the owner. The stone is soft as silk to the touch, like polished marble. Frobenius wrote of agate bracelets worn by the Tuareg, but in fact they are only made of a greenish slate that feels like soapstone.

Again with the help of Bernard Dudot, I got to know a young Tuareg smith who lives in the remote Abardac oasis in the Aïr mountains. His family had long specialized in the making of stone bracelets. In his village I saw the worksites, little slabs of stone, and broken bracelets, and I was also offered bracelets for sale. But, unfortunately, no one was working at the time because there was a dearth of stone. Sometimes these smiths are also settled farmers who become caravan folk and sell their bracelets in markets throughout the Western Sudan. The raw material comes from the Adrar Aré massif at the eastern edge of the Aïr. First, the people go far to the east, for about three or four camel-travel days, until they reach their quarry. There they remain for several days, break off slabs, and break these into pieces about five by ten inches and about two inches thick. Then, with several camel-loads of these stones, they set out on their way, usually not homeward but in a southwesterly direction to Agades. The stones are worked on the long evenings and at every longer stop where there is good pasture for the caravan animals. When they reach a town, they already have a number of

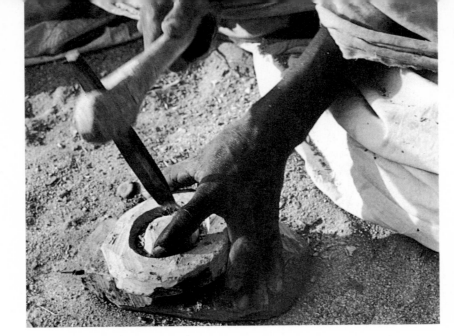

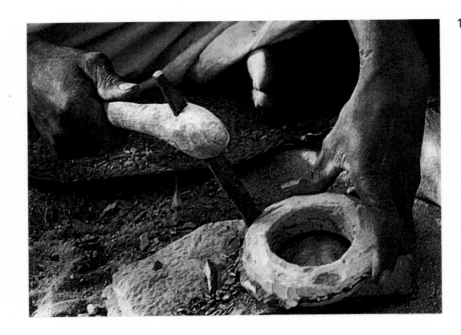

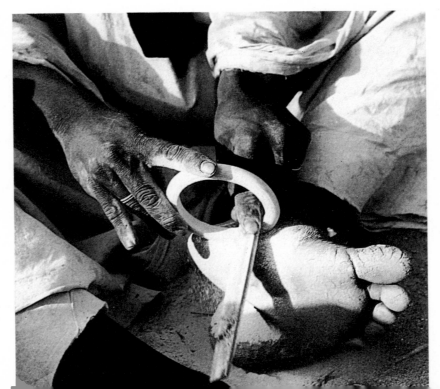

bracelets, and there they offer them for sale to Tuareg wandering about town. But the little caravan only stays in Agades for a few days and soon moves on. The goal is the city of Dakoro, north of Maradi, in southern Niger. There, in this important marketplace, where both nomads and settled people meet, one can get at least twice as much for a bracelet as in Agades, so it is worth the hard, week-long trip.

One day the young smith from Abardac appeared at Dudot's house in Agades. That was a double windfall for me. Moktar, who was only twenty-two years old, had attended a little wilderness school and spoke rather decent French. He was one of the rare young people who did not leave his village and who had not given up his profession even though he had learned to read and write.

In this respect he was almost unique. He told us that he was enroute to Dakoro with a few other people, and that their caravan camp, which we never would have found in the wilderness without his help, was only fifteen miles from Agades. That is how I got the pictures on these pages. The little group of smiths intended to rest for a few days in the shade of some pitiful thorn bushes. The packs with the provisions, the stones, and the almost-finished bracelets lay about, and a few mats located the sleeping-places of the five people. The community teakettle hung over the hearth from an iron tripod. The camels were nowhere in sight. No house, no tent, hardly any shade—a simpler worksite would be difficult to imagine. Moktar, who had gone back to sit with the others immediately after we arrived, was proud to show us their techniques. Moktar, the youngest among these artisans, was without doubt the most capable. He was their recognized leader, and he also took responsibility for the caravan.

The pieces they had carried from the quarry are cut in half. The stone is so soft that it can be sawed up by any bit of sheet iron into which a few notches have been filed. The resulting pieces are about four-and-a-half inches square. One of these is then roughly cut into a round shape with an adze. Then a deep groove is cut into it from both sides with the same tool (top picture at left). As soon as the grooves meet, the core naturally falls out, and the result is a crude bracelet called a *maraba*. If flat bracelets are desired, the thick maraba is cut in half, and two flat bracelets result.

In the center picture, a bracelet with a circular profile is to be made. It is worked with a slightly finer adze and then with a soft file. As is so often the case, the handcraftsman uses his feet as a vise. Bit by bit the bracelet gets its final form (bottom picture), and from the sure sense of the craftsman, if he his not a bungler, it becomes completely circular. In earlier times, bracelets were made without the help of European files. They were worked with even smaller axes, and surely more carefully, and in those days they were presumably polished with sand and ashes instead of the much more convenient files.

As soon as all the irregularities are smoothed off, the bracelets are washed clean and rubbed dry. They are still very pale, as can be seen in the picture below. Then each bracelet is vigorously rubbed with peanut oil. The oil has to penetrate deep into the porous, soft stone. The color picture on page 183 shows the next step; the bracelets are blackened. After each one is oiled, it is hung from a stick and held over a straw fire for a short time. When the oil catches fire, the craftsman waits a few more seconds and then rubs the bracelet energetically with a rag, polishing it until it glows with a soft black sheen. But the bracelets' beautiful, shining, silken patina is attained only by wearing.

A good worker can produce almost twenty bracelets in a day. Of those, he breaks about three or four through carelessness or wrong strokes of the adze. There are losses due to transport, too, for the rather delicate ornaments are much more fragile than one might suppose. This fragility contradicts the idea, mentioned in Saharan literature, that the bracelets protected their wearers against sword-blows in man-to-man combat.

At the time, I asked Moktar (picture at right) to make me a sample from each of the various phases of the work—in other words, a series from the raw beginning to the final product, as they are shown lined up on the mat below. I think the young smith never completely understood why I was buying half-

143

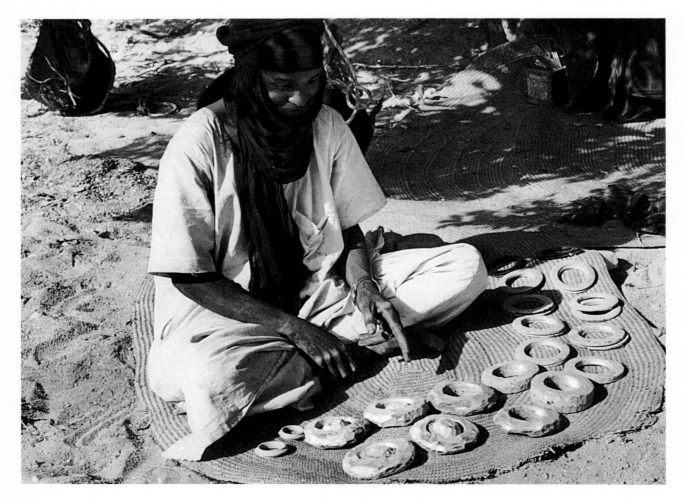

144

finished bracelets, and I discovered that, with him, as so often on other occasions, a work only begun costs just as much as the finished product. I prevented him from finishing the bracelet he had begun, argued Moktar, so he could not sell it later. He thought that I was very stupid not to understand this immediately. If I took the stone away before he had finished, he lost the bracelet, and so I must pay him as if it had already been finished. The working time saved was not taken into consideration.

There are four different varieties of bracelets, two of which are shown below. The rounded bracelet in the middle is called *abambay* and is usually worn by the lowest caste, former slaves. The other two, with the ribs on the inside of their flat shapes, are called *agosrer.* This means "the most beautiful of bracelets." The bracelet on the left, once worn by a young man, has simple scratched decorations that I did not often see. The bracelet at the right has certainly been worn for decades, as can be seen from the polish and the marble-like patina. Yet a third form exists: imagine the bracelet at the right without the inner rib. It is completely flat, like a hat brim. The fourth style is thick, with two deep grooves between three ribs. I should also mention that the smiths of Abardac also make pots out of the same stone. The women store cosmetic salves in them.

14

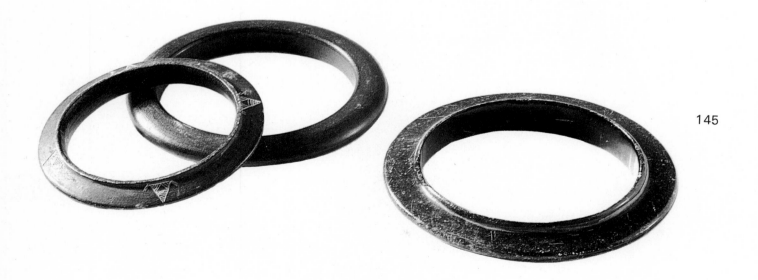

145

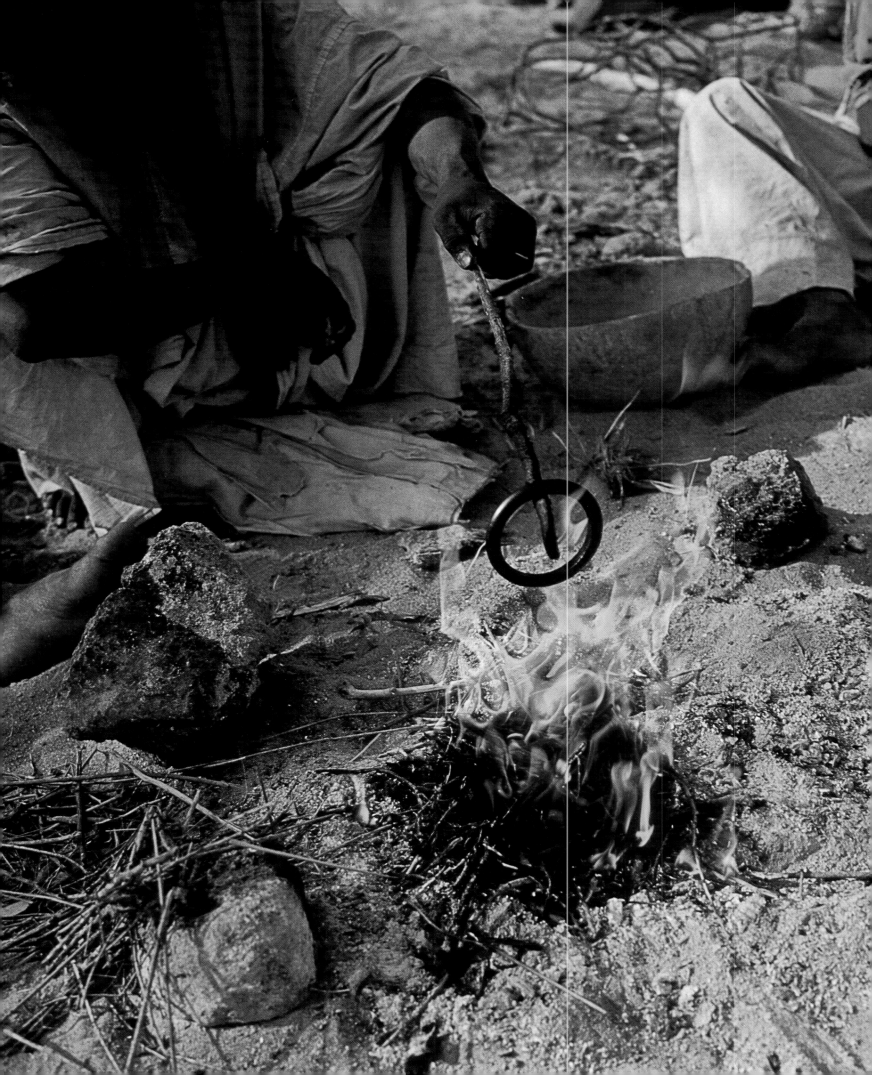

47

The old Senufo woman in the picture opposite whiles away her time spinning, and she does it no differently than any other woman throughout the world. She has loosened cotton on the distaff, and she lets the spindle with the clay flywheel dance and pull at the cotton, which she spins into a more or less tight thread.

Less than fifty years ago in Cameroon, King Nachoya, leader of the Bamum and a well-known reformer, had 1,300 looms in operation, and his weavers were constantly trying out new patterns that the king himself had designed. In the spring of 1968, in northern Ivory Coast, I still saw many weavers at work and received the impression that weaving was a very widespread profession. In the little village of Waraniéné, a few miles from Korhogo, more than forty people sat at looms under the shade trees in the village square, and many of them were still youths. It was impossible to think that the craft could soon be condemned to extinction.

It must be worse in other areas. The ethnologist Himmelheber reported a blossoming weaving culture among the Dan in Liberia as late as 1958, but a few years later his son, who had gone to look up his father's old friends, discovered that they had all given up the profession. The reasons are easy to understand. An ever-greater selection of cheaper, bright, light European fabrics is sold at all the marketplaces. With ready cash, these fabrics can be bought immediately, whereas in the village the yarn must first be delivered to the weaver; then there is a wait until he begins the work, and still another wait until he is finally finished. It is so much simpler to go to a dealer. The material he offers is wide, and it is not necessary to sew together the six-inch-wide strips that are the only size produced by the African loom.

But happily it can be reported that a reaction is beginning to set in. In the

lands of the Western Sudan, increasing numbers of men are again wearing the voluminous, handwoven robes, *boubous,* which they put on over their European-tailored clothes. The heavy robes, woven in the country and rather expensive, are becoming a symbol for the wealthy. An African weaver could scarcely ask for anything better.

The photographs on these two pages show the preparations for weaving. The picked cotton must first have the seeds removed. The seeds are squeezed out with a round iron rod onto a flat stone or a board. Picking them out singly is very laborious. The rod is rolled back and forth under strong pressure, so that the seeds fall down in the front or at the upper edge, or are, at least, easy to pick out.

Then the cotton must be loosened. In the picture at right sits a pretty, light-skinned Fulbe girl in the woven-mat house of former herdsmen who have become settled. She is patiently plucking and loosening cotton with her fingers as tools. This is the oldest and simplest procedure. In other areas, the cotton is laid on the string of a small bow and the string is vibrated to loosen it. But in many places the flax-comb, brought from Europe, is in use. The balls of cotton are plucked apart with wire brushes of European origin. And only then can the cotton be spun. Although in most tribes the weaving is almost exclusively men's work, spinning is a task that is assigned to the women.

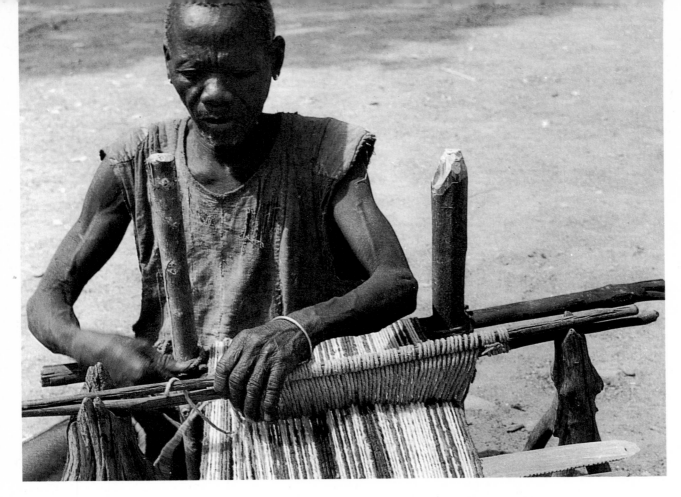

150

151

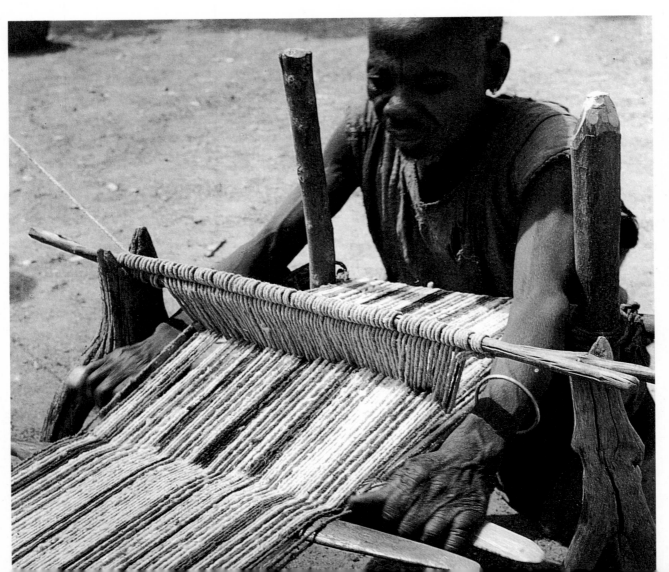

The treadle loom shown on page 195 is in use almost everywhere. But among different tribes in northern Cameroon I saw an even older weaving arrangement that used a firmly mounted horizontal warp, as shown in the pictures on the next few pages. The warp threads are strung between two sticks thirty to sixty feet apart, and the weaver slides forward along the warp with his weaving apparatus, which rests on two forked sticks. Thus, here the warp is stationary and the weaving apparatus is moved as the work progresses. There are no weaving implements. When threading the heddle, the weaver hangs every other warp thread in a cord sling, and he uses only a sword-shaped piece of wood to catch the initial thread (pictures at left).

The pictures on pages 188 through 193 were taken among the Doayos, an unimportant little tribe located in almost trackless hill country south of the Benué River, and to the west of the main north-south highway in Cameroon. Their woven strips are made of very coarsely spun thread dyed in the simplest manner. Since only the warp threads are dyed, the patterns run the length of the fabric. The strips are conspicuously thick, almost like rugs, so clothes could never be made out of them. They are used for more serious things. A bridegroom must give his father-in-law such strips as part of the ceremonial bride-price for a young woman. Ten years ago, the bride-price still amounted to two hoes, two earthenware jars, and at least two strips, as

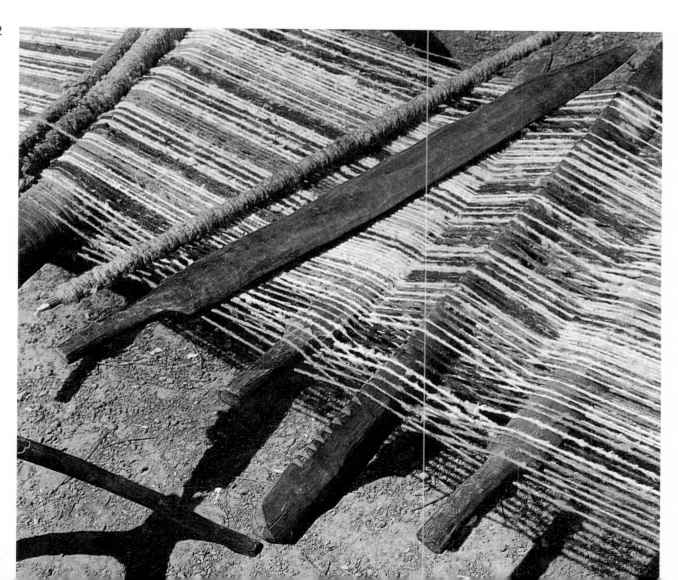

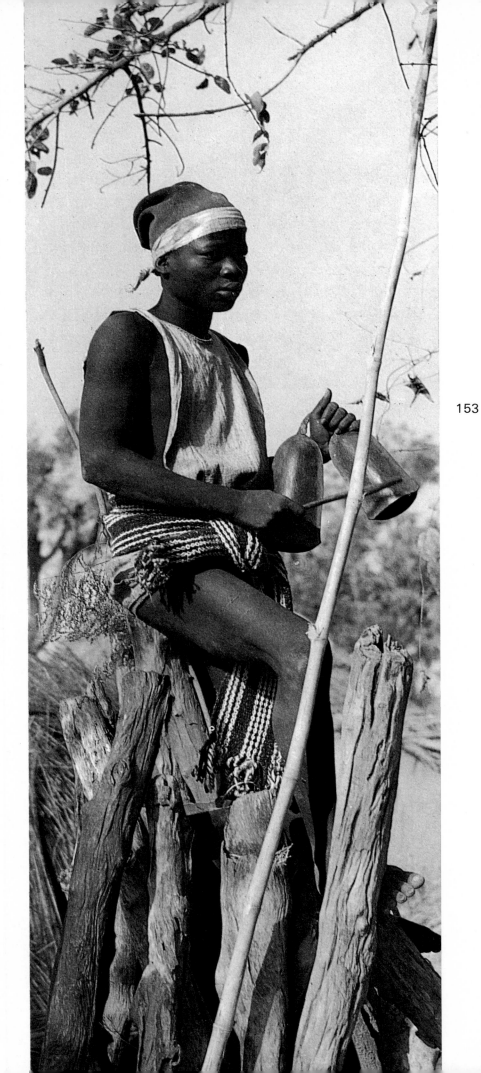

153 154

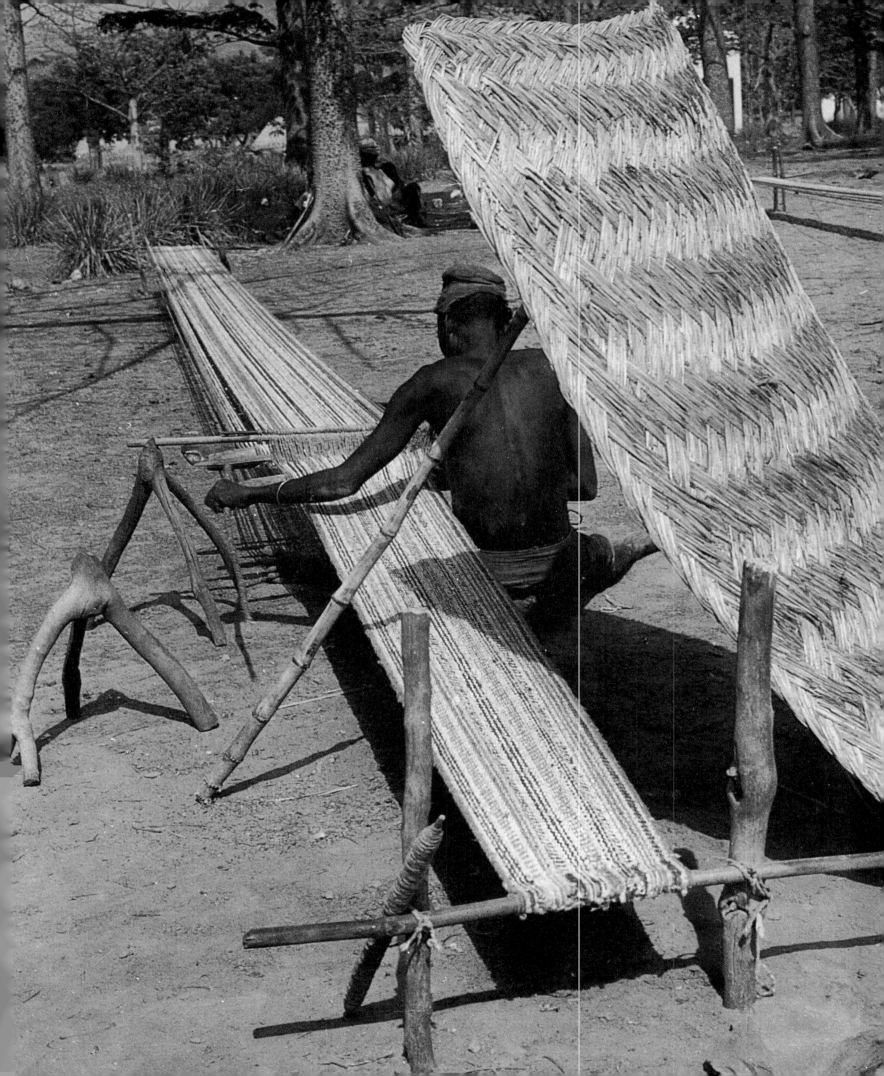

long and as wide as possible, that the father of the bride would then hide under the roof of his hut. And there they would remain until someone in the family died, because they serve little purpose other than to wrap up corpses, particularly that of the head of the household. The richer or more powerful a man is, the more cloth strips are used for him. I found another use for them. My wife made cushions for the garden out of the ones I was able to acquire from the Doayos before they were put to their usual use, and we covered an old deckchair with them. At the time, I was staying in the large village of Poli, and one day we sent messengers to two different villages in the area to summon the best dyers and weavers. They actually came, bringing undyed yarns and roots and herbs for dyeing. Encouraged by all sorts of presents and promises, they agreed to take part in a contest to see which group could produce the longest strip in two days. The people from Garé triumphed over those from Godé. For blue dye, they boiled a few little branches of an indigo plant. Thus they used no prepared, steeped colors, no potash, nothing else. They got red dye from a pressed root that they called *manguina.* This was boiled too. If they dissolved a few chunks of natron salt in this brownish-red brew, it turned yellow, and if in turn they mixed this yellow with their indigo, they got green. The yarn turned black if it was put in swampy soil for a few days. The weavers, who would relieve each other from time to time, always sat on the right side of the strip (looking in the direction of the movement of the work), and they sometimes protected themselves against the sun with a mat of millet straw (picture on page 191). For a shuttle they had only a long staff around which the yarn was wound in long diagonals. As a result of this diagonal winding, enough yarn could be released from the staff with a simple turn of the hand as it was pushed back and forth through the warp (picture at right).

Later, during a stay of several days at Fignole, a little village about fifteen miles from Poli, I attended ceremonies in honor of the deceased village chief. I could continue for pages to report all sorts of strange proceedings. There were circumcision ceremonies performed over the corpse, attempts to reawaken him, mourning songs, noisy processions, and the death-bells that a son, decorated with a corpse-strip, was ringing (picture on page 190). But this is not actually the place to talk about all those details. I would only like to explain how the strips were used on this occasion. The Doayos bury their dead in a squatting position. When I arrived in Fignole, a large pear-shaped bundle had already been standing under a woven-mat roof near the house of the deceased for several days. The corpse was in a squatting position, with arms close to the sides. The strips had been wrapped around the dead man and, because he had been important, twenty-four strips of varying lengths had been used. The number is accidental. The skins of four sacrificed bulls served as further wrapping. So an enormous, shapeless package

15

resulted, with only the head, wrapped in the soft skin of a black goat, sticking out in a ghostly way.

No one knows the exact origin of the numerous tribes who inhabit the hill and swamp country in northern Cameroon. The Doayos fall in this same category. It is assumed that these peoples do not correspond to the original population but immigrated centuries ago from the east and were later pushed by the Fulbe into areas to which access was difficult. If one could further assume that the use of these long strips in the cult of the dead is a remnant, a memory, of Upper Egyptian embalming (the meaning of which has been completely lost over the centuries), then this fact would be a nice building block in a thought-structure that should prove the eastern origin of these small tribes. But, unfortunately, this is only a theory proposed by a few ethnologists. I also found the horizontal loom with its fixed warp among the Voko, the Koma in the Alantika Hills, and also—although only once—in a very remote and mountainous region among the Matakam of the Mandara Hills. There, men's trousers were tailored out of the strips.

The usual treadle loom is shown in the picture at right. Here a Bariba tribes- man, from northern Dahomey, sits working. This system is in use in all the countries south of the Sahara. In some areas the weaving implements do not hang from a crossbar as they do here, but rather on a tripod, but this is not a major difference in technique. Further details of work with this kind of loom appear in the black-and-white photographs on pages 198 through 201.

The warp extends from the weaver's position out into the open square. This allows him to weave very long strips. The warp threads end in an enormous ball that sits on a board weighted with a stone. The weight of the stone keeps the warp tightly stretched. It is always pulled up slightly by the weaver when another finished section of the strip is rolled up on the crossbar resting in his lap. The apparatus consists of two shafts. Between two little boards are strung cords that have a loop in the middle. This is the "eye" through which each thread is drawn. The second, fourth, sixth, and so on—the even threads—go through the eyes of the front shaft and the odd ones go through the eyes of the shaft behind. These shafts hang from a roll, and at the same time they are connected to the two pedals, which are quite clearly visible here. By pedalling, the shafts are pulled simultaneously, one up and the other down, and then the reverse, alternately, so that they can shuttle through the angle thus created between the even and odd warp threads. The threads are then woven! As long as no warp threads are skipped, the usual linen weave results. This type of weave can be seen in every gauze bandage. Patterns result only when warp threads are skipped now and then accord- ing to a more complicated preconceived arrangement. That is, of course, done in Africa, too. The weaving is tightened with a weaver's reed, which can be seen in the pictures on pages 198, 200, and 201. It is pushed against the pat-

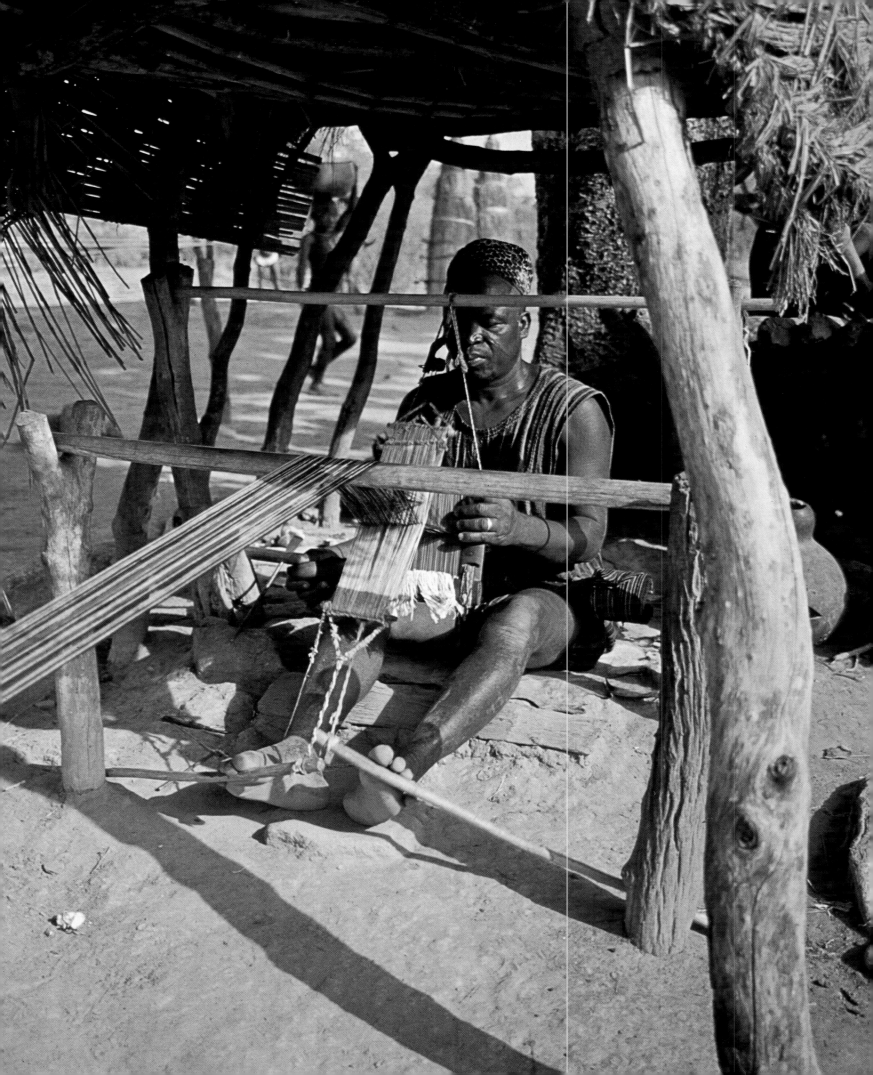

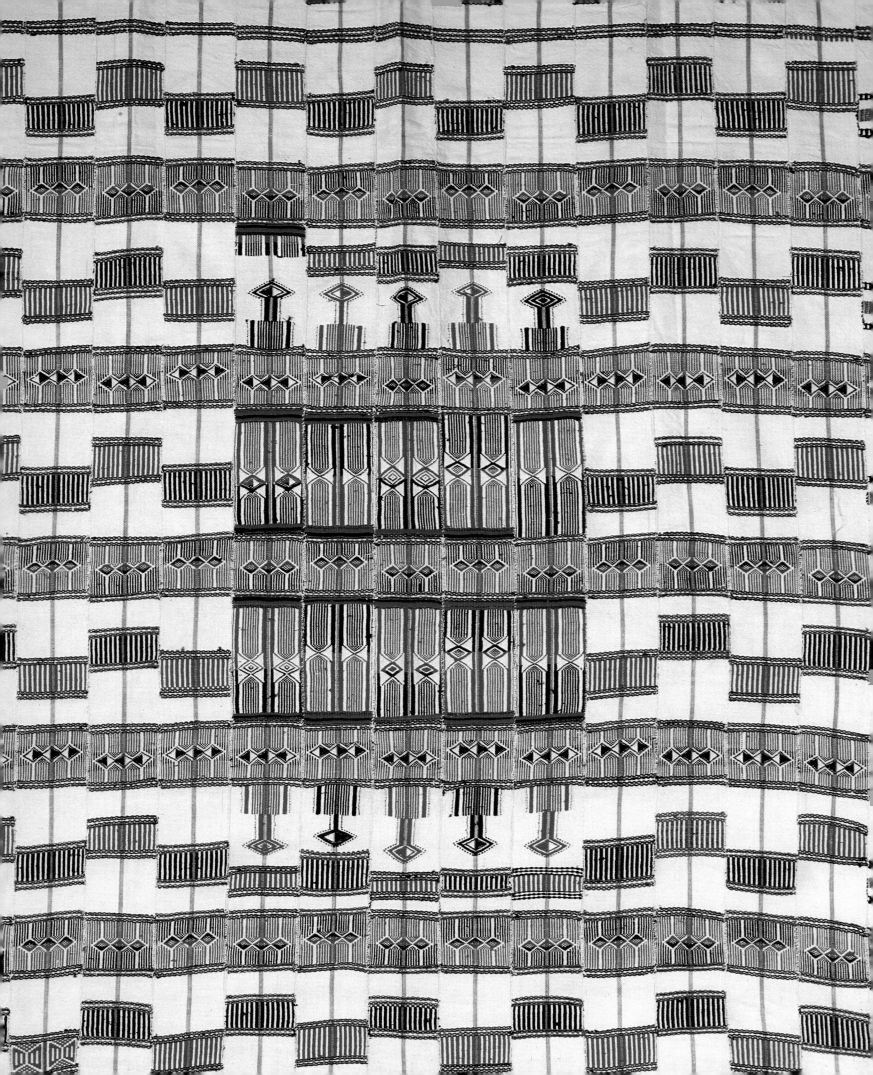

tern after every sequence. The ribs of palm leaves are used in the construction of the reed, since it is easy to drill holes in them. Hard plant fibers are set into these as separating ribs. Rods tied onto the sides stabilize the frame of the reed. So that it will have more strength at the forceful stroke, a heavy piece of round wood is often selected for the lower horizontal of the frame.

I must not forget to mention the shuttle. Sometimes only a simple woof-staff is used, but usually it is a shuttle that holds the roll of thread. The weaving apparatus is easy to take apart. In the evening, when rain threatens, or whenever the weaver feels he has done enough, he gathers up his tools, the reed, and the hanging apparatus. He rolls the warp into a skein and wraps a cord around the whole thing in order to avoid too much of a tangle. Only the wooden frame with the crossbars remains standing in the village square under the trees. There are also some weavers who carry their weaving equipment on their backs and move to other villages in search of work.

Striped patterns are made on these simple looms by different colored warp and woof threads. Sometimes they are just horizontal bands or longitudinal stripes, although by skipping and by heddling by hand, artistic patterns can be produced. From the strips, blankets like the one at left are made. The blankets are used to sleep on or to wrap oneself up in on cold nights. Some strips are made into clothing. A particularly beautiful example of weaving is shown below. It is a ravishingly decorated front of an enormous tent of the Iforas-Tuareg. The roof is made of red-dyed goatskins, and the front and back walls consist of many blankets, all made of six-inch-wide strips sewn together. The blanket at the left comes from the vicinity of Gao on the Niger. Actually, I had watched the weaver at work much farther downstream, in Malanville, and then learned from him that he had emigrated. But he still used the patterns that he had learned at home. In earlier times, black, indigo-dyed, or

158

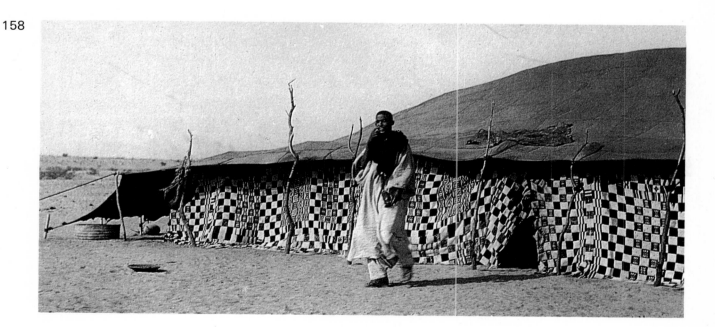

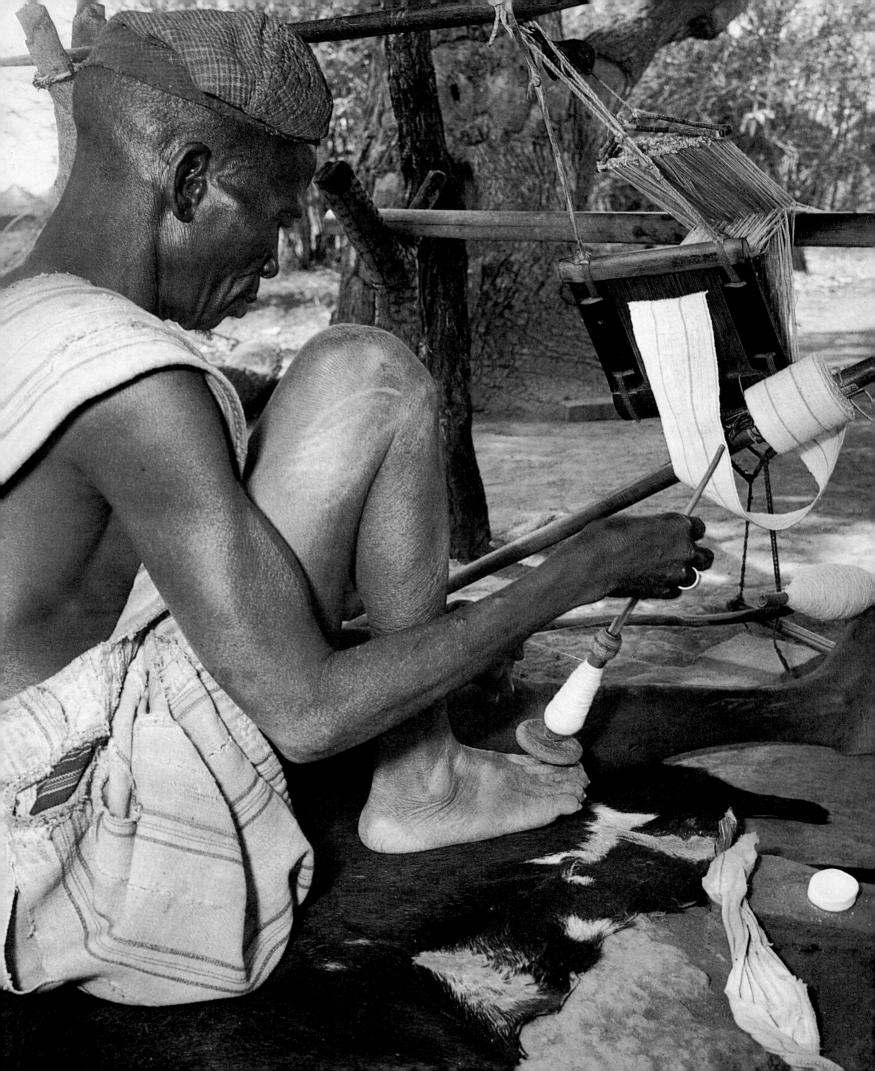

natural-colored yarns were used, but soon powdered European dyes were added to the stores. The weaving patterns are multitudinous, and they vary from place to place. Many of the patterns are very old and they are consciously differentiated with names and designations. In order to be able to put a blanket together as symmetrically as possible, the good weaver uses a measuring stick. With it he determines while he is weaving where the long strip should be cut. He also has a rather exact idea of how long the individual pieces must be, and how long the individual designs must be, in order for a symmetrical pattern to result. Thus, the single woven strips in the picture on page 196 fit together very harmoniously.

The old Bariba man at the left, who weaves only strips with very simple lengthwise patterns, is in the process of unwinding thread from his supply for the spool of his shuttle. It is interesting to see how cleverly he uses both his hands and his feet. I often noticed that feet were used much like a vise. The shafts of this loom hang from a roll that, unfortunately, is no longer part of a beautifully carved heddle-pulley. But among various tribes in the Ivory Coast—the Baule and the Senufo, for example—I still often found a pretty carved wooden figure over the spool: a bird's head, an animal head, a human face, or a double human head. The picture below shows three examples of these stirrup-like figures that have long been known and admired by collectors as heddle-pulleys. But the fine pieces have already become very expensive, and, as is too often the case, the ones that are carved today are of significantly lower quality. Still, it is a comfort to see that the little figures are still present on most of the Senufo looms. Himmelheber, whom I appreciate greatly for his humane point of view, once got the following answer to a question about the meaning of the figures: "We just do not want to live without these pretty things!"

160

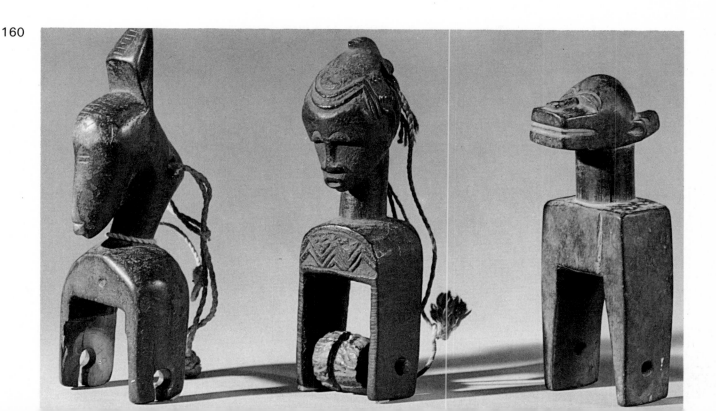

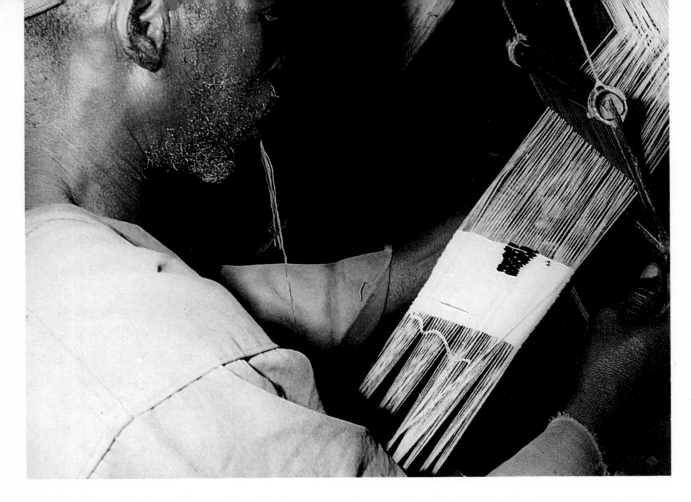

161

162

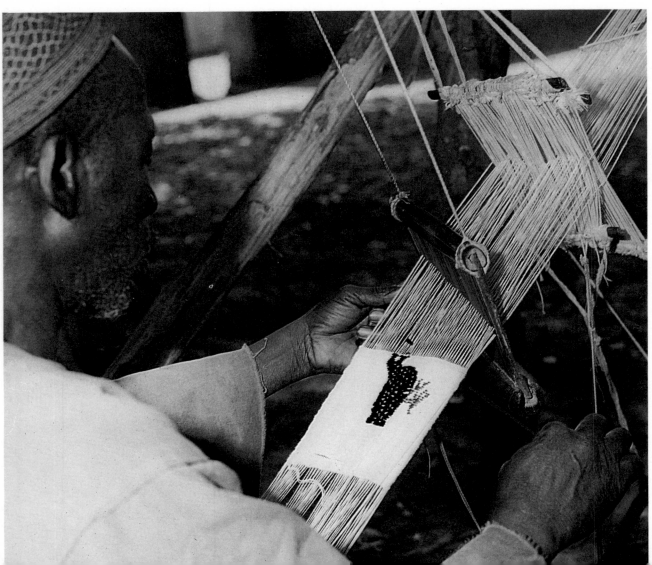

I very much admired the old weaver shown on these two pages, because he was capable of weaving not only the usual decorations but also figural representations. On one of his blankets I saw birds, turtles, crocodiles, and a cow suckling its calf, as well as men and women. These figures were so large that parts of them were on separate woven strips. When sewn together into a blanket, they fit together perfectly. He had to think of this all during the weaving. The man had an enormous capacity for previsualization.

Here we show how he first makes a partridge on a light background, and then a white rooster on a dark background. The usual strip is first woven on the treadle loom (top picture at left). But then he begins to pull the colored threads in with his hands. In the beginning it is impossible to understand what it is going to be. The figure is at a right angle to the length of the strip, and so the tail comes first. After each introduction of a colored thread comes a white thread, and both of them are packed together with the reed so tightly that the thinner white thread is hardly visible next to the thicker colored yarn. So the animal slowly grows. The feet are red, the eye is white, and then the yellow bill is put on (bottom picture at left). The rooster is almost finished in the picture below. One can see by the movement of the weaver's hands that he is about to put in the last red thread of the comb.

I have already mentioned Fatagoma Ouatara in preceding chapters. Mon-

163

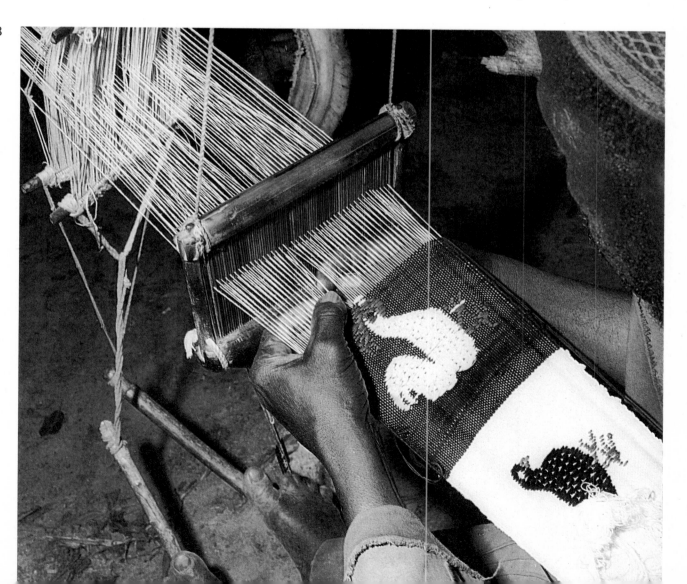

sieur Escarré, the uncrowned king of Korhogo, had placed him at my disposal as an interpreter. I gratefully recognize that without the help of Europeans settled in Africa it would have been impossible for me to have discovered so many details, and, for the time being, I am shamelessly taking advantage of my friends' knowledge and experience. The Escarré family—themselves extraordinarily interested in African art—sent their excellent cook, Fatagoma Ouatara, with me. He actually did not need to cook for me, but he acted as a guide and interpreter. Naturally it was Fatagoma who one day led me to the figure-weaver, because, aside from Madame Escarré, no one else knew of him. I discovered only later that my interpreter got a nice bit of extra money on the side this way. He made certain that no one else got to know the old man, but he bought all his blankets, paying handsomely, and forbade him to sell to anyone else. Since the fabrics were really beautiful, he could easily sell them at a tidy profit in Korhogo, without revealing his secret. So one day we drove thirty miles from Korhogo to Kadioha, via Dikodougou, and then into a little bush village named Sounsori. It is completely unnecessary to write down the name, but isn't it nice to listen to its sound? The names all sound like songs. There I watched the man weave partridges and roosters. In the color picture at the right is a weaving square in a Senufo village. The weavers sit across from one another in two rows. The posts for hanging up the weaving apparatus and the benches for sitting are firmly installed. The crossbars are tied fast. Everything else is movable, and can be left or lifted off. The looms are situated so as to be in the shade almost the entire day, and the warps that belong to the looms in the background are almost long enough to reach over to those on the other row, and vice versa.

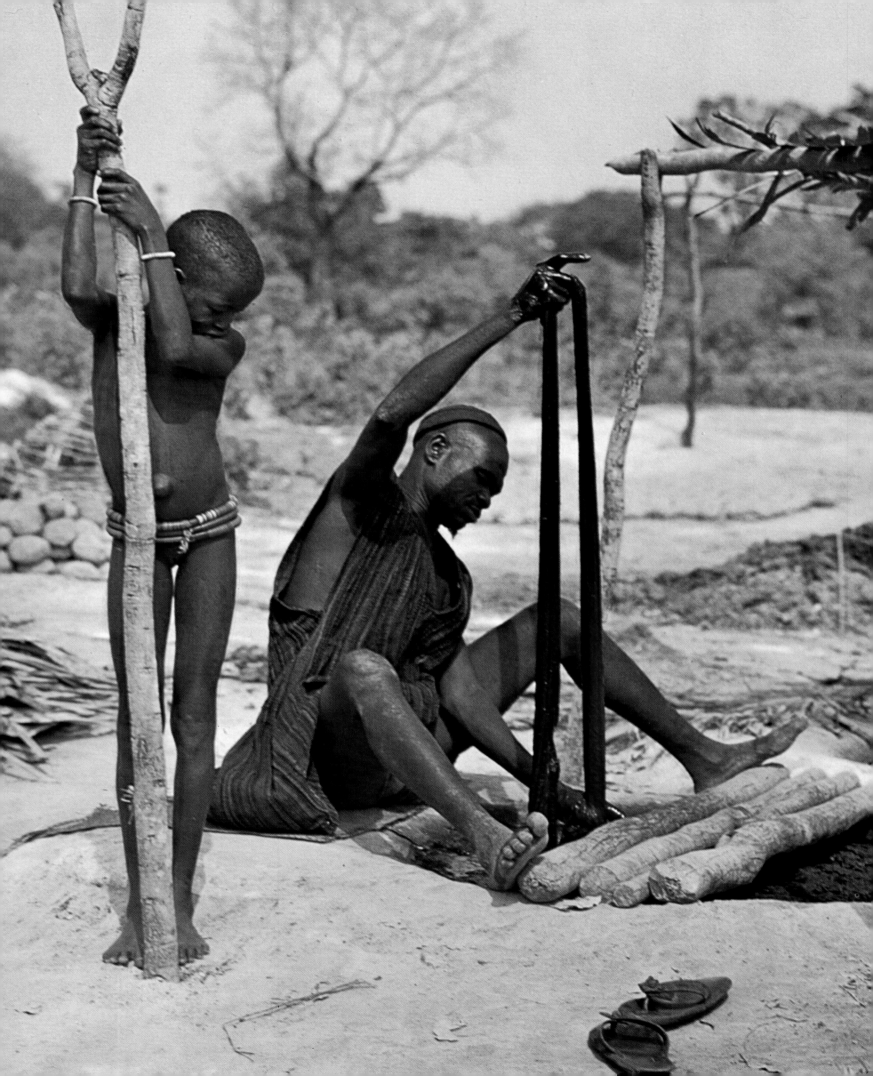

165 Poli is the name of a little provincial capital in northern Cameroon, and *poli,* in the local language, means "doves." Thus we lived, at that time, in the land of the doves, and the happy birds inhabited trees, bushes, and roofs. They cooed, as they are wont to do, and they cheerfully called and cried, "Barbara, Barbara," throughout the countryside. The village lies in the region of the Doayos, that animistic and little-developed people of whom we spoke in the preceding chapter. Their cult of the dead is particularly impressive, and their "textile industry," as I described, is exclusively in the service of this cult. Besides the Doayos, numerous other immigrants live in Poli. Above all there are the Muslim Fulbe and blacks from the region around Lake Chad who are culturally superior to the local people. They are active as tradesmen and craftsmen, and, as Muslims, they wear flowing white and indigo robes, in contrast to the rather more sparsely dressed Doayos. They live together in the enclosed village behind high walls, in huts sometimes decorated with simple clay reliefs.

When I was in Poli, a few dyers from Bornu, a region lying on the western shore of Lake Chad, also lived there. As is the case in most villages, all the dye-pits were together because the various crafts are usually organized into guilds and are subject to a single guildmaster, and also because they find working together more pleasant. The pits are at some distance from the clay huts because of the foul smells that emanate from them.

The dye-pits of Poli are no different from those that I saw in Kano, south of Lake Chad, on the Niger, in northern Dahomey, in the Ivory Coast, or in any other region of the Central Sudan. Indigo dyeing is widespread. From the Mediterranean countries across the Western Sudan to Guinea, it is found everywhere. It does not exist, however—with the exception of Madagascar

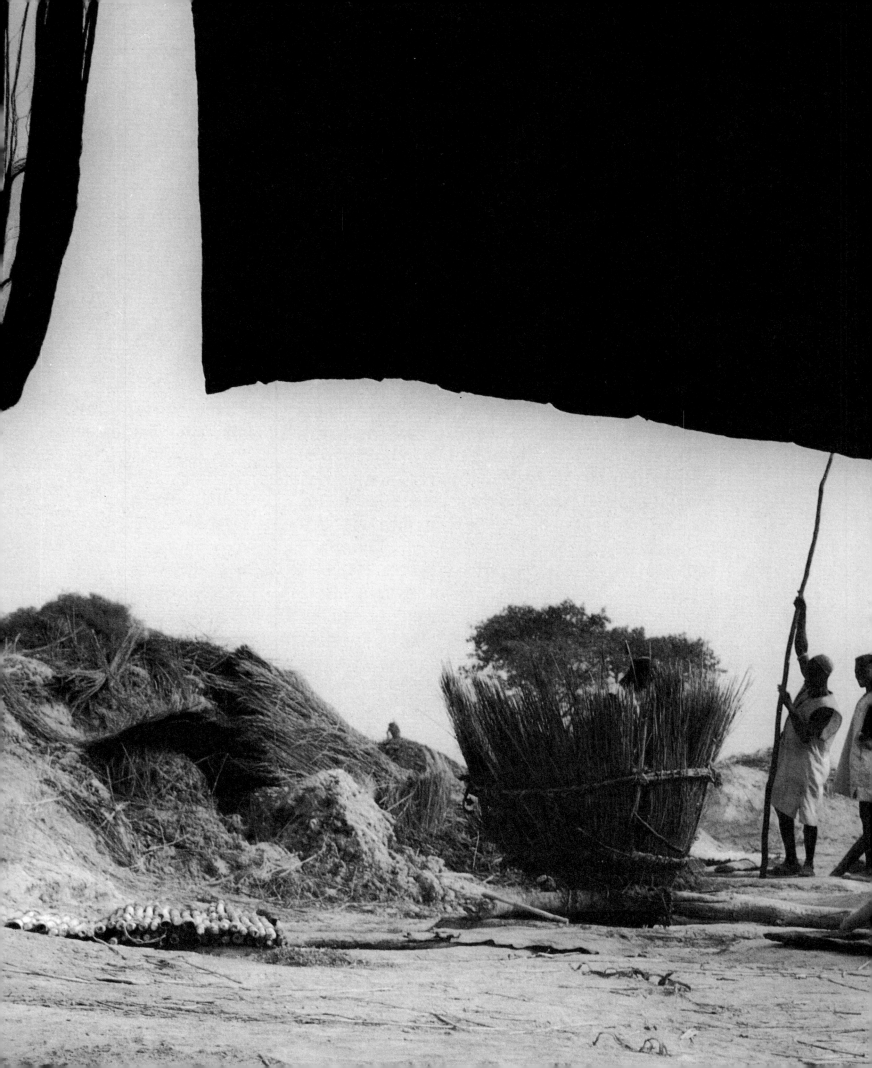

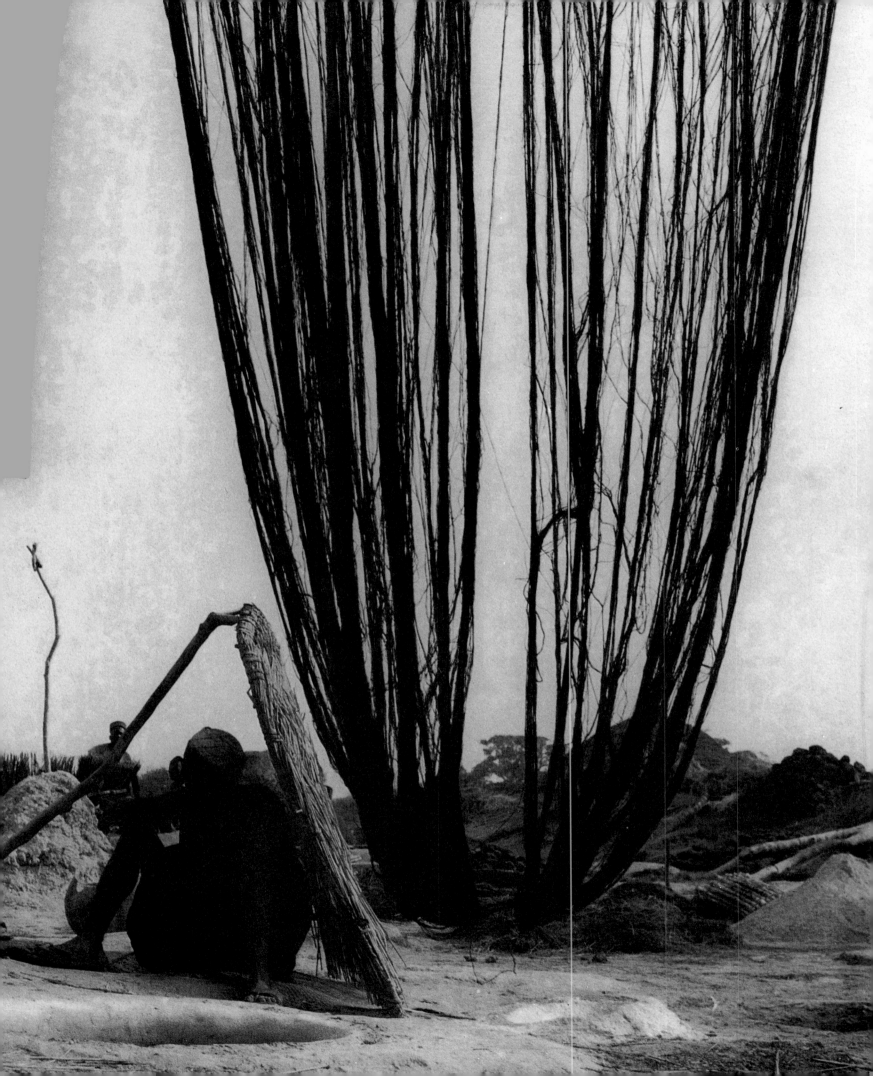

—in the southern part of the continent. Natural indigo comes—as the name implies—from India. There, and in other Asiatic countries, it was gleaned from the *Indigofera* plant. For centuries it has been the king of all dyes, and until it was dethroned by modern dye chemistry it was regarded as an important natural dye. Marco Polo described the preparation of indigo that he saw in India. From the twelfth century on, indigo was brought to Europe via Baghdad, and, according to old account books, seven Dutch ships brought 333,545 pounds of indigo, worth 500,000 talers, from northwest India in 1631. In 1880 the world produced about eleven million pounds of indigo. Since a pound cost about ten francs, more than one hundred million francs changed hands. Indigo-dyeing plays a large role among all pastoral peoples. Except for Australia and Antarctica, it has been found on all the world's continents. At present, more than fifty different plants from which indigo can be obtained are known to scientists. Since most peoples who are at the primitive-craftsman stage work directly with fresh colors and do not distill the dye and preserve it, one can conclude that dyeing with indigo did not begin its triumphal march across the world from only one or two centers. It must have been discovered by various tribes, independently of one another, in widely scattered locations.

In the Sudan, the indigo dyestuff is usually obtained from a flower of the pea family *(Lonchocarpus cyanescens)*. It is a liana vine that is also cultivated. It is not always obvious that it is a liana, since it has no opportunity to climb when it is planted in open country. Then it develops in the form of a shrub of which only the young twigs are used.

In Poli, the dyers showed me chunks of color, cylindrical or shaped like buns, each weighing about a pound. They were fibrous to look at and to the touch. They are made in the following way: the young branches of the indigo plant are ground and squashed in a mortar until they become a paste out of which these lumps can be formed. They are then dried in the sun, and in this primitive way the color is preserved. The chunks are then offered for sale to the dyers at the markets.

But this indigo is not water-soluble. For dyeing it must be changed into soluble form by releasing the reduced form of the indigo from the plant. Chemists call this process "steeping."

The Poli dyers did not use a dying vat but rather put the colors into large holes that had been dug into clayey soil. The holes are about six feet deep and have diameters of about three feet. The inner walls are carefully painted with clay. In more recent times the dye-pits have been finished with cement. Such a pit holds about 400 gallons of water, into which about thirty to forty pounds of the dried indigo mass are introduced, plus a few handfuls of European potash. Before the potash was available, certain kinds of wood were burned and the ashes were leeched. The brew, which soon turns brownish and not

208

indigo blue, is left to ferment for a few days. In East Asia this fermentation process is speeded up by the addition of sugar-bearing substances. This method is unknown in Africa, but fermentation soon sets in, even without additions, as a result of the unavoidable impurities.

Dyeing is done with cold water, and the color brew is a weak solution. If the client asks for an intense color, the dyer must repeatedly immerse the fabrics and yarns, pull them out, and immerse them again for one to two hours. The cloth is laid out on the ground or hung over walls or on lines to dry. Only in the air is the color brew oxidized, and then the blue dye sets into the fibers of the cloth. It was always miraculous, like sheer magic, to watch the wet, dirty-brown cloth slowly turn blue as it dried to a true indigo color. The dyers of Poli did not concern themselves with the chemical process. They explained simply that it was the wind that dyed things blue. And so it was—it was the oxygen in the wind that took effect.

The people of Poli did not yet use any machine-woven fabrics. They used only their own, which were sewn together from the narrow *gabags,* the strips that every ordinary treadle loom produces (picture below). I often sat at the

167

edge of the village in those days, under the slight shadow of a papaya tree, and watched the dyers work (picture on pages 206-207). I watched their easy movements as they stood at the dye-pits, in billowing white or blue robes, stirring the brew with long poles, throwing their wide sleeves over their shoulders again and again, skimming off the dirty scum. I watched them as they crouched, plunged in the dampened cloth, lifted it out, and plunged it in again, meanwhile pushing their brown-black arms into the color up to their elbows. It was beautiful to watch their hands with the slender fingers, beautiful to follow the harmonious movements. And, as always, it was wonderful to see that the dyers, like all craftsmen, worked with dedication.

When, after two or three hours of work, they carefully spread out the pieces of cloth the size of a tablecloth to dry in the sand, before they wandered off home, their white clothes were still clean, despite the work with the dirty, foul-smelling dye brew.

The dyers always work only on order. They take over the goods from the weavers, who usually sit together in groups under a woven-mat roof, and, gaily chattering to each other, patiently sew the narrow gabags together into pieces scarcely as long as a man and as wide as a table. Or they take them directly from the client, who tells them whether he wants pale blue or dark blue cloth.

After they are dry, the pieces of cloth are folded up and beaten until they are almost stiff with wooden clubs against a wooden beam. They then look as if they had been pressed with a hot iron. The intense sheen, which many people particularly love, comes from the beating. The picture at the right shows three girls from a completely different region. They are pretty Tuareg, of a tribe from the Aïr, in festival costumes that include much silver jewelry. The pieces of indigo cloth they are wearing are stiff, shiny, and contain so much blue dye that the color rubs off and turns the skin darker than it is already.

But cloth was always dyed without any pattern in Poli, simply dyed blue, until one day I dug out a catalogue of a textile exhibition from the Basel Ethnological Museum. I sat down with it with a dyer, and, pointing to a picture of a piece of fabric decorated with a simple reserved pattern, asked him if he could dye me a cloth like that (it was a simple plangi pattern as in the picture on page 212). The old man looked at the picture carefully, his eyes lit up, and he told me that once he had dyed all fabrics this way. Oh, he still knew exactly how, but in these bad times that had gone completely out of fashion; no one wanted to pay for such a big job anymore. "Will you make me such cloth if I pay you well?" I asked him, and he promised to discuss it with his friends. He himself was only the dyer, and others had to "bind off the knots" or "sew the folds" (in other regions of Africa it is always the dyer who does the re-

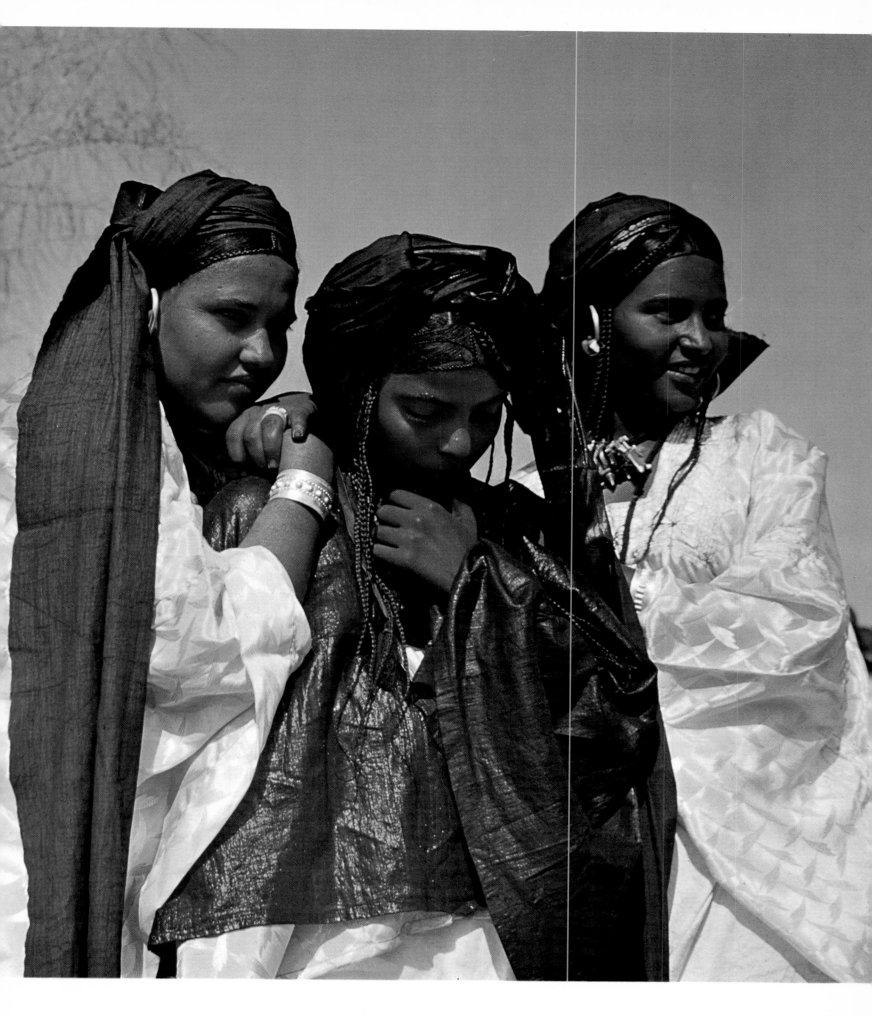

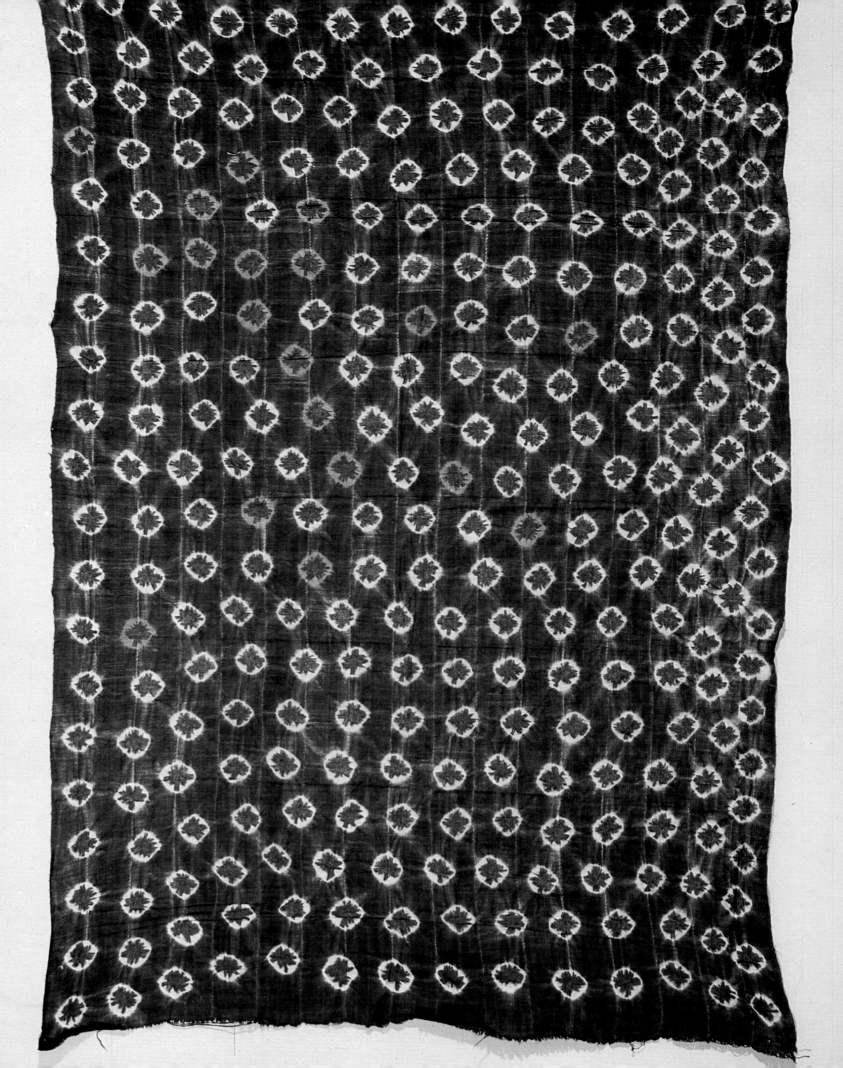

serving himself). Naturally I did not relent; I immediately went back to the village with him, and we displayed the picture with the prettily patterned blue-and-white cloth and the white rings. (In the picture opposite it is also easy to see how the cloth is sewn together out of narrow strips.) The men, squatting in front of their houses, nodded their heads, the women giggled, and everyone who was there in Poli at the time remembered exactly that once everyone had used such cloth.

Thereupon began a ten-day flurry of activity among the weavers, the tailors, and the dyers. At the market, I bought many rolls of the wound-up strips that look like small millstones. Three tailors sewed the cloth together, and others did the reserving. The following discussion is intended as a theoretical introduction to the pictures in this chapter. I have copied some of this material word-for-word from the publications of my friend Professor Alfred Bühler of Basel. It is to Professor Bühler, moreover, that I owe my interest in textile techniques.

The reserve technique is the term generally applied to methods of patterning that have as their purpose the ornamentation of a great variety of objects. It is usually applied to textiles, in which case certain parts of the cloth are protected from the dye by reserving or covering them. Such processes differ fundamentally from other decorative forms utilizing color in that the figures or decorations are not added to the background color but rather the reverse: they are reserved against a colored ground. One of the most conspicuous and highly developed methods is the well-known batik technique. There the reserving is done principally with wax.

Now, there are all sorts of other methods for making patterns by reserving, and I shall mention here only those known in Africa: reserving by pleating, where the color is kept from the inside of the folds, and reserving through knotting or braiding. In the latter cases, no reserve material is necessary either. The wrap-and-tie reserving is obtained by wrapping a piece of cloth or strands of yarn with pliable material that is impermeable to dyes. The simplest plangi technique results in circular dabs or flecks. This design is made by pulling out small sections of the spread-out fabric at regular intervals, tieing the knotlike shapes, and removing the ties again after dyeing. If the little knots are bound only at the base, leaving the upper part free, then a ringlike form will result (pictures on page 219).

The so-called sewn reserves, which today are almost always described by the name "tritik" so widespread in Java, are suited to the production of plangi patterns with complex outlines. A thread is sewn through the fabric in short stitches and is drawn as tight as possible (picture on page 218). Plangi and tritik are necessarily almost always connected with pleat-reserving. If one pleats radially or in zigzag forms and ties off the cloth in places, a very effective pattern results (color picture on page 223).

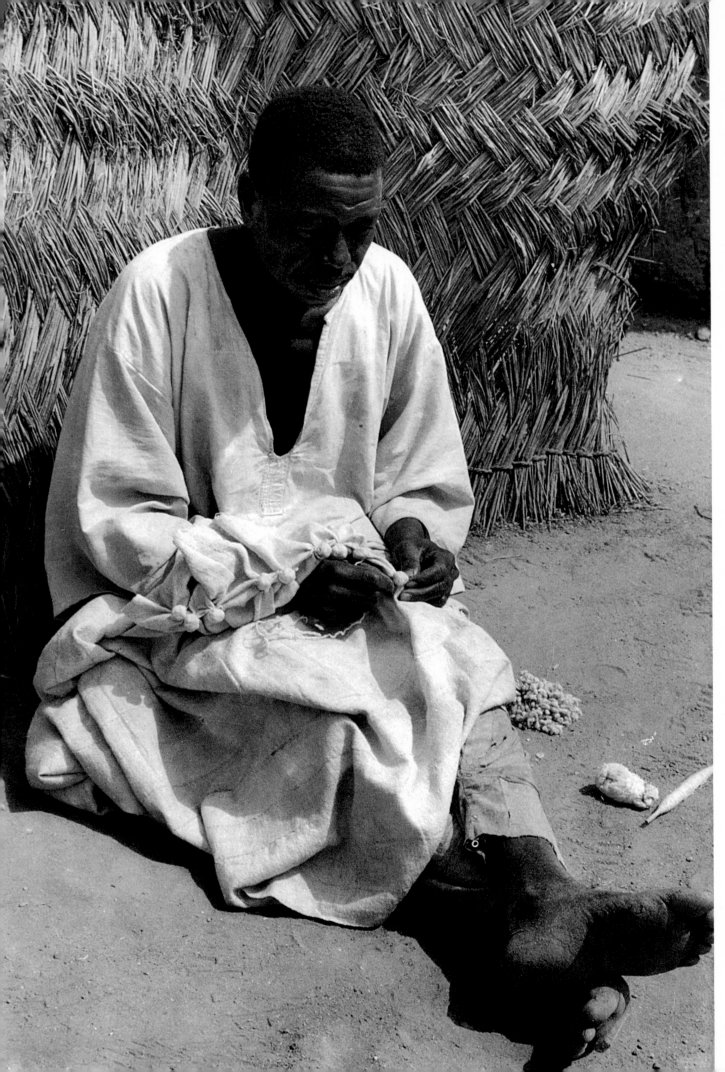

The picture below shows a plangi cloth prepared for dyeing. Six or eight black cottonseeds are bound up into each of the berry-sized knots. Ordinary cotton thread is used for tieing off. Now it is easy to imagine how the pattern is made. Where the knots are tied off by the thread, the fabric stays white. So, white rings are formed. But they are not very regular or sharply defined. Since the fabric near the thread is strongly folded and pressed together by the tieing, the color does not penetrate very well there, and starlike white rays are formed toward the inside and the outside. If the knot is not just bound off at the base, but completely wrapped, naturally it is not a ring that results, but a sunburst. Sometimes the dyers in Poli made all the knots in regular rows, and all the same size, but sometimes they arranged them in rows of gaily curving lines and varied the number of cottonseeds tied inside, so that the rings came out all in different sizes.

After a few days, we replaced this classic plangi technique by tritik, that is, by pleating the material. The pleats, held together by basting stitches, were allowed to run parallel to one another, or to cross over one another. The threefold pleating prevents the penetration of the dye, and white bands with vaguely defined edges result. In most of them, every stitch remains recognizable, since the thread was dyed but the fabric beneath was not. The photographs on the next two pages show a pure plangi fabric from the front

171

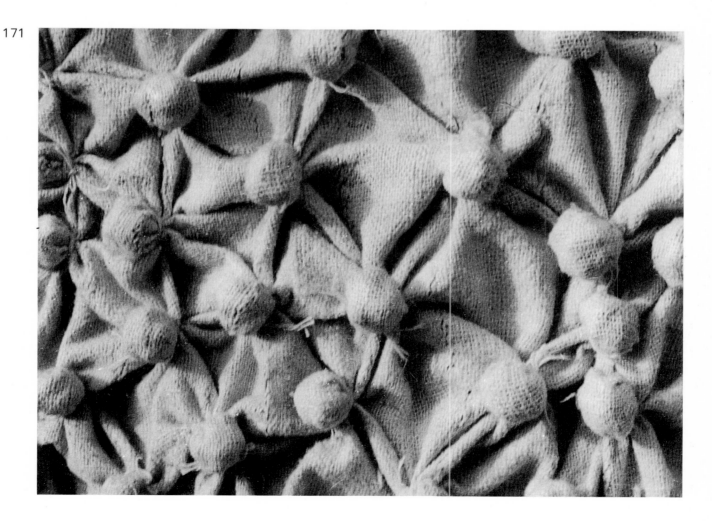

(below) and from the back (opposite). Part of the tied-off areas has already been untied, and, in the picture at right, one can see here and there some of the bound-in cottonseeds that have not yet been removed. Now it is easy to understand that white rings must result (picture on page 212). By comparing the two pictures here one can see that the knot is only dyed blue on one side. Rings appear on the outside, but on the inside where the seeds touched the fabric there are plain, white, round areas. The dye did not penetrate through the tied-off knot. That is fairly unusual with this rather loosely woven fabric, but in this case the oil of the pressed-together cottonseeds prevented the color from taking on the inside.

When I was in Poli, I ordered and received several dozen pieces of cloth. I do not know who was happier; I, delighted with my beautiful, genuine plangi cloth, or the friendly people from the Bornu country, who were not only smiling over the good price but were pleased that someone still appreciated their work. Occasionally, I tapped them on the shoulder in a comradely way and said, *"Bodum, bodum, bodum* (good, good, excellent)!"

The old dyers of Poli were too pessimistic in their judgment of the situation, because many varieties of cloth dyed in the country are still offered for sale in many markets, and since then I have seen many African women wearing dresses with plangi and other reserve patterns. The more this cloth is

172

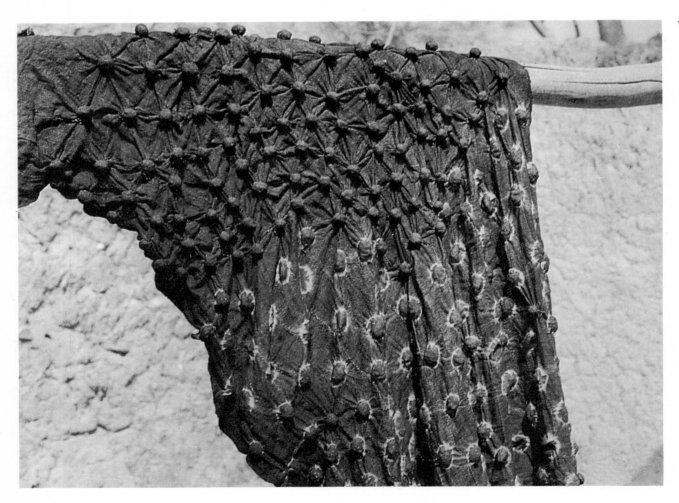

174

washed, the more beautiful it becomes. It becomes silky-soft to the touch, and the indigo turns a delicate shade of sky blue. The women, off whose backs I bought "faded cloth," were not at all of the same opinion, and they let me have their old things willingly if I paid them enough for a new cloth. They then had another reason for amusement—laughing and giggling over the peculiarity of the whites, whom they could believe capable of any stupidity.

In Bohicon, a village near Abomey, in Dahomey, I got to know Madame Delmados, who is shown sewing pleats here at the left. She is the daughter of an African mother and a Frenchman. As was all too often the case, the white man paid off his companion with a sum of money, but then he left her with a number of children—this happened while Madame Delmados was still a little girl. Now she has set up a sort of "cottage industry" and makes plangi and tritik cloth with some young girls. The dress that she is wearing in this picture was dyed by this technique. Now she is teaching men and women that the cloth with old African patterns is at least as beautiful as the printed fabrics from Europe, which are also more expensive. Madame Delmados uses machine-woven cotton fabrics, and she no longer dyes in the old vats but in enamel basins with synthetic indigo. That is understandable, but the main thing is that with her fabrics she is encouraging delight in their own artwork among her people. When I met her she never had any problem selling her work.

175 · 176

The dyers in Korhogo shown at the right—immigrant Djoula men from Upper Volta—also used indigo from a can. It is a product of the German firm, Badische Anilin und Soda Fabrik, which was the first to produce synthetic indigo dyes shortly before the turn of the century. The two dyers are just pulling dozens of pleated and sewn-together blankets through the color bath, and light stripe patterns form in the dark blue. The dye-pit has become unnecessary, and the dyers no longer wait for fermentation but stir the color in the big bowls and mix in a handful of white salt-potash. They wear thick rubber gloves for working, and the color bath—greenish, not blue—is usable immediately. Here, as with true indigo, the typical indigo blue color results from the oxidation during drying. The cloth in the background is indigo blue and kola-nut brown. The dyeing was done in the following manner: the cloth was grasped in the middle, the four corners fell together at the bottom, and tight folds were carefully made. Where the white lines were to be, it was wrapped, and, because of the pleats extending out from the middle, radii appear during the dyeing.

The blue and the brown often mix into colors reminiscent of marble, or Venetian glass, or even Easter eggs (pages 222-223). The brown is produced in the following way: mashed kola nuts are mixed with water in an earthenware jar, producing a thin porridge. The tied-off cloth is put in this "soup" for twenty-four hours. Then the still-wet cloth is drawn briefly through the indigo bath once or twice. No changes are made in the ties or folds between the two baths. In this way the dyers are capable of producing numerous variations. They use plangi and tritik techniques. They pleat from the edges, and out from the middle. They pleat parallel to the edges and on the diagonal. They tie in plangi knots, so that they get large, light "suns" or just plain white rings, but the marbling, the mixed color, is purely accidental and can hardly be planned. That is why here, as with the lost-wax technique, each two-color cloth is a nonrepeatable original.

"Et voilà encore un autre modèle," Dieubatie Zisse would say with pride when another cloth that he wanted to sell me was finished. And because I had promised him I would buy each cloth that was different from the others, it became a rather expensive proposition, since the variations seemed endless. "Et voilà un autre modèle," the old fox would grin. Two of his variations are reproduced on pages 222 and 223.

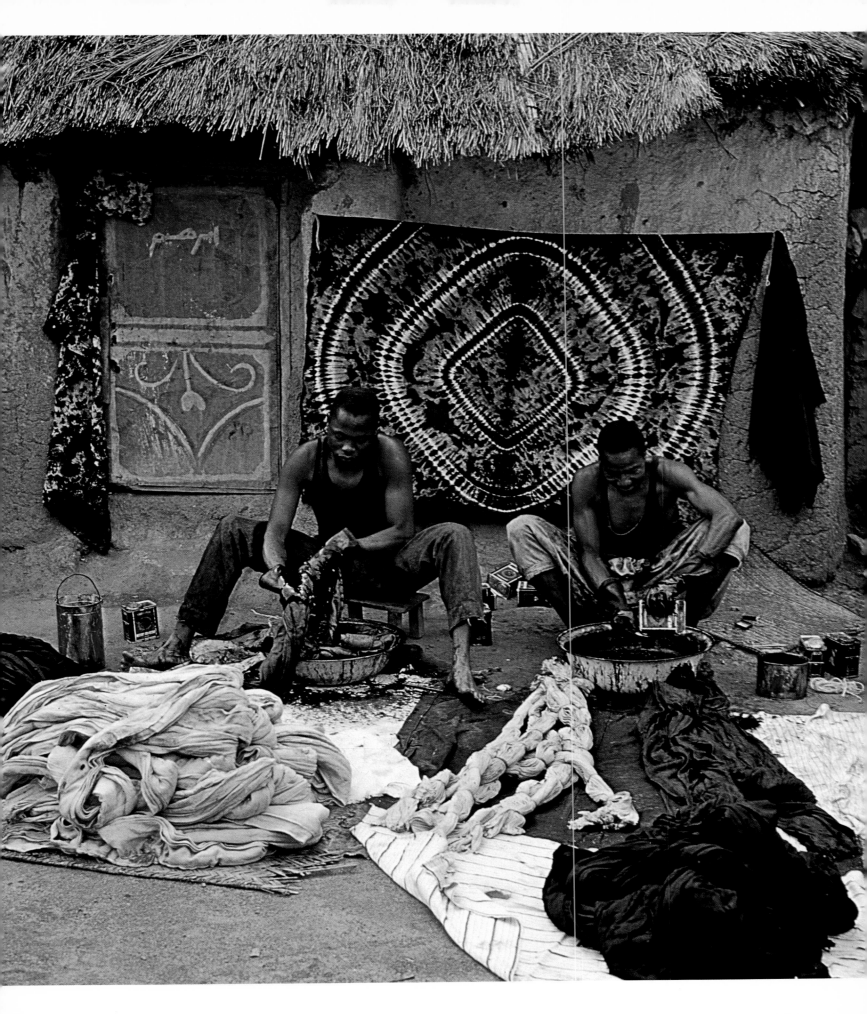

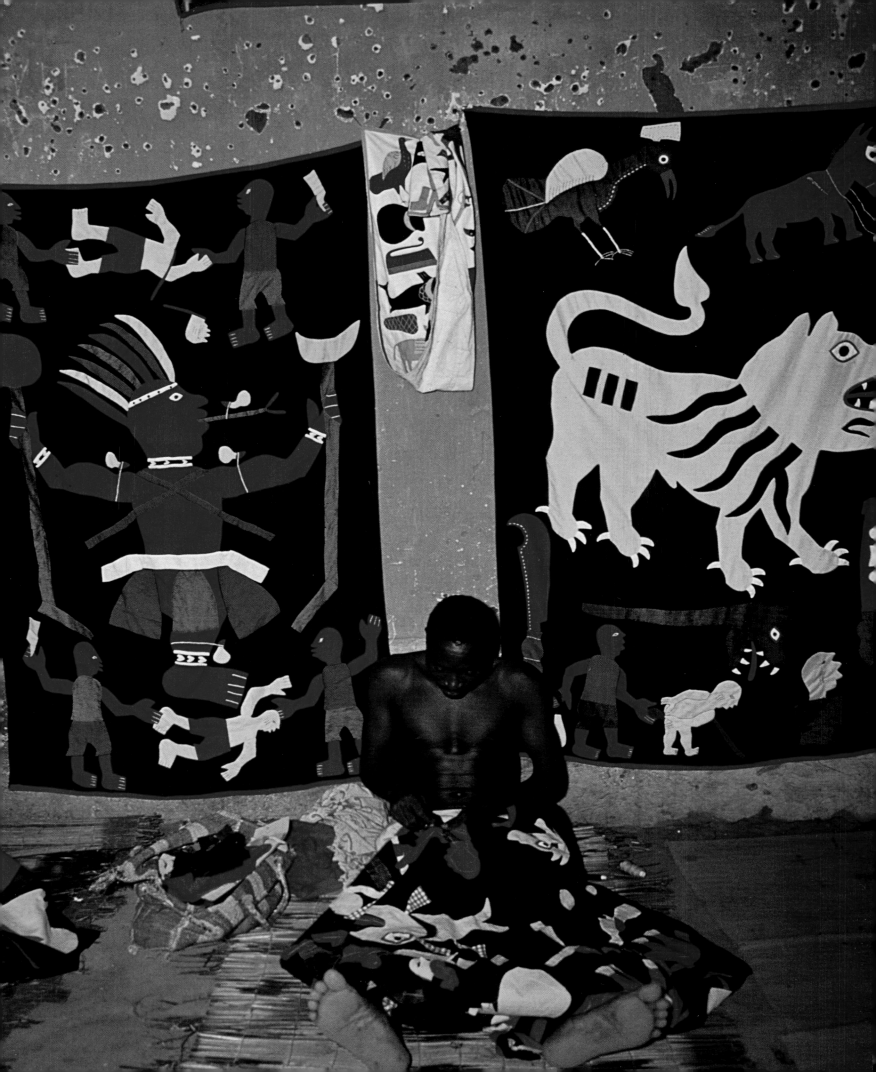

At one time, a powerful dynasty of eleven kings ruled for many years in what is now Dahomey. The name of the capital city, in this land then known as the Slave Coast, was Abomey. The last of these feared kings capitulated to the French in 1894. The kingdom was not particularly large at that time, but their mighty armies, in which there were even amazons, had often conducted slave raids in territories that were much bigger than their own country.

At the time of the dynasty, various handicrafts were flourishing in Abomey, and magnificent works of art were created for the kings and their ministers. Much of what was not carried off to Europe can now be admired in the Abomey Museum. Prudent Frenchmen rescued what was still in the country, so an historical museum was born. It is now diligently visited by the citizens of Dahomey. The Museum, recently rearranged by my compatriot Jean Gabus, stands in the area of the former kings' palace.

Very early, individual kings brought particularly talented craftsmen to the court. There they worked exclusively for the king and the palace. They carved beautiful thrones and chairs, large animal figures, symbols for kings' names, and representations of historical events. All objects were connected with the dynasty or had religious motivation. Besides the wood specialists there were smiths, gold- and silver-casters, and above all weavers and embroiderers. There was a time when one of the embroiderers kept 130 workers occupied—all were in the service of the king. Wall hangings, cushions, festival tents, and ceremonial parasols were made from the fabrics. The appliqué technique came later, but, as in the earlier embroideries, all the figures, symbols, and representations had their meanings. It was a picture script that everyone could understand. And today the tailors still sit in an open hall of the old royal palace and decorate their fabrics with the old motifs.

Admittedly the old appliqués that hang in the Museum are more impressive. The two pictures on these pages show examples from the Museum's collection, while the other pictures in this chapter show modern representations. The new designs are worked in a more disorderly way; the fabric is pleated fourfold, so that, for example, a lion is cut out four times right away. It is mass-production, and the tailors today certainly have no spiritual relationship to the figures they are appliquéing. However, they are still capable—at least the older ones among them—of interpreting the symbols. Again and again one discovers gruesome warlike scenes, corresponding to earlier times. The head of a decapitated enemy is presented, a prisoner is hanged, another impaled. Such representations are always direct references to the specific heroic deeds of a specific king, and because these stories and deeds were told over and over again, everyone knew what was meant by them, and every child learned his country's history this way.

Aside from that, the symbols for the kings' names recur often. They allude to events or characteristics. The figure of the clothed buffalo in the picture below is the symbol for King Tegbessu: "It is impossible to take his clothes away from him." Everyone knows the old story that corresponds to this. The brothers of the king put poisonous herbs in his tunic in order to prevent his accession to the throne. The endangered king noticed it in time and from

then on it was impossible to take his clothes--that is, his life—from him. The lion on pages 224 and 228 refers to King Glélé (1858-1889), the last mighty ruler before colonization. He succeeded his father Guézo, the memory of whom is still alive today. From this, one can understand that for the son Glélé, who had to prove himself after his famous father, the following magic saying was chosen: "The lion's teeth have grown in, and he is the terror of all." The buffalo was the symbol for King Guézo, and his saying goes roughly like this: "The buffalo announces himself and traverses the land." That is, no one could resist his strength. The large ship in the picture below is the symbol of King Agadjy (1708-1740), whose campaigns of conquest went as far as the coast, so that the first contacts with the Portuguese were made through him.

Thus these colorful appliqués were, and still are, living history books. They are filled with heroic deeds from those pitiless times, but, at the same time, they contain all sorts of maxims and worldly wisdom. For example, the fish and the net next to each other signify: "A fish that has escaped from the net will never let itself be caught again."

Well, all these motifs are tirelessly copied by the modern tailors. Their cloths are more colorful than before, perhaps just a bit too colorful. But now they are not only bought by tourists but also hang in many a room in Dahomey.

182

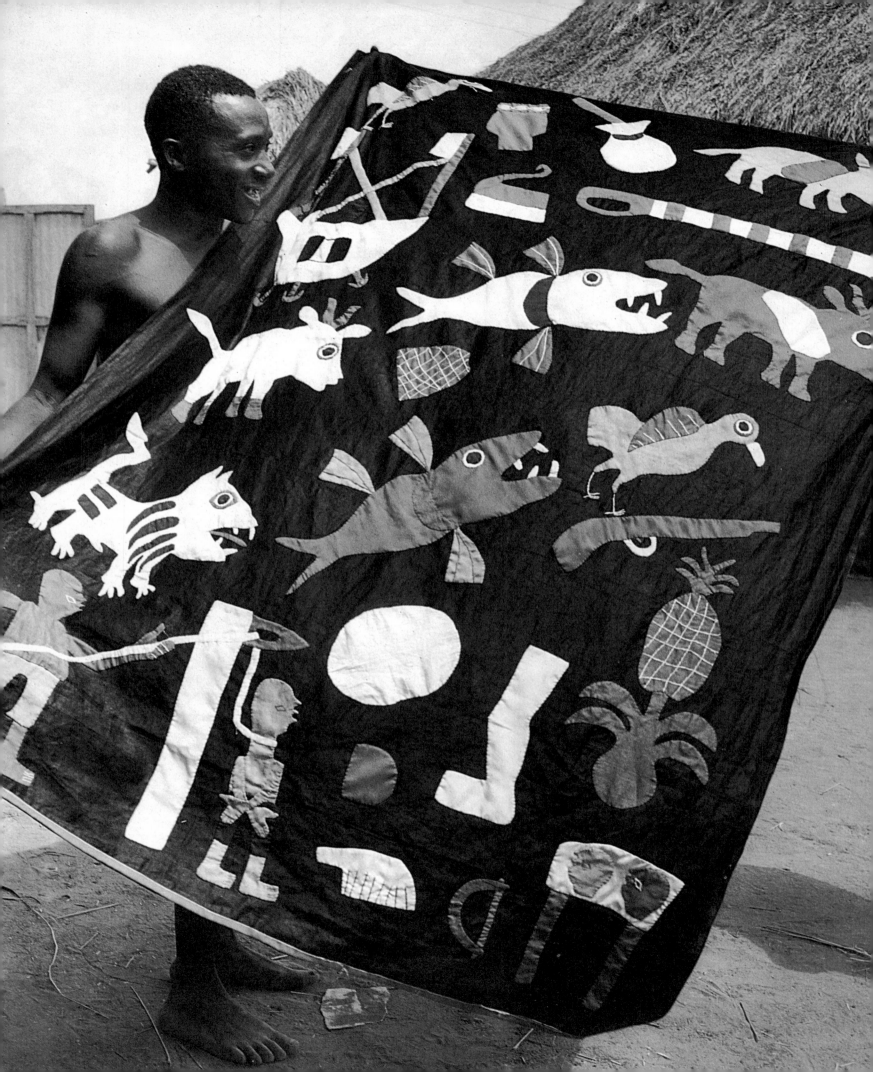

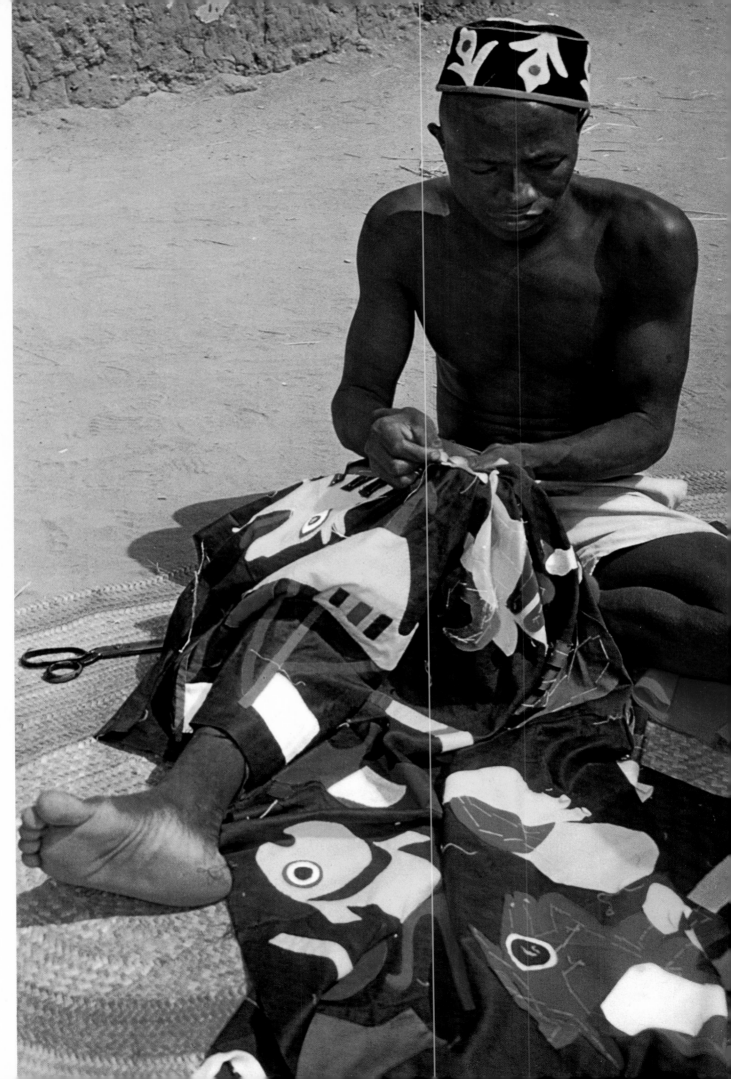

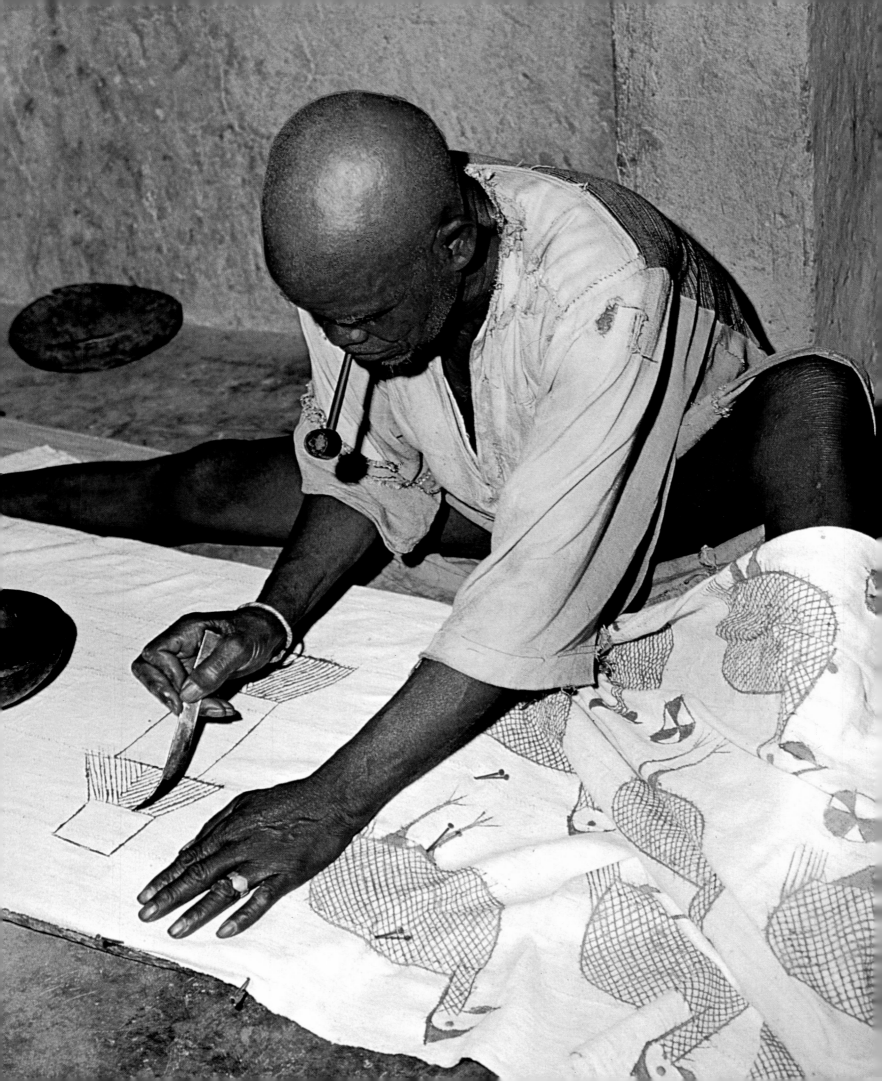

The man who is shown at left covering cloth with guinea hens and other figures is named Gbomoko Silué. He lives in Fakaha, a little Senufo village that lies lost somewhere "in the bush" several miles beyond the subprefecture of Napiélédougou, in Ivory Coast. He practices a rather rare art, and I am not exactly sure what he should be called. He is not a dyer, nor does he weave patterns. Does he draw, is he a painter, a graphic artist? In his village, his sons and a considerable number of the men and youths have specialized in painting stylized animal and poro-figures on fabric. Although the best work still comes from the old man shown here, I was told that previous masters surpassed him.

Cloth and fabric are decorated in many different ways. Some of the techniques have already been described in part in previous chapters. Yarn may be dyed so that pleasant longitudinal or crosswise patterns, or both together, result from the weaving. Patterns, very particular decorations that all have names and often religious significance as well (although the young weavers hardly know this any more), are sometimes woven in. The fabric can be dyed afterward, by any one of a number of different methods. It is dyed by reserving, or it is tied off (plangi), or pleats are sewn into the fabric to be dyed (tritik). Stamps are used to print patterns, and several batik methods are also known. They know masterly ways of embroidering hats and the large surfaces of ceremonial robes, and the art of appliqué is not unknown either. I first noticed the cloth shown here in my hotel in Korhogo. There it was being sold to Europeans. I bought a dance dress on which, aside from lines, little figures and mythological animals such as turtles, crocodiles, and snakes had been painted. The dress belonged to a member of a secret society, and played a part in the poro-cult, of which I have already spoken. But all

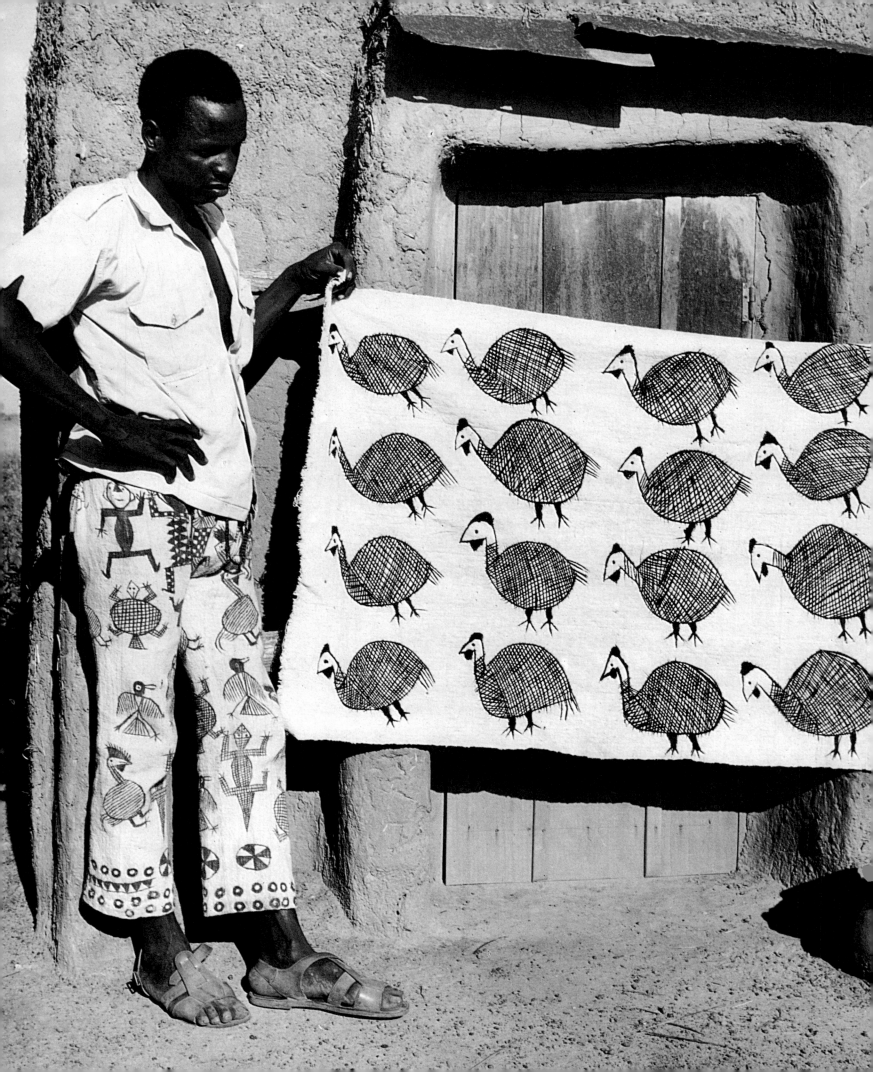

187

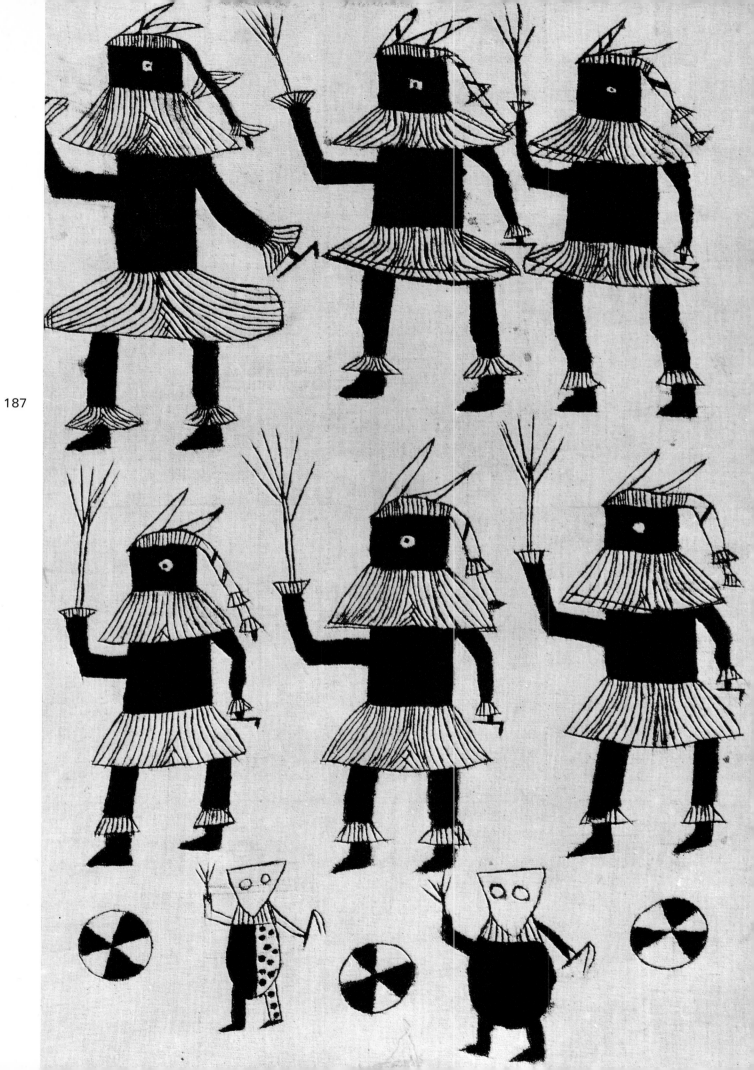

these figures were only three to four inches high. Then, one day, as I was travelling to Fakaha with my interpreter, Fatagoma, we picked up a young man who was to show us the way. He was a hunter, and wore a pair of pants made of coarse cotton cloth richly painted with these little figures. The cloth was made up of the usual narrow strips, with figures scattered over it pretty much at random (picture on page 232). There were birds, fishes, a crocodile, a turtle, and various poro-figures: masked dancers and fetishes, and circular ornaments, suns, and triangles. Later I saw similar hunting clothes, partly dyed dark, but also so dark from dirt that they really looked like camouflage suits. The figures were intended to bring the hunter luck and to protect him.

Happily we found the village, and there sat the people at their work. At the right is the son of the old man—his name is Penagkon. He was kind enough to sit in the sun. The old man, however, remained in the shade under the wide overhanging roof of his hut, and did not want to be bothered. He was already old, and of uncertain health, so he felt that too much sun was surely not good for him.

The technique used is clearly visible in this picture. The cloth must be pieced together out of the coarsely woven strips common to the area. (The colors are apt to run on more finely woven European fabrics.) It is stretched tight over a board with a few nails, and the figure is not actually painted but rather drawn on. In his hand, the man holds a dull knife, which he dips into his bowl of color. There is just enough color for only a few lines. He does not predraw. He fills his cloth with figures arranged in rows, as the pictures show. The motifs correspond to tradition; they are usually mythological animals and masked dancers. But today this cloth is much more popular than used to be the case, and the cloth is seldom made into dance or hunting clothes anymore. It is now sold, as mentioned above, to anyone who finds it beautiful for

188

234

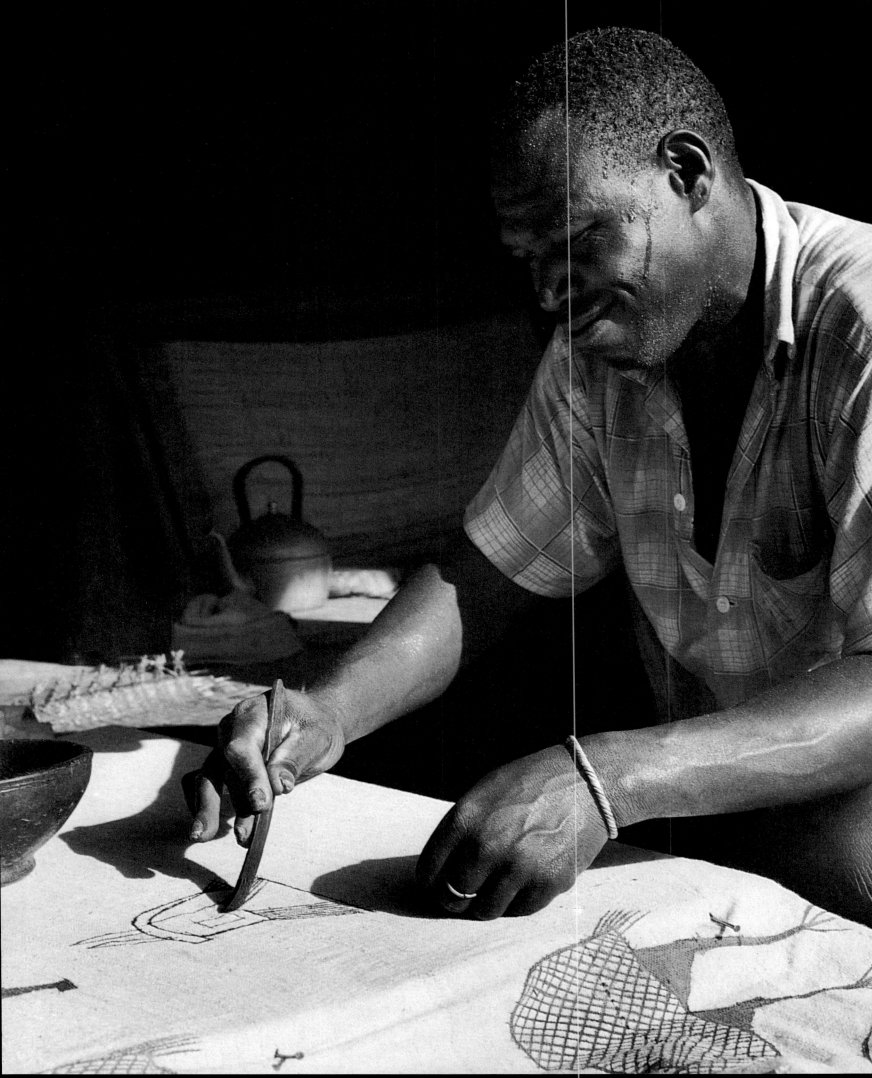

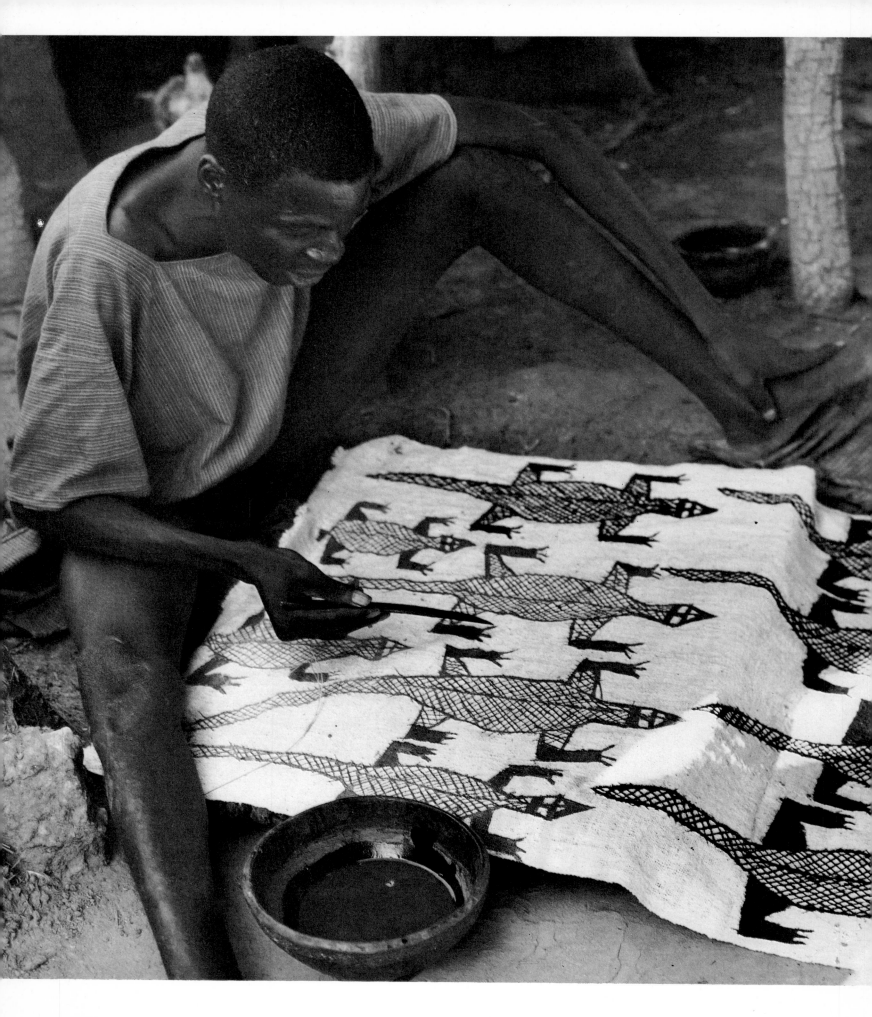

use as ornamental fabrics, curtains, and wall hangings. These cloths are wonderfully suited for wall decorations, and all my artist friends, to whom I was able to show a good two dozen of them, were very enthusiastic. This Senufo cloth can really hold its own among many graphic techniques. I always found the stylization particularly admirable. The guinea hens, for example, as seen in the color picture on the next page, are greatly simplified, without having lost any of their characteristic peculiarities.

The making of the cloth is tied up with a little story that I would like to relate here. My compatriot Emil Storrer is a connoisseur and lover of African art, and he has been known to museum people as a serious importer for a long time. He has travelled regularly for years to well-known centers of African art. He is very particular, so he always brings home genuine rarities. Furthermore, it is to Emil Storrer that I owe my contacts in the region of Korhogo, and especially the friendship and help of the Escarré family, who made my work so much easier. Several years ago, Storrer had the idea of suggesting to the old master, who has, unfortunately, died in the meantime, that he make his figures somewhat larger. He also suggested that the old man arrange the figures slightly differently. And so these pictures on fabrics were made. They immediately delighted many people, and a small native cottage industry grew out of it—it now provides a number of families with a secure income.

90

191

Now these cloths can be bought at the market of Korhogo, and—for not much more—they are also sold at the hotel. They are exported as far as Abidjan, and Emil Storrer also arranged for transport to Europe. I think this is an excellent example of how traditional art can be adapted to present-day needs and interests.

Unfortunately there has also been a decline. At the market on my last visit, I was repeatedly offered cloth that was no longer painted with the old vegetable dyes, but with commercial black ink. And the fabric, too, came from Europe. The effect is completely different, and all the charm is gone. With the good cloth, the material is coarse to the touch, and it is pieced together out of the narrow strips. The figures are first drawn with a greenish-yellow dye made from boiled leaves. Plate 185 shows that the figures are light colored. But now a second layer goes over that, with a second color, which is obtained in the following way: it is produced from a sludgy, decayed mud dug out from between the roots of trees in swampy areas. This sludge, which is then purified, filtered, and stirred to a thin solution with water, apparently contains fermenting agents and iron-bearing substances. This second color appears deep black in the pot, but spilled on the hand it seems to be completely transparent. Now every line is covered as exactly as possible a second time. A metal or wooden knife is used for this. An insoluble black is formed by chemical reaction, as a result of the fermenting agents and the iron bonding material contained in the mud dye. Through these agents, the color is insolubly combined with the plant fibers. The color chemists call this a mordant dye, and it is interesting to know that in many places country peoples have developed, by empirical observations, dyeing methods that now play an important role in modern dye chemistry. For what good are the most beautiful drawings if they bleach in the sun, or if they are dissolved by water at the first washing?

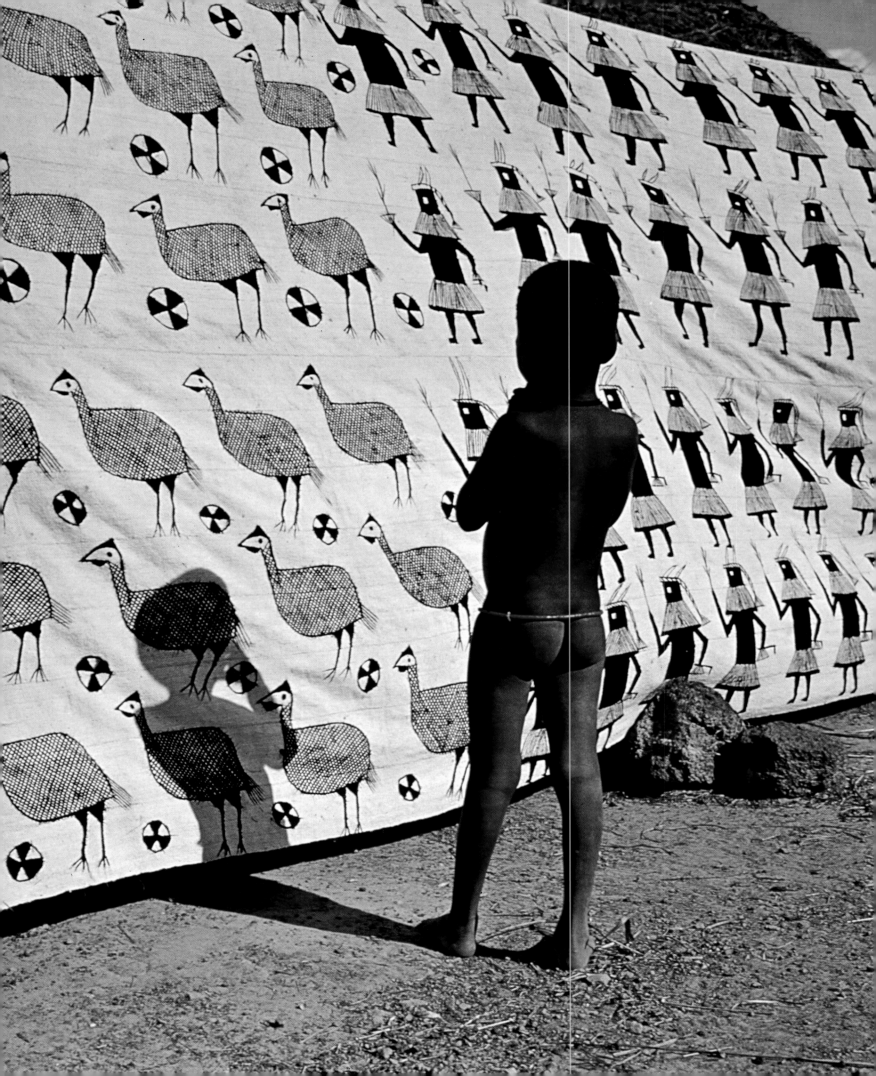

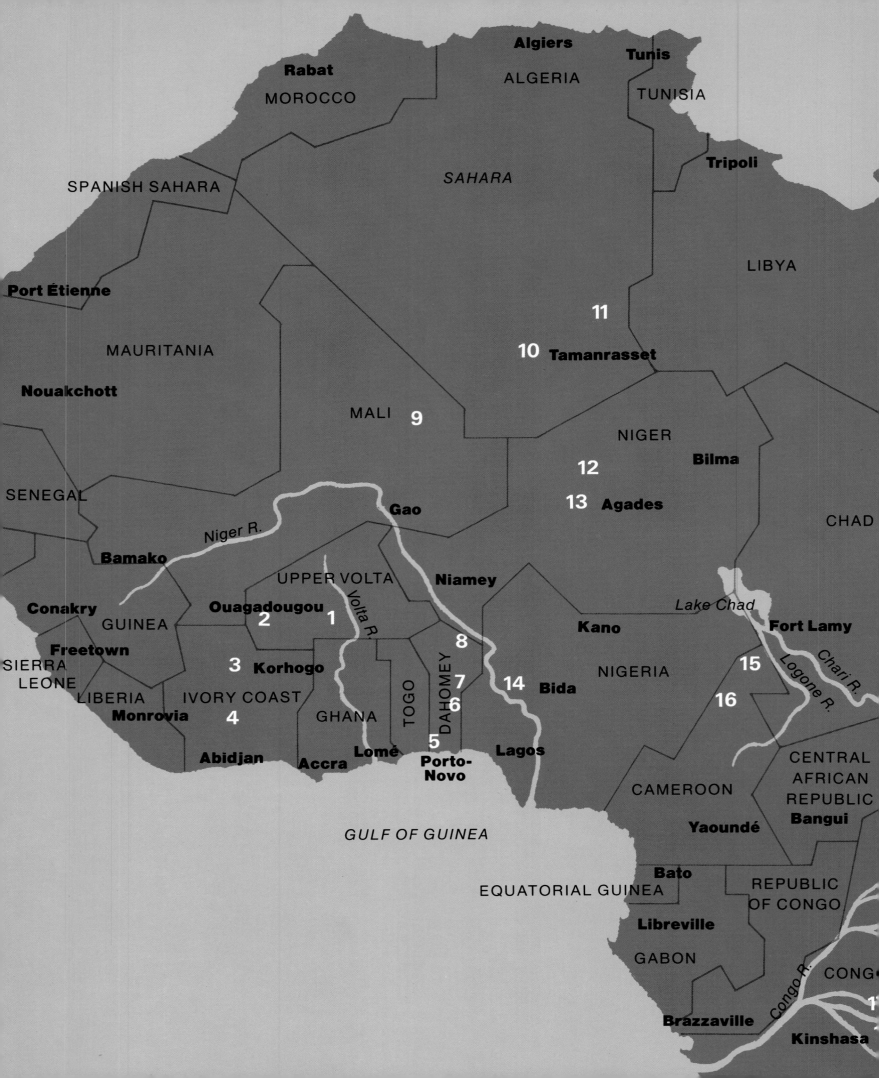

Remarks on the Map. The map at left shows the boundaries, the names of the individual countries and their capitals, and a few rivers as well. The names of the capital cities are different from other place names that are mentioned often in the text. It is entirely impossible to include on a map of this scale all the places mentioned in this book. The numbers have the following significance: each picture, or each group of related pictures, corresponds to one of the numbers, so that the site is more or less easy to locate. But this is only true in a general sense since, for example, the same number is applied to places in northern Ivory Coast that in actual fact are as much as fifty miles apart. On the map, as in the text, the French transcription for place names has as a rule been adopted.

Chapter	Plate number	Place name	Map number	Chapter	Plate number	Place name	Map number
On African Crafts	1	Near Kandi	8	Decorated Parchment Boxes	126-138	Agades	13
	2	Near Malanville	8	Bracelets Made of Stone	139-146	Agades	13
	3	Goffet, Aïr mountains	12	Spinning and Weaving	147	Near Korhogo	3
	4	Djanet Oasis, Sahara	11		148	Poli	16
The "Iron Cookers"	5-11	Near Mokolo, Mandara	15		149	Near Malanville	8
	12	Tourny, near Bobo-Dioulasso	2		150-154	Poli, south of Garoua	16
	13-22	Koni, near Korhogo	3		155	Bimleru, Alantika	16
	23	Tourny, near Bobo-Dioulasso	2		156	Near Bembereke	8
	24-27	Nagbéléquékaha, near Korhogo	3		157	Malanville	8
The Cross of Agades	28-41	Agades	13		158	North of Gao	9
					159	Near Bembereke	8
The Brass-Founders of Korhogo	42-55	Korhogo	3		160	Purchased in Bouaké	4
Dibi Koffi, the Goldsmith	56-57	Collection Hans Schwarzenbach			161-163	Sounsori, near Dikodougou	3
	58-63	Bouaké	4		164	Near Korhogo	3
The Glassmakers of Bida	64-81	Bida	14	Dyeing of Fabric	165-166	Near Bembereke	8
Pots and Pitchers of Clay	82	Market scene, Porto Novo	5		167	Poli	16
	83	Near Mokolo, Mandara	15		168	Agades	13
	84-85	Bimleru, Alantika Hills	16		169-173	Poli, south of Garoua	11
	86-87	Tourou, near Parakou	7		174-176	Bohicon, near Abomey	6
	88	Near Malanville	8		177-179	Korhogo	3
	89	Near Napiélédougou	3	Living History Books	180-184	Abomey	6
	90	Cotonou	5	Figures Painted on Fabric	185-192	Fakaha, near Napiélédougou	3
Real and Fake Masks	91-94	Near Luluabourg	18				
	95	Near Dekese	17				
	96-98	Korhogo	3				
	101	Ouagadougou	1				
	102	Korhogo	3				
	103	Sakete	5				
	104	Korhogo	3				
Calabashes from Wangai	105	Iférouane	12				
	106	Near Malanville	8				
	107	Near Kandi	8				
	108-110	Wangai	16				
	111	Market scene, Parakou	7				
Decorated Leather	112-117	Agades	13				
Haidara, the Saddlemaker	118	Tamanrasset	10				
	119-124	Agades	13				
	125	Djanet	11				

This book did not happen overnight. I occupied myself with its contents, African crafts, on all my travels to the "Dark Continent"—sometimes very thoroughly, sometimes only marginally. Thus, as a result of fifteen African journeys since 1948, the photograph file became even more extensive, and on going through it I would always come upon pictures of craftsmen. And yet a large number of the pictures and the foundations of the text came into being during a long trip in 1968. The only purpose of that trip was to document this planned picture book as thoroughly as possible. It had a precursor. In 1956 I wrote, under the title *The Black Hephaestus,* a monograph on the smiths of the Matakam tribe—those men who still master the art of cooking iron, that is, of producing everyday household iron for their own use.

This time I have tried to describe sixteen different professions in one book. Of course, it was not possible to cram all the art-crafts there are into a single volume. So the specialist will probably find a number of things missing, or be of the opinion that a certain subject got short shrift. But my work is intended above all for the layman, for the reader who is interested in Africa, in the beauty of African art-crafts, and in the basic craft techniques as they were also similarly used among Westerners at earlier periods. Perhaps the anthropologist will also have found things here and there that were not familiar to him, as, for example, in the chapter on glass, or on the making of boxes out of untanned leather.

Africa is big, and I know the Sahara and West Africa best. It could be concluded, from the map on page 240, that the selected pictures come only from a relatively small part of the continent. But even so, the agony of choice was great in trying to select significant photographs from among thousands.

It is mentioned in the text more than once that the old handicrafts are threat-

ened in Africa as they are everywhere. This fact cannot be altered, but only lamented. This book contains a number of pictures that it will no longer be possible to take in a few years. Despite the steadfastness and the obstinacy of many craftsmen, and their resistance to innovation, one day tradition will succumb to technology. The fires in the ovens of the iron-cookers will be finally extinguished, the treadle-looms will rot, the carving knives will rust, and the women will no longer find time to cover their calabashes with super-fluous ornamentation. One traditional craft after the other will disappear, one sooner, another later. So there probably is a point to describing working techniques and photographing the work processes while it is still possible. And the chief value of this book probably lies in showing the African crafts-man in pictorial documents that might soon become rarities. In the forsee-able future, these splendid figures, with all their needs, worries, joys, and stubbornnesses, will live on only in the memory of those who knew them.

Without the help that I found everywhere in Africa, this book would never have come about. And so it is fit that I should thank the administrators and authorities who, although I never asked anything of them, never hindered me in my freedom of movement or my activities. That is rather rare in the present-day world. Above all I have to thank the good-natured craftsmen who patiently answered all the dumb questions, who put up with me, who ac-cepted, in a relaxed way, all the disturbances that photographing brings with it, and who were always helpful in clearing away all obstacles.

But many of these craftsmen friends—insofar as friendship between natives and Europeans is possible at all—I would never have found had it not been for the help of Europeans who had lived in Africa for many years. Through them, contacts were established, and I profited from their knowledge and their experiences, and they knew a thousand things found nowhere in books. It is impossible to enumerate all these people to whom I owe thanks—merchants, technologists, missionaries, educators, and officials. But I would like to mention the missionaries Mr. and Mrs. Eichenberger of Mokolo in northern Cameroon, the teacher Bernard Dudot of Agades in Niger, and the merchant family Escarré of Korhogo in northern Ivory Coast.

Naturally I also have to thank my travelling companions, who did not object to spending the night somewhere under a tree, in a sooty hut, who attended to the expedition vehicle, took care of the *popote,* worked hard, let them-selves be infected by my enthusiasm, but also put up with my moods and did not let themselves be discouraged by any adversities. I further thank the Historical Museum of Bern, which was helpful to me in a number of ways. The book was produced on my own initiative and without any material aid from official sources. Therefore, in conclusion, I heartily thank every buyer who allows me, with his decision to purchase the book, to forge new plans.

René Gardi

Picture Captions

Since the pictures are discussed extensively in the text, these are just a few scant notes for an initial orientation on leafing through the book. The C after a plate number indicates a color photograph.

1	Smith from northern Dahomey.
2	Young Fulbe, northern Dahomey, with a blanket of African origin.
3	Young Targia from the Aïr mountains braiding bands of palm-leaf fibers from the Dum palm. The bands are sewn together into mats for tent covers.
4	Sahara nomads playing a favorite game.
5-11	*Iron production in the Mandara Hills of northern Cameroon; Matakam tribe.*
5	Farm tools of the Matakam; hoes and sickles made out of their own iron.
6	A harp-player sits by the oven next to the bellows operator.
7	The pipe that conducts the air down from the bellows to the oven.
8	A smith named Truada brings a blood sacrifice to his oven.
9	Slag is scratched out at regular intervals.
10	The result, the big puddle, lies in front of the opened oven.
11 C	The sacrificed chicken is roasted at the hot oven.
12 C	A reduction oven with puddle iron (foreground) in Tourny, a small village in southwestern Upper Volta.
13-22	*Obtaining iron among the Senufo, northern Ivory Coast.*
13, 14	Magnetite-bearing soil is brought up out of deep shafts.
15	An old Senufo, the guildmaster of the smith village of Koni.
16 C	Washing the ore out of the red laterite soil.
17 C	The iron ore is formed into balls.
18	The reduction oven of the Senufo. The opening is at the lower right, where the smith crouches.
19	Preparations for the firing. First, dry grass is burned.
20	Making the clay air-pipes; six of them are needed for each production process.
21	Two air-pipes are built in; the opening is walled up.
22	The oven is supplied from above with charcoal.
23 C	Smith's workshop in Tourny, Upper Volta.
24 C	Senufo smith in his workshop, vicinity of Ferkessedougou, Ivory Coast.
25	The smith's son with the great bowl bellows.
26, 27	A large, very worn hoe is patched and lengthened with kernels of iron.
28-41	*Production of silver ornaments by a Tuareg smith; near Agades, Niger.*
28 C	Targia woman, richly ornamented with silver crosses, in festival dress.
29 C	The smith Mohammed Umama casting.
30	Mohammed's primitive workshop in the desert, about two or three miles from Agades.
31	First the cross to be cast is shaped out of beeswax.
32, 33	The wax models are covered with clay; then the wax inside is melted and poured out again. Thus the mold is prepared.
34	Two Maria Theresa talers, coins that are still in circulation, are melted down in the crucible.
35	The liquid silver is poured into the mold.
36	Mohammed breaks the mold. Next to him is his apprentice, his son Sidi.
37	The cast pieces are cleaned in a hot bath of natural salt.
38	The silver cross is ornamented with fine engraving.
39	A customer sits next to the smith and orders jewelry. Mohammed works only on commission, not to build up a supply.
40	A few examples of silver crosses as they are produced at Agades and other places.
41 C	Mohammed engraves an Agades cross.
42-55	*Brass-founding in Korhogo, in the land of the Senufo, Ivory Coast.*
42 C	A wax mask is modelled over a clay core.
43	Shaping small figures for the lids of pitchers.
44	Wax pitchers with hollow clay cores. They are upside-down and the casting cords have already been attached to the bottoms. The figures shown in plate 43 are on the lids.
45	The wax model is covered with a fine clay paste.
46	The workshop under a tree in an outlying quarter of the city of Korhogo.
47	The clay used for the molds is ground to a fine consistency.
48	The wax is melted out of the mold.
49	A funnel has been built up over the casting channels. It is filled with scrap metal for the casting.
50	The funnel, mounted above the mold.
51	As soon as the metal is packed in the funnel is closed with clay.
52	The form is placed in the smelting oven in such a way that the clay ball with the metal inside is at the bottom.
53	After melting down, the form is taken out and turned over. The metal then flows downward.
54	After cooling, the form is broken.
55 C	Senufo caster shaping a wax mold.
56, 57 C	Old Ashanti and Baule goldweights made of brass.
58-63	*The goldsmith Dibi Koffi in Bouaké, Ivory Coast.*
58	View of the little smithy.
59	The goldsmith makes thin threads of wax on his moistened workboard.
60	A gold pendant is to be made. Koffi winds the thin wax threads into a delicate spiral.
61	Tiny wax birds are set along the axis. The axis will be hollow after the casting.
62	The very delicate wax model is covered with a fine paste of charcoal and clay.
63	The oven is guarded by a fetish.
64-81	*On the production of glass beads and bracelets in Bida, Nigeria.*
64 C	Colored glass beads from Bida; they are now made out of European bottle glass.
65 C	A boy of the Nupe tribe offers bracelets and beads for sale.
66	In the Massaga quarter, the glassmakers' guild in the Nupe city of Bida.
67	A Massaga at work in front of the glowing hot oven.
68	An old glass bracelet from the Orient.
69 C	Glass bracelets from Bida, as they are made today: seamless and with flat insides.
70 C	Celtic bracelets from the vicinity of Bern, Switzerland: also seamless and with flat insides.
71 C	A Massaga at work at the oven.
72	View of a glassmaker's workshop. After a watercolor from the year 1911, by a colleague of the anthropologist Leo Frobenius.
73	My photograph, taken about fifty years later, shows a remarkable similarity.
74	The tools: tongs; flat, broad knife; iron rods. Behind the protective matting sits the bellows operator.
75	The bowl bellows is common throughout the entire Sudan.
76	Soft glass is wrapped around the iron rod.
77	The profile is pressed in with a knife and tongs.
78	The glass wrapped around the rod is stretched out over the fire with the tongs.
79	The bracelet, still hot and soft, is shaped.
80	The finished bracelets are left in wood ashes to cool.
81	A dealer offers glass beads, bracelets, and little snakes for sale.
82-90	*On the art of pottery-making.*
82	Cheap cooking pots; market scene in southern Dahomey.
83	Matakam woman from Cameroon building up a pot with the coil technique.
84	Pot from the Alantika Hills, Cameroon. It is smoothed with a piece of damp leather.
85	Koma woman, Alantika Hills. A bowl is used in place of a potter's wheel. The pattern is the result of rolling braided material along the surface.
86, 87	Woman from a little village near Parakou, Dahomey, shaping figures for a large cult lamp.
88 C	A Dindi woman from Malanville on the Niger painting a large water jar with ochre colors.

59743

OVERSIZE

GARDI, RENÉ

AFRICAN CRAFTS AND CRAFTSMEN.

TT
119
W4
G313

DATE DUE

Fernald Library
Colby-Sawyer College
New London, New Hampshire

GAYLORD

PRINTED IN U.S.A.

PRINTED IN U.S.A.

23-520-002